POSTER TO POSTER

Railway Journeys in Art Volume 2: Yorkshire and the North East

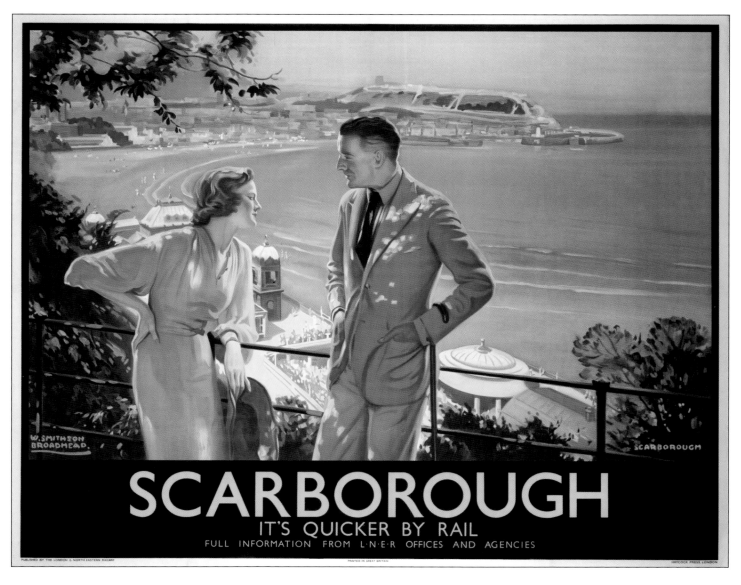

Richard Furness

Published by JDF & Associates Ltd

Rydal Water, The Old Pitch

TIRLEY, Gloucestershire GL19 4ET UK

First Published MMX

This Book is produced under licence for the National Museum of Science and Industry Trading Ltd. Royalties from the sale of this product help fund the National Railway Museum's exhibitions and programmes.

ISBN Number 978 0 9562092 1 4

A catalogue record for this book is available from the British Library

Layout/Graphics Design: Amadeus Press (Steve Waddington)/Richard Furness

Printed in England by

Amadeus Press, Cleckheaton, West Yorkshire BD19 4TQ

Bound in Scotland by

Hunter & Foulis, Haddington, Scotland EH41 3ST

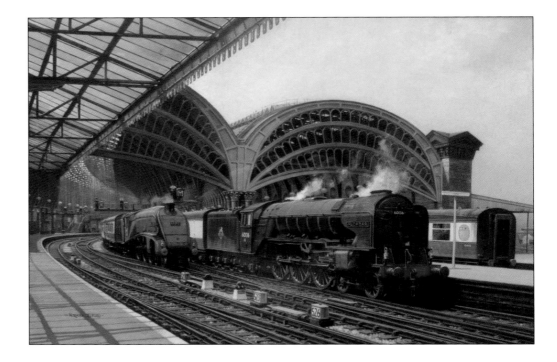

A1 and A4 Pacifics at York: Artist Norman Elford GRA (1931-2007)
Author's Collection

The National Railway Museum at York is the largest railway museum in the world. Its permanent displays and collections illustrate more than two centuries of British railway history, from the Industrial Revolution to the present day. The vast NRM archives also include a fabulous collection of railway advertising posters, charting the history of rail. Researchers can access this priceless collection via the new Search Engine.

Visit www.nrm.org.uk to find out more.

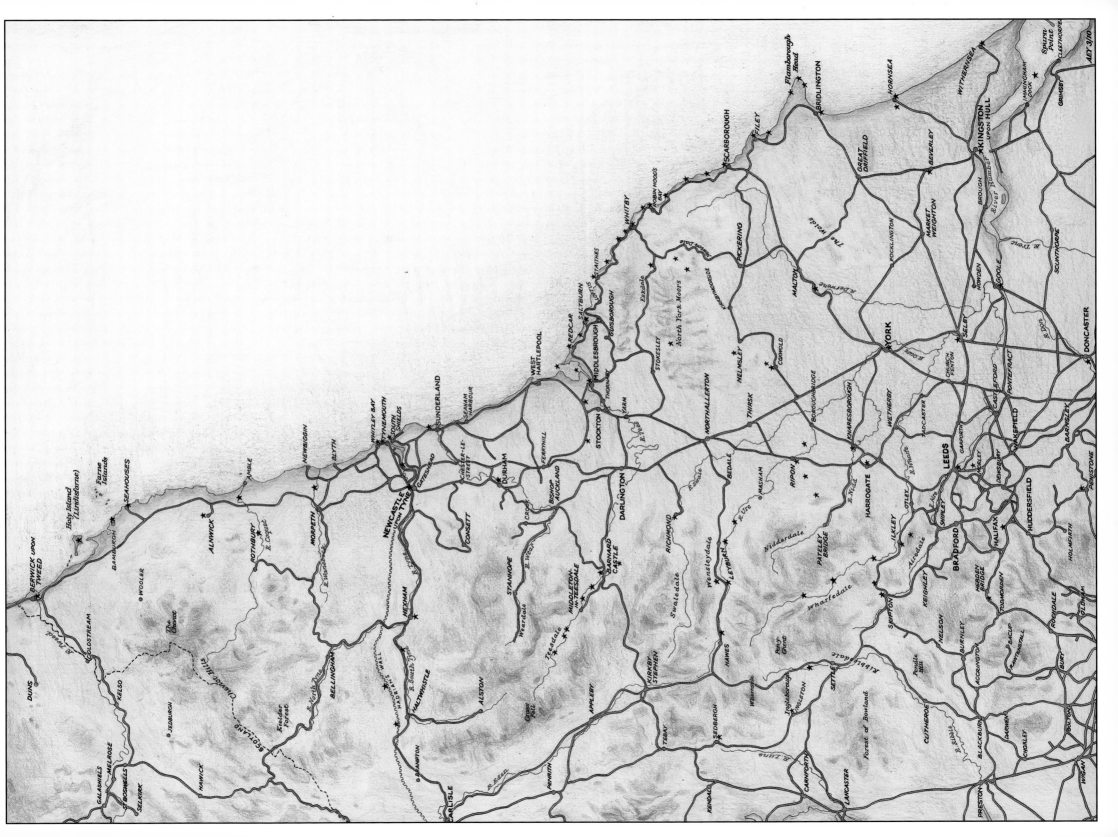

Map of Northumberland, Durham & Yorkshire by Alan Young

Abbreviations

Throughout this book, abbreviations are used aplenty. Many of the railway fraternity are well versed with these, but maybe the art market is less so. This short list explains these; with only those relevant to the area covered being included.

AONB Area of Outstanding Natural Beauty (Yorkshire Dales and Moors for example)
BR British Railways (formed 1st January 1948)
BR (CAS) Central Advertising Services (of British Railways)
BR (CPU) Central Publishing Unit (of British Railways)
BR (NER) North Eastern Region (of British Railways)
ECML East Coast Main Line (Kings Cross-Edinburgh via Grantham, York, and Berwick)
GNR Great Northern Railway (Pre-1923)
LMR London Midland region (of British Railways)
LMS London Midland &Scottish Railway (1923-1947)
LNER London North Eastern Railway (1923-1947)
LYR Lancashire and Yorkshire Railway (Pre-1923)
MR Midland Railway (Pre-1923)
NER North Eastern Railway (Pre-1923)
NRM National Railway Museum, York
SSPL Science and Society Picture Library, London
WCML West Coast Main Line (Euston to Glasgow Central via Stafford and Carlisle)

Maps Indicating the Poster Locations

At the start of each of the first nine chapters, readers will find a poster location map to help us on the route. The red stars on each map refer to posters included in that part of the journey: the **black stars** refer to posters used in other chapters. The aim was to try to cover the entire region in art, as summarized by Alan Young's hand-drawn map of the three counties featured at the start of this Volume. Some of the posters have not been located exactly: therefore some of the stars may have been located slightly incorrectly. The majority however are correct.

CHAPTER 7 Moors and Dales

CHAPTER 10 Marketing Yorkshire and the North East

Appendices

ACKNOWLEDGEMENTS

The production of this Volume has been made possible by many people, some who have supported throughout, and others at various key stages. It is therefore right and proper to acknowledge their help during the eight years this book has taken to develop, write and publish. It would not have been possible at all without the commitment from the National Railway Museum. At York, former Curator of Collections **David Wright**, encouraged me right at the start, but the actual development of this Volume has been supported all along by Curator **John Clarke** and Deputy Director **Helen Ashby**. In London, Publishing Executive **Deborah Bloxam** and Image Sales Executive **Tom Vine** have both given me first class support throughout. As with Volume 1, **Patrick Bogue** gave constant encouragement, and has provided some images. **Alan Young** (who helped with the '*Book of Station Totems*' and with Volume 1 of this series), has again produced all the superb hand-drawn location maps found throughout the book.

I was delighted that the renowned TV broadcaster **Paul Atterbury** agreed to write the Foreword. Paul is internationally known in the world of antiques, and has a particular interest in all railway artefacts, but regularly gives professional opinions on railway posters on the BBC's *Antiques Roadshow*.

The database information in Appendix B, the first of its type ever attempted for this region, is down to literally thousands of hours spent by **Valerie Kilvington**, son **Simon** and myself over many years. We have gone through hundreds of auction catalogues (where we could find them), trawled the Internet, spoken to experts and collectors alike, to try to amass as much information as we could on railway posters for the region. Val and Simon have been instrumental in all the database support work that is an essential part of this work. We plan to keep the enormous database up-to-date (in real time) and my sincere thanks go to them for great support. **Greg Norden** has also assisted with artist information and with some carriage print images. Please go to page 277 to see how to continue your artistic journeys.

Literally hours of chapter checking and proof reading has again been undertaken by **Belinda Brennand** and technical checking was the province of **Mike** and **Judy Fish**. In the railwayana world, I have to mention **Tony Hoskins** & **Simon Turner** at GWRA, Pershore, **David Jones** & **Mike Soden** at GCRA, Stoneleigh and **Chris Dickerson** at SRA, Derby, all of whom have provided information and support at various stages throughout. As well as the Onslows data, some pictures and information came from **Nicolette Tomkinson** at Christies and **Joanne Hardy** at the Bridgeman Art Library, both in London. I also have to mention **Elizabeth Pepper-Darling** (at Morphets in Harrogate) who has supplied much information via the Malcolm Guest Collection, recently auctioned. **Terry** and **Andrea Buckle** have provided data and images of some of Claude Buckle's wonderful artwork. **Gabrielle Jandzio** from Scarborough Borough Council gave permission to use poster collage images from their poster book of 1990 and helped clear copyright. In the final production stages, Amadeus Press provided endless support: **Richard Cook**, **David Crossland** and anchor man **Steve Waddington** (who undertook all the digital cleaning) are responsible for the final quality of the Volume. Thank you all for helping to make this book a real pleasure to write and publish.

The final and the greatest thanks go to my wife **Judi,** who has patiently put up with my long hours on the computer over many years. Her critical eye and influence is always there. She chose the cover images for this Volume and helped with the selection, ordering and layout of all the posters throughout, so this is really her book as well!

Railways are deeply woven into the fabric and history of the Yorkshire and the North-east of England. The railway age started here early in the nineteenth century and since then a litany of great railway names have been associated with the region, from Doncaster to Newcastle and from the Stephensons to Sir Nigel Gresley. As a railway enthusiast growing up around suburban London in southern Britain in the 1950s, I was familiar with all of this, but it was well outside my actual experience. My world was limited to Southern Region trains running in and out of Waterloo, Charing Cross and Victoria. As a child, I never went to Kings Cross. Later, in my early twenties, I made my first visit to the north east, and fell in love with the region's landscape and history. Other trips followed, usually in my elderly Bedford van, and bit by bit I came to discover the rich architectural legacy and landscape delights of Yorkshire, County Durham and Northumberland. By that time my railway interests had broadened into a more general enthusiasm for Britain's industrial history, and so trains had ceased to be the focus of my life. However, they never disappeared completely and I remember on one of these trips in 1968, driving down a winding road into a glorious valley that seemed to have come straight from a poster, and seeing a dirty steam locomotive drifting over a bridge at the head of some old goods wagons. I knew at the time that it would probably be my last sight of main line steam on the British Railways network, and it was.

At that time I was working as a graphic designer and had begun to look properly for the first time at the transport posters of the 1920s and 1930s. As a student I had been taught by Tom Eckersley, without realising, to my shame, that he had been a great poster designer! I was constantly amazed by the quality of the graphic images, the originality of the artists and their pictorial vision. At the same time, I was developing a passion for landscape that has never left me. I found a couple of London Transport posters in a London street market, but the great discovery was an LNER poster with a striking picture of Norwich cathedral by Charles Ginner, found for 50p in Norwich market, within sight of the cathedral itself. I soon began to appreciate that, even in railway posters, there was an artistic hierarchy, with names like Fred Taylor, Norman Wilkinson, Tom Purvis, Frank Mason, Frank Brangwyn and Frank Newbould standing out from the crowd. However, what I enjoyed above all else was the relationship between the posters and the landscape, and particularly the wonderful landscapes of the North-East and Scotland. Time and again, I saw images that brought to life in remarkable ways my own memories of the countryside, architecture, towns, resorts and industry of that region.

The transport posters of the inter-war period seemed to me to represent an actual fulfilment of that old Victorian dream, the marriage of art and industry. Forward thinking businesses with an imaginative approach to publicity, notably the 'Big Four' railways, the GWR, the SR, the LMS and the LNER, and London Transport, along with shipping lines and petrol companies such as Shell, commissioned posters from the leading artists and designers of the day, in an explosion of corporate patronage probably unmatched in the history of British art and design. It took me, and I suspect others, a while to appreciate that this marriage lived on into the post-war world of the 1950s and 1960s, with the newly-nationalised British Railways initially maintaining the artistic poster tradition.

Over the years, visits to the north east took me in many directions, introducing me to the North Yorkshire moors, to the coast from Scarborough northwards to Whitby (always a favourite place) and then onwards to Berwick and the Border. I also visited Durham, the Tyne and the Tees, the quieter coastal towns of East

Yorkshire, and the classic towns and cities, York, Harrogate, Leeds and Newcastle. Many journeys were by car but I have also travelled on most of the railways that still serve the region. The East Coast main line northwards from Durham and Newcastle is something I always enjoy, and one of Britain's great railway journeys. Another favourite is the Eskdale Valley line to Whitby, an extraordinary survival and the only way to enter that great port. In the course of research for my railway books, I have also explored on foot some of the lost railways of the region, lines remembered by their physical traces on the ground and by posters that promoted them during their heyday.

My work for the *Antiques Roadshow* has also brought me into contact with an interesting variety of railway posters. There have been a number of classic Cuneos, but more memorable have been two great collections discovered in cupboards, untouched since they were received from the railway publicity offices decades earlier. Both included remarkable examples from the north east, including charismatic designs by Tom Purvis and a wonderful image of the Flying Scotsman winding its way through a northern landscape. I am rarely acquisitive about things seen on the *Roadshow*, but that is a poster I should have loved to take home.

Actually I have never been a poster collector, merely owning a few that luck brought my way. I have, therefore, long been able to enjoy, without any sense of envy, the great collections held by the NRM, and other museums, even though the percentage of those collections ever on display is small. There have also been various special exhibitions and, from the 1980s, posters began to be sold regularly at auction. All this began to reveal the extraordinary wealth and diversity of railway posters. Books began to appear but, by their limited nature, they could never be comprehensive. There was also little attempt at linking posters to particular parts of Britain. For this reason I am delighted to be associated with this series and with this volume in particular. The posters included herein represent for me a journey through treasured memories, of places I have seen, and of great images by exciting artists and designers. The North-East of England gave us the railways, and some of the best railway posters.

--

Part of my Favourite Railway Poem ***"The Night Mail"*** **by W.H. Auden (1907-1973)** Born in York

This is the Night Mail crossing the border,
Bringing the cheque and the postal order,
Letters for the rich, letters for the poor,
The shop at the corner and the girl next door.
Pulling up Beattock, a steady climb:
The gradient's against her, but she's on time.
Past cotton-grass and moorland boulder
Shovelling white steam over her shoulder,
Snorting noisily as she passes
Silent miles of wind-bent grasses.

Birds turn their heads as she approaches,
Stare from the bushes at her blank-faced coaches.
Sheep-dogs cannot turn her course;
They slumber on with paws across.
In the farm she passes no one wakes,
But a jug in the bedroom gently shakes

Dawn freshens, the climb is done.
Down towards Glasgow she descends

Towards the steam tugs yelping down the glade of cranes,
Towards the fields of apparatus, the furnaces
Set on the dark plain like gigantic chessmen.
All Scotland waits for her:
In the dark glens, beside the pale-green sea lochs
Men long for news.

Letters of thanks, letters from banks,
Letters of joy from the girl and the boy,
Receipted bills and invitations
To inspect new stock or visit relations,
And applications for situations
And timid lovers' declarations
And gossip, gossip from all the nations,
News circumstantial, news financial,
Letters with holiday snaps to enlarge in,
Letters with faces scrawled in the margin,
Letters from uncles, cousins, and aunts,
Letters to Scotland from the South of France,
Letters of condolence to Highlands and Lowlands
Notes from overseas to Hebrides
Written on paper of every hue,
The pink, the violet, the white and the blue,
The chatty, the catty, the boring, adoring,
The cold and official and the heart's outpouring,
Clever, stupid, short and long,
The typed and the printed and the spelt all wrong.

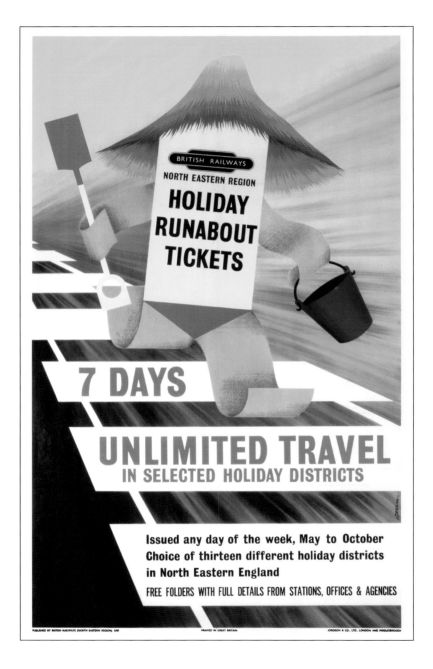

Opening Remarks

This second Volume in the series sees us in the North-East quarter of England. This really is the home of railways, even though locomotives were designed and built at Coalbrookdale, Shropshire and Pen-y-Darran, South Wales before the momentous events from 1811 onwards. In some respects, this area is similar to Scotland, which we visited in Volume 1. Historically it had grown up almost as its own kingdom. There is a culture and a language that somehow seems slightly different to the rest of the UK. 'Geordies' and Yorkshiremen are instantly recognized as soon as they begin to speak – just like the Scots. In this Volume we are travelling from Berwick-upon-Tweed to York, via historical, scenic and industrial images – just as in Volume 1.

Some Railway History

The story of the North-East railways begins not at Stockton & Darlington – though we shortly come to the Stephenson's – but to a small colliery near Leeds. This was run by John Blenkinsop, who was born on Tyneside in 1783. Coal was moved by horse-drawn vehicles running on wooden rails, but Blenkinsop had other ideas, having invented the rack & pinion system to improve adhesion in 1811. The Middleton Colliery owners authorised him to build a locomotive, following Trevithick's success in South Wales.

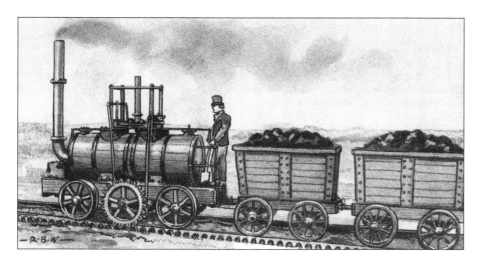

Blenkinsop's 1812 Middleton Colliery Locomotive – *"The Salamanca"*

Blenkinsop approached Matthew Murray (also born on Tyneside), who had patented a two cylinder steam engine and had separately patented sliding valve gear, both in 1802. The Blenkinsop-Murray partnership was to have profound effects on steam engines. Combining all their inventions produced the locomotive shown below left. This first appeared in 1812, more than a decade before George Stephenson produced his famous engines. The North-East can therefore still lay claim to the title *'The Birthplace of Railways'*.

The Middleton Railway was the first to be granted powers by Act of Parliament in 1758 to carry coal from the colliery to Leeds, and ships on the River Aire. The line was built to a gauge of 4ft 1" (1.245mm), but in 1881 it was enlarged to standard gauge 4ft 8 ½" (1.435mm). Blenkinsop took his flat rails and turned them into cast iron upright lines with teeth on one of the rails. (A central rack was not possible because horses were still used). Murray's engine had two vertical cylinders which drove crankshafts connected by gears to the rack wheel, which was mounted on the left hand side of the engine. Notes from the time by Blenkinsop said the 'engine could do the work of 16 horses' and proved an immediate success, though rack systems do not seem to have been favoured by other designers of the time.

Blenkinsop believed that smooth rails would never give enough grip, so he never tried to build engines without rail gears. Time was to prove him wrong, as in 1813, 'Puffing Billy' ran on smooth rails with no gears, pulling a load of 50 tons at more than five miles an hour. However, Blenkinsop's engines were a success and eventually the 3.5 miles of lines had four engines that worked well until 1831. They weighed around five tons each and cost in the region of £400. Some 20+ wagons could be hauled at a steady three miles an hour on level track. This meant the engines were hauling 80 tonnes of coal per trip. But even before these events, records at York show there was a myriad of wagon-ways in all parts of the north-east. As early as 1671, Sir Thomas Lyddell had laid a wagon-way from Ravensworth colliery to the Tyne. Tanfield and Beamish were two more important wagon-ways in Durham, and today this industrial heritage is preserved at both those sites. Indeed Beamish has developed into a social museum, where life sciences relating to the development of the North-East can be studied at close quarters.

Over the next 100 years these infantile railways grew apace, and it soon became clear that horse-drawn wagons could not convey coal quickly enough. The development of mechanised transportation began purely out of the necessity to make more money.

Soon railways moved from coal, minerals and general freight towards passengers. Rich industrialists realised that there was a lot of money to be made in transporting people. One of George Stephenson's first engines was the *'Locomotion'* which took to the rails in 1825, and is depicted in the 1925 poster below.

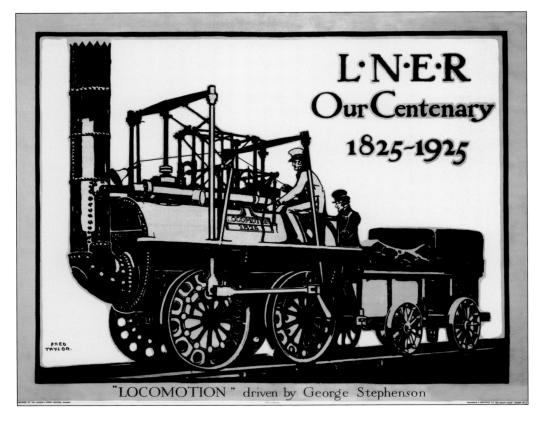

LNER 1925 Quad Royal Poster Showing Stephenson's '*Locomotion*': Artist Fred Taylor

Stephenson's locomotive firm was formed in 1824. The first engine was finished in September 1825 and was initially called *'Active',* (but later named *'Locomotion'*). It was similar in design to those produced for the collieries at Killingworth and Heaton. The boiler had a single fire tube and two vertical cylinders let into the barrel. The four driving wheels were coupled by rods and not chains, as Taylor's 1925 poster for the LNER Centenary shows above.

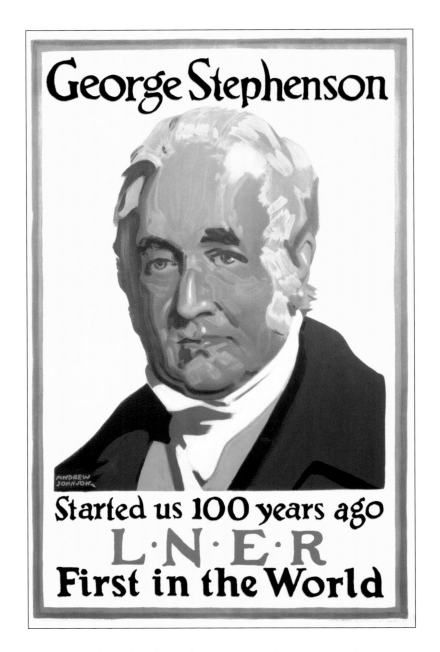

The 'Father of Railways': 1925 Poster by Andrew Johnson

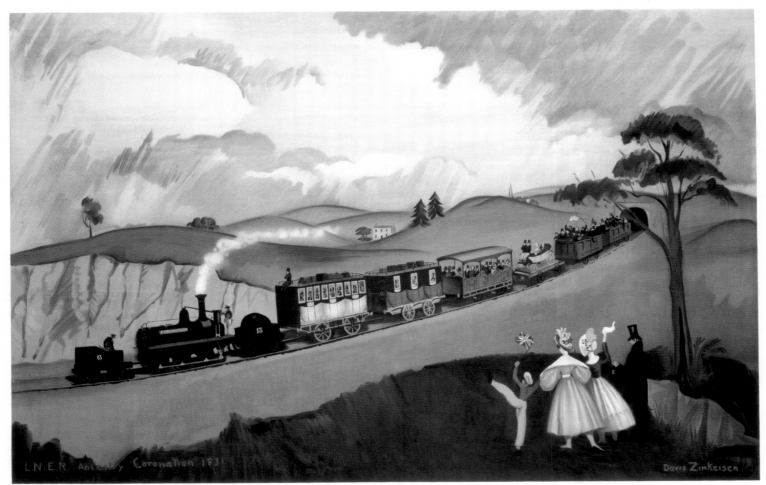

1937 LNER Poster Celebrating the Forerunner of the Famous LNER Train Service: Artist Doris Claire Zinkeisen (1898-1991)

The railways developed at breathtaking speed, as both track and locomotive technology improved. One of the names that frequently crops up is that of Timothy Hackworth, a member of Stephenson's staff. He was born at Wylam in 1786 and lived a large portion of his life at Shildon, County Durham (now home to the NRM's extension collection). He was loco superintendent of the Stockton and Darlington Railway, but was a notable engineer in his own right. His engine *'Sans Pareil'* was a Rainhill Trials entrant, but it was Stephenson, with his famous *'Rocket'*, who won that contest.

Nevertheless, Timothy Hackworth is also remembered in railway posters, as this 1937 painting by Doris Zinkeisen (see page 19) shows. In 1831 he built a locomotive in honour of William IV's Coronation' and this famous locomotive name was then set firmly into railway folklore. In 1836, from his Shildon factory, he built the first locomotive that ran in Russia (for the St. Petersburg Railway), and in 1838, his *'Samson'* was produced for the Albion Mines in Nova Scotia. (This was the first engine to run in Canada).

The poster shows a six-coupled engine hauling both closed and open carriages. It was amazing how far railways had developed in the 20 years since John Blenkinsop's *'Salamanca',* with both speed and hauling capacity greatly increased.

North Eastern Advertising

The richness of North Eastern railway history has been covered in many books and papers and is beyond the scope of this railway poster book, but I cannot pass without reference to two of the many posters in the National Railway Museum. These are shown alongside. Most early railway posters were informative and not at all colourful: the techniques of lithography were not even invented in the 1840s. However, the area's railway heritage meant that a lot of informative posters were produced and the two examples here are merely representative.

The Newcastle and Carlisle Railway (known as the Tyne Valley Line) was built in the 1830s. The 60 miles (100 kms) was inaugurated on 18 June 1838, so the first poster here is dated just over seven years from the start of the railway. It allowed the Company to participate in non-railway events and in the early days of railways, it was clear such powerful organisations were going to influence all aspects of the area's development.

The second poster, again informative, is meant to show the rich railway heritage of the North-East of England. This is advertising the sale of steam engines via the Secretary of the Stockton & Darlington Railway. These were all static engines, but the important point is the horsepower rating. The Brusselton Engine in particular is an excellent example of the influence the many great engineers from the North-East had on British development as a colonial power. This is what is missing today from our world influence. Our engineering and manufacturing prowess has recently gone through a period of rapid decline, and the UK is all the poorer because of it.

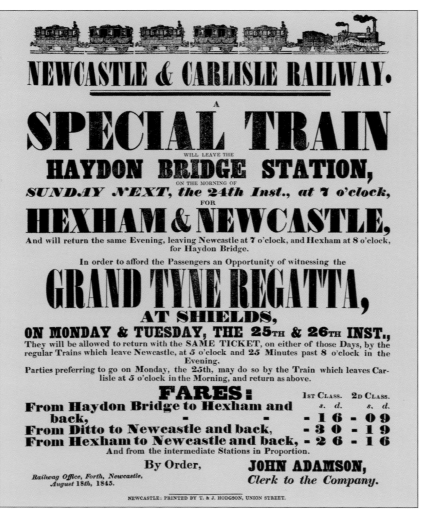
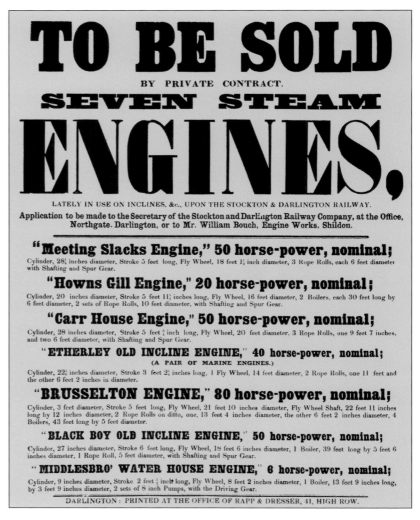

Two Victorian Railway Posters Relevant to North East England Railway History from the National Collection York

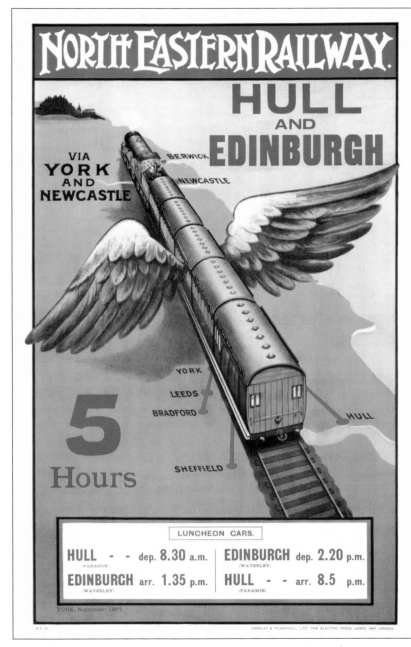

1907 Poster Advertising NER Services: Artist is Unknown

In the late Victorian/early Edwardian period, lithography had moved on greatly and artists were used to replace the dull, informative 'letterpress' type posters. Now we start to see creativity and flair entering railway propaganda, and at that time nobody was better than the North Eastern Railway Company. Many people believe imaginative posters appeared when the 'Big Four' were formed in 1923, but these two show that this is not true. The poster alongside dates from 1907 and shows a flying express between Hull, York, Newcastle and Edinburgh. This type of image was to surface again when Teasdale took over as Publicity Manager of the newly formed LNER, but the seeds of the future were already present in NER and GNR posters. This superb 1913 artwork below would not be out of place today, and a century has not dented its appeal or message. I love the luggage label on the dog's collar. This is real artistic flair. These two are magical posters, typical of the rich treasures at the NRM that I have been fortunate to choose from.

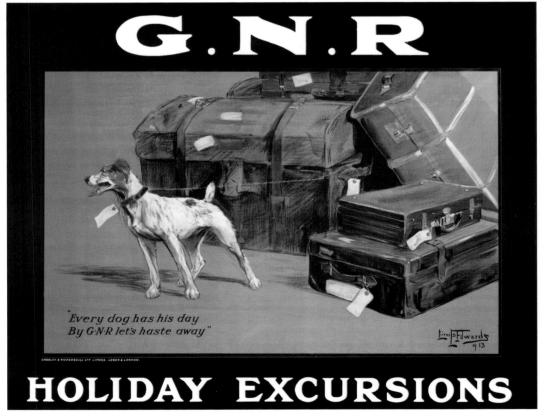

1913 GNR Poster Advertising Holidays to the North-East: Artist Lionel Edwards

If anybody needed further proof of the lead the NER had in commercial art, these two gems should provide it. Below is a quite stunning piece of commercial art. As we will see in Chapter 4, some of the best railway posters ever made were devoted to travel to Scarborough. This is one of the earliest, dating from around 1910, superbly painted by J.F. Woolrich. The colour, composition and subject matter was rarely matched for many years. Even today, such a poster is highly sought-after.

The double royal poster alongside was painted two years earlier by an artist we currently know nothing about. The tranquillity and solitude advertised is highlighted by the muted palette and calmness of this poster. It is only when posters such as these are compared against later, more contemporary works, that the true artistry of some of the seemingly mundane posters produced around this time becomes apparent.

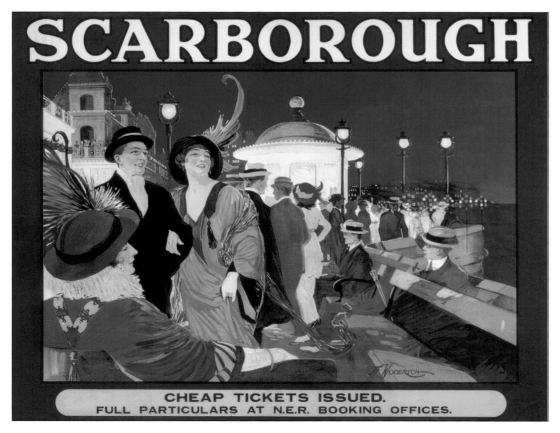

NER 1910 Quad Royal of Scarborough Elegance on the Promenade by J.F. Woolrich

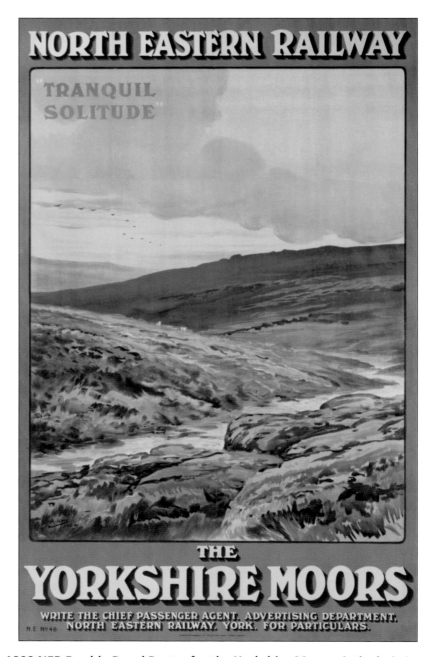

1908 NER Double Royal Poster for the Yorkshire Moors: Artist is A. Ions

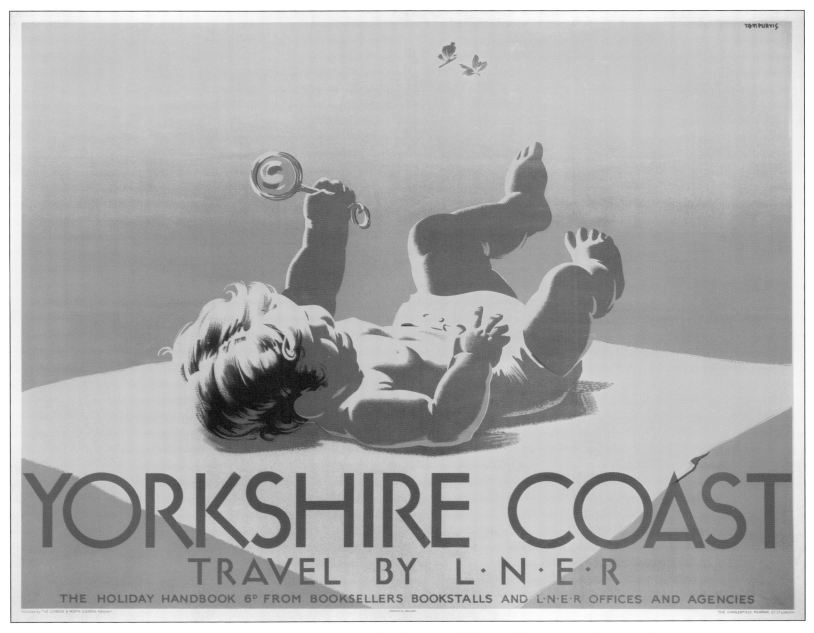

Powerful Late 1920s LNER Poster Advertising Yorkshire Holidays: Artist Tom Purvis

The LNER Makes Its Mark

The NER was in many ways the first advertising leader, so when the railway companies were amalgamated in 1923 to form the LNER, advertising already had a firm base. What was needed was a man of vision, and this came along in the form of William Teasdale. He had been influenced by the London Underground's styles (and the work of Frank Pick in particular), so on his appointment as the LNER's Chief Publicity Officer he knew exactly where he was going.

As a result of his vision, those artists commissioned to create his LNER message were unconfined. Take the work of one of his favourites, Tom Purvis. The poster here appeared in the late 1920s, but only a visionary would think of publishing a large poster in sunshine colours of a baby lying on its back on the beach!

Teasdale (and his successor Dandridge) used posters in a direct way. Images were bold, large and distinctive. All the many quad royals we will see throughout this Volume are powerful, and the 'Golden Age' for the LNER was actually between 1925 and 1939. These 14 years saw some fabulous examples of commercial poster art (as here). They ranged from abstract to the classical; from monochromatic to very colourful, but all had the same message – the LNER is here and we are the best!

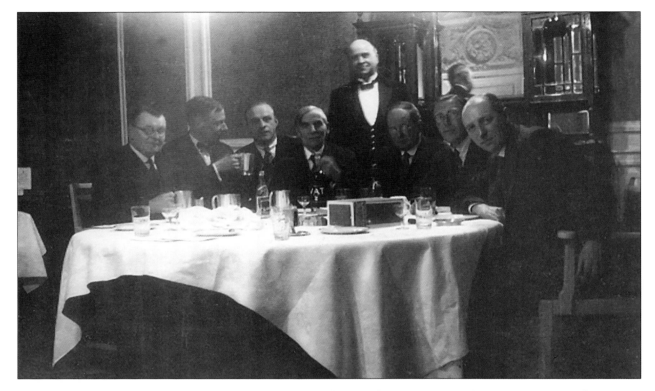

The Great LNER Artists Meet – London March 1928 (Courtesy Patrick Bogue – Onslows)

Teasdale developed the first *'Artists' Superteam'*, almost like Real Madrid today buying the best players to try to conquer the football world. FC Real may not have succeeded – yet, but in the 1920s, Teasdale's team did conquer, even though the LMS had recruited Royal Academicians as the core of their advertising campaign. The significant photograph above, from Patrick Bogue's Library at Onslows, shows Teasdale (centre) sitting with his assembled masters. Alongside is their dinner menu, signed by Austin Cooper, Frank Newbould, Frank Mason and Fred Taylor. Along with Tom Purvis, they formed the backbone of a quite fabulous era, and all through this volume are classical examples of their work.

The LNER relied on freight haulage for a large proportion of its income. Some of the largest coalfields, steel and woollen mills were found in this area, so Teasdale devised industrial posters that fitted with the glamour, pizzazz and glitz of his perception of the premier railway. On page 9 is a small selection of industrial adverts, painted by some of the 'Big Five' shown above. Teasdale expected his artistic team to glamourize any subject he thought appropriate to the wellbeing and best image of the railway.

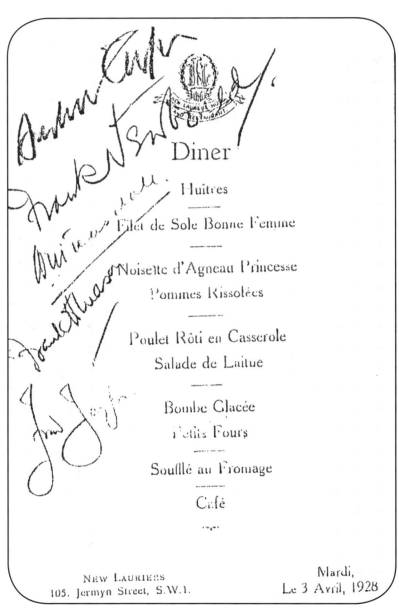

The Great Artists' Signatures – and their 1928 Dinner Menu

(Courtesy Patrick Bogue - Onslows)

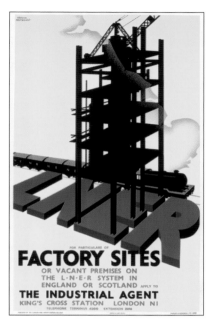

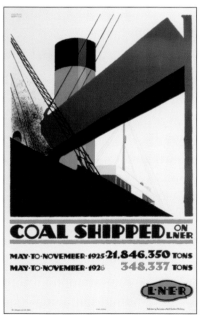

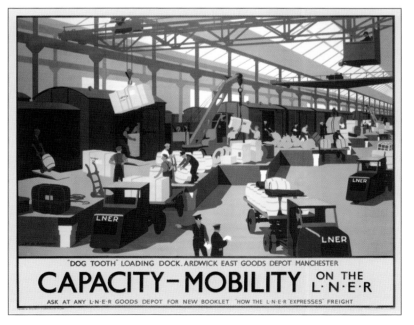

The quad royal showing the LNER's Manchester Depot is a very good example of industrial art. However, as we will see in Volume 8, this domain may have been started by the LNER, but the three rival companies soon caught up. The LNER worked hard with their industrial customers and, as we saw on page 189 of Volume 1, even their posters of boring performance matrices were presented in a way that the Microsoft Excel graphs of today have struggled to meet.

BR & Recent Portrayals of the North East

British Railways carried on the tradition of colourful adverts, which will be discussed in more detail in Chapter 10. Yorkshire and the North East can be cold and forbidding places in the depths of snow storms sweeping in from the North Sea, but the spirit of the people has always been traditionally strong. During our journey through this area we will see wonderful posters spanning the whole history of railways

After the decision to nationalize the Big Four companies on January 1st 1948, the newly formed British Transport Commission decided to sever all contracts with external advertising agencies and companies and bring the work 'in-house'. This meant all the various interests could operate under a unified policy and corporate message, handed down from the British Railways Board. Their Commercial Advertising Division (CAD) was based in Cranbourn Chambers, London. In 1960, CAD was renamed 'British Transport Advertising'. In their 12 years of existence and work, CAD produced some quite superb posters for the general commercial area of the railways.

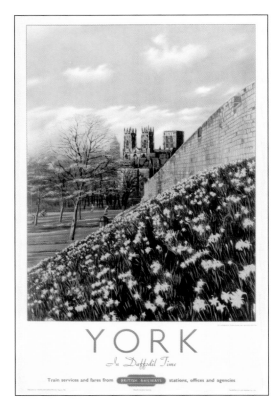
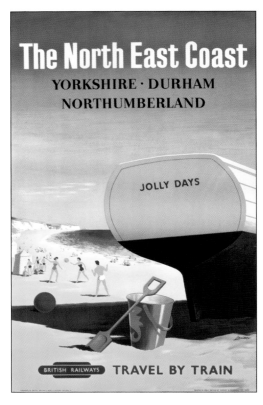
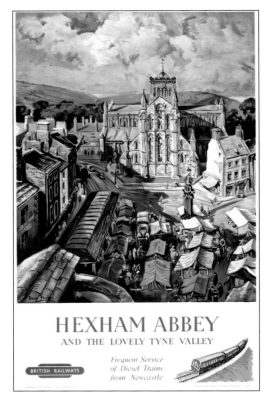
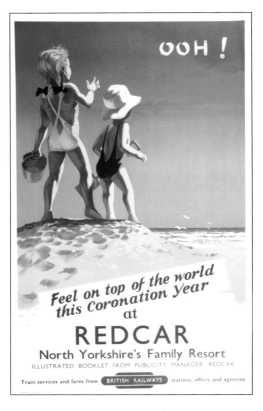

Selection of 1950s British Railway Advertising for the North East: Artists in Sequence (Left to Right): Unknown, Reginald Lander, Dennis Flanders and Unknown

The small selection above, from many held at York, shows British Railways had lost none of the NER and LNER heritage when it came to advertising. Beginning from the left, the anonymous painting of the city walls near York railway station is timeless. Travellers can go today and stand to admire this same view in April every year – and York in springtime is highly recommended. Reginald Montague Lander painted the second poster around 1956, for issuance a year later. The traditional fishing boats have featured on numerous posters (see Chapter 1) so this image of the North-East sends a powerful message. Lander was a popular artist in British Railways circles, and throughout this series we will see examples of his work. This was one of his first commissions from CAD. Hexham is towards the top of the Tyne Valley, and when the monasteries were dissolved in 1537, the Abbey became St. Andrews Church. Dennis Flanders captures both the church and the bustling market square in this 1958 poster. (It was in the late 50s and early 60s when CAD produced some really superb travel posters, as the Flanders poster shows). The final poster in this small selection appeared in 1953, and contrasts with the other three in this quartet, that appeared on stations from 1957 onwards. The combination of Redcar and Coronation year showed that all towns traded on the accession of Elizabeth II to the Throne.

Once CAD was abolished to become British Transport Advertising in 1962, it seemed to usher in 'modern' thinking. Far more photographic and 'collage type' posters started to appear. Very few collectible (or indeed good marketing) posters were published: the majority were forgettable and poor examples of the power of poster marketing. In addition, the appeal of the seaside poster had weakened, as package tours, and the guarantee of more reliable hours of sunshine, lured people to sunnier climates.

The Layout of this Book

We are travelling from Berwick-upon-Tweed to the ancient City of York, taking in the sights of the three counties of Northumberland, Durham and the Yorkshire Ridings that compose the North-Eastern quarter of England. I was fortunate to go to College in Yorkshire, and coming from Shropshire, this was my first time living away from the Midlands. What struck me about the people from these three counties were their kindness, hospitality and forthrightness. When deciding on a printer, it proved to be my best decision to go back to the area where I had studied. It was the same when it came to advertising. The posters are honest, bold and direct. Planning this volume was not easy, as the poster database showed the enormous number of posters for Yorkshire compared to Durham and Northumberland. Nevertheless I hope I have done the whole area justice.

Chapter 1 is devoted entirely to Northumberland. This often-forgotten county has some very collectible posters, from artists who made the most of the landscape. **Chapter 2** sees us in County Durham, home to vast coalfields of the past and also some desirable posters. The beauty of the Upper Tees Valley is highlighted in this chapter. The rest of the book covers Yorkshire, with the three Ridings being in effect three counties in one. In **Chapter 3** we travel down the coast from Redcar to just north of Scarborough. I called this chapter 'Along the Scenic Coast' – for obvious reasons. Scarborough has always been a tourist and holiday destination, and not surprisingly has figured in railway advertising since day-trips by rail started. **Chapter 4** includes some of the best seaside posters ever made. Today, steam engines haul the *Scarborough Spa Express* from York to the last remaining station in the town. In the summer months these are immensely popular. **Chapter 5** is entitled 'Beside the Seaside', and features some of the many posters from the Yorkshire Coast southwards to Bridlington. Chapters 6 to 9 see us make a large sweep from the East Coast, through the industrial heartland to the Dales and the Moors. **Chapter 6** covers East Yorkshire, allowing us to look at industrial and seaside posters. **Chapter 7** covers Ribblesdale, Wharfedale and up to the Lancashire border, before we swing eastwards and visit the solitary (but haunting) North Yorkshire Moors. Again in British Railways times, some lovely paintings were produced for tourism from this area. **Chapter 8** focuses on Yorkshire elegance with the Spa towns of Harrogate, Knaresborough and Ripon taking centre stage. The whole of **Chapter 9** is devoted to York. Not surprisingly, given the city's heritage, York has enough posters for a chapter all to itself. Readers may have spotted that there is no West Riding coverage: Sheffield, Leeds, Bradford and

Huddersfield. But do not fret; we will include some of the few promotional posters from this area in chapter 10. This tries to look at more general aspects, using other posters for the whole area to discuss poster variations and messaging throughout the 20th century. There is no doubt that styles and fashions change and the poster was responsible for a large influence on the development of seaside towns in this area. However the natural beauty does not change, and as if to reinforce this message, the poster below is a modern interpretation of the 1957 York poster on page 10. All aboard – we are about to leave!

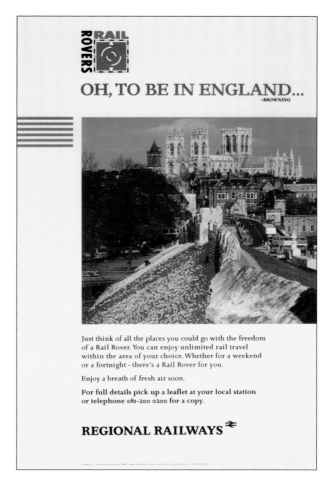

1992 British Railways Poster for the City of York

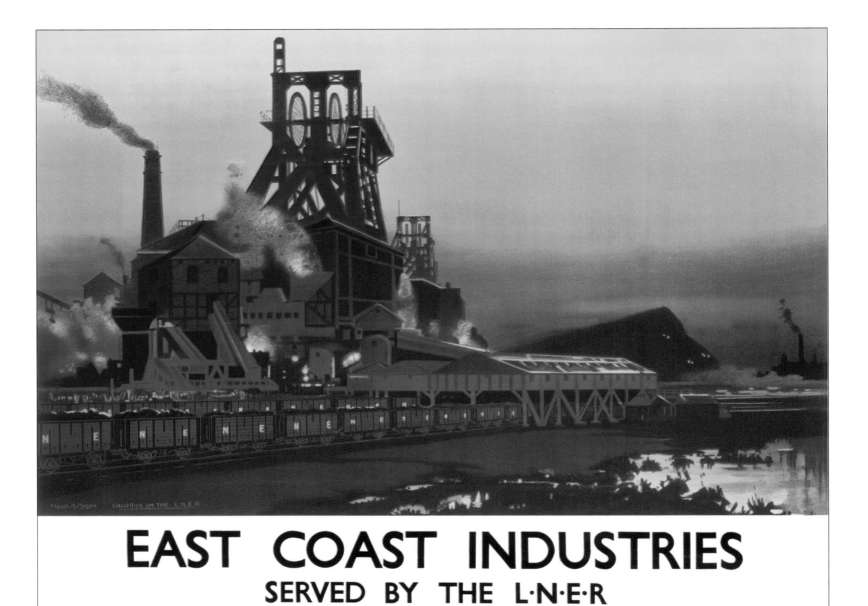

A Wonderful 1938 Industrial Poster to Start the Journey: The Coal Industry of the North-East by Frank Henry Mason (1876-1965)

Chapter 1 Northumberland: Scenery and History

Chapter 1 Northumberland: Scenery and Industry

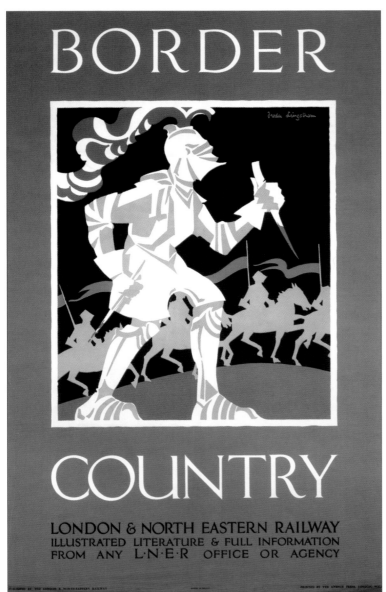

1930 LNER Poster of Border History: Artist Freda Violet Lingstrom (1893-1989)

We Begin Again at Berwick

Today we start a journey where railways have had the greatest impact in the whole of the United Kingdom. We are travelling south from Berwick-upon-Tweed to Newcastle-upon – Tyne, through the ancient Kingdom of Northumbria. Northumbria was one of the largest and most powerful of the Anglo-Saxon Kingdoms and the poster alongside is a fitting beginning to the trip. The Kingdom of Northumbria was far larger than the area we know today as Northumberland. Raids by the Scots in the Cheviots to the north and the Danes to the south around the Tees took away large portions of the Kingdom. When the Normans came in the 11th century, they used the Rivers Tyne and Derwent to divide what was left. To the south was the County Palatine of Durham and to the north the Earldom of Northumbria.

Northumberland is the English 'border region', hence this rather unusual choice for the opening poster in a major railway journey. The north-east is the cradle of railways, whose primitive beginnings go back well before the Stephenson family burst onto the scene in the 1820s. George Stephenson may not have invented railways, but over the years he has gained the title of *'The Father of Railways'*. The region was criss-crossed by many ancient minerals routes, is bisected by the East Coast Main Line and has seen feudal battles as fierce as any upon our shores. This is border country, the birthplace of railways. Northumberland is not just a county to pass through coming south from Edinburgh to London. It contains some of the most remarkable buildings in England, some beautiful coastal and inland scenery, and a history that has to be stopped and admired. If we go back to the 1950s and look at the areas of English counties, Northumberland ranks fifth behind Yorkshire, Lincolnshire, Devon and Norfolk. Therefore, in this Volume, we will travel through two of the five largest English counties that existed during my 'Golden Period' of railway posters.

Freda Lingstrom's poster shows knights about to do battle. One of the most powerful families in the Middle Ages was the Percy family from Northumberland. Described by Shakespeare as 'the Proud Percies', they overthrew an English King (Richard II), but while doing so, their greatest son, Henry Percy (*Hotspur*), was killed at the bloody battle of Shrewsbury (1403). Hotspur was joined by his uncle, Thomas Percy, Earl of Worcester and this poster could be the Percy family going into battle to defend the rights of their Border Country. We will see their ancient headquarters later in this chapter.

Wonderful View of our Journey Captured in this 1934 LNER Poster: Artist Montague Birrell Black (1884-1961)

Our second poster shows the Kingdom of Northumbria in another of Montague Birrell Black's remarkable aerial works. This poster dates from around 1934, as indicated by the LNER 'winking eye' logo that appears. It shows Newcastle in the middle of the right hand side and this is about halfway down ancient Northumbria. The Cheviot Hills straddle the English-Scottish Border and to the south we see the northern spine of the Pennines and the coastal industry around Middlesbrough.

The Cheviot Hills form the source of the Rivers Aln, Coquet, Rede, Till, Tweed and Wansbeck, and during this chapter we will see some of these depicted in some wonderful artwork. This poster sets out the area geography beautifully. Newcastle has over 75% of Northumberland's population and is the largest city in the North-East. The 70 miles (110 km) of coastline from here up to Berwick has a wide variety of scenery, ranging from the hustle and bustle of Whitley Bay to the quieter fishing villages of Alnmouth and Seahouses. The coastline alternates between sandy areas and rocky shores. The former is characterized by the sand dunes and flats around Holy Island, and the latter is represented by Dunstandburgh Castle, the largest ruined castle in the country on the promontory to the south end of Embleton Bay. Northumberland is full of scenery and industry, hence the title for this chapter.

This rare and seldom-seen poster has us viewing the Border Bridge from Hallidon Hill, as the train crosses heading for Berwick. The other bridges spanning the Tweed are clearly seen, the early 15-arch structure being most prominent. Grainger Johnson painted this in the early 1920s for the LNER, and it featured on both a poster and a holiday guide. He also painted for London Transport around 1922.

The bridge was commissioned at the same time as the High Level Bridge in Newcastle and the four viaducts at Alnmouth, Coquet, Bothal and Plessey. All the bridges took two years longer to build than the rest of the Berwick to Newcastle line. Robert Stephenson was the line engineer, though most of the work was actually undertaken by Thomas Harrison. However, records show that Stephenson took much more interest in the bridges and all turned out to be elegant structures. Some information about the bridge was given in Volume 1 page 15, so another aspect is considered here.

Particular care was taken with the bridge foundations. A steam-driven pile-driver went down almost 40 feet through very dense gravel, and large coffer dams fitted with pumps were built to allow easy construction of the foundations. Once these were completed, the land piers were built and construction proceeded from both ends. Careful shaping of the piers prevented ice build-up in the river sections during the winter months.

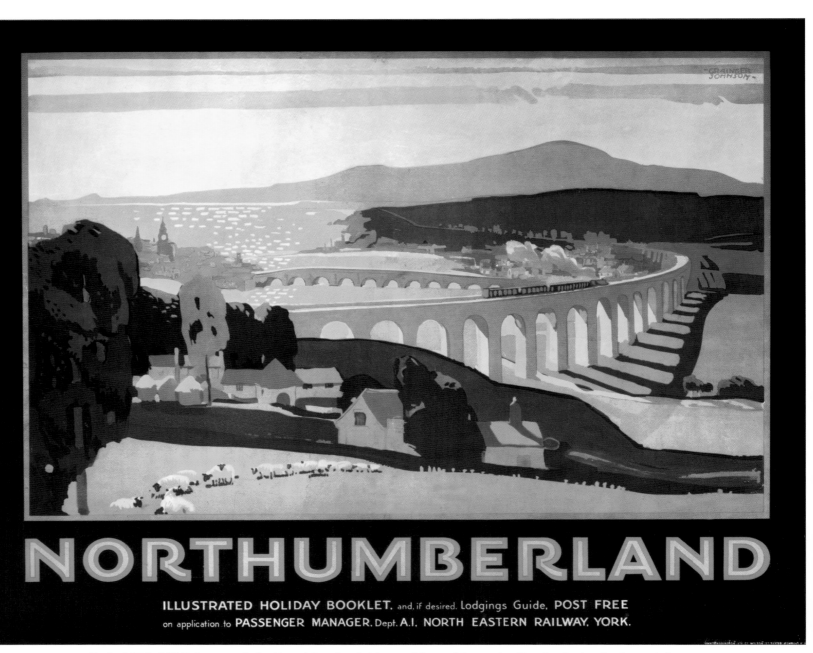

Early 1920s LNER Poster of the Royal Border Bridge as Viewed from the North: Artist Grainger Johnson

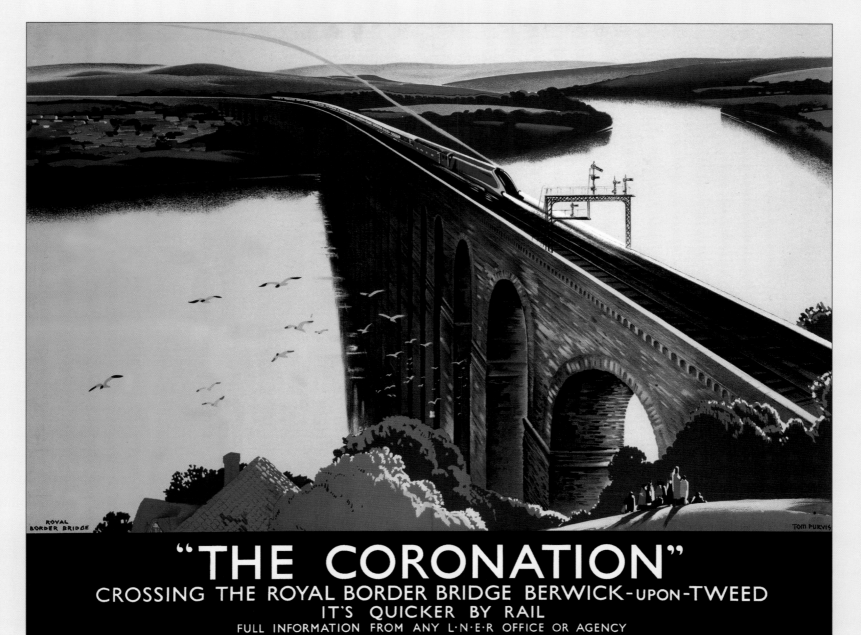

ROYAL
BORDER BRIDGE

TOM PURVIS

"THE CORONATION"
CROSSING THE ROYAL BORDER BRIDGE BERWICK-UPON-TWEED
IT'S QUICKER BY RAIL
FULL INFORMATION FROM ANY L·N·E·R OFFICE OR AGENCY

The Classical Poster for the Royal Border Bridge, Painted in 1937 for the New Coronation Service: Artist Tom Purvis (1888-1959)

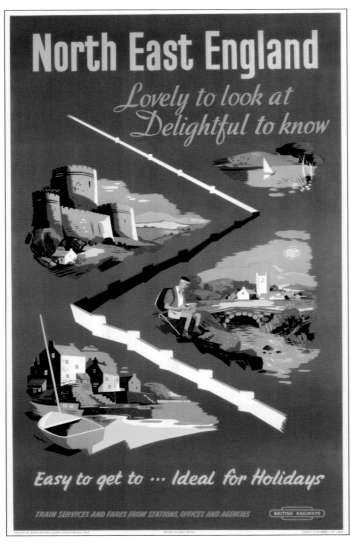

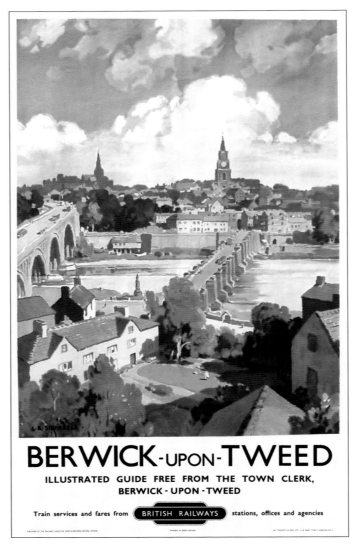

We saw in *Poster to Poster* Volume 1 that posters for Berwick-upon-Tweed were more numerous than its status might suggest. This Volume confirms the small border town has a rightful place in art, history and railways. Tangerine station totems from here are also highly prized.

If we disregard Jerusalem, Berwick upon Tweed changed hands more than any other city on earth in the period 1296 to 1482. Both the English and Scots recognized its importance and it changed sides 13 times in less than 200 years. King David made it a Royal Burgh and for around 200 years Berwick prospered under Scottish rule. This came to a violent end in 1296 when our favourite Royal bully (Edward I) sacked the town, beginning almost 300 years of strife, conflict and determination from both sides that it should be held.

The present day town fortifications came from Queen Elizabeth I, who was adamant that it would remain English. Her lasting legacy on many facets of English life ensured this wish was enshrined. But she lost out when Berwick Rangers FC was accepted into the Scottish Football league! It is right and proper that Berwick features prominently in two Volumes in this series, with Carlisle, the only other place to do so. I recommend a walk along the city walls to take in the history and atmosphere of the town: peaceful now but in the past very violent. I had a real job deciding which posters to place in which volume, so I hope my decisions meet with readers' approval.

Two Mid-20th Century Posters for the Northern Corner of England: Artists Nevin (L) and Squirrell (R)

In contrast to the two classic posters of the previous pages, here we have two rather more modern pictures, both from around the mid 1950s, but quite different in style. The Nevin poster from 1959 was actually ahead of its time and shows how some artists approached the marketing of the North-East of England. The more classical 1956 treatment of the Berwick bridges by Leonard Squirrell illustrates that good paintings always make a good poster. The artistic composition and colour palette on both posters is truly first class.

Talking of Edward I leads us nicely to the next poster. This unusual work comes from Doris Zinkeisen, a most eminent poster artist and a quite stunning looking lady. Though not generally including artists' pictures, I will make an exception here by showing a painting of her alongside her work. She and her sister Anna featured prominently in the artistic plans of the LNER. This exquisite self-portrait in oil is held by the National Portrait Gallery.

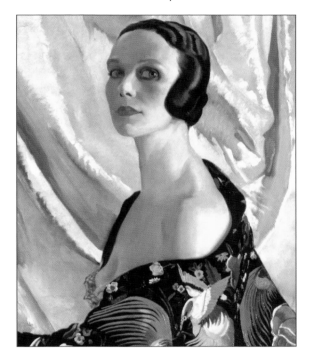

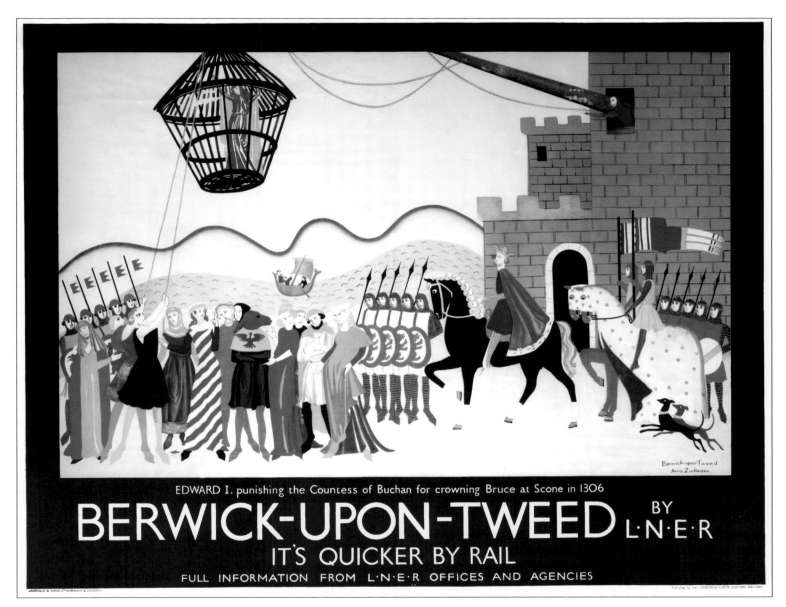

Unusual Historic Poster Subject for Berwick-upon-Tweed Painted by Doris Claire Zinkeisen (1898-1991)

The poster (shown right) shows the Countess of Buchan being pilloried by Edward I. The Countess joined the Scottish cause but her brother went to the English side. She crowned Robert the Bruce, so as punishment after the Battle of Methven, Edward ordered her to be hung outside the Berwick town walls in a cage.

It is not known how long she remained above the crowds in this manner and records are sketchy as to her eventual fate. Other records show that Mary Bruce was treated in a similar manner at Roxburgh Castle. I did say Edward was a bully!

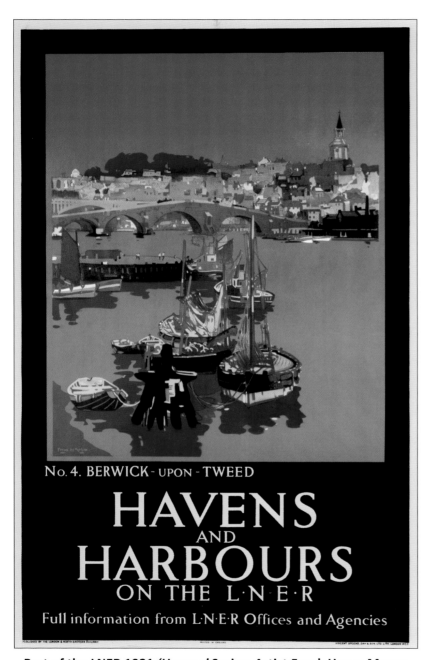

Part of the LNER 1931 *'Havens'* Series: Artist Frank Henry Mason

We have now arrived down at the harbour in Berwick. It is an atmospheric place and features on two LNER posters produced in the 1930s. Both of these are colourful and both were painted by Frank Mason about four years apart, but not exactly from the same spot. I could not decide which one to use, so my wife Judi said *"show both, to contrast the palettes that Mason used"*; so here they are!

When it comes to water scenes, Mason is a bit like a chameleon. Sometimes he paints details (as the rear cover of Volume 4 will show) and at other times, as here, they are monochromatic but very effective. Mason figured heavily as a poster artist over a long period of his life, and today his works are all prized and sought in auction.

By the mid-18th century this was a busy harbour, and although the posters show a wide expanse of water, entry is not easy, especially when on-shore easterlies blow and when contra strong currents persist after heavy rain. The piers were built around 1810 and today Berwick is revitalised, with more than 250 ship movements per year and over 200,000 tonnes of cargo handled in and out.

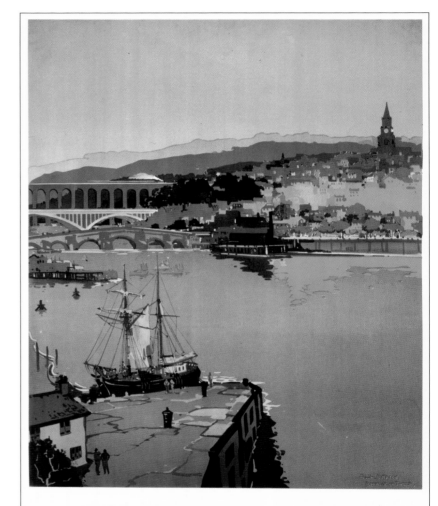

1935 Poster for Berwick-upon-Tweed: Artist Frank Henry Mason

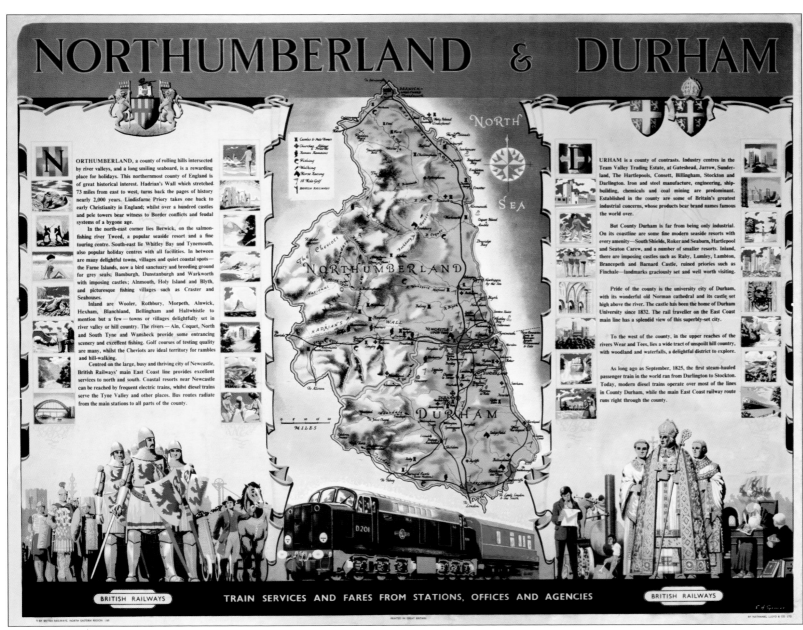

1960 Historical Montage for Northumberland and Durham: Knights, the Church and Railways: Artist E.H. Spencer

South into Northumberland

Northumberland is a county of historical extremes, and our next poster tries to summarize some of the many events in a very colourful way. The excellent historical painter E.H. Spencer produced this wonderful montage in the late 1950s. It shows history and railways, not represented by steam but by a Class 40 diesel. Some 200 were built between 1958 and 1962, so dating the poster to around 1960. Northumberland is depicted by Romans, knights and coal mining, with Durham having railways, the church and scholars. The poster sums up the area extremely succinctly. Key points in the history of both counties are depicted by small vignettes, reminiscent of the posters of 50 years earlier. The Class 40 hauled train would be typical of the East Coast expresses that ran at this time. They were the forerunners of the Class 55 *'Deltics'* that appeared in late 1961 and which dominated East Coast Main Line express travel for 20 years.

However, it is the relief map in the centre that is a real work of art and shows Spencer's painting skills to perfection. This is as good as any modern OS map produced today. As far as I am aware this is the first time this poster has ever appeared in any publication. The whole poster is a mass of information and may not appeal to most tastes. However, as an informative poster from 1960, it is for me a classic and very desirable image.

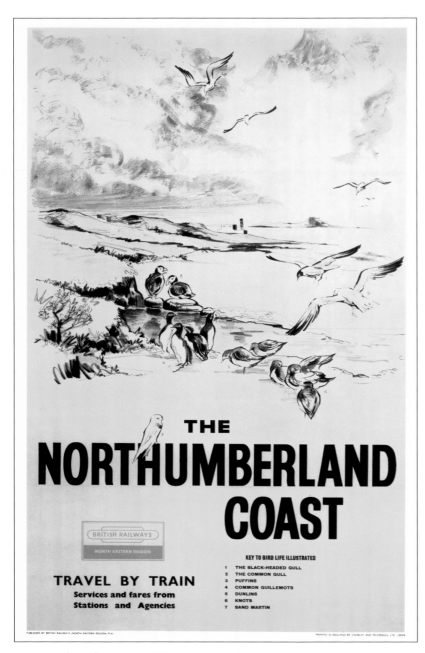

1961 BR (NER) Poster of the Northumberland Coast: Artist Unknown

It is now time to move south, and along the 70+ miles of coast which is designated an Area of Outstanding Natural Beauty (AONB). Quite rightly, this area has some magnificent pieces of poster art to do justice to the subject matter. South of the Tweed the coast has alternating outcrops of hard and soft rocks. The more resistant formations of hard sandstone, limestone and basalt form headlands between a series of wide bays. The best of the coastline lies north of the mouth of the Coquet, where apart from Berwick and Seahouses, the coast remains undeveloped. Its expansive sands and panoramas are as fine as any coastal scenery in England. Historic castles punctuate the coast, with majestic Bamburgh being the best known. These two posters are but openers for things to come. Purvis's silhouette of Bamburgh is a classic.

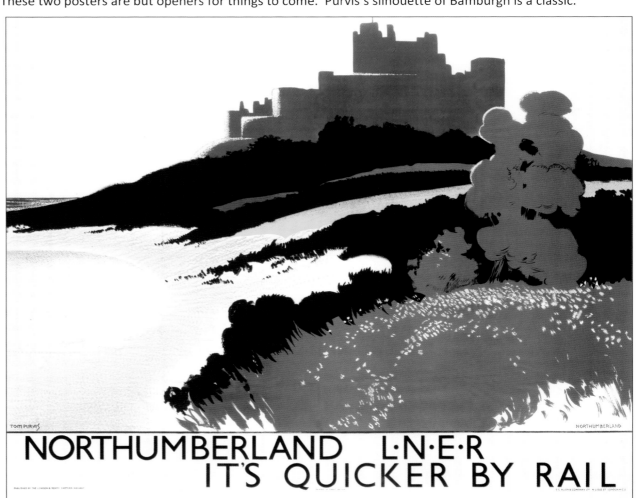

The Classic 1934 LNER Poster of Bamburgh Castle Northumberland by Tom Purvis (1888-1959)

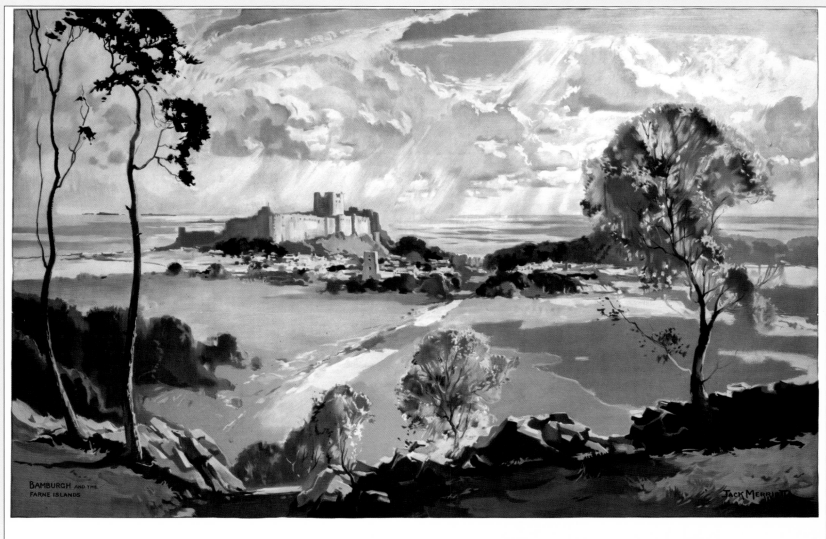

Truly Magnificent 1950s British Railways Poster of a Magical Location: Artist Jack Merriott (1901-1968)

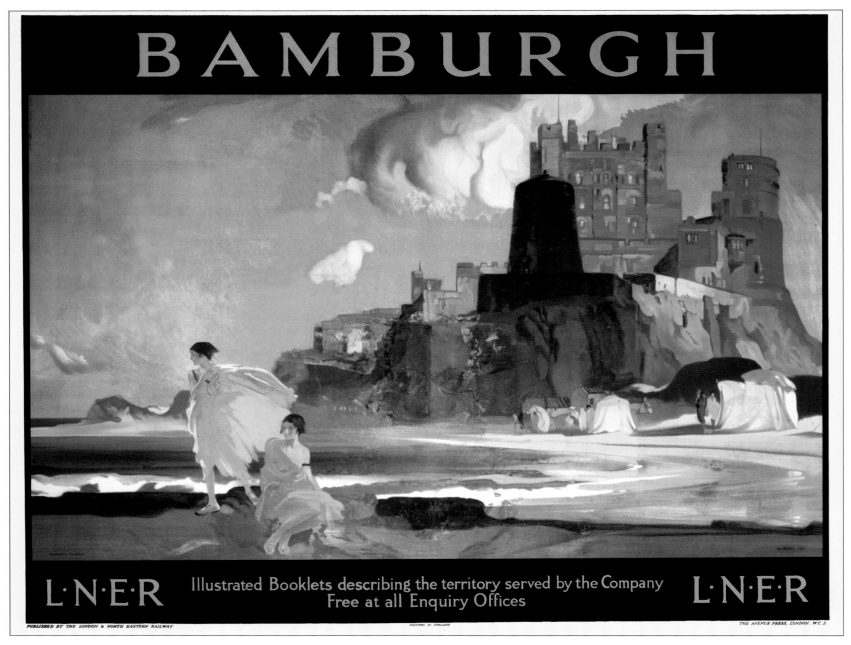

1925 LNER Quad Royal of Bamburgh by Sir William Murray Russell Flint (1880-1969)

The poster on the previous page was a cover contender but as I had used the Merriott poster of Loch Etive on Volume 1, I felt we could not have another Merriott, so I gave it a page to itself instead. Contrast Merriott's contemporary treatment with Russell Flint's 1925 classic painting here for the LNER. The beauty of the scene is somewhat diluted by the bathing huts and the two ladies but Russell Flint's work is highly prized and this is beautifully painted.

Bamburgh is imposing from any direction, whether viewed near or from a distance. It is built on a basalt crop of rock and has Grade 1 listed status. Numerous fortifications have stood here since 540 AD. In 547 the citadel was captured by Ida, an Anglo-Saxon ruler and it became his seat. His grandson Aethelfrith gave it to his wife Bebba, from which the castle was named Bebbanburgh, later shortened to Bamburgh. The Normans built the core of the present castle. The keep was built by Henry II and for many years it was the property of the Kings of England. During the Wars of the Roses it was the first castle to fall to the new artillery (Richard Neville, Earl of Warwick). After periods of decay then rebuilding, the famous Victorian industrialist William Armstrong bought and fully restored it. Today it is truly magnificent.

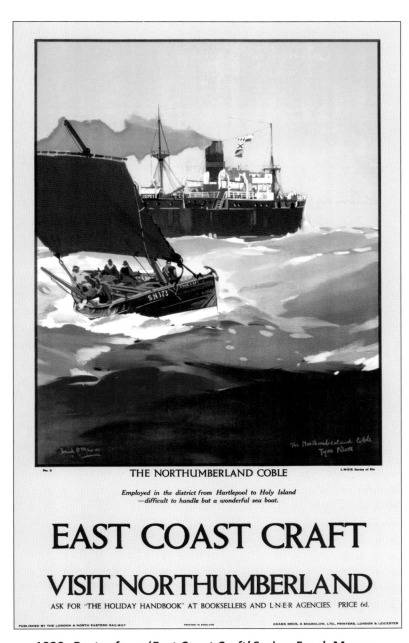

1930s Poster from '*East Coast Craft*' Series: Frank Mason

Time to Go Fishing

This coastline is fishing territory and these two posters sit nicely together. Both dating from LNER times, they show the prey and the means of locally catching them. Both form parts of a series of posters about fishing craft (left) and sea life (right) and neither series has featured in books before. The Coble is a small boat fitted with oars and sails that is used in the area. The most famous story about Cobles is that of Grace Darling and her father William. In 1838, the ship *Forfarshire* wrecked off the Farne Islands. In quite appalling weather, the Darlings rowed from the nearby Longstone lighthouse to rescue nine seamen in peril. Grace became a national hero and both were awarded silver medals for bravery.

The Coble has a distinctive shape: a flat bottom to cope with expansive beaches and high bow to cope with the North Sea conditions. This unusual boat poster dates from around 1930. It was painted by the prolific Frank Mason, who was also responsible for the series of sea life posters in late 1933. Contrast the way he has painted water here with his two posters on page 19. Salmon and sea trout are both migratory fish and highly prized as a catch. They are found in many parts of the British Isles and Scandinavia, but especially in Scotland and the northern coasts. Both return to freshwater rivers to spawn.

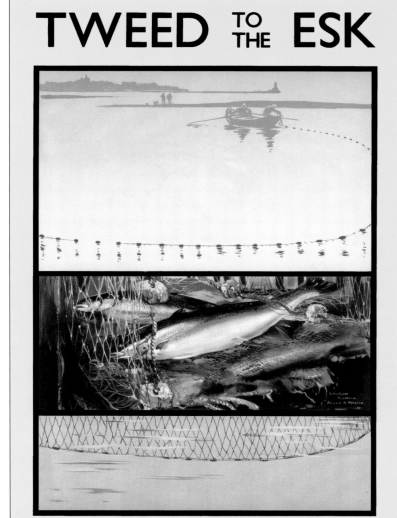

1933 LNER Poster from a Series Painted by Frank Mason

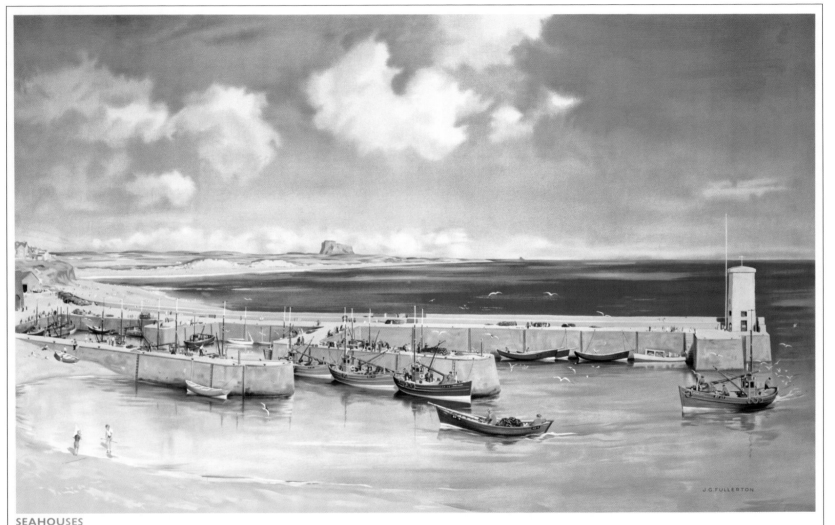

SEAHOUSES

NORTHUMBERLAND

BRITISH RAILWAYS

SEE BRITAIN BY TRAIN

BRITISH RAILWAYS

Magnificent BR (NER) Poster of Seahouses Painted by J.G. Fullerton Around 1950

Just down the coast from Bamburgh, we arrive at the small fishing village of Seahouses. It has been beautifully captured in this expansive painting by Fullerton in this early BR poster. Bamburgh Castle can be seen in the distance. A high-prowed Coble precedes a small fishing trawler into harbour. The painting also allows the openness of the Northumberland Coast to be fully appreciated.

Seahouses is a great place from which to take boat trips out to the Farne Islands for bird watching and natural history studies. There is also a marine life and fishing centre here with large aquarium tanks containing examples of the local sea life. The village developed as a result of its sheltered harbour and ideal location for fishing. That industry may have declined, but the village retains a wonderful charm based on its maritime background. Its religious heritage is also strong with ties back to St. Aiden and St. Cuthbert. Both were responsible for the early conversion to Christianity.

It is today a popular base for tourism, and one of the delights is a walk along the flat sands up to Bamburgh to view the castle from the south. This is thoroughly recommended. The painting by Fullerton captures peace and serenity. The composition gives a study of sea and sky in equal measures, punctuated by the colours and activity in the harbour.

Into the Land of Castles

We cannot leave this part of the journey without a visit to Lindisfarne. Considering its historical and spiritual significance, this has not received very much poster treatment. It is, however, a superb place to visit, but watch out for those incoming tides or the stay may be longer than planned!

These are two more of Frank Mason's north-east pictures, again in a set of six, but this time painted for the North Eastern Railway at York around 1910. To the left is Lindisfarne and alongside is Bamburgh. Lindisfarne has a considerable religious and spiritual past. The 7th century monastery was founded by St. Aidan, an Irishman who was sent from Iona on the Scottish West Coast (see Volume 1 page 115). Later, one of the monks became equally famous and eventually the Bishop of Lindisfarne. This was Saint Cuthbert, whose life and miracles were later recorded by the Venerable Bede. Mason's stock poster shows the priory at the front with the castle beyond. The priory was one of Anglo-Saxon England's most important buildings and it was a great shame it was first suppressed and then desecrated in 1537. Around the same time, the castle was being built and material from the priory almost certainly found its way to the nearby construction site.

The castle sits at the highest point of the island, which was vulnerable to attacks from the Scots and Norseman. The existing structure of the 1500s was considerably strengthened by Elizabeth I. Much later it was acquired by Edward Hudson, a publishing magnate. and he had the famous architect Edwin Lutyens restore it.

The lovely walled garden was also restored a few years later, and today visitors can marvel at the landscape, the castle and the restoration. Therefore it really is surprising that nobody else has made a painting of this location to adorn a railway poster. Sadly, not even good photo-image posters were produced to display on stations in the 70s and 80s.

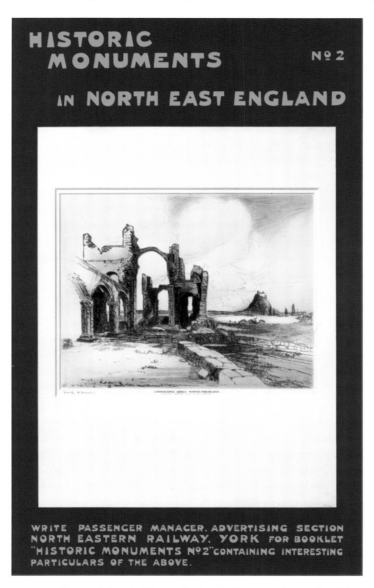 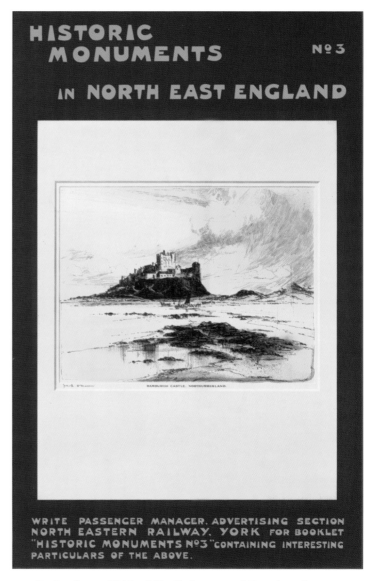

Two of Frank Mason's Stock Posters from the *Monuments Series* from 1910 of Lindisfarne and Bamburgh

Moving down the coast from Seahouses, we come to another great fortress, the great castle at Alnwick. This is the home of the Duke and Duchess of Northumberland and has featured in many film and TV programmes including 3 *Harry Potter* films. This is the real Hogwarts School!

After Windsor, this is the largest inhabited castle in England and has been home to the Percy family and then the Northumberlands for 700 years. The present Duchess has recently created one of the largest gardens ever built during the 20th century, a magnificent £40m+ structure to which the Duke donated many millions. Fred Taylor's 1933 LNER poster shows the substantive nature of the castle. Taylor chose to use a simple block of green in front of the castle, so the eyes immediately go to the building and the hunt itself. Since the Potter films were made there, the castle has featured on far more film posters than railway posters.

From 1300 onwards, the Percy family progressively added to the buildings, but in the 17th century neglect and then decay appeared, until the first Duke and Duchess commissioned Robert Adam to look at the buildings, and Capability Brown to look at the gardens and the landscaping. It is their wonderful legacy we see today. As well as a residence, parts are used for education, and the Abbott's Tower is home to the Regimental Museum of the Royal Northumberland Fusiliers. It is a fabulous castle, and yet we have only one poster!

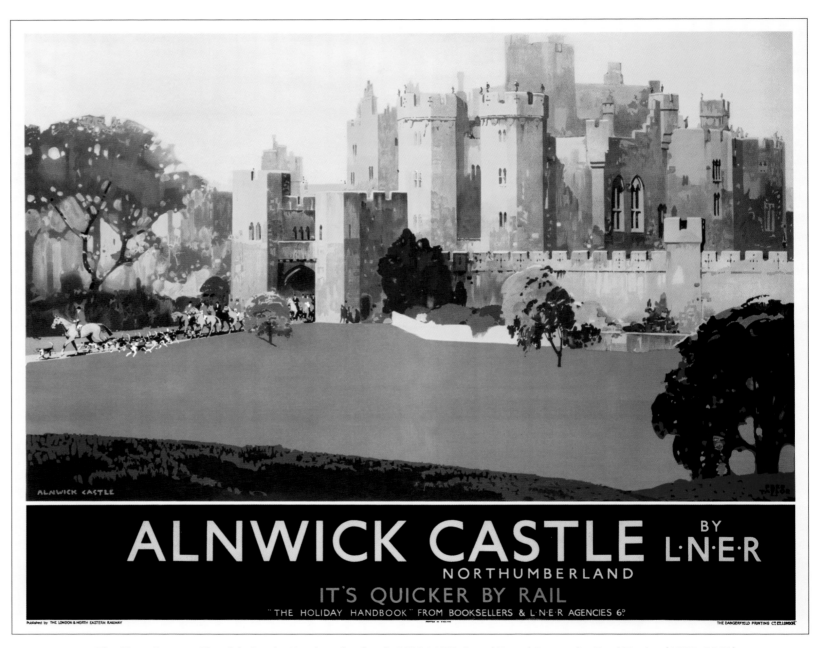

The Hunt Leaves Alnwick Castle Northumberland: 1933 LNER Quad Royal Poster by Fred Taylor (1875-1963)

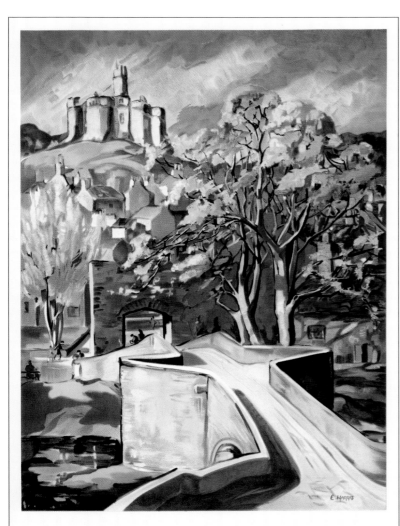

Northumberland is a land of castles, some 45 in fact, in various states of habitation and decay. Our next two posters from the BR era show views of the same castle, Warkworth. Today it is a ruin, but its commanding position in a loop of the River Coquet made it formidable and it was again in the *'Empire of the Percy's'*. These two posters show views from opposite sides. Edward Harris's more colourful work (left) dates from 1948, quite a departure for the early days of BR. John Chater's 1952 painting is in the classical style, but makes for an equally lovely image. He was known for his use of colour but in a less flamboyant way than Harris used to depict the same scene.

The keep was added in the 14th century and some 500 years later much face dressing was carried out by the Northumberland's to preserve the building. Today it is Grade 1 Listed.

These two posters are further evidence that the golden age of posters went well into the BR tenure, and neither is that well known. However, what is surprising is that BR chose this castle for two commissions, and yet Alnwick, a short distance away, did not receive a BR commission. Warkworth is now in the very capable hands of English Heritage.

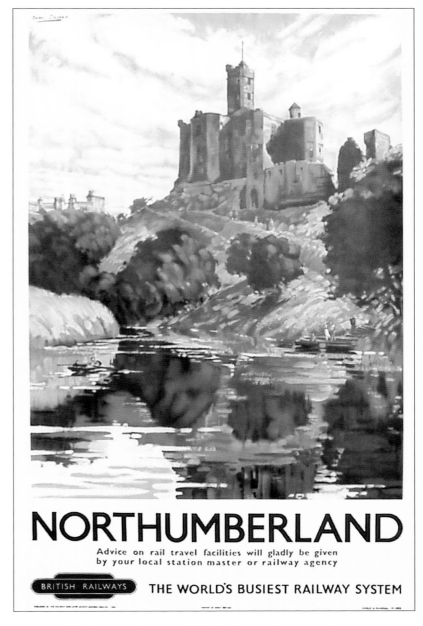

1948 BR (NER) Poster of Warkworth: Edward Lawson Harris

Warkworth Castle: 1952 BR Poster by John Chater

Back to the Seaside

It is now time to move south again and back towards the coast. The East Coast Main Line is a mile or so away from the castle and the little station was exactly 300 miles from Kings Cross, but it was a pre-Beeching closure in 1958. Leaving Warkworth station by train we pass through Morpeth at high speed and soon come to Killingworth some 25 miles south and pass an ivy-leaved cottage where George Stevenson lived. This whole area was once a thriving coalfield with mines and shafts all over southern Northumberland. It was the need to move coal that eventually drove the development of the railways. The coalfield occupied a triangular area that stretched from Prudhoe in the west across to Tynemouth on the east coast, and northwards all the way to Amble near Warkworth. As we moved south, mines used to be active around Ashington, Bedlington, Blythe, Cramlington and Seaton. From the 1830s onwards, the pits at Cramlington and Seghill had a maze of railways built to service them. They produced wonderful steam coal. Blythe harbour was developed to provide export facilities. All these hard working miners had to have somewhere for R+R, so the coastal resort of Whitley Bay developed. Not surprisingly many railway posters feature the town and the hardest part of the journey so far was deciding which ones to include here!

Whitley Bay boasts a fine stretch of sand that runs all the way from St. Mary's Island in the north, through the urban centre to Cullercoats in the south. Today the town has a population of around 35,000, but in holiday season in the 1950s and 1960s, it was far more than this. As well as attracting holiday makers from all over the north-east of England, Scots also visited from north of the border around this time. We begin in the north at St. Mary's Island, which boasted a fine lighthouse. Though not a working lighthouse today (it was decommissioned in 1984), it was built towards the end of Queen Victoria's reign in 1898. There is a causeway that links the Island to the shore: this allows access to the visitor centre there at low tide.

Frederick Donald Blake's lovely 1951 poster alongside captures this structure far better than any of the many photographs taken in recent times and posted on the Internet. This is yet another example of classic north-eastern posters commissioned in the early days of BR, to attract tourists to the area. Today, taking the 137 steps to the top of the structure affords panoramic views of the Northumberland coastline. Blake was born in 1908 and became a distinguished artist. He painted several wonderful canvasses for British Railways and some lovely carriage prints. Shortly after this poster appeared he was made a Member of the Royal Institute. After living in London for most of his life, he died there in 1997.

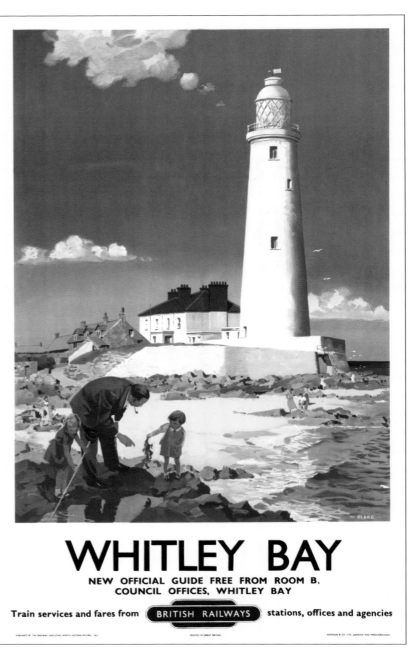

1951 BR (NER) Poster of St. Mary's Lighthouse: Artist F. Donald Blake

The town has a rich history, being mentioned in charters from Henry I, Henry II, Richard I and King John. After the dissolution of the monasteries, the manor was held by the Crown until it passed to the Earl of Warwick, later Earl of Northumberland. It has remained in the family and its descendants ever since and the present Earl is still Lord of the Manor and the main landowner. It was called simply 'Whitley' until the late 1890's and acquired the suffix to distinguish it from Whitby (Yorkshire), which we visit in a later chapter.

The large Dome was the centrepiece of Spanish City, so named after the Toreadors Concert Troup had performed there. For many years it was the dominant feature of the Whitley Bay fairground and in 1920 it was renamed the Empress Ballroom. Its Grade II Listed status ensures it is still the centre of a new planned seafront development.

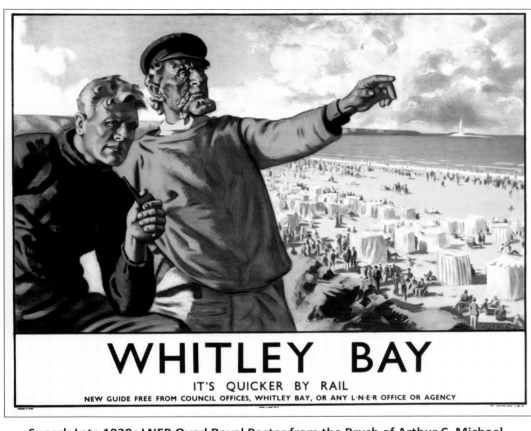

Superb Late 1930s LNER Quad Royal Poster from the Brush of Arthur C. Michael

After the preceding British Railways Posters, it is time to go back to LNER days for a wonderful pair of quad royals. The first (above) comes from Arthur C. Michael and dates from the late 1930s. Exact dating is still to be made, but the poster is very reminiscent of the St. Andrews poster from 1939 (Volume 1 page 58), so late 1938/early 1939 is thought most likely. Two of the local fishermen are prominent, set against the sweep of Whitley Bay sands, with St. Mary's in the distance. The older fisherman is pointing south towards the seafront and probably has the view seen in the Fred Taylor poster alongside. The LNER logo and the style dates this poster to around 1927, possibly early 1928. It is another example of Taylor's wonderful poster style: detail backed by a block of colour. Any detail of the sky would detract the eye from the people and the buildings. Notice elegance appearing on the seafront of Whitley Bay in the late 1920s.

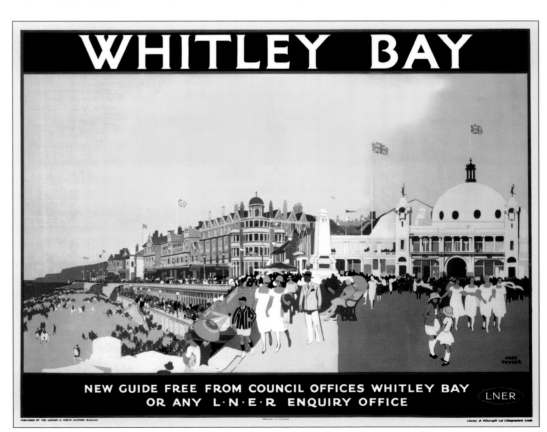

Circa 1927 LNER Poster of the Whitley Bay Seafront: Artist Fred Taylor (1875-1963)

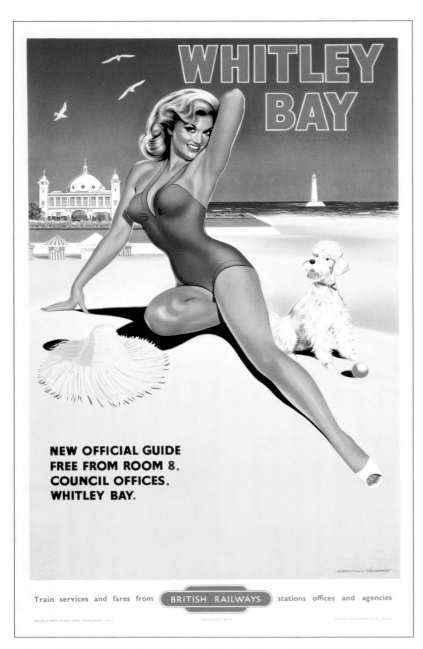

Superb BR Whitley Bay Seaside Poster from 1957: Artist Davies?

The sub-title of this part of the journey was *'back to the seaside'*, so where are the bathing belles I hear you say! Well, what about these two for starters. Maybe these are what the old sailor on the previous page was really pointing at. The lovely Dome of the fairground and the lighthouse frame our 'California style' belle on the left, while the retro bikini set against the busy Whitley Bay sands is a poster rarely seen.

Both date from around the same time (1957) but it is strongly suspected that the Arthur Michael poster (right) was painted much earlier. The database shows that Arthur Michael was most active in poster art during the 1930s and, from the fashion in this poster, it is suspected that this piece of art may have lain dormant for a decade before being used as part of a concerted campaign to increase tourism at Whitley Bay. Compare also the style of this poster with Michael's 1939 quad royal on the previous page- similar or what?

Rather curiously there seem to be two artists attributable to the poster featured left. Some copies carry the name 'Davies' and others carry the name 'Ostrick'. We have yet to resolve this conflict, but that apart it is a fine poster – and an even finer subject! Whatever the story, both posters would probably draw people to the seaside at Whitley Bay – exactly the intention.

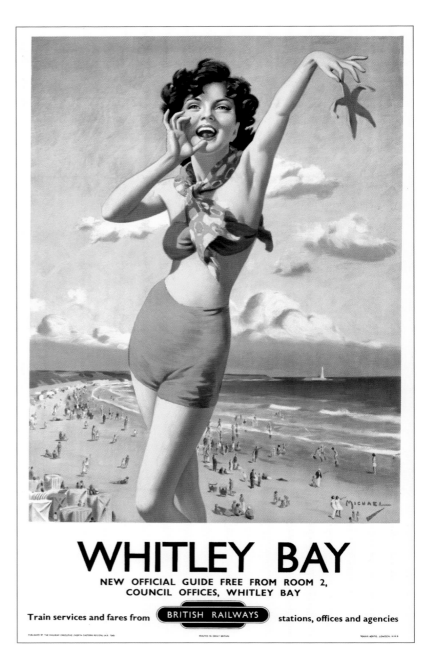

1950s BR (NER) Poster from Artist Arthur C. Michael

This is a contrasting seaside poster from 1927, painted by Frank Newbould as part of the artists' agreement he made with LNER Publicity Manager William Teasdale. He was one of the 'Big Five' poster artists contracted to improve the image of an already great railway company.

With minimalist details and the use of bold blocks of colour – hallmarks of great poster artwork – Newbould captures a timeless scene. Again, the Dome of the famous seaside fairground appears, contrasting against the red sandstone buildings further down the coastline. Here we are looking southwards towards Cullercoats and Long Sands. The sand in this poster is treated monochromatically in classic Newbould style.

Here we are only nine miles from the centre of Newcastle-upon Tyne, and if we travelled down the coast from the position shown here, we would soon reach Tynemouth. Today, Whitley Bay is connected to the City Centre by the Metro: a journey that takes only 25 minutes. Consequently the town is something of a dormitory for City workers. It is nothing like as busy as in former times. In the 1950s to 1970s, the place simply rocked at weekends. Today, weekend boisterousness is often prevalent, echoing the past and the posters we have presented thus far also show the beach was invariably busy.

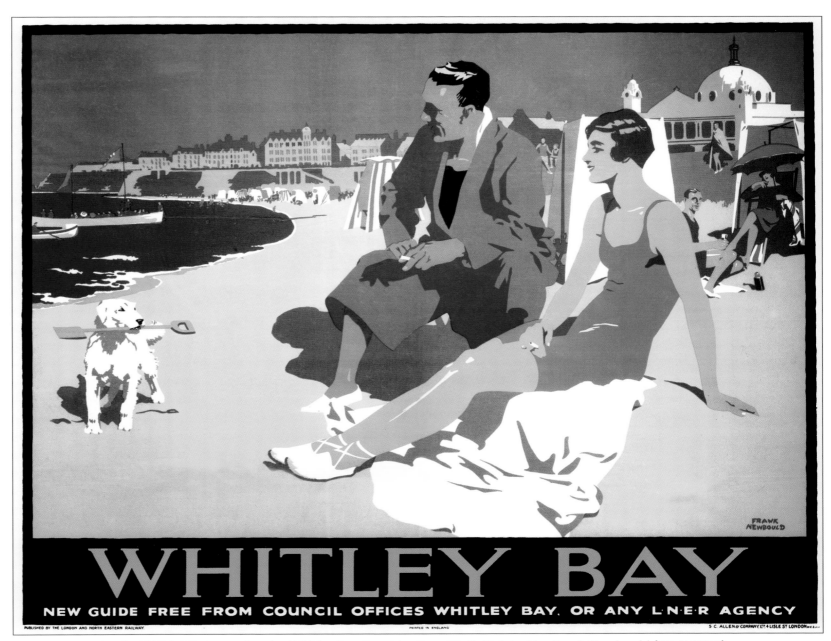

Classic 1927 LNER Poster for the Whitley Bay Seaside, Beautifully Painted by Frank Newbould (1887-1950)

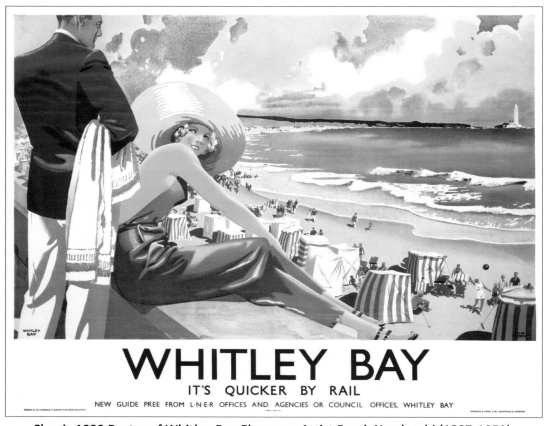

Classic 1939 Poster of Whitley Bay Elegance: Artist Frank Newbould (1887-1950)

The older residents probably remember much quieter times, and these two posters portray an elegance that many believe would be a welcome return. Here we have another classic 1930s LNER quad royal above and alongside a 1950s BR poster showing an evening stroll on the seafront. What I want to know is why so many Whitley Bay posters featured dogs along with people? Is this the same lady featured on page 31, with the same dog? The British Railways poster again features Spanish City Dome. Some of the attractions in the fairground were the Social Whirl, The Water Chute, The Figure of 8 Railway, the House that Jack Built and the Hall of Laughter. The Corkscrew appeared later and this was dismantled and rebuilt at Flamingoland near Malton. The Fairground gave much pleasure over the years and it was a sad day when demolition began in May 2001. The next page gives a collage of some other posters, including one that is now not politically correct!

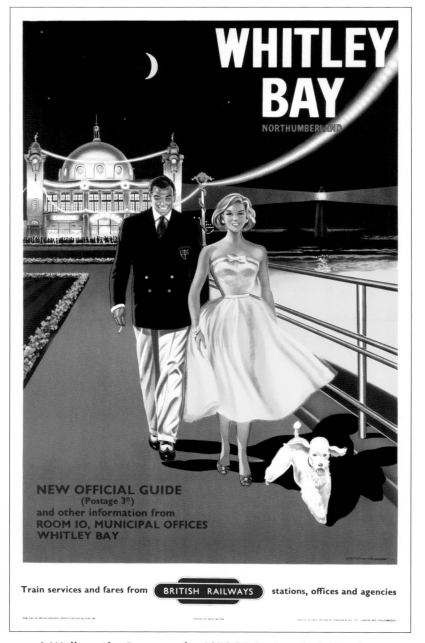

A Walk on the Promenade: 1958 BR Poster: Artist Davies

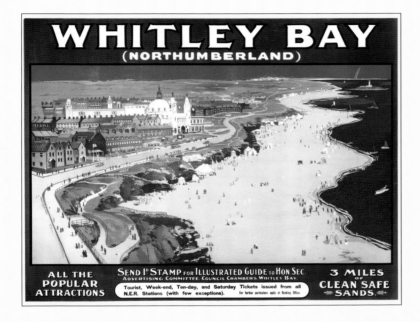
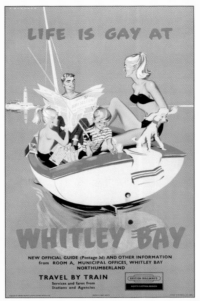
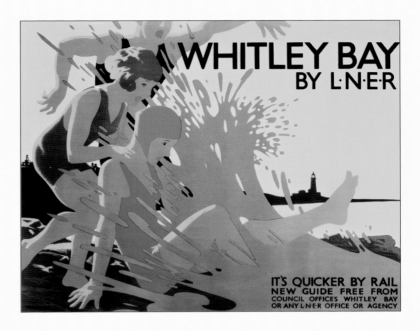

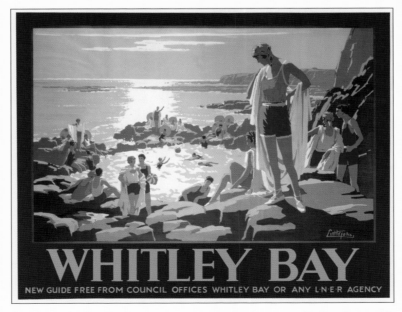
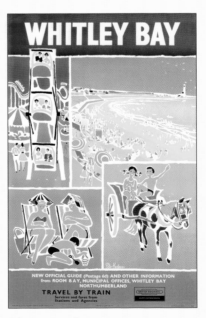

Collage of Posters for Whitley Bay Spanning Almost Seventy Years; All Show a North-Eastern Playground

creative talent who always worked with new materials. He was the first, for example, to experiment with Perspex in art. We will see another of his north-east posters in a later chapter.

This poster, produced for BR as part of his 1950 commission, shows a tranquil English scene, possibly Redesdale or Coquetdale to the north. Whichever it is, Armengol painted a fine canvas, showing the unspoilt landscape and a shepherd trudging homewards for lunch. Much of inland Northumberland is designated a National Park today. Within its 385 square miles are some of the quietest places to be found in England. Anybody into walking can go for a whole day without seeing another person. The park stretches from the Scottish Border down to Hadrian's Wall (our next stopping-off place).

As we travel south, scenes such as the one in Armengol's poster appear before our eyes. Maybe it reminded him of the hills in his beloved Catalonia. In the west of the county is the Kielder Forest and Kielder Water, with a shoreline more than 27 miles (43 kms) long, and Europe's largest man-made lake. In this part of the county we find many marked footpaths leading to waterfalls (e.g. Linhope Spout) and numerous iron-age forts and communities. Near Wooler, the lovely Harthope Valley gives the more adventurous hikers access to the High Cheviot, Northumberland's highest point at 2,600 feet (790m). In summer, the upland hay meadows at Falstone and Barrowburn put on a spectacular show of colour, and in August many places are bathed in heather, together with the heady scent of honey. Here also are red squirrel, black grouse & the curlew, a moorland bird with an unforgettable cry. This is truly a place to savour.

NORTHUMBERLAND

England's most northerly county, famed for its golf courses and fishing streams, its castles and Roman Wall.

SEE BRITAIN BY RAIL

Expansive Poster of Rural Northumberland: BR Executive from Early 1950s: Artist Mario Hubert Armengol (1909-1995)

Rural Northumberland and Real History

It is time to move from the coast and head inland to explore some of the most unspoilt countryside in England, and home of some remarkable structures from the past. The poster above comes from the brush of Mario Armengol, a Spanish-born artist who fled Spain to escape the Franco repressions of their Civil War, and settled in England, eventually becoming a naturalised citizen. Armengol painted some works that turned into railway posters, but is better known as a sculptor, book illustrator and a

In southern Northumberland we come to some real British history. In Roman times this was, for a period, the northern extremity of the Empire and in order to keep out those *'wee pesties'* from Scotland, the Romans built their famous wall. They could not subdue the Pictish tribes, so keeping them out was their solution. Building began in 122 AD in Emperor Hadrian's reign and at its height, it was the most fortified & heavily defended border of the Roman Empire.

NOTE: There was a second wall built further north (The Antonine Wall) from the Firth of Forth near Bo'ness to Old Kilpatrick in West Dunbartonshire, but this was never as secure as the wall shown in the poster depicted here.

What is so remarkable about Hadrian's Wall is that so much of it has remained intact. The central section is in quite superb condition and today English Heritage keeps a close eye on this UNESCO-listed site of immense historical significance. When the Romans wanted infrastructure, they just went ahead and did it. Today we dawdle and procrastinate, with endless planning laws to negotiate and long periods of consultation, so little gets done quickly – Hadrian for Prime Minister? This collectible poster shows the wall disappearing westwards into the distance. It was indeed a masterly feat of engineering and construction.

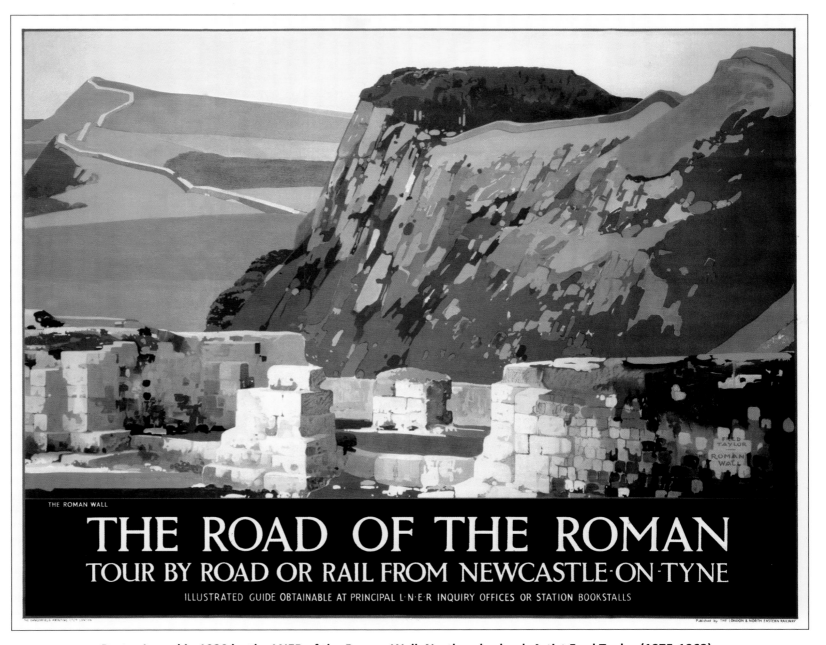

Poster Issued in 1930 by the LNER of the Roman Wall, Northumberland: Artist Fred Taylor (1875-1963)

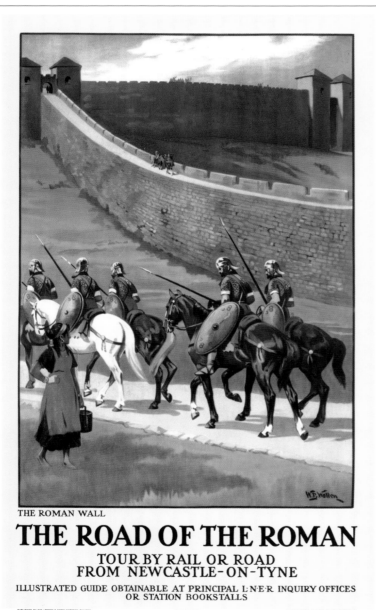

LNER 1925 Poster of Hadrian's Wall: Artist W.B. Wollen (1857-1936)

We are now magically back to the year 150 AD. Rome rules Britain and a patrol is seen here returning to barracks. This poster (L) by the military artist William Barnes Wollen appeared around 1925, and shows how the wall must have looked shortly after completion. Wollen was an army major and seemed to capture pageantry and historical scenes extremely well.

Contrast this with a 1950s scene produced for the North American market. Leonard Squirrell painted this in the early 50s and the poster appeared in 1953. Walkers are taking advantage of the wonderful scenery and history to 'walk the wall'. Again the expansiveness of this part of Northumberland comes through in the painting.

Somebody more familiar with the area than I can probably pinpoint the exact location of this poster, but from studying photographic images, this poster may depict the wall in the Housesteads area. What is so amazing is how the Romans used natural features as additional defences and contoured the wall to exactly match the local landscape features. Squirrell's poster shows this quite superbly.

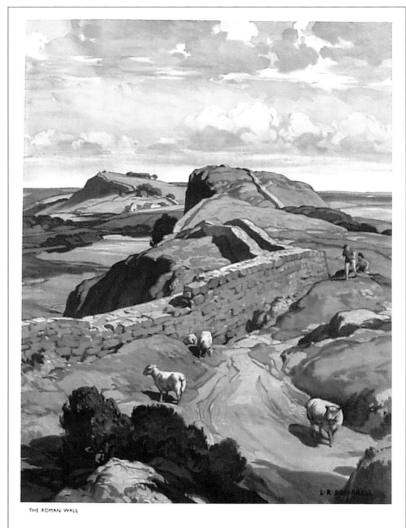

1953 Poster for the American Market: Artist Leonard Squirrell

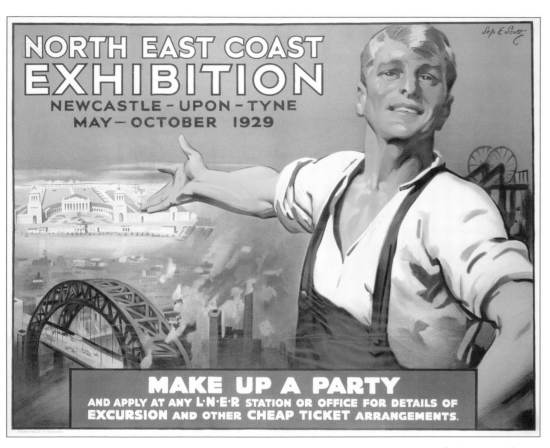

LNER Poster for the 1929 Newcastle Exhibition: Artist Septimus Scott (1879-1962)

Newcastle and the Tyne Area

It is time to return from rural to industrial Northumberland and our next poster is inviting us to attend the famous 1929 exhibition. This was opened by The Prince of Wales on 14th May 1929 and quickly became a symbol of regional pride and industrial success. Its purpose was to bolster local industry and commerce, and maybe also to promote tourism. This is the only poster I have found (so far) for this event. More than four million people attended and over the years much of the memory has been erased, but the military museum building is still standing. The artist, Septimus Edwin Scott, became a famous poster artist, and during this series we will display several of his wonderful artworks.

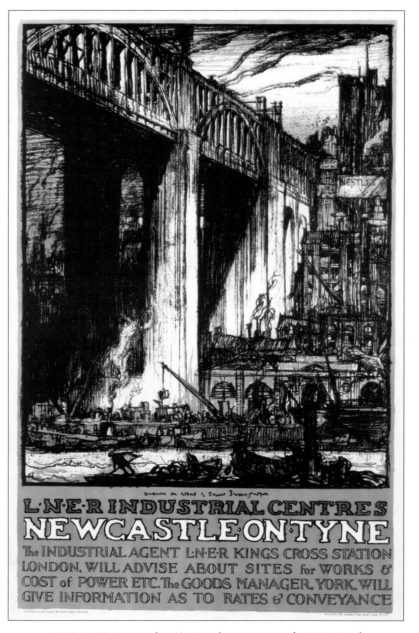

1924 LNER Poster by Sir Frank Brangwyn (1857-1956)

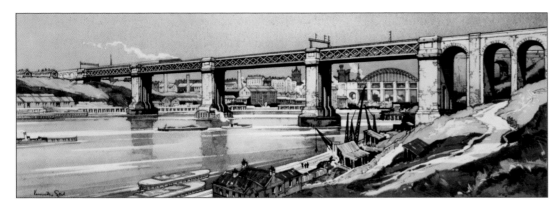

Carriage Print Artwork of the King Edward VII Bridge: Artist Kenneth Steel (1906-1973)

Newcastle is situated on the north bank of the River Tyne and took its name from the castle built by Robert II (eldest son of William the Conqueror) around 1080. However, there had been a Roman settlement and people had lived here for more than a 1000 years. The sheep we saw in earlier posters were responsible for a thriving wool trade and when coal was found all over the area in the 14th century onwards, the town began to grow. Shipping facilities appeared on the Tyne and soon ship-building and repair work were established. Though these have long since all disappeared, the city today is a major business hub for the north-east with excellent educational and cultural facilities.

The city also has a spectacular series of bridges, two of which are shown on the previous page and the top of this page. Brangwyn's poster depicts the High Level Bridge, built between 1846 and 1849. The Tyne Gorge is steeply sided so when the railways arrived, the need to cross high above the river arose. The bridge carried road traffic on the lower level and railways on top. The designer was Robert Stephenson and his structure has recently undergone a £40M+ refurbishment. The King Edward Bridge was started in 1902 and completed in 1906. When rail travel increased in the late Victorian era, it became increasingly inconvenient to reverse trains out of Newcastle Central to continue the journey north. The North Eastern Railway commissioned one of their engineers Charles Harrison to design it and The Cleveland Bridge Company built it. Once commissioned, there was a loop south of the station, so trains could enter and leave far more easily. The famous Tyne Bridge, built in 1928 is also depicted in Steel's picture. This single arch structure, of the type built in Sydney and New York, is the most celebrated and well known, but has yet to appear on a railway poster.

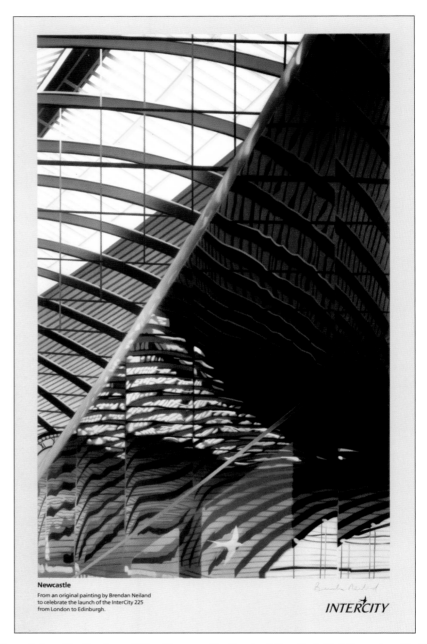

Newcastle
From an original painting by Brendan Neiland to celebrate the launch of the InterCity 225 from London to Edinburgh.

INTERCITY

Modern Intercity Poster of the Newcastle Central Roof: Artist Brendan Neiland

The previous Intercity poster of the fabulous curved roof at Newcastle Central Station comes from Professor Brendan Neiland. We saw several of his images in the Scottish Volume and more feature in this journey. It is part of a series of station posters commissioned in 1996 by Intercity. The trainshed at Newcastle was designed by John Dobson and opened in 1850. Its classical three arched, curved design set the style for all the NER's main station layouts (as at York), culminating in the rebuilding of Hull Paragon in 1904. Neiland's treatment is very distinctive and contemporary and not the expected classic view of the famous interior.

Our next poster sees us on the River Tyne, the lifeblood of Newcastle in past times for ferries, the exporting of coal and other goods, plus shipping facilities that few ports possessed. This poster was one of a series painted in 1932 by the great artist Frank Mason. The style is somewhat unusual for this prodigious painter, with a monochromatic appearance that surely would have looked better in full colour. The Tyne (62 miles (100km) in length) is actually two rivers upstream of Hexham. Waters from Cumberland (The South Tyne) and those from the Kielder Forest area (North Tyne) meet at Hexham, and flow eastwards through the Tyne Gap to enter the sea at Tynemouth. Rather interestingly, Hadrian's Wall is north of the river and I often wonder why the natural barrier of the river itself was not used to better effect. Tyne Dock and South Shields were important coal export docks for over 600 years but today the Tyne Dock is an import terminal for coal. Now I can use the phrase *'taking coals to Newcastle'* and it is quite literally true!

FAMOUS RIVERS OF COMMERCE

THE TYNE

MODERN EQUIPMENT FOR HEAVIEST SHIPMENTS
L·N·E·R DOCKS ARE THE LARGEST FOR COAL
EXPORTING IN THE WORLD
REGULAR SAILINGS TO NORTHERN EUROPE
ADJACENT HOLIDAY RESORTS – WHITLEY BAY TYNEMOUTH AND SOUTH SHIELDS

LONDON AND NORTH EASTERN RAILWAY

1932 LNER Quad Royal Poster one of a Series of 'River Posters' Painted by Frank Henry Mason (1875-1965)

1912 NER Quad Royal of the Tyne/Wear Transportation Links: Artist Percy Home

We finish the descriptive part of our journey with two rather uncommon posters. The pre-WWI quad royal above shows the lower reaches of both the Tyne and the Wear, so the concentration of shipbuilding at the mouth of both rivers can be appreciated. This poster also shows how far upstream Newcastle is from the sea (just over 6 miles or 10kms). The main bridges shown in earlier posters can clearly be seen.

Alfred Lambart's 1926 colourful LNER poster of the elegance at Tynemouth is quite a classic. Composition and style change only 14 years after the poster above is clear. The beaches shown here are 'bracing' (especially in winter) but there is a charm surrounding the 18th and 19th century buildings that have made the village a conservation area. The two posters on the next page see us in our hotel in Newcastle for a pint of *the Brown Ale*, whilst we study the route we have just taken in the right hand poster.

LNER 1926 Poster of Tynemouth Elegance: Alfred Lambart

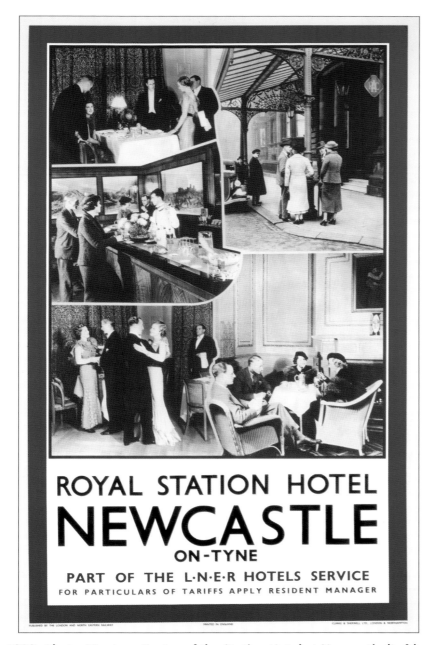

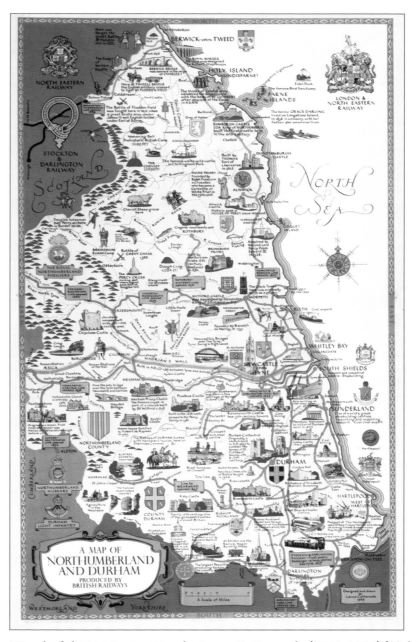

1930s Photo-Montage Poster of the Station Hotel at Newcastle (Left) and a Wonderful 1949 Poster Map by Lance Cattermole (1898-1992) (Right)

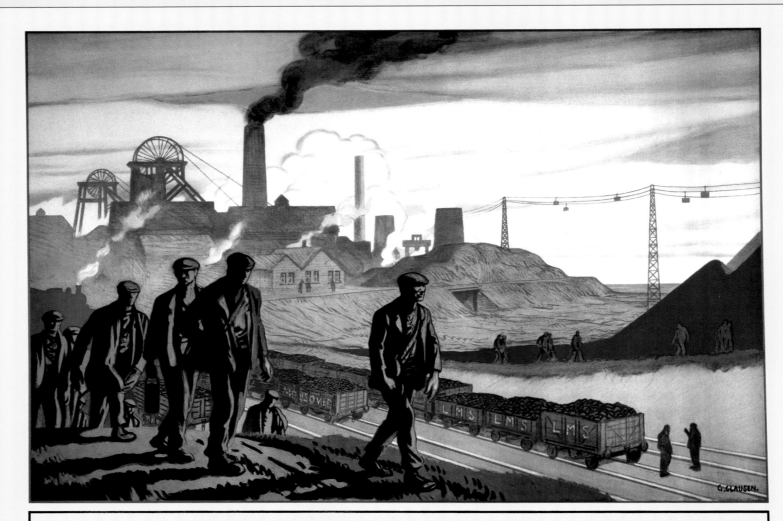

A Symbol of the Industry of the North East: Coal Mining as Depicted in this 1924 LMS Poster: Artist G. Clausen RA

Chapter 2 County Durham and the Tees Valley

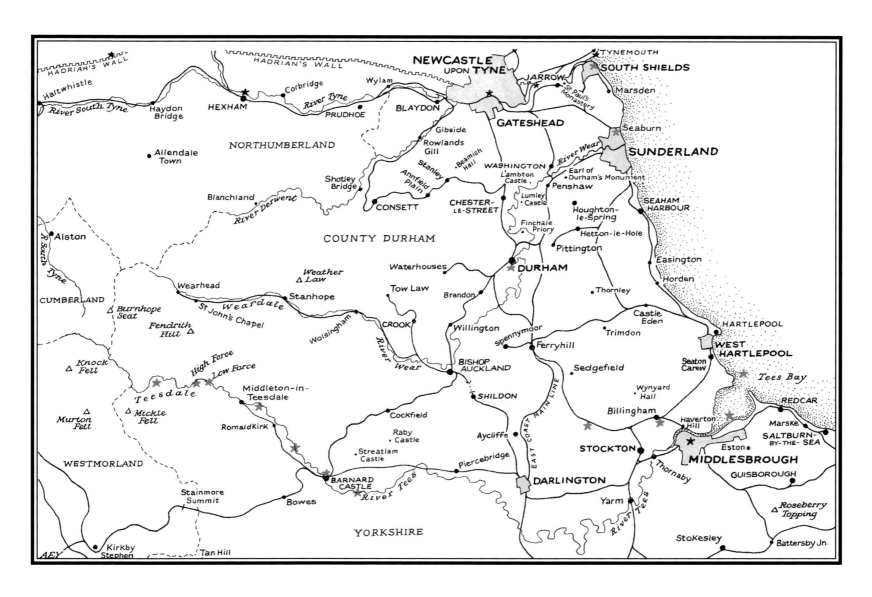

Chapter 2 County Durham and the Tees Valley

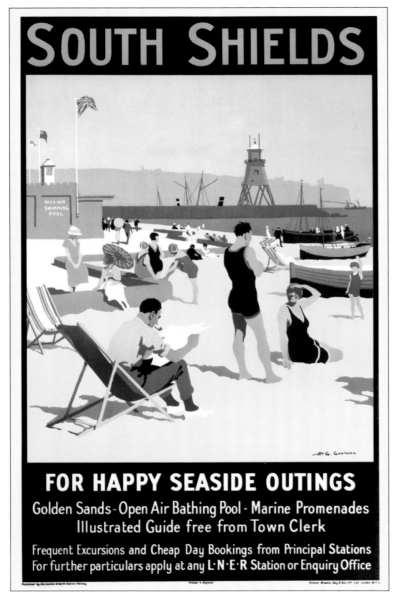

1925 LNER County Durham Holiday Poster: Artist H.G. Gawthorn

We Begin Again at the Seaside

After our short poster visit to bustling Newcastle, it is time to move south of the Tyne and into County Durham. We begin at the seaside in the Tyneside Borough of South Shields. The sands both north and south of the Tyne were popular in the summer months, and a rarely seen poster from Henry Gawthorn shows a beach scene typical of the time. The poster appeared in 1925, when Gawthorn was a favoured artist in the LNER fold. The town was a dormitory for workers in the city and still maintains some of that tradition today. The population is around 90,000, but this includes the riverside towns of Jarrow and Hebburn with villages such as Boldon and Whitburn. Shipbuilding was carried out at Jarrow and as Gawthorn's poster shows, this activity was close to the beach area. There are six miles (10kms) of coastline and three miles (5kms) of river frontage that are dominated by large piers (also illustrated in this poster).

To the south of the area shown here, there are sand dunes as well as dramatic limestone cliffs with grassy areas above (known as the Leas). These areas are protected by the National Trust. A mile or two further south is Marsden Bay. Here the rocks and cliffs have been weathered by fierce winter storms driving inland off the North Sea. The limestone has been sculpted into wonderful pinnacles and stacks. These are ideal bird nesting places, so herring gulls, kittiwakes, shags, cormorants and others are found. In the nesting season, go there with your ear defenders if you are bird-watching! Off-shore we find Marsden Rock, which used to be part of the mainland, until nature reduced some of the cliffs to rubble. It too is a bird sanctuary. Even further down the coast are the remains of Marsden Colliery and other signs of industrial dereliction, such as coloured industrial waste and mine tailings. Whitburn Colliery was also nearby, another sign of industry long gone. South Shields itself has Victorian and Georgian buildings in the Westoe Village area and these were the setting for several novels by Catherine Cookson. The coal industry flourished in Victorian times, bringing with it an influx of immigrants, many of whom were Yemeni. There is a large and well known Arabic community still resident in the area. The shipbuilding and sea-faring added to this immigrant population. It was the mines, however, that drove the local economy and also drove the local population from around 20,000 in 1800, to more than 75,000 by 1860. The mines in turn drove the need for railways, so it is not difficult to see that Durham and Northumberland really were the birthplace of railways, because of the real need for railways. South Shields had seven collieries and some went miles out and under the North Sea.

Some three miles (5 kms) south of Whitburn, the River Wear runs out into the sea through the heart of Sunderland. Here there are more long piers, and in former times, many cranes pointed skywards from the numerous shipyards. On the north side of the Wear, we find the seaside towns of Roker and Seaburn, merged together to form a single resort. This is our next poster, a British Railways issue in 1953, which shows a family enjoying the joys of the beach in Coronation Year. The obligatory 'dog on the beach' is also there - with quite a suntan! It was painted by Alfred Lambart, who was born in Darlington in October 1901 and died in Hull in October 1970. He spent almost his entire life painting views of the seaside places all around the English coast, and several made it onto evocative railway posters. His Tynemouth poster, painted when he was 25, appears at the end of the previous chapter (page 42). Notice the contrast in both style & colour palette between that poster and this one. His first poster (Southport Lancashire) appeared in 1923, and this Roker/Seaburn poster is the last one I have recorded, so Lambart boasted quite an illustrious commercial art career.

To the Heart of Durham

It is time to leave the coast and head inland to the City of Durham. The city can trace its heritage back many centuries to the arrival of a religious community who were looking for a permanent site to lay the body of St. Cuthbert to rest – or more correctly his bones, as he died in 687. Our next poster (following page) is another of Doris Zinkeisen's historic works. Here the site for the shrine is chosen on a hill where a 'dun cow' is standing. This ultimately gave rise to the city name. The monks first built a wooden church here, and then a small stone structure. The site is within a large bend of the River Wear, so they were protected on three sides. After the Norman invasion and conquest of 1066, the victors also recognized the immense strategic importance of the location. The Cuthbert community had by this time become Benedictine Monks and, encouraged by the conquerors, they began work on the present day cathedral, whilst the Normans themselves started work on the castle right alongside. It was a building site that was comparable to today's new Olympic site in East London, but without the technology of machinery to aid the construction. We can but marvel at the immensity of the Durham building work. The Bishop had been appointed by the King to rule this part of the country, so his residence was in the castle and it was just a short walk to the massive interior of a Norman Cathedral for prayers and worship.

The Zinkeisen poster shows two angels flying alongside to protect Cuthbert's bones, with the entourage led by a weird looking 'pied piper'. The cow shows the site and above it is the outline of the magnificent Norman cathedral that was to come. Doris Zinkeisen's artwork is crisp, colourful and evocative – and today is very collectible.

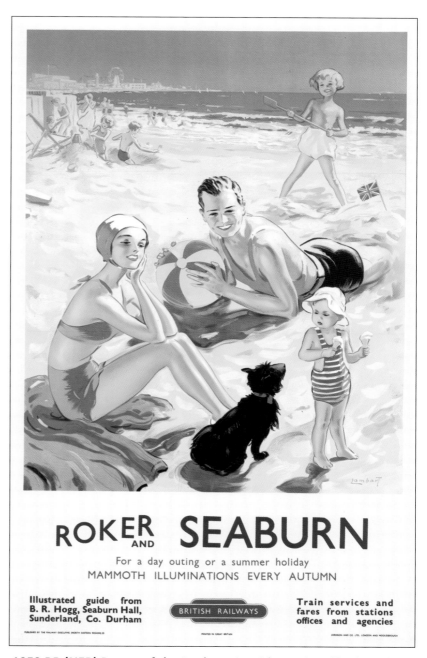

1953 BR (NER) Poster of the Durham Seaside: Artist Alfred Lambart

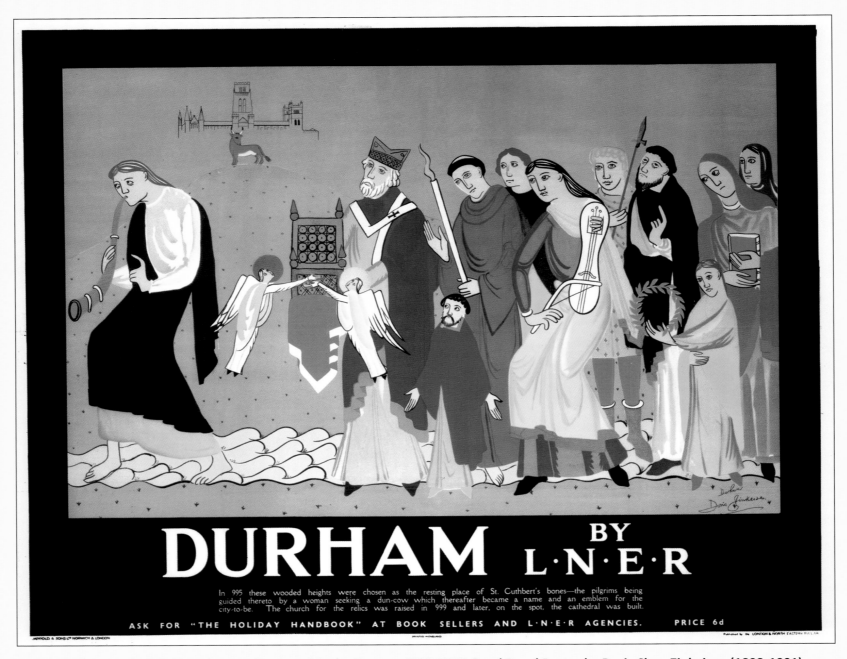

Foundation of Historic Durham as Portrayed in the Famous 1930 LNER Quad Royal Poster by Doris Clare Zinkeisen (1898-1991)

History and Architecture

Durham Cathedral features on several railway posters, spanning more than half a century. It is not until we approach more closely that the size becomes apparent. Looking at it from across the river (as in these two works of art) does not prepare visitors for the view when standing in front of the imposing West Front. This is a very large building, and at 1000 years old, one can only marvel.

These two pieces of poster art show the size of the exterior. Fred Taylor painted the nearer poster around 1933, to be issued with the new LNER slogan *"Its Quicker by Rail"* a year later. The autumn tints of the riverside trees show the time of year that Taylor undertook the LNER commission. The drawing on the far side comes from one of my favourite poster artists, Claude Buckle. He will feature throughout the rest of the series, but he undertook the painting of many of the English cathedrals for the GWR and later for BR (WR). This would have been quite a collectible item if it had been turned into a station poster. The view is taken from the bend in the river to the southeast of the cathedral. By including a house in the foreground, one can get an idea of the scale of the Norman building. But even this simple sketch shows the huge talent Claude Buckle possessed. No wonder he painted many railway posters and carriage prints.

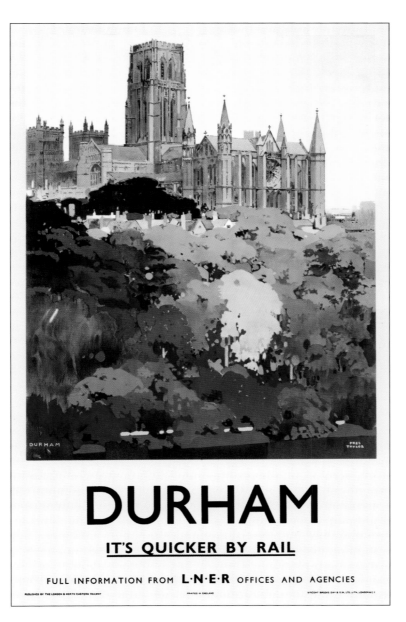

Mid 1930s Classical LNER Poster for Durham: Artist Fred Taylor

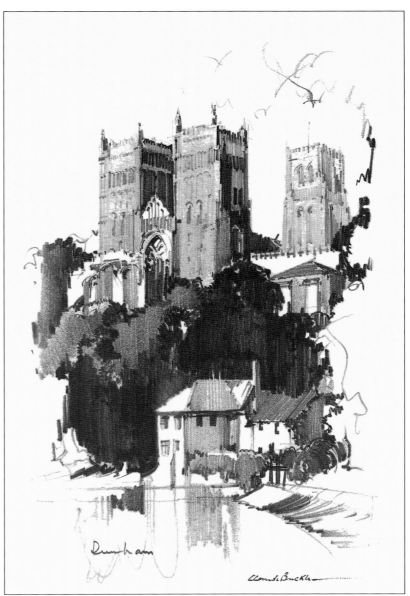

**Sketch for a Poster by Claude Buckle (1905-1973)
(Courtesy *ClaudeBuckleArt* – The Claude Buckle Estate)**

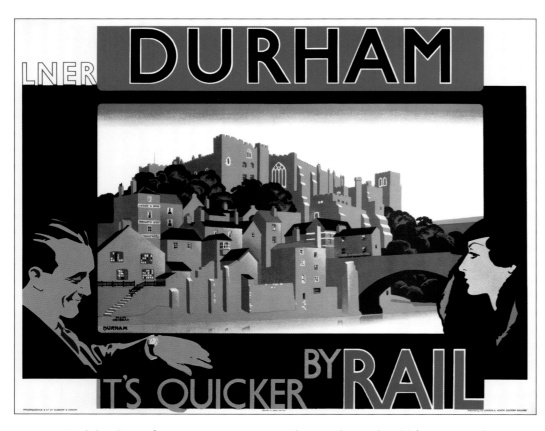

Arriving in Durham: 1935 LNER Poster by Frank Newbould (1887-1950)

The distance from Newcastle to Durham is a mere 14 miles (22 kms). Midway, we pass through Chester-le-Street, built on the site of a Roman fort: 'le-Street' is of course the Great North Road which runs through the town. It was a temporary resting place for the bones of St. Cuthbert around 822 AD, prior to the next move south into Durham. Soon the bulk of Durham Cathedral looms into view and the view shown in our next poster greets us. This was an attempt by the LNER to emulate the earlier Caledonian Railway posters that put subject matter into the borders, with a central framed subject to draw the eye. Compare his treatment of the buildings and Norman panorama with that from Harry Tittensor shown alongside. This is far softer and typical of the very early posters that the LNER put out after consolidation. Large though the castle is, it is dwarfed by the central cathedral tower. Both make evocative posters, but the commercial eye of Newbould makes a sharper railway poster that is only spoilt by the large lettering.

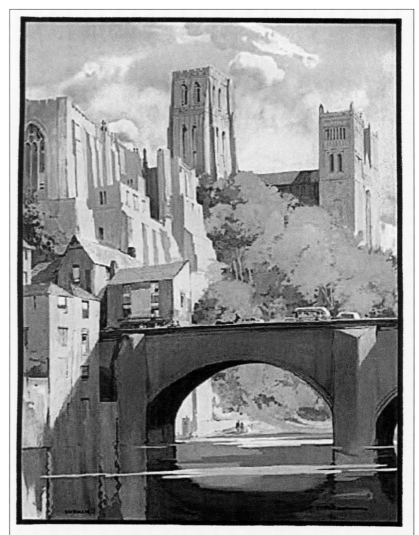

1924 Durham Cathedral Poster: Artist Harry Tittensor (1887-1942)

The poster below was, for me, the obvious choice for the rear cover. Brangwyn painted several posters with a muted palette, and yet with a raw, distinctive quality. In former times, living under the shadow of the imposing castle must have been daunting, and somehow this poster echoes that. Using just a few colours, Brangwyn has captured the magnificence of this location. His treatment of light and shade is quite masterful.

The castle is Norman but for the past 160 years has been the home to part of Durham University, an establishment with a tremendous past and an excellent academic reputation. The castle itself is a classic example of a motte and bailey design. Its condition, design and heritage mean it is one of Britain's UNESCO-listed sites. In the Middle Ages it was the seat of the Bishops of Durham, but when they moved to nearby Bishop Auckland, the castle became a college and a seat of learning.

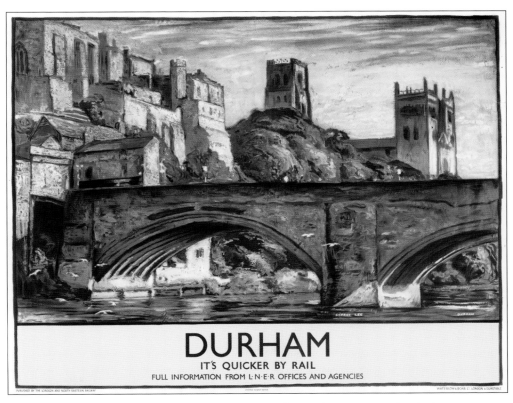

1935 LNER Quad Royal of the UNESCO Site from the Wear: Artist Sydney Lee

The second of the views looking up from the River Wear comes from Sydney Lee. This was commissioned a year after the Brangwyn poster - (I wonder why they wanted a second very similar poster?). The colour on this poster contrasts with Brangwyn's moodiness, but I think there is a bit too much bridge, which detracts from the steepness of the riverside buildings. The overall composition is good, but in my humble opinion, the Tittensor on the previous page is rather better. The afternoon sunlight picks out the bridge piers and adds vibrancy to the lower half of the poster.

When the Site was nominated for the UNESCO award, the Citation from the UK Government said *"Few buildings in England can boast a better history of continuous occupation than Durham Castle. Founded soon after the Norman Conquest, the Castle has been rebuilt, extended and adapted to changing circumstances and uses over a period of 900 years"*. This sums up this wonderful view perfectly and a visit to see the actual location of these two posters is highly recommended.

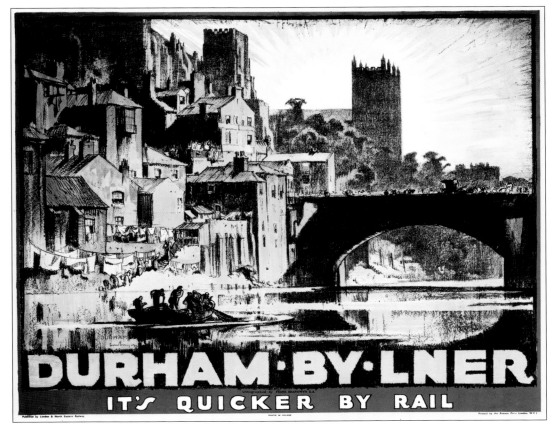

1934 LNER Quad Royal of the Wear at Durham: artist Frank Brangwyn (1867-1956)

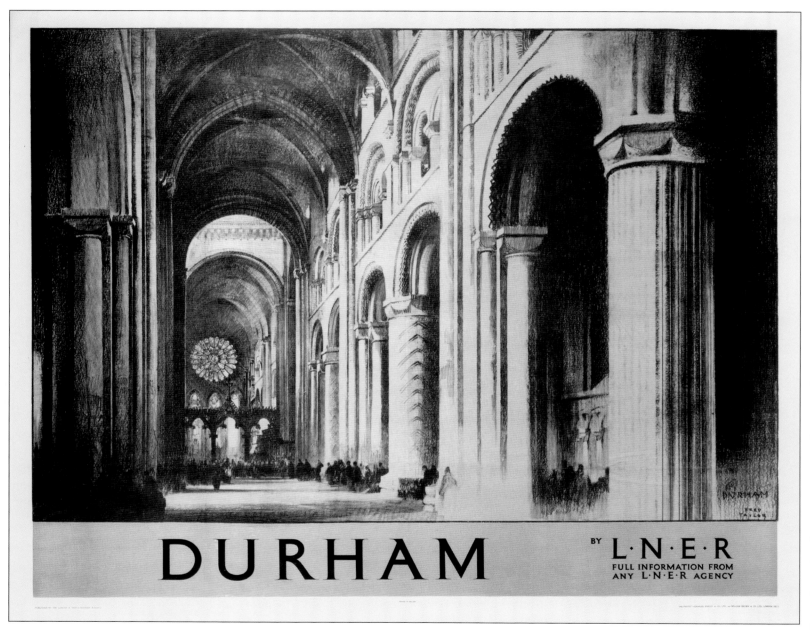

Magnificent Interior of Durham Cathedral Painted by Fred Taylor (1875-1963) in 1923: Issued by the LNER a Year Later

We have now moved inside the cavernous cathedral ,and in Fred Taylor's 1923 painting we are looking along the Nave. The northern front of the Cathedral faces onto Palace Green and here the full 496 foot (143 metres) length from west to east can be appreciated. Many of the buildings surrounding the Green originated in the Middle Ages, and entry is gained via the medieval gate house which is still locked every night. On a summer's afternoon this is a great place to take in the historical atmosphere.

The nave, quire and transepts are all Norman. At the west end is the 12th century late Norman style Galilee Chapel, and at the east end, the 13th century Chapel of the Nine Altars is in the Gothic style. The western towers date from the 12th and 13th centuries, while the great central tower is the most recent addition; it dates from the 15th century and displays perpendicular Gothic detailing.

The cloisters are on the south side of the cathedral, and though begun at the same time as the main building, they contain much work from the 15th century or later. During the Civil War, Cromwell closed the cathedral in 1650, and had the audacity to use the building to hold 3,000 Scottish prisoners: I leave it to the reader's imagination to think what that must have been like! With the Restoration in 1660, the new Bishop of Durham – John Cosin – set about a complete refurbishment, and some of his handiwork can be seen in the form of rich carvings in the quire. The 19th century saw the introduction of much of the stained glass in the Cathedral, and the Scott screen in the crossing.

This poster is a personal favourite. Kenneth Steel drew and line-painted this panoramic image in 1949, to be issued as the poster a year later. I am most privileged to have the original artwork hanging in my home, so I can see architectural drawing at its best each day. The artwork is small (39cm x 31cm) but it is incredibly detailed. It is quite amazing to think this was enlarged three times to quad royal size, with no loss of resolution. We can now see the size of the bridge in relation to the buildings: contrast the scale of the bridge here with that of Lee's poster on page 51.

The 1961 Flag of County Durham

Durham has a very rich history, a subject that we all can and must learn from. Heraldry and pageantry is a key part of history, and I could not exclude the striking 1961 blue & yellow flag of the County. Notice the white rose in the centre, signifying that from 1961, part of Yorkshire had been moved into the County. The blue & yellow Durham colours date from the 15th century.

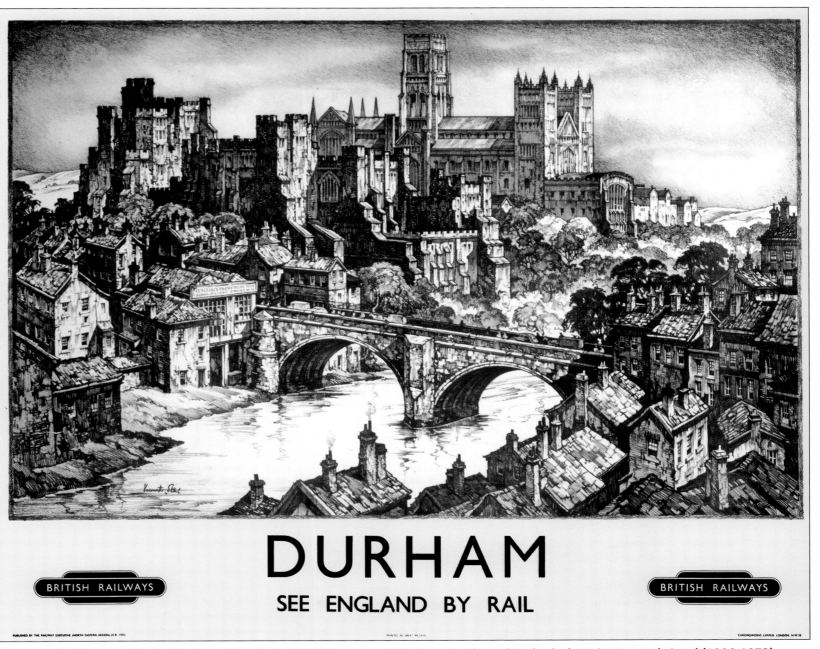

Architectural Art at its Best: Wonderful 1950 Drawing of Durham Castle and Cathedral: Artist Kenneth Steel (1906-1973)

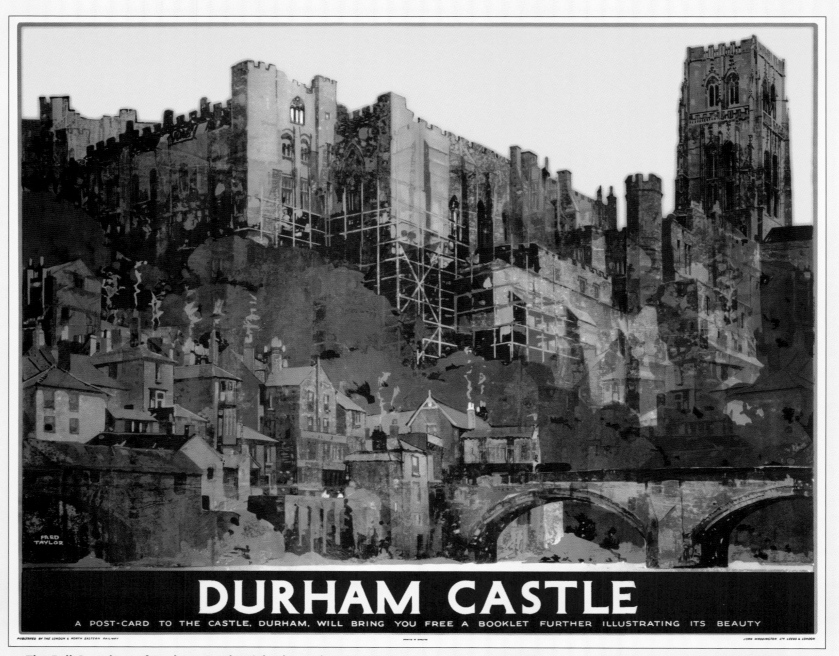

The Full Grandeur of Durham Castle High Above the River Wear: LNER Poster Dating from Late 1928: Artist Fred Taylor (1875-1963)

A Visit to the Castle

These two Fred Taylor posters both detail the true grandeur of Durham Castle. Taylor's unmistakable style of painting buildings comes through strongly on these posters. Over the years he undertook commissions of many eastern and north-eastern landmarks for the railway companies. The quad royal poster on page 54 shows better than the others the true scale the castle, towering over the dwellings, bridge and river below.

The Castle began as a simple structure atop an earth mound around 1072. The earth mound is the 'motte' and the surrounding walled enclosure is the 'bailey'. William the Conqueror saw the site as ideal for subduing the rebellious local inhabitants following his victory at Hastings. The north was slow to accept Norman rule. Waltheof, Saxon Earl of Northumberland was charged with the building on William's specific orders. The present day castle covers three sides of the main courtyard – the original inner bailey – but by reading the coats of arms on each wall, visitors can trace the historical development. Each Bishop in turn added to the structure, and at the end of their work, their personal coats of arms appeared on the section of wall that they constructed. Therefore, the whole castle has been developed over several centuries. This is what makes it unique. The keep would normally be thought of as the oldest part (being built on the Norman mound), but it is in fact a fairly modern reconstruction. The first stone structure appeared during the episcopacy of Thomas Hatfield (Bishop from 1385) in the 14th century, but over the centuries it deteriorated and was eventually rebuilt around 1840 as student sleeping quarters, after the castle became University College. The great Inner Courtyard is entered from the imposing Gatehouse near to the site of the moat. The Gatehouse was primarily the work of Bishop Pudsey (Bishop from 1153-1195) but alterations occurred around 1540 and 1800. The Great Hall was constructed by Bishop Anthony Bek (1284-1311), but it was Bishop Hatfield who extended it, only for Bishop Fox to shorten it again around 1500. It was Fox who built the medieval kitchens.

The castle requires continual maintenance and care. In the late 1920s it was discovered that the north-west corner of the Castle, and the Great Hall in particular, was in danger of sliding down the steep slope into the River Wear. Major work was undertaken to install new foundations and to tie these to a central concrete plug beneath the courtyard. It is interesting that Taylor chose to include all the scaffolding and foundation work in his poster on page 54: this dates it to around 1928 (previous records placed this poster as 1923). In recent years, the roofs have been replaced under a grant from the Northern Rock Foundation, and English Heritage has been involved with work at the Gatehouse and the Norman Arch on Tunstal's Gallery. Further work under the Great Hall was completed in 2008. Taylor's poster alongside shows us the true architectural beauty.

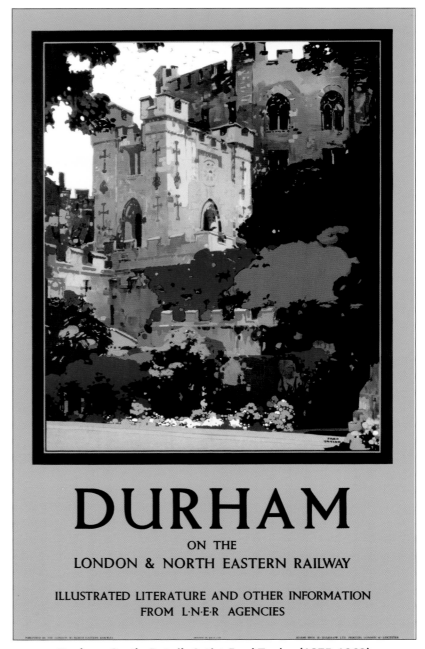

Durham Castle Detail: Artist Fred Taylor (1875-1963)

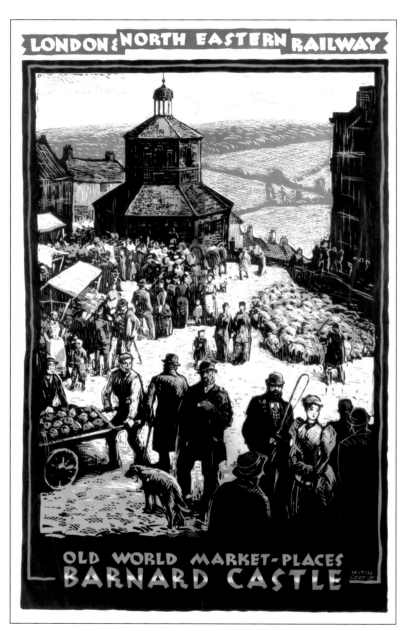

Two Early 20ᵗʰ Century Posters for Barnard Castle: Artists Frank Mason (Left) and Austin Cooper (Right)

Out and About Again

We now go back in time. Travelling southwards by train from Durham, we soon reach the junction of the line down to Bishops Castle, home to the Bishops of Durham at Auckland Palace. This was also the junction for the Durham coalfield railways. Lines used to come out of the town on all points of the compass, and so warranted a substantial station. This was duly designed by Thomas Prosser. One of the lines takes us to our next pair of posters, at Barnard Castle. This 15 mile (24 km) branch used to allow connections to be made westwards over the Pennines. As the railway usage and coal suppliers ran down, the list of closed lines from Bishop Auckland grew. The first was just before WWII and other services felt the axe in 1953 and 1956. The line we travelled down on from Durham was itself a victim of rail rationalisation in May 1964. All services to Barnard Castle closed in 1962, but during former times this town saw some poster activity, and two early images are depicted here. Barnard Castle is a historic market town that grew up in the shadow of Bernard de Balliol's Castle. This was built in a strategic location around 1125 and is shown in the poster far left by Frank Mason. This is one of his *'Monuments'* series, produced for the NER around 1910. Alongside is an LNER poster from Cooper's *'Old World Market Places'* series that appeared in 1932.

These two posters show nothing of the panorama of the town, but a carriage print by one of my favoured artists, J.C. Moody, shows Barnard Castle to far greater effect. The artwork of the town in this painting is exquisite. It is here we get our first glimpse of the Tees (we will travel upstream before coming back to the coastal industry). The ruined castle dominates the river-side fringe of the town. The Balliol structure was developed first by the Beauchamp family and then Richard III. High above one of the windows in the inner courtyard, eagle-eyed visitors can see the emblem of Richard III: the boar. The castle was last besieged in 1569, when forces loyal to Elizabeth I eventually surrendered to 5,000 northern rebels.

Carriage Print Artwork of Barnard Castle by John Charles Moody (1884-1962)

Visitors can follow the line of the castle wall, and entering the centre of the town brings a remarkable building into view. This is the Market Cross (also known as the Butter Mart) and is the strange building shown in Austin Cooper's poster on the previous page. This is a curious octagonal building built in the town square in 1747 by Thomas Breaks. It has had many uses in the past 260 years, including the Town Hall, the Fire Station, the town Courthouse and as a focus for selling produce and dairy goods (as in the Cooper Poster). This gave it the alternative name of The Butter Mart.

But it is the Tees that we now follow, and the colourful poster alongside contrasts markedly with the two sombre images of the town on the previous page. The style and palette is instantly recognizable: that of the wonderful Jack Merriott. The ruins of the castle are cleverly disguised and the focus of the painting is the River Tees. Merriott was superb at painting flowing rivers (see Volume 1 page 19 for the Tweed at Neidpath). The use of two coloured shirts adds interest, without domination, and the eye is pushed to the central bridge by the line of the trees above. The composition is quite superb.

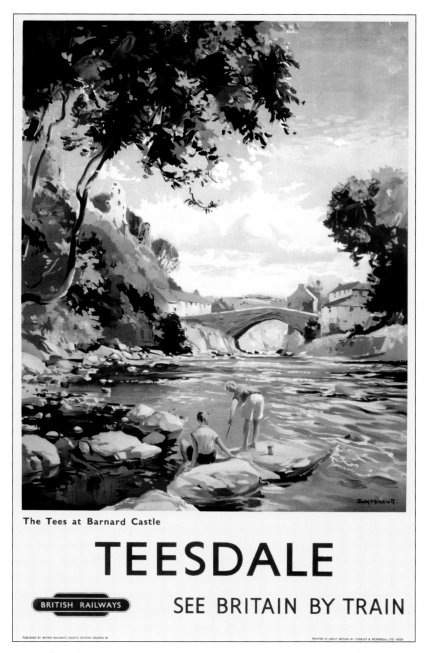

The Tees at Barnard Castle

TEESDALE

BRITISH RAILWAYS

SEE BRITAIN BY TRAIN

1956 BR (NER) Poster of Barnard Castle: Artist Jack Merriott (1901-1968)

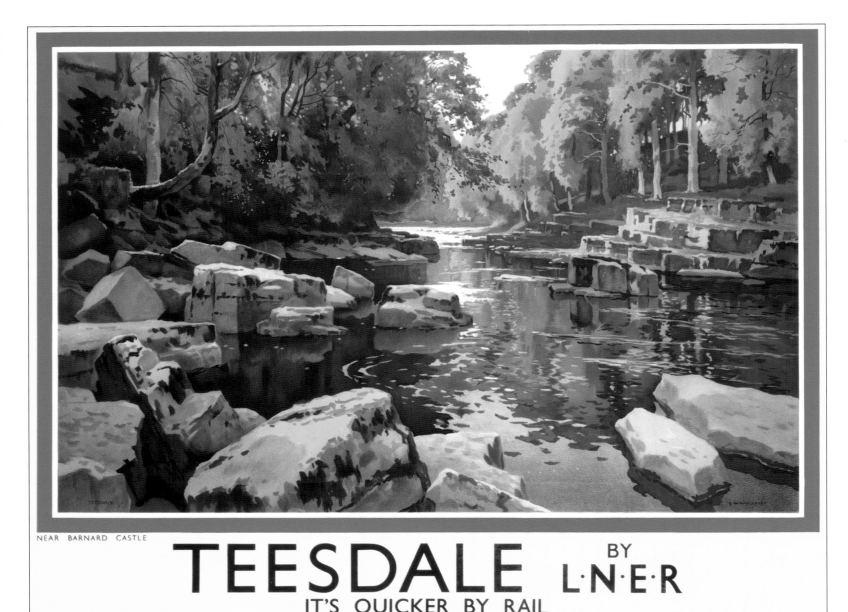

NEAR BARNARD CASTLE

TEESDALE BY L·N·E·R
IT'S QUICKER BY RAIL
FULL INFORMATION FROM L·N·E·R OFFICE AND AGENCIES

The Autumn Tints in the Tees Valley: LNER 1935 Poster by Ernest William Haslehust (1866-1949)

Into Beautiful Teesdale

Moving up-river from Barnard Castle, we have magically been transported from summer to autumn. The golden tints of this lovely time of year appear reflected in the Tees in this quite wonderful poster by E.W. Haslehust. It was part of a trio of paintings he was commissioned to produce by Cecil Dandridge in the mid 1930s, and surprisingly all three were accepted. Haslehust was very busy during the 1930s. As well as railway poster commissions, he also undertook paintings for travel books published by Blackie and Sons under the banner *"Beautiful England"*. When you see this poster full size, it is really stunning and no amount of digital enhancement can match the beauty of his work. The Tees actually forms the border between Durham and Yorkshire, so these next few posters have us straddling the two counties. The upper reaches of the Tees form the boundary between Durham and the former county of Westmorland.

The river rises on the eastern slopes of Cross Fell on the Pennine Chain. From there it is a journey of around 85 miles (132km) down to the sea, between Hartlepool on the northern bank, and Redcar on the southern bank. (It is Redcar, North Yorkshire where we start the next chapter). During its journey, it drains an area in excess of 700 sq miles (over 1800 sq. km.) and interestingly has no major tributaries.

Here we have the second of the trio of Haslehust posters produced for Cecil Dandridge. The detail is wonderful, but here the artist has chosen a dark portion of the Tees gorge. The sombreness of the rocks is lightened considerably by the vibrant green of the moss in the foreground. He has also allowed shafts of sunlight to highlight the sinuousness of the river. This is painting by a master artist.

The poster sub-caption says *'Near Barnard Castle'*. Looking at the Ordnance Survey map sheet 84 shows the location could be near East Holme, upstream of Barnard Castle. The contour lines suggest this is a likely spot, but it is a wonderful painting wherever the location is.

Referring again to OS sheet 84 shows only the upper section of the Tees (above Barnard Castle) is known as Teesdale. The area bordering on the river has a grandeur and desolation with surrounding hills to 2500 feet (760m), and large expanses of moorland. This is all within the North Pennine AONB (Area of Outstanding Natural Beauty). The AONB and the river itself have been designated a geological Europark, the first in the UK.

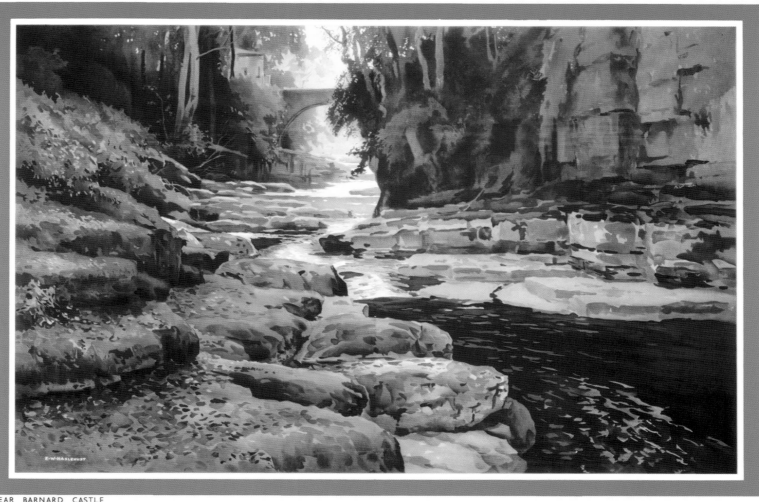

1935 LNER Quad Royal of Beautiful Teesdale: Artist Ernest William Haslehust (1866-1949)

There are some mills along the course of the river and one of these makes the subject for our next poster stop. The artist here is John Moody and a copy of this poster is in my own collection. The LNER logo on this poster was used from 1934 onwards and strangely, the poster does not carry the usual slogan *"It's Quicker by Rail"*, instead urging us here to *'Travel by Rail'*. This dates the poster to after the end of WWII. Moody's work is characterized by fine detail: the rocks in the river are painted meticulously.

Contrast this with the 1910 poster below. We are now further upstream and the Edwardian style is evident in this painting just across the Durham border in Yorkshire. This shows why the area is worth visiting today. However, it is a pity that the painting is rather sombre for such a magnificent subject. Besides the moorland, visitors can see a succession of waterfalls and rapids, where the river flows over a series of black basalt rocks, in an area called the 'Cauldron's Snout'. One of the falls is depicted here.

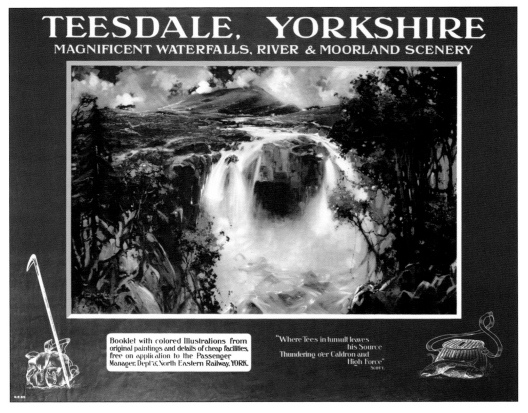

1946 LNER Poster for the Upper Tees Valley: Artist John Charles Moody

1910 NER Poster for the Upper Reaches of the River Tees: Artist is Unknown

Carriage Print Artwork of Low Force, Teesdale: Artist Ernest Haslehust (1866-1949)

The most notable waterfall on the river is High Force, some 4.5 miles (7 kms) upstream from Middleton-in-Teesdale. Here the Tees plunges almost 70 feet (21m) over the edge of the whinstone (black basalt) seam. This is a hard rock, difficult to erode, but in the base of the pool below, the rock is far softer, being made up of carboniferous limestone. The angularity of the whinstone is shown in Edward Wesson's wonderful poster alongside. At the time this was painted, the river used to split and fall either side of the central rock core. The building of Cow Green Reservoir in the upper Tees valley has reduced the flow of the river, and this seldom happens now. Above is the earlier painting of the area by Edward Haslehust. This is of Low Force, a couple of miles further downstream from the location of Wesson's poster.

Many guidebooks state that High Force is the largest waterfall in England, but this is actually not the case. Hardraw Force (at the head of Wensleydale) has a drop of almost 100 ft (30m), and in Cumbria, the Cautley Spout Falls (just north of Sedbergh) are almost 600ft (180m) high. However, the Tees falls are superb and many paintings have appeared over the years, with these two being the subject of railway commissions.

Over time, slow erosion of the hard rock is causing the waterfall to move upstream. Currently there is a gorge almost half a mile (700m) in length downstream of the 70 ft drop. Drive up from Middleton-in-Teesdale in the autumn and marvel at the colours: trees of rich gold contrast with the white water thundering over the falls after a rain storm. No wonder Wesson chose to paint the falls with three visitors revelling in the wonder of nature. Such subjects were popular for many early BR commissions. But we cannot stay too long, as the journey back down the Tees will show us the relative calmness of the rest of the river downstream of these falls.

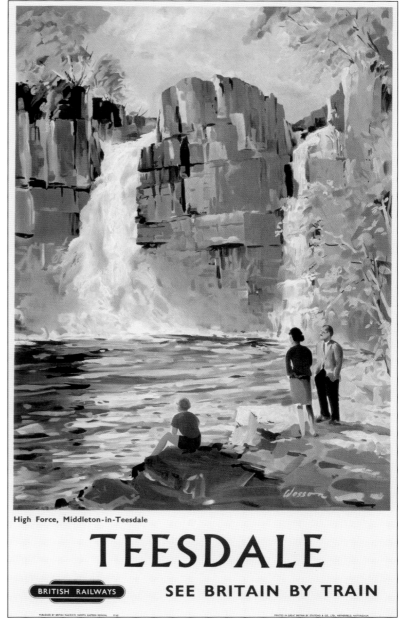

High Force, Middleton-in-Teesdale

TEESDALE

BRITISH RAILWAYS **SEE BRITAIN BY TRAIN**

Magnificence of High Force: Artist Edward Wesson (1910-1984)

The Serenity of Teesdale: LNER Quad Royal Poster from 1935: Artist Ernest William Haslehust (1866-1949)

As we move back downstream, Haslehust treats us to the third of his wonderful paintings of the serenity that is Teesdale. This is located around Middleton-in-Teesdale. The different shades on the ferns in the foreground make this a wonderful piece of art, so I rightfully gave it a page to itself.

Downriver To the Industry

The two posters on this page show something quite different. In 1927, the UK had a rare opportunity to witness a total eclipse of the sun. It started on the east coast at Hartlepool and crossed over to Lancashire and North Wales. Astronomical records showed the total duration was three minutes and 40 seconds with just 15 seconds of 'totality' in the Teesdale area. Alongside this most unusual poster is one of a series painted by Schabelsky in the mid to late 30s, which were published in 1938. Most were all in colour, but this black and white photograph was found in the NRM archives, and is included as I have not seen an original of this poster. They were produced to advertise a series of Ramblers' Guides that covered most of the LNER areas in eastern England.

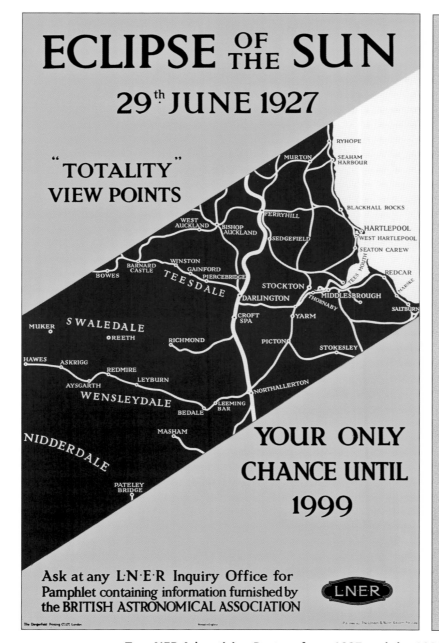

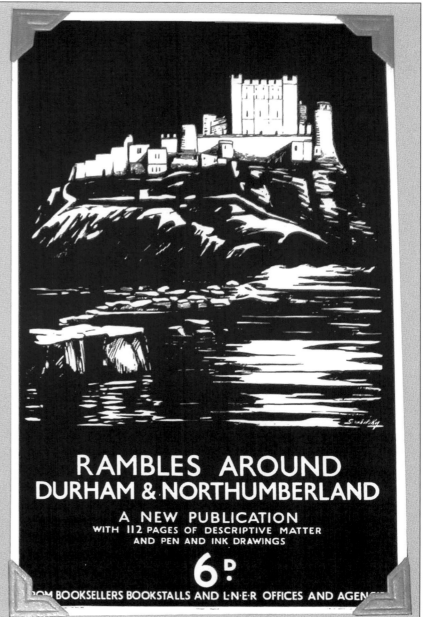

Two NER Advertising Posters from 1927 and the 1930s: Artists are Unknown (Left) and Schabelsky (Right)

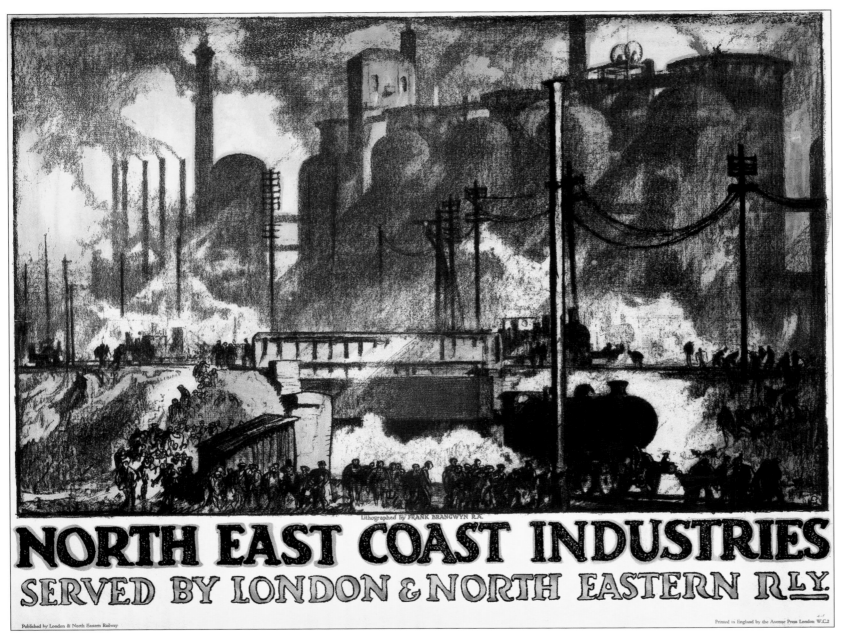

Lithographed by FRANK BRANGWYN R.A.

NORTH EAST COAST INDUSTRIES
SERVED BY LONDON & NORTH EASTERN R.LY.

Published by London & North Eastern Railway

Printed in England by the Avenue Press London W.C.2

1930s LNER Quad Royal of the Heavy Industry of the North East: Artist Sir Frank Brangwyn (1867-1956)

Near the coast we come to an area where man's interference has completely changed the landscape. In Saxon times, Billingham was a small settlement and even in 1801 the population was less than 400. However, our need for explosives in WWI (and later chemicals), led to a dramatic transformation of the area. Some of the places looked as shown in the poster alongside. Ammonia and other chemical plants sprung up, and by the late 1920s, this was the view confronting the local people.

In the Shell Guide for County Durham, Billingham is described as *"one of the most extraordinary of experiences, a sight almost unique in England. On either side of the road are the works. Steaming, sizzling - tall steel towers, great cylinders, pipes everywhere... At night the whole industrial world along the banks of the Tees comes to life... brilliant with a thousand lights, the girders of the Transporter Bridge dark in silhouette: a magic city."* Having worked in chemical plants, I agree!

By the mid 1930s, the population had grown to more than 30,000. Anhydrite was being mined in the area, and plastics production began in 1934. With the onset of WWII, synthetic ammonia was needed again for explosives, (the reason for the first chemical plants).

After the end of WWII, industrial development really quickened, as ICI expanded its chemicals business, and jobs in the area were plentiful. The ammonia plants returned to fertilizer production, as had happened when ICI was formed after WWI. Indeed, Billingham was the Headquarters of the ICI Agricultural Division before the other chemicals production began.

Terence Cuneo took a more colourful view of the industrial landscape, and this 1962 poster for the BR Executive was meant to promote the importance of railways to industrial businesses that now spread all over the area. (All his posters contain a mouse, and if you look carefully, it can be seen).

From Stockton-on Tees all the way downriver there was industry (and most of it heavy industry). Iron and steel mills intermingled with other large plants. Just because this is an industrial poster does not mean the image has no interest. In fact the reverse is true. This work is full of life and shows the time when diesel power was beginning to replace steam engines. The subject makes a fine poster. ICI no longer has a presence in Billingham, having sold many of its businesses during the company's restructuring of the 1990s. Some of the company's former chemical production plants are still in operation, but are now run by other chemical companies.

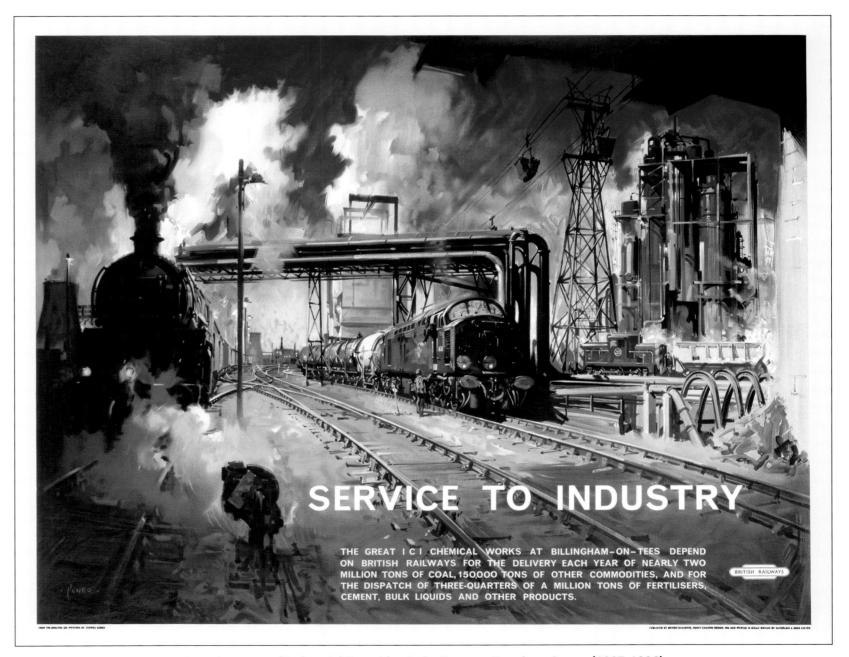

Superb Poster of Industrial Teesside: Artist Terence Tennison Cuneo (1907-1996)

The industrial theme continues in this monochromatic poster by Frank Mason of the heavy industry near the mouth of the Tees. The poster sums up the scene well with Middlesbrough being a centre of iron and steel but major shipbuilding at all places downstream of the Stockton-Thornaby area. Records show a lot of shipbuilding took place on the Tees in the 19th and 20th centuries with names such as Furness & Co (no relation), Craggs and Sons, Harkness & Son, Craig, Taylor & Co, Swan Hunter and many others being prominent.

For many years in the 19th century, Middlesbrough set the world price for iron and steel, so great was the influence of steelmaking here. Iron ore was discovered in the Cleveland Hills in 1850 and by 1851, with coal being available from nearby Durham, the first iron blast furnace was operational: Bessemer plants for steel appeared in 1875. The famous firm of Dorman and Long were major employers and the main components of the iconic Sydney Harbour Bridge came from here. The words *'Made in Middlesbrough'* can be found stamped into the structure. If you go to Teesside today the great silhouette of the transporter bridge can be seen for miles. This was built in 1911 by the Cleveland Bridge Company and at 850 feet (265 m) long completely straddles the Tees to Port Clarence. With Brangwyn's earlier poster, this image shows what the environment must have been like

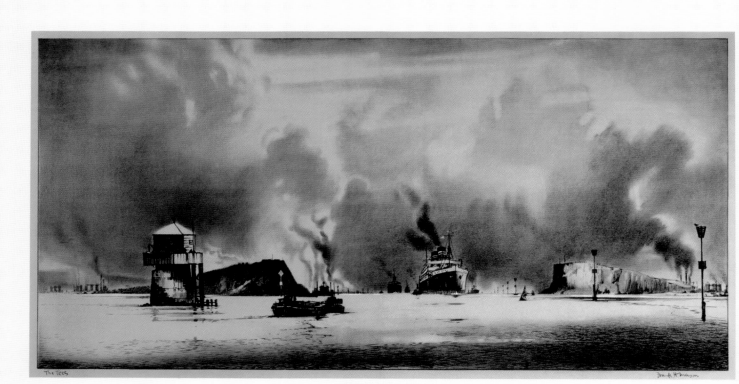

Early 1930s Poster Showing the Industry around the Mouth of the Tees: Artist Frank Henry Mason (1875-1965)

We can see what Billingham was like before its industrialization by looking at the carriage print below of nearby Norton. When industry started to decline, some of the chemicals sites around Billingham were landscaped, and the Beck Country Park now has wetlands and other wildlife refuges within its 120 acres. (Billingham Beck is a major tributary of the Tees, entering just downstream of Stockton-on-Tees). Stockton, as everybody knows, has immense railway significance, and many books have been written about its place in railway folklore. Surprisingly few posters feature the town and as this is not a railway book, but a journey in art, we must quickly pass through.

Carriage Print of Norton, Billingham, County Durham: Artist Kenneth Steel

We are now at the mouth of the Tees, and this bird's eye view poster was produced by the North Eastern Railway in the early Edwardian years. Percy Home, the artist, produced similar posters for other main river outlets, and this poster gives a good understanding of the Tees-side structure at the start of the 20th century. Notice there are no chemical plants or industry on the north bank opposite Middlesbrough, but there are significant harbour facilities at both Middlesbrough and Hartlepool. There are also many railway lines on the south side of the Tees and a multitude of lines running westwards from Stockton.

The railway lines to Hartlepool enabled Durham coal to be exported when the mines flourished. The Victorian development of major shipbuilding facilities meant the town was a WWI target. The poster also shows major shipping facilities in the Middlesbrough area and today Teesport is the UK's third largest port. This is some 3 miles (4.5kms) downstream of the dock facilities shown in this poster. These were started around 1840. It is now time to cross over to the Yorkshire side and our hotel in Saltburn.

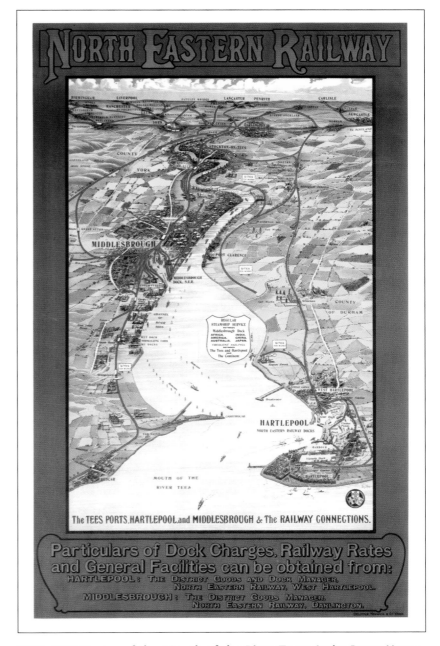

1900s NER Poster of the Mouth of the River Tees: Artist Percy Home

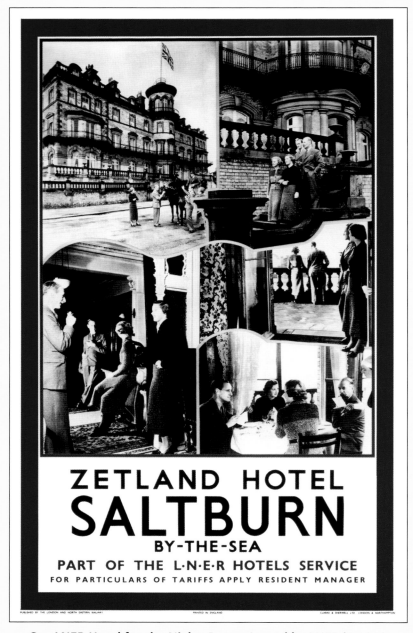

Our LNER Hotel for the Night: Poster Issued by LNER in 1930s.

Chapter 3 Along the Scenic Coast

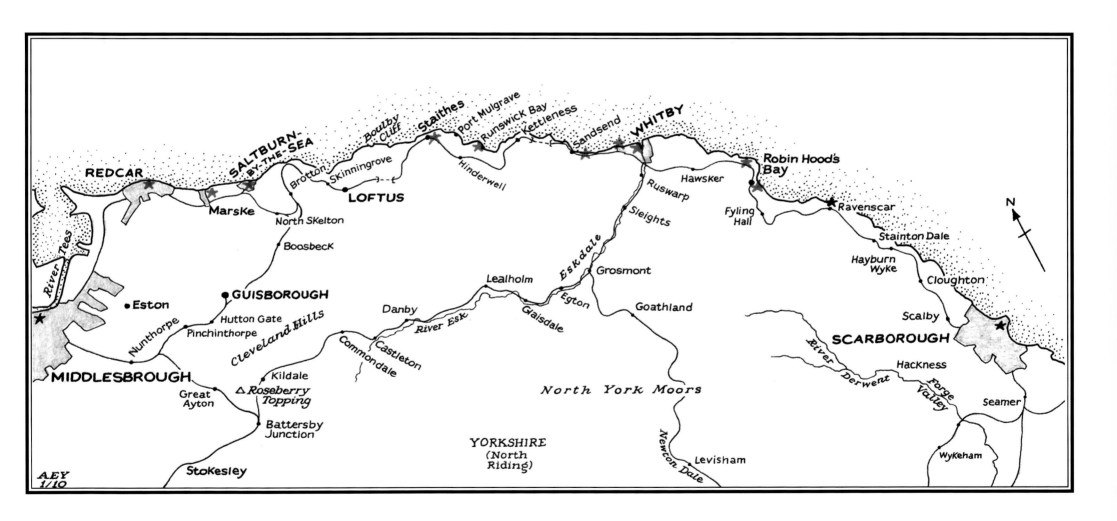

Chapter 3 Along the Scenic Coast

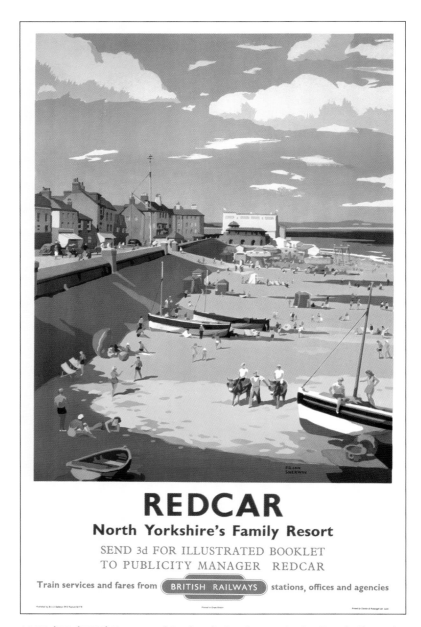

1958 (BR (NER) Poster of Redcar's Seafront: Artist Frank Sherwin

Redcar Beckons

For the rest of our journey over the next seven chapters we are going to be in Yorkshire. This is by far Britain's largest county (with Lincolnshire second and Devon third). Before the Government started to tinker with boundaries, the maximum area covered almost four million acres (over 15,500 km2). It is home today to more than four million people and has a wonderful history. In the 7th century it was part of the Kingdom of Northumbria, when Edwin threw out all the local kings and nobles of small Celtic kingdoms that arose after the Romans left. In 886 AD the Vikings arrived and eventually conquered all of Northumbria and named the area around York as Jorvik. Visitors today to the City of York can visit the Jorvik Centre, which visualizes what life was like in medieval times. We will see more of the extensive history of the county through the following chapters and of York in particular in Chapter 9.

Yorkshire is so large (more than twice the size of Lincolnshire) that it was split into three administrative areas, known as Ridings. Historically the northern boundary is the Tees, as seen in the previous chapter. The Eastern boundary is the North Sea. To the south the Humber Estuary, plus the Rivers Don and Sheaf define the boundary, whilst along the Western side, the border meanders along the eastern edge of the Pennine Chain to eventually reach the Tees in the north-west corner of the county. In the 1960s, Yorkshire bordered seven other English counties – County Durham, Lincolnshire, Nottinghamshire, Derbyshire, Cheshire, Lancashire and Westmorland.

Having crossed the Tees and spent the night at the Zetland Hotel in Saltburn, we come back north again to begin our journey at the seaside town of Redcar. For day trips from Industrial Tees-side, this was the nearest place for some R+R. With the opening of the railway from Middlesbrough to Redcar in 1846, it became easier for people to travel to the coast and Redcar began to develop as the local tourist town. However, once iron ore was found in the nearby Cleveland Hills in 1850, Middlesbrough grew rapidly and so did Redcar. In 1875, a racecourse was built in the middle of the town and now local punters had the seaside, the horses and a good train service to make 'a grand day out'. This first poster comes from Frank Sherwin. He produced some wonderful seaside town paintings in the 50s and 60s and this is a rarely seen poster. The expansiveness of the area and the size of the sea defences protecting the town are evident in this work. Behind us is the pier and in the centre of the poster is the bandstand, for summer evening concerts.

We now move just up to the other side of the bandstand, and turn to look south along the Coast Road, as shown in this rare 1925 poster issued by the LNER. The poster gives a wonderful impression of life at this Yorkshire seaside playground in the mid 20s, but it is curious that Martin went with a beige sky. Little is known about this artist, but we will see a superb example of one of his GWR commissions in Volume 5.

The Redcar pier shown in this painting was demolished in 1981. Records show it was struck by several ships. It was first shortened then extended, but it suffered damage due to storms over many years. Its use declined after WWII. There was a ballroom in use around 1925, and for a period it was the hub of the town. A second pier, at Coatham, has also long since gone.

Martin's poster shows the wide expanse of the promenade, with people in 'summer whites' taking in the bracing sea air. One of the parts of the town is named Zetland, which also happens to be the name of the world's oldest surviving lifeboat that can be found on the main esplanade in the centre of the town.

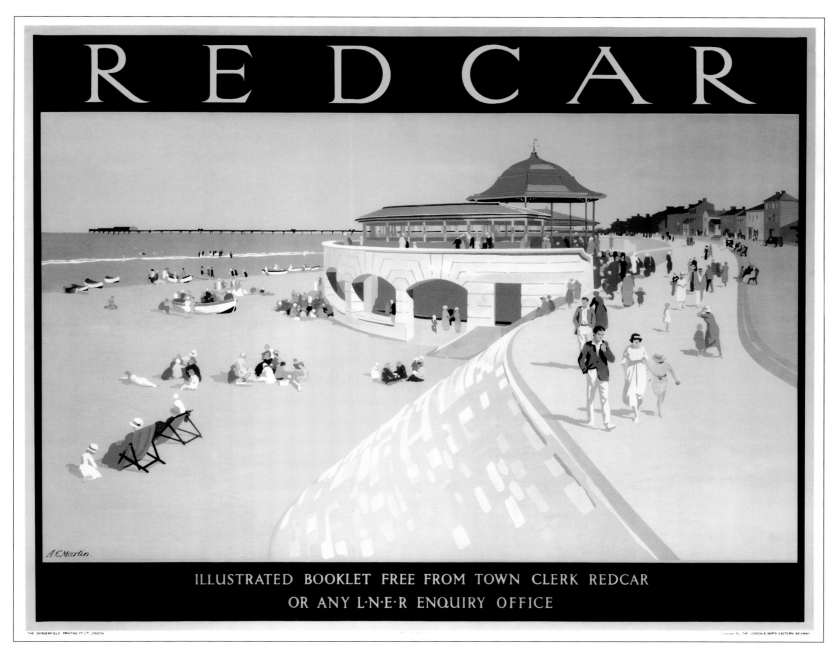

1925 Classical LNER Quad Royal of Redcar Seafront: Artist A.E. Martin

Our next poster by Edmund Oakdale (about whom we know little) shows a hive of activity on the Redcar sands on a busy summer's afternoon in the 1930s. The bandstand is again seen top right hand corner. Redcar has several miles of fine sands, stretching from the mouth of the Tees to the north, all the way to Saltburn, quite some distance to the south. This is one of the longest unbroken stretches of sand anywhere in the UK.

These sandy beaches and bays are known today for their surfer's waves, but in the 30s, the weekend saw the whole beach area thronged with workers and their families, partaking of the sandy delights. The area around Coatham Pier, the bandstand and down to the old Redcar Pier was particularly popular. This poster is complete with almost 'cartoon-like' faces on all the people. Our eyes are immediately drawn to the centre and the vibrant red swimming costume of the eldest of the three bathers, (who look rather large in comparison to the two 'Shetland-sized' donkeys behind). Nevertheless this poster was one of a series used to lure families to the town's delights and in the 30s: it certainly worked!

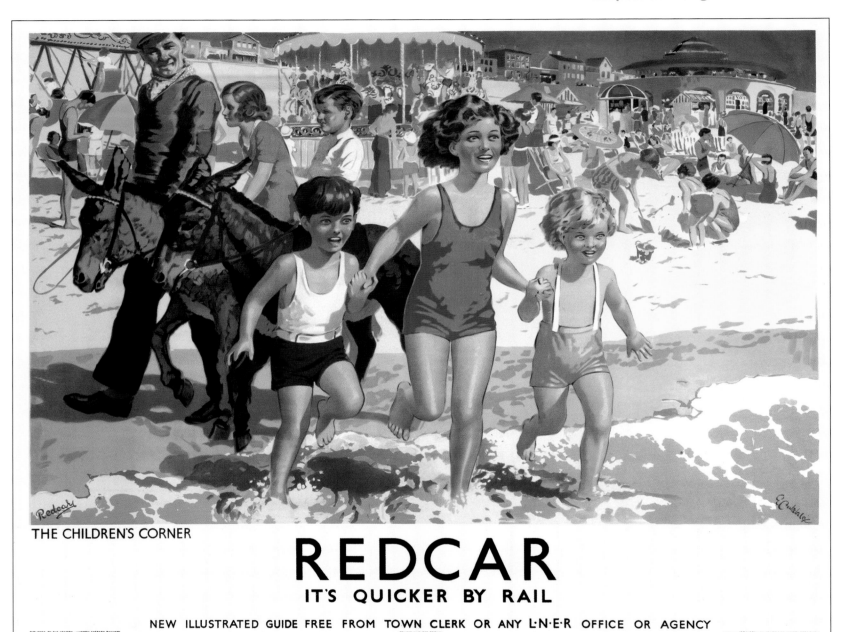

THE CHILDREN'S CORNER

REDCAR
IT'S QUICKER BY RAIL

NEW ILLUSTRATED GUIDE FREE FROM TOWN CLERK OR ANY L·N·E·R OFFICE OR AGENCY

1930s LNER Poster of North Yorkshire Seaside Delights: Artist Edmund Oakdale

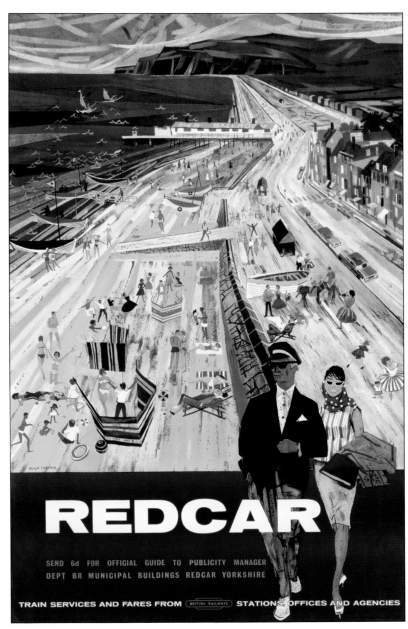

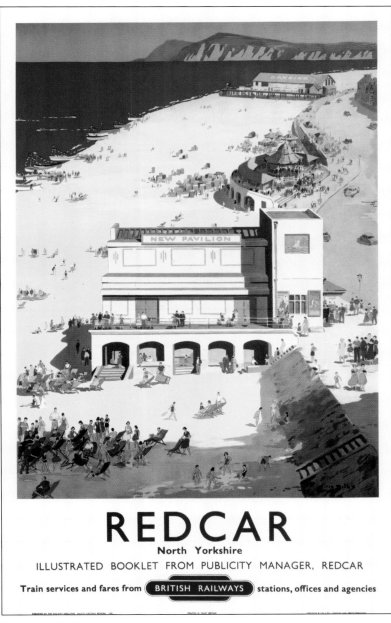

In contrast with the LNER quad royal alongside, here we have two BR posters from the 1950s and 60s. The more modern looking poster on the far left comes from Hugh Chevins, and shows the beach area to the south part of the town, where old Redcar pier used to stand. When this was demolished, the Pier Ballroom was built on the same site

The New Pavilion shown in the Silas poster (R) was built on the site of the old Victoria Pier at Coatham. This was intended to be the main pier at almost 2000ft (700m) long, but a ship collision shortened it and later storms and various other mishaps meant it was finally demolished in 1928.

As shown in this poster (and that of the Sherwin on page 70) this pier was located near the bandstand. The theatre, built around 1930, was made into a cinema some 30 years later, as the popularity of live shows declined. Both posters show the seafront filled with people, indicating the popularity of the resort in the first half of the 20th century.

Two BR (NER) Posters from the 1950s and 60s: Artists Hugh Chevins (Left) and Ellis Silas (Right).

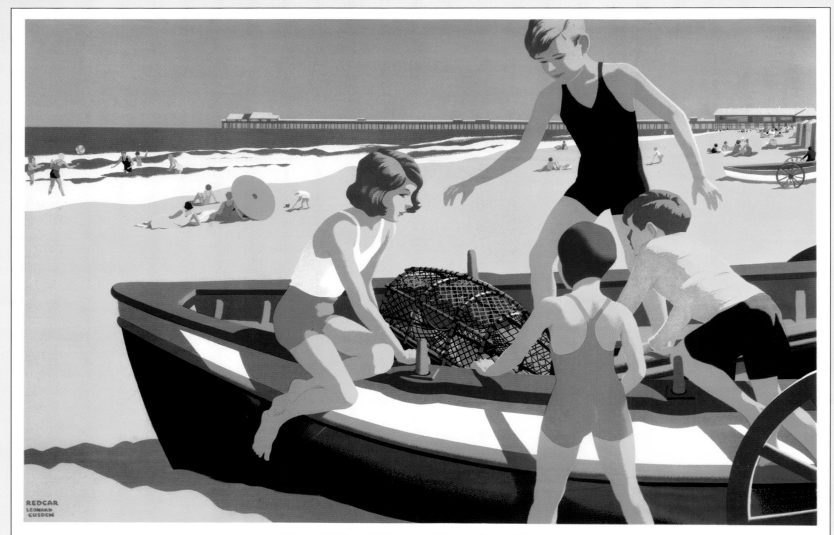

Superb Poster for Redcar Beach Holidays: Issued by LNER in 1936: Artist Leonard Cusden

These two pages feature two classic railway posters. The wonderful quad royal opposite is a first class example of great poster art from a rather underrated artist. Leonard Cusden was very active in the 1930s, and produced this fabulous composition that is arguably the best ever produced for Redcar. Composition, balance and interest oozes as the children gaze intently at the lobster pot: I wonder what was inside? If readers surf the net for reproductions of poster images, this is one that often appears. The reason is simple: it is a great holiday poster.

The poster on this page would have raised some eyebrows when it first appeared in 1960. The 'Spanish looking' bathing belle really does advertise the delights of Redcar, and is maybe the real reason people flocked there, hoping to find the 'Senora'. This is a really eye-catching poster and was keenly contested the few times it has appeared in auction. It was one of many posters the great commercial artist Laurence Fish painted during his career. Fish signed his railway posters "Laurence" to distinguish them from other commercial work, especially his illustrations and technical images for magazines and journals, such as Flight International and Aeroplane. These showed amazing details of the latest jet aircraft and flying technology to readers in the era before colour photography became routine. He had joined the RAF at the start of WWII, but his eyesight was not good enough to fly: his drawing skills meant his artwork for mechanisms, bombs and booby traps gave him a first class service reputation. He painted many seaside posters in this same style (see Volume 1 page 172 for Ayr poster for example) and the wonderfully captioned *'Life is Gay at Whitley Bay'* on page 35. He is a former winner of Railway Poster of the Year (for this one maybe?) and exhibited at several galleries up and down England. His technical artwork is present in many corporate offices and is always sought-after.

In the heyday of Redcar as a seaside town most people arrived by train. Tangerine station signs from the 1950s are as highly prized as the belle shown here – well maybe not quite! The station first appeared in 1846, but was soon partly demolished so that an enlarged structure could be built in 1861, when the line was extended down the coast to Marske. Once this occurred the remains of the first station east became Redcar East Halt, and the new station became Redcar Central to distinguish the two. Most visitors naturally alighted at Central station for the delights shown here. The brick-built structure and trainshed roof were in the grand NER style, but surprisingly, built with only a single platform. This became inadequate when tourism exploded, and in 1935, a westbound platform was built outside the main central shed. In the mid 1980s, a new eastbound platform was built opposite the 1935 westbound platform, and the Grade II Listed Victorian station was rather tastefully converted into a small business park.

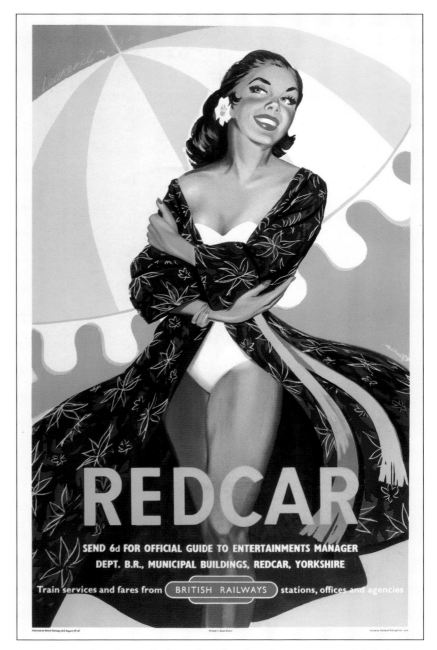

1960 BR Poster for the Delights of Redcar! Artist Laurence Fish (1919-2009)

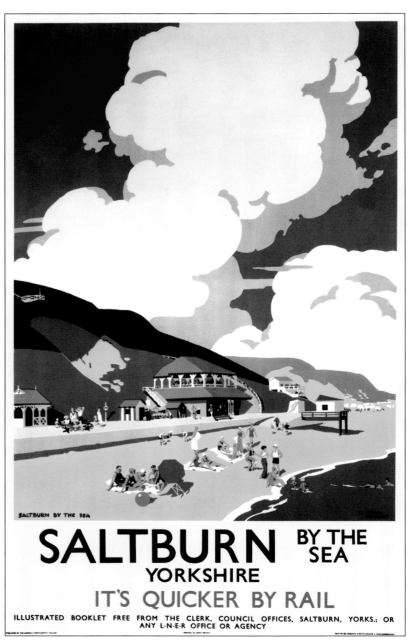

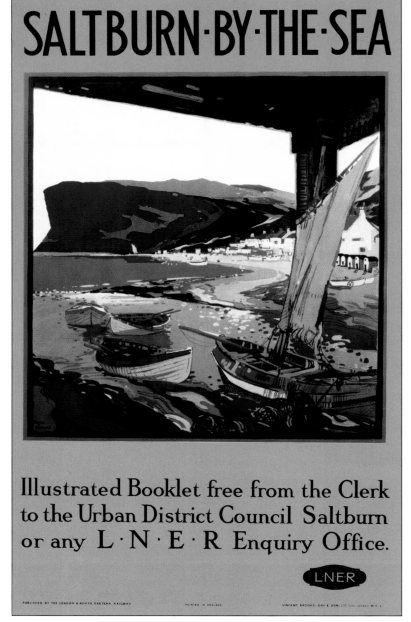

Two Contrasting Poster Adverts for Saltburn: Frank Newbould in 1930s (Left) and Frank Mason in 1925 (Right)

South to Saltburn-by-the-Sea

We have now moved a few miles down the coast to the next seaside resort of Saltburn, where we stayed at the end of the previous chapter. This small resort was the vision of Henry Pease, the renowned entrepreneur. He came from the Darlington Pease family who also founded the Stockton and Darlington Railway. They were also responsible for much of the early development of Middlesbrough. He began work here in 1860 and in 1861 the railway station opened as the private platform of the Zetland Hotel. This was one of the world's first purpose-built railway hotels, and is an imposing structure built right on the seafront. Today it is a restored apartment complex, but in its heyday it was <u>the</u> place to stay.

Another mark of the Pease family all over the town are houses constructed with 'Pease bricks'. When building the town, Pease had the family names cast into the brick itself. I guess he really wanted to be remembered! For such a small place (population in the 2001 census was 5,912), there are a surprising number of railway posters. However, with the railway-linked heritage this is probably not so surprising. What is unusual is that they are all LNER. I have yet to find any BR-era posters.

On the opposite page we began with two contrasting posters and here we have two classic posters. (These four posters span about 12 years). The wide and flat beach at Saltburn gave Malcolm Campbell the chance to set a world land speed record there in 1922 in the first 'Bluebird'.

Before we look at the town, it is worth mentioning the Zetland Hotel. The contract to build it was won by William Peachey, a Darlington based architect. The foundation stone was laid in October 1861 by Lord Zetland and it opened in July 1863. The stable block at the rear was built first, and this was also the first part to be renovated and converted to apartments in the 1980s. The railway line from Middlesbrough continued a short distance to within yards of the hotel's rear entrance. A purpose-built shelter protected the wealthy guests from any inclement weather. The interior was sumptuous, but sadly the original plans and costs have not survived. The guests could then walk out of the front entrance to the sights shown in these two posters. Saltburn was always an elegant place in Victorian times, so the dress codes shown here were typical up until WWII.

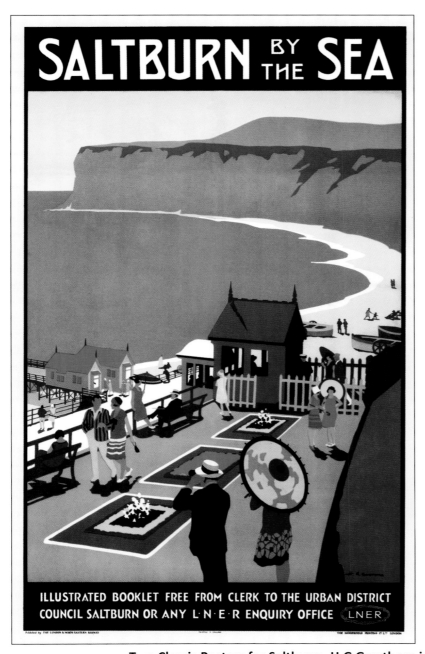

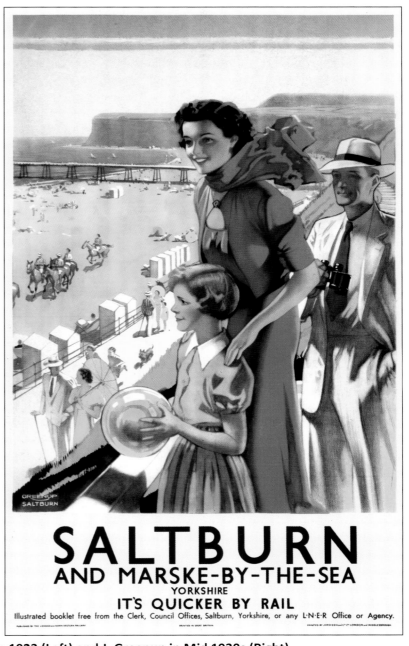

Two Classic Posters for Saltburn: H.G Gawthorn in 1923 (Left) and J. Greenup in Mid 1930s (Right)

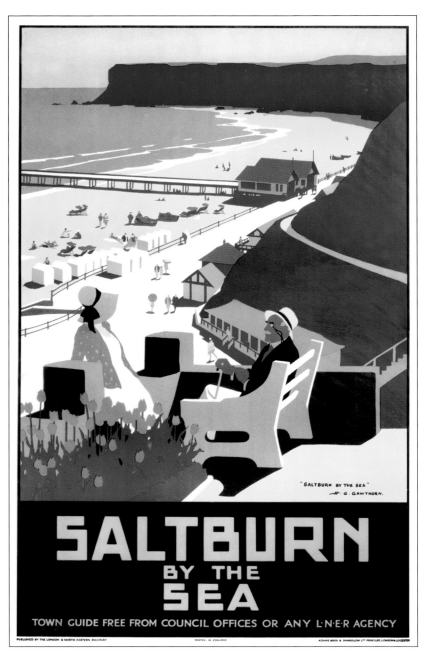

Early 1920s LNER Poster of Elegant Saltburn: Artist Henry Gawthorn

The town was well planned, as befitted ladies and gentlemen of the times. Along the seafront, all the roads were named after precious stones (Amber, Coral, Diamond, Emerald, Garnet, Pearl and Ruby Streets). There were many attractions, including some lovely Victorian buildings, the pier (recently renovated) and the Valley Gardens. Mason's mid-1920s poster shows the panorama to great effect. The large building towards the left is the Zetland, and to the right are the elegant terraces, built to take in the sea views and the bracing air.

There was also a cliff railway, built to replace an early lift and most unusually powered by water. The old lift closed in 1883, and two years later the funicular cliff railway opened. The pressures were balanced by water columns, but from 1924, the pressure was controlled by pumps. The system was very reliable and the first real maintenance took place only ten years ago, when a new braking system and winding wheel were installed. The pier in Gawthorn's poster almost points north as the coast here runs east-west. The cliff railway links the beach with the town, and both posters show the hilly nature of this area.

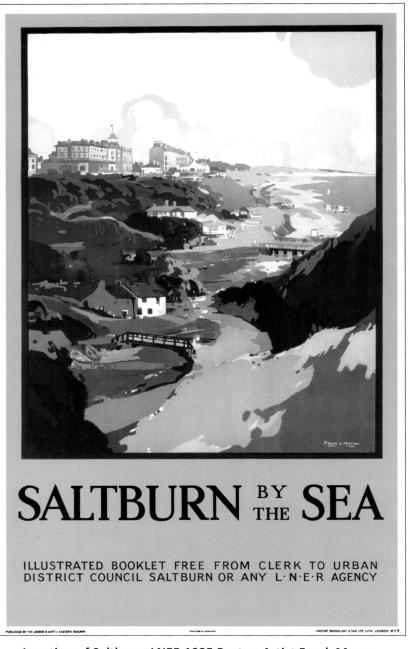

Location of Saltburn: LNER 1925 Poster: Artist Frank Mason

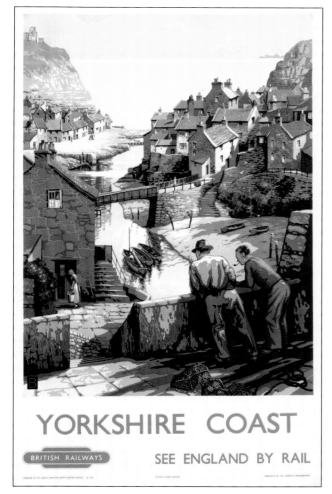
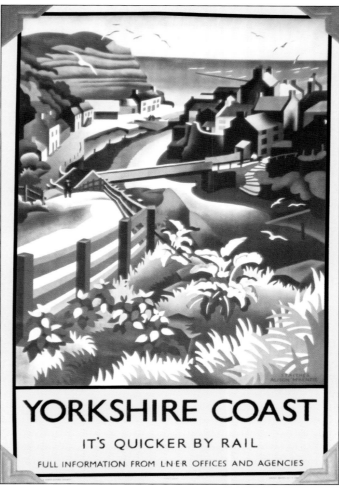
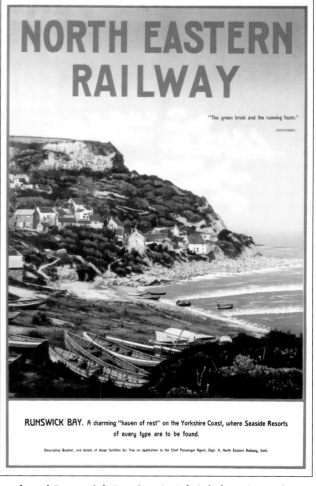

Travelling from Saltburn to Runswick Bay: 1950s Staithes by John Bee (Left): 1930s Staithes by Alison Mackenzie (Centre) and Runswick Bay in 1910 (Right) Artist Unknown

The train journey down the coast to Runswick Bay was a joy to take. It is a great pity this line was not saved, but it was rarely profitable; sections were progressively closed from 1958 to 1965. After Saltburn, the line made a large loop towards the coast around Warsett Hill, through Loftus, then Easington tunnel, to emerge at Easington Woods. (A section of the line to Easington Woods still serves the local Alum Works). The line then used to turn coastwards to Staithes. The left hand and central posters show this delightful fishing village, nestling as it does in a valley where Roxby Beck flows into the sea. John Bee's mid 1950s poster (colour image) followed Alison Mackenzie's poster from almost the same location (at Cowbar) that first appeared in 1935. This rare photograph of a poster I have not yet seen was found in the NRM archives during my research. This peaceful fishing village is 11 miles (18km) north of Whitby. In 1744 a teenager called James Cook (later the famous Captain Cook), moved to the village to work for a local shopkeeper. The maritime nature of the area soon grabbed his attention. The *'Staithes Group'* of artists was formed here around 1800 to paint the magnificent coastline shown in the 1910 LNER poster of picturesque Runswick Bay. Red-roofed cottages appear to tumble down the cliff to the seafront.

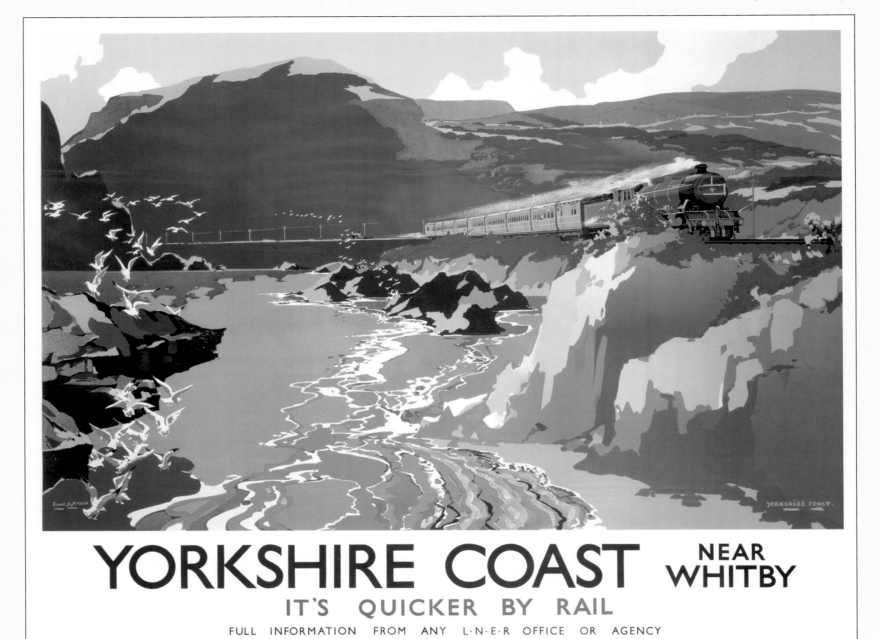

A Poster Classic: The Magical Yorkshire Coast Issued by the LNER in 1937: Artist Frank Henry Mason (1875-1965)

After leaving Runswick Bay, the line used to hug the coastline around Kettleness before entering a tunnel that emerged at Sandsend Wyke; a sweeping bay that heralds our entry into the romantic town of Whitby. Now, here we have a place with so many railway posters that is has been difficult to juggle those available to show how the town's portrayal has changed over the years. I currently have 22 listed, and many of the modern (1975-1995) posters are not properly catalogued, and are therefore not yet included. Tourism and fishing have, for most of the 20th century, formed the backbone of the local economy.

Our Whitby Visit

It is at the mouth of the Esk Valley, where the Esk Valley line crosses and re-crosses the river, before passing under the coast line and into Whitby. The station has been variously called Whitby or Whitby Town, to distinguish it from Whitby Westcliff, which was on the coast line. Anything from either station is greatly prized today by collectors. Hundreds of red-roofed houses cling to the hillsides on either side of the steep valley that the river has carved during the centuries where it enters the sea. The railway arrived in 1847, by which time Whitby already had the reputation of a seafaring and fishing town. Its arrival allowed cargoes to be brought to and from the docks far more easily.

Ships, shipbuilding and the harbour have featured on many of the posters over the years. I thought I would start with something different, and show a photographic image of the harbour and the ruined abbey beyond that overlooks the town. This image was produced by British Railways in the early 1960s, and represents one of the first posters for this area using this medium. The harbour covers an area over more than 80 acres (40 hectares), and has developed since the 16th century. At first, minerals were exported from nearby mines, but gradually coal was imported from the Northumberland and Durham coalfields. Then around 1635, boats began to be built here and the thriving boatbuilding industry developed. By 1700 Whitby had the sixth largest series of yards in Britain, but larger-scale boat building ceased in 1908, when the 6,000 ton 'Olive' was launched. Whaling was another thriving industry during the 18th century, and the port economy was really strong at this time. Today, boats are still built using traditional methods, but these are the more traditional and smaller Yorkshire Cobles. The two arms of the entrance breakwaters extend far out, sheltering the inner harbour from everything except storms from the northerly direction. Inner quays and better unloading facilities were built in the 1950s and 60s, so Whitby has a good future as a working port. The local Council operates two dredgers to maintain sufficient drafts for docking.

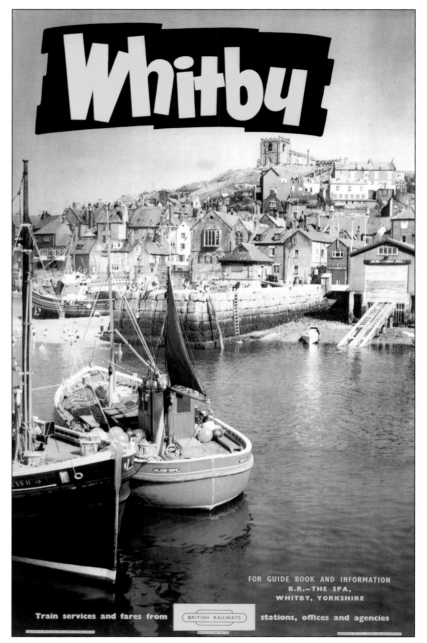

Photographic 1960s Poster by British Railways of Whitby Harbour

These next two images show the more traditional poster views of Whitby, though the BR poster opposite from 1950 is not often seen. The poster here, painted by Hauff in the early 1930s, shows the inner harbour upstream of the swing bridge. This was built in 1908, and the two sections span around 75 feet (22m) across the main harbour entrance. The two sections can swing independently so that boats can leave in a two-hour window either side of high tide each day.

This poster is one of the most desirable from this Yorkshire town. It seldom appears in auctions, but when it does good prices are always obtained. I have found little about the artist, but the image is colourful and very eye-catching. The many small houses, arranged 'higgledy-piggledy' down the sides of the hills around the harbour make for a most pleasing composition. The small sail boat approaching the harbour side is a typical Yorkshire Coble, and I love the way the artist has mirrored the reflections, so emphasizing the boat.

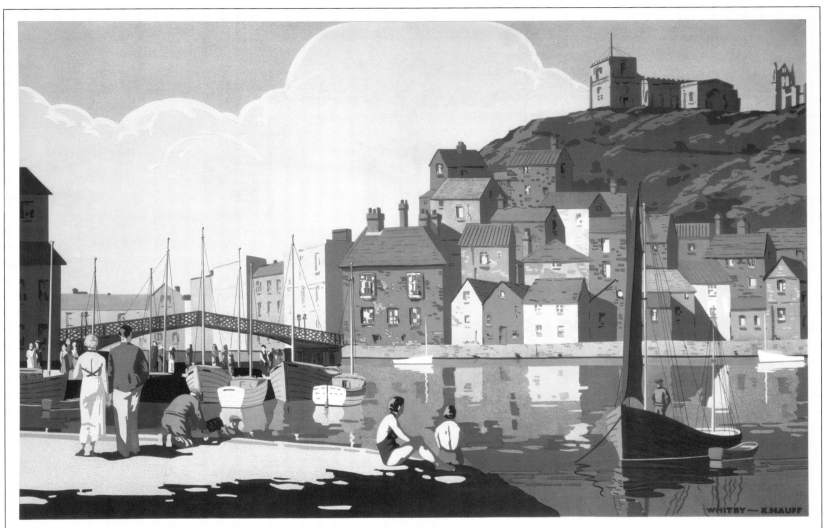

Classical 1930s LNER Poster View of the Inner Harbour Area at Whitby: Artist K. Hauff

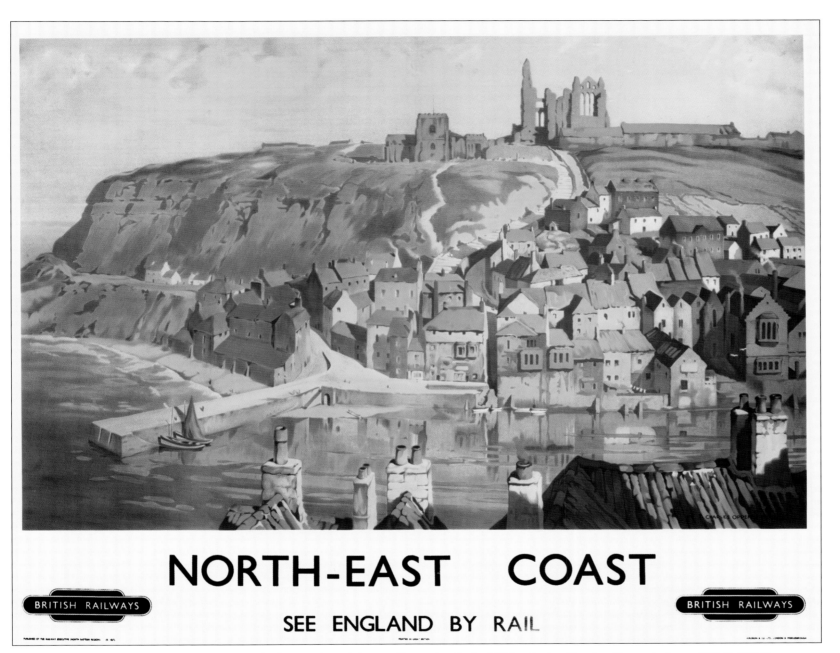

NORTH-EAST COAST

BRITISH RAILWAYS

BRITISH RAILWAYS

SEE ENGLAND BY RAIL

Expansive View of Picturesque Whitby: BR (NER) Poster from the Early 1950s: Artist Charles Oppenheimer (1875-1961)

In contrast with Hauff's harbour view, Oppenheimer chose to show the harbour entrance area from the west cliffs. Now you have the real feeling of the steepness of the housing around the sheltered harbour. Charles Oppenheimer was born in Manchester, but for most of his life he lived in Kirkcudbright and is well known for his colourful and detailed poster work, as well as for some notable non-railway oils. British Railways clearly recognized his poster potential and from 1948 onwards, they commissioned several works.

This is just wonderful, and for me, arguably the best of the Whitby posters, depicting as it does the rich colour palette of the town basking in the late afternoon sun. The breakwater shown in this poster is a short distance upstream of the main harbour entrance piers. Sitting proudly above the town are the Abbey ruins, and these feature on several of the posters that follow. However, let us savour the view for a few moments longer. Because of posters such as this, BR deserves full recognition for their often spectacular use of commercial art in the early 1950s.

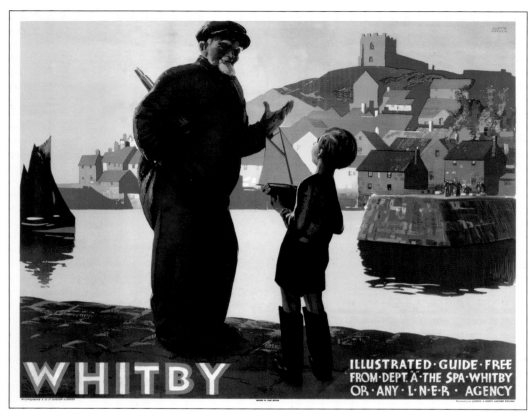

1923 LNER Quad Royal of Whitby Harbour: Artist Austin Cooper (1890-1964)

I said that Whitby is a sea-faring town and this next group of posters reinforces this statement. Right from the early days of advertising, the railways have portrayed Whitby as the boating and fishing capital of North Yorkshire, and one of the LNER's earliest posters by Austin Cooper shows a fisherman telling tales to a young boy who has been sailing his toy boat. Contrast this style with that of Frank Mason (alongside). We are now inside a large quayside wharf, where the lines, nets and sails are attended to. Mason must have been making his sketches inside the dark building, but with a sunny day outside. He punctuated the gloominess of the building with tantalising glimpses of the sun picking out the red roofs of the harbour buildings. I can imagine him with his easel and brush putting together a very underrated poster. Note the way he used the white sail being mended by the fisherman to lift the interest in the front of the poster. To the best of my knowledge, neither of these posters has previously been given book space.

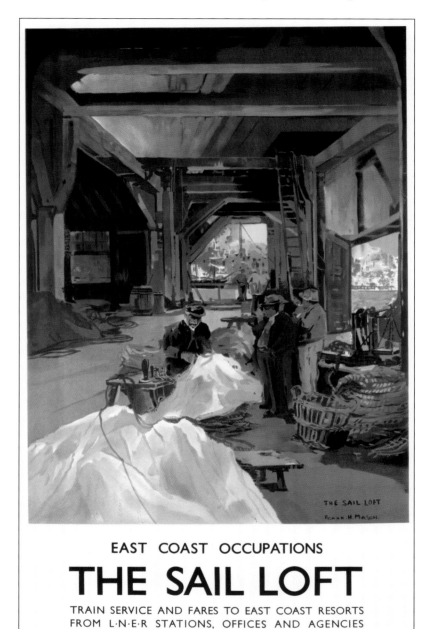

1930 LNER Poster for Whitby Fishing Industry: Artist Frank Henry Mason

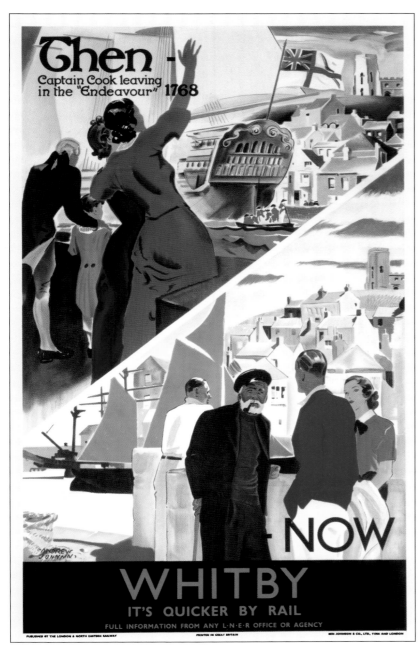

1931 LNER Poster of Contrasting Whitby: Artist Andrew Johnson

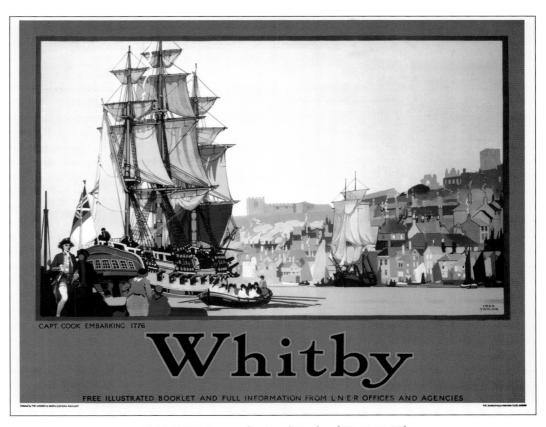

1928 LNER Poster by Fred Taylor (1875-1963)

Both of these two posters refer to the famous seafarer, Captain James Cook. Alongside we have the 1931 poster by Andrew Johnson, and above we have Fred Taylor's quad royal poster that appeared in 1928. I wonder if Taylor went to Whitby to paint the scene, and then placed the galleons in front of the present day buildings. Those eagle-eyed readers will notice Cook departed in 1768 and 1776. Well the answer is he actually sailed from Whitby three times. The 1768 voyage on the *'Endeavour'* ended with Australia being claimed by Britain and the first survey and charting of New Zealand. He also made two voyages on the *'Resolution'*. The poster above depicts the second of these (his last departure from Whitby). It was during this third voyage that he visited the Californian coast and made landfall in the Hawaiian Islands. He mapped much of the Alaskan coastline and closed gaps in Russian and Spanish maps of the most northerly Pacific area.

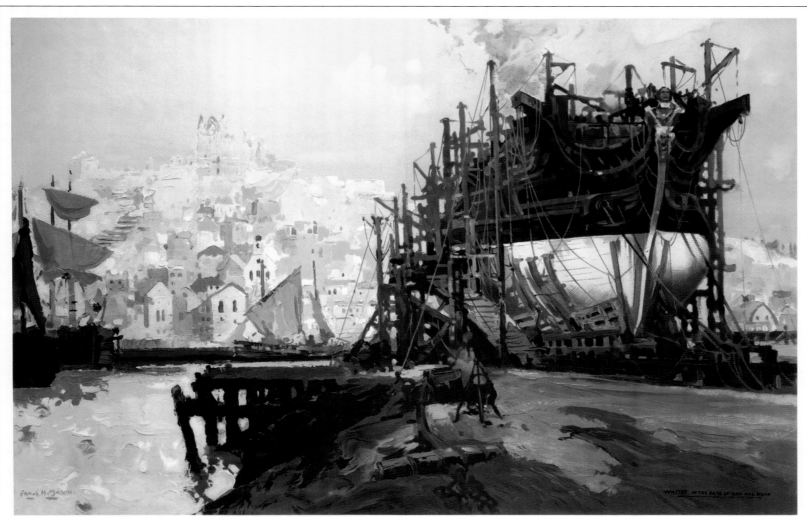

THE BUILDING OF "THE EARL OF PEMBROKE" (CAPTAIN COOK'S "ENDEAVOUR") 1764.

WHITBY AN ANCIENT PORT AND MODERN RESORT
IT'S QUICKER BY RAIL
Illustrated Guide free from L·N·E·R Offices and Agencies or Department A. The Spa. Whitby.

The Building of a Famous Whitby Ship, Cook's *Endeavour*: LNER Poster from 1934: Artist Frank Mason (1875-1965)

These next two posters focus on the great man. Here we have the building of his first ship in 1764, and opposite is Doris Zinkeisen's famous poster of Captain Cook on the quayside at Whitby, in readiness for one of his voyages. Neither poster is common, nor have they appeared previously in other railway poster books.

Cook was born in Marton (now a suburb of Middlesbrough) in November 1728. When he was 16, he moved to Staithes, as an apprentice grocer and the atmosphere of the village played a momentous part in shaping his future life. He loved the sea and he loved Staithes. However he decided <u>shop</u> life was not for him, and so he changed one letter to make <u>ship</u> life his destiny!

Moving to Whitby in 1747, he was soon on board local trading vessels and his career was then set as a merchant navy apprentice. He studied algebra, trigonometry, astronomy and navigation and his 'personal toolset' to become a Captain was complete! He volunteered for the Royal Navy in 1755, and the rest is history – as they say.

Mason's poster shows his first ship on the building skids at Whitby. He was hired by the Royal Society to go to the Pacific in 1766, after his mapping skills of the early 1760s around Newfoundland came to their attention. *HMS Endeavour* had originally been built as a collier (the *Earl of Pembroke*), and it was purchased and renamed by the Navy for the first Cook voyage from 1768 to 1771. Cook went via Cape Horn to reach Tahiti. In 1769 the vessel was off the New Zealand coast, and in 1770 Cook landed at Botany Bay, Australia.

After numerous repairs he landed back in Dover in July 1771 after being away for almost three years. But his discoveries and mapping were priceless. Two more Pacific Ocean voyages followed on *HMS Resolution*, a former collier (*The Marquis of Granby*) and also Whitby-built. Therefore the poster here could relate to either ship.

On the second voyage it crossed the Antarctic Circle, and during the third voyage it crossed the Arctic Circle. So Cook's reputation as a mariner and explorer is due in part to the Whitby-built vessels.

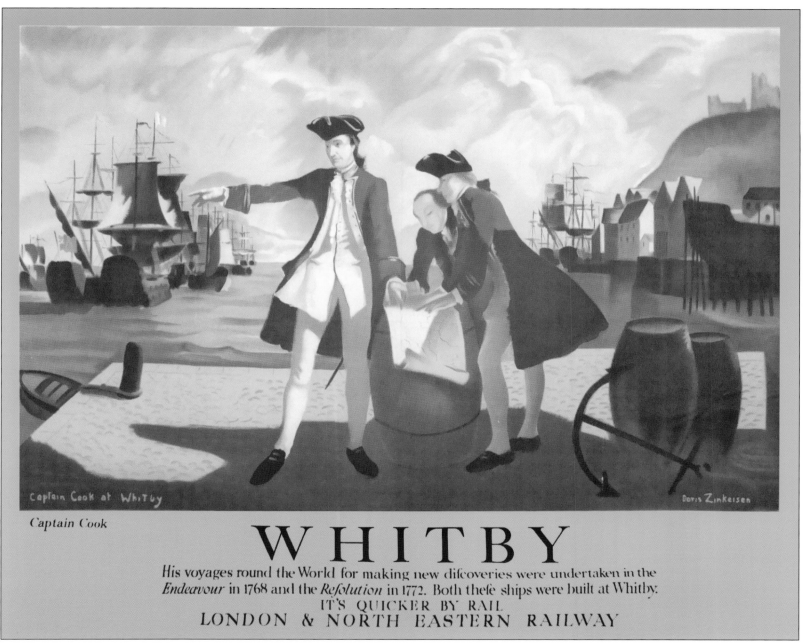

Famous LNER Poster from mid 1930s Issued by the LNER: Artist Doris Clare Zinkeisen (1898-1991)

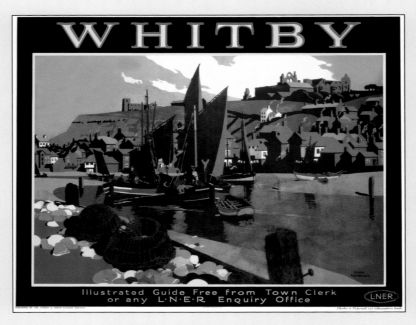

A Collage of Whitby Posters from 1920s to the 1960s [see page (v) for poster listing details: Numbers 133-138]

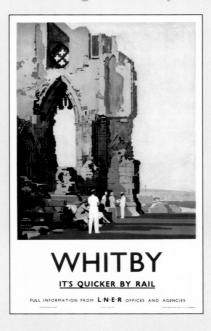
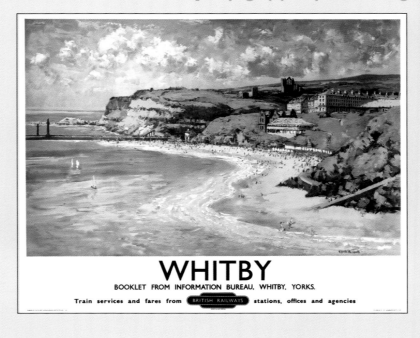
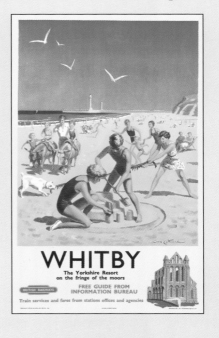

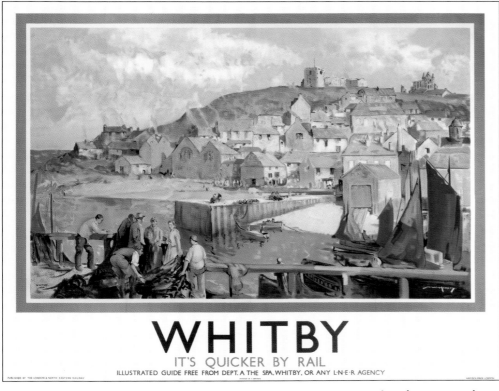

Classical Whitby on a 1935 LNER Poster by William Lee-Hankey (1869-1952)

Following the small collage of Whitby posters on the previous page, the poster above is one of the least common from Whitby, and was painted by William Lee-Hankey in the old 'Dutch Style'. He created some masterful images, which we will see in other Volumes. This is the last of the Whitby posters, so I hope my selection illustrates how the railways prized Whitby as a tourist destination.

To Robin Hood's Bay

It is now time to leave, and we move forward to the 1960s to catch our DMU down the coast to Scarborough. After Whitby, the coastline moves inland through Hawsker, before reaching the coast again north of Robin Hood's Bay. Stoupe Beck is about half way along but the whole of this part of the journey is spectacularly beautiful. The quad royal from Frank Sherwin on the next page, is one of the most wonderful railway posters ever produced. It shows very clearly why I called this chapter 'the Scenic Coast'.

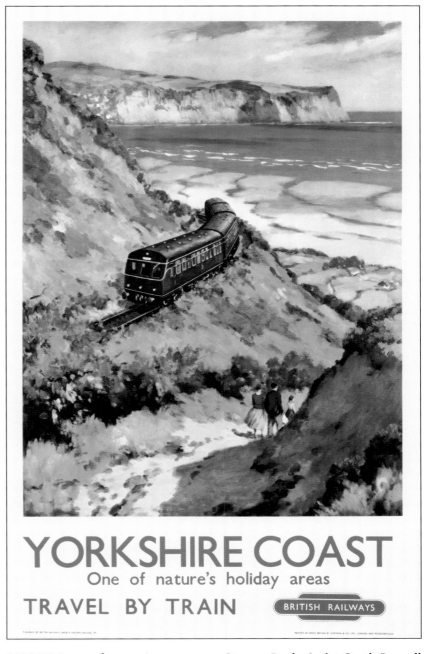

1959 BR Poster for our Journey near Stoupe Beck: Artist Gyrth Russell

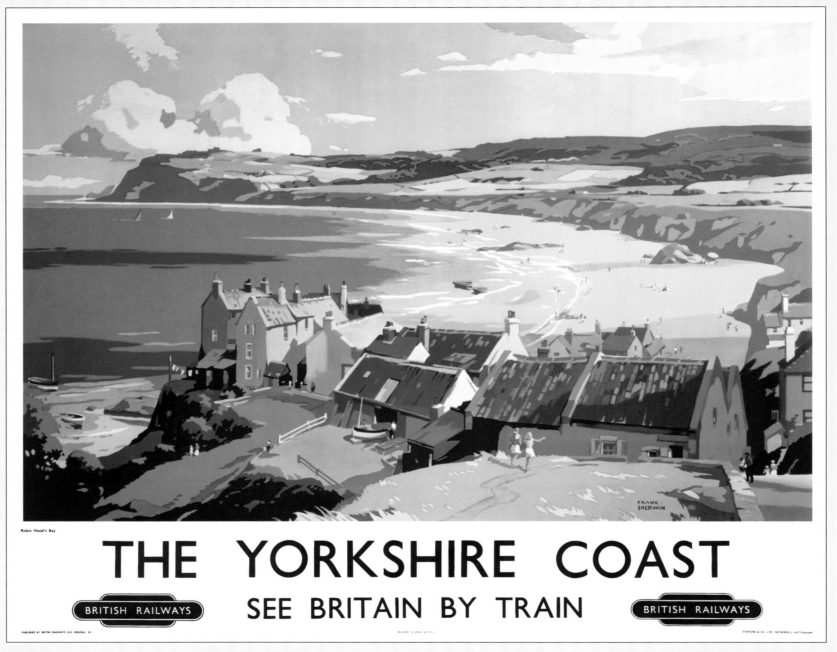

The Natural Front Cover: A Truly Magnificent Railway Poster Issued by British Railways in the Late 1950s: Artist Frank Sherwin (1896-1986)

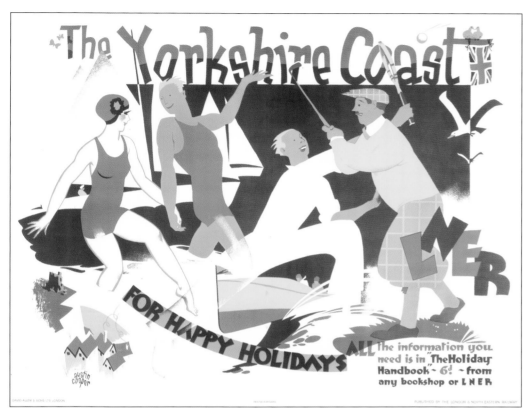

Cutting-Edge Marketing by the LNER in the 1930s: Artist Austin Cooper (1890-1964)

This pair of posters has certainly not been published before, and I can just imagine some readers possibly saying 'I am not surprised'. However, they do illustrate how the railway companies chose to sell this wonderful coastline, and were ground-breaking posters for their time. The quad royal above is LNER and by Austin Cooper. He often used considerable artistic skills in semi-abstract posters and this one is actually very clever, if one studies the detail. It is most un-LNER-like but does summarize the journey from Redcar to Scarborough very nicely. The double royal alongside says 'why go to Spain when the UK suntan is equally superb'! I say this because the artist is Spanish-born Mario Armengol. It cleverly combined artwork with photographs, and was ahead of its time (this was produced in 1955). Armengol was always an experimenter in poster art. Our final poster for Chapter 3 has us back at Runswick Bay, with its distinctive cliffs, as portrayed in the LNER poster by Andrew Johnson –and a wonderful place to end.

Cutting Edge BR Marketing from 1955: Artist Mario Armengol

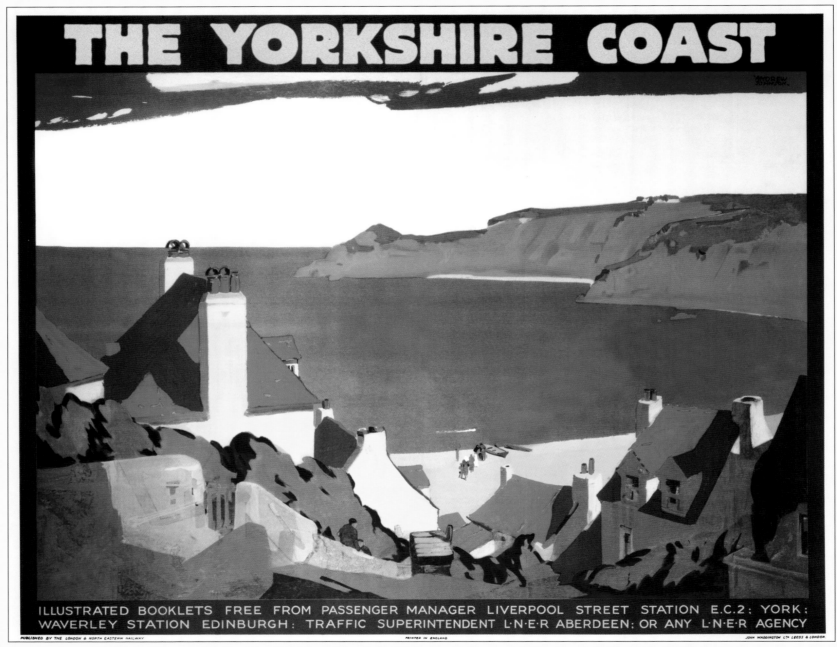

Late 1920s LNER Poster for the Beautiful Yorkshire Coast; Location is Runswick Bay Looking South: Artist Andrew Johnson

Chapter 4 South to Scarborough

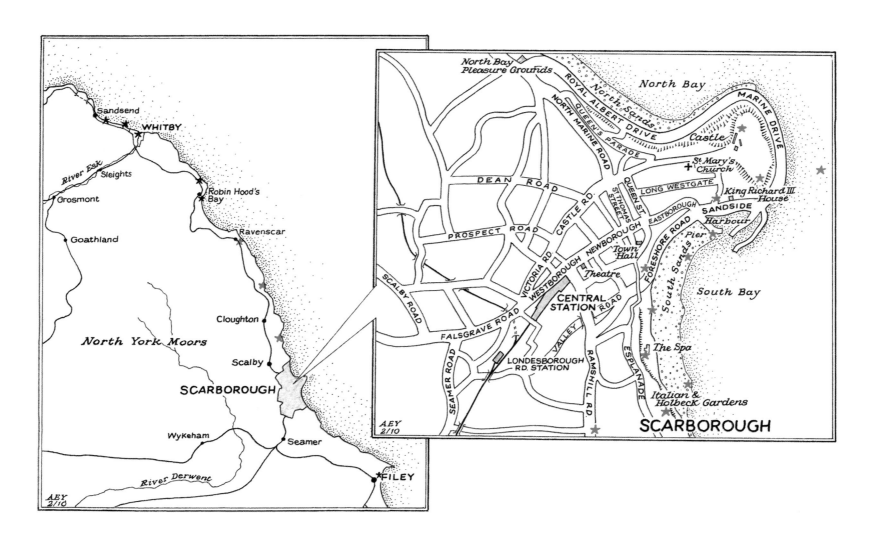

Chapter 4 South to Scarborough

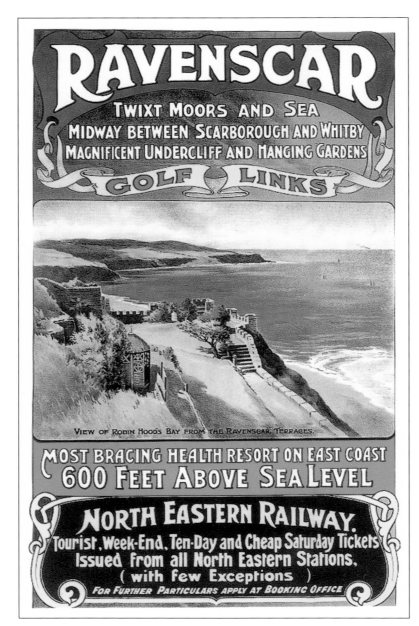

1909 NER Poster Promoting the Ravenscar Resort: Artist William S. Tomkin

Along the Cliff Tops

The start of Chapter 4 sees us heading south from Robin Hood's Bay and travelling the 11 miles (18 km) to Scarborough, where the vast majority of posters in this section of the book feature this most popular of Yorkshire seaside towns. At the far end of Robin Hood's Bay the forbidding cliffs at Ravenscar rise as a barrier to railway line builders. It meant a short tunnel had to be blasted through the rock to satisfy the landowner, who did not want to watch trains from his windows! The coastline here is rich in fossils, and the latent geological students amongst you can pick out thin bands of coal in the majestic cliffs that fall into the sea south of the Old Peak. On the cliff top and just before the tunnel entrance we find Raven Hall Hotel, built on the site of a former 4th century Roman Signal station. This reinforces the strategic nature of the cliffs. Leaving the train we move onto Ravenscar Terraces (built as a folly), and look back towards the bay we have just left. This is actually the place that never was. At the turn of the last century, a plan was made to construct a purpose-built resort here. Building plots were marked out and a good deal of the support infrastructure was laid. But it just did not happen, and the plots can still be seen almost a century after the dreams died. Today, apart from the hotel, the village of Ravenscar is just a handful of houses, the church and little else. Naturally, the station that used to exist near the southern entrance of the tunnel was closed, when the decision was made to abandon the line. This station had opened as 'Peak' (the old name for Ravenscar), but it closed forever on 8th March 1965.

Tomkin's poster shows the magnificent views from the cliff tops. Does the expression 'most bracing' on this poster really mean *real parky* when using the local language? From the terraces shown here, it is a drop of almost 600 feet (185m) into the sea. Maybe this is one reason why the Edwardian residents did not materialise. There is however a rich haul of ammonites for those who do make the long walk down the cliff to the beach. The cliffs are sandstone from the lower Jurassic period (170-180 million years old), and the view when looking up from the small beach is rather daunting to those who are about to walk back up. After leaving Ravenscar by train, the line snaked along the cliff top to Hayburn Wyke, where Thorny Beck has punctuated the cliffs and cut a channel down to the sea. The line passed through numerous small cuttings before we reach Hayburn Wyke station. This was built at the 250 feet contour line (76m) level), some 250 feet below that at Ravenscar, but even so, it was still a trek from the train to the shore. Like Ravenscar, this station closed in March 1965.

Early Poster from Frank Mason of Yorkshire Coast: NER Quad Royal from 1910

To our right, the timeless North Yorkshire moors roll away westwards from the track, towards the dark forest of Harwood Dale. South of Cloughton Wyke (another coastal punctuation), the landscape changes and we begin to lose the rocky cliffs. The old railway track is losing height more rapidly now as we travel ever closer to the always-fashionable resort of Scarborough.

The 1925 poster below by F. Gregory Brown, shows us looking backwards along this wonderful coastline. This is another seldom seen poster that captures the area in all its glory. It is quite amazing that the NER and then the LNER put so much effort into marketing the line, and yet despite all this commercialism, it was a poor revenue-earner. Maybe today this line would have more success? However, we are left with a legacy of some of the most stunning railway posters.

This is a daunting place in winter as the storms sweep in from the east, and standing on the cliff tops, visitors can feel the full force of a North Sea gale! The line between Ravenscar and Hayburn Wyke used to pass through Staintondale, a valley full of bracken and forests of shoulder-high foxgloves at certain times of the year. To our left is Beast Cliff, a complex mixture of hard and softer rocks that cascade down 500 feet to the seashore. It is probably the best example of vegetated sea cliffs on the whole north-east coast. Seldom visited and completely natural, it forms the most wonderful unplanned nature reserve. Sadly the cascading rocks cannot be seen directly from the railway, but a walk today along the bridleway is possible and is recommended. (Check the route out on Google Earth – most enlightening!) The early Frank Mason poster from around 1910 shows how the North Eastern Railway Company marketed this area. It is a rarely seen poster and one of Mason's first non-maritime pictures used for a poster. The style is instantly recognized as Edwardian – detailed and precise.

1925 LNER Poster for the Rocky Yorkshire Coast: Artist F. Gregory Brown (1887-1941)

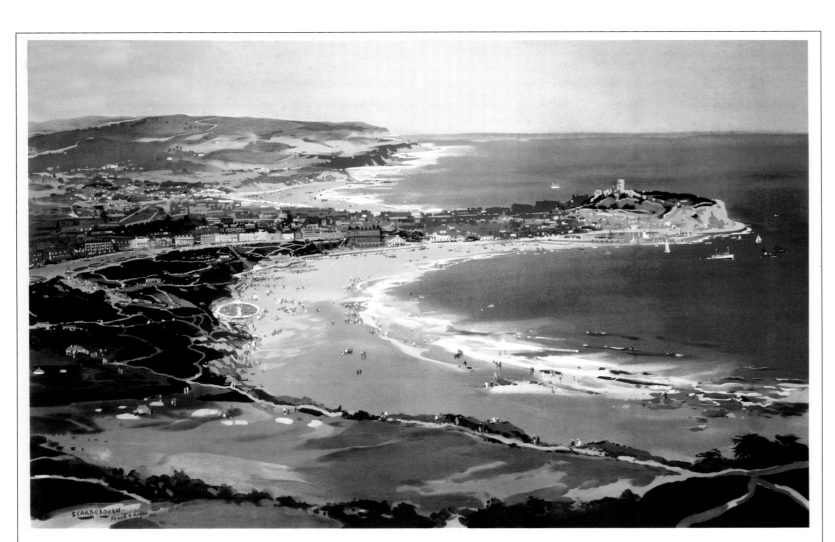

SCARBOROUGH

GUIDE FREE FROM PUBLICITY MANAGER, SCARBOROUGH

Train service and fares from BRITISH RAILWAYS stations, offices and agencies

Superb Vista of Scarborough Bay looking North and Issued by British Railways in 1948: Artist Frank Henry Algernon Mason (1875-1965)

Magically travelling southwards (and upwards), our next poster has us looking northwards from high above Frank Cliff to the south of Scarborough. The rockiness of the Beast Cliff area is on the horizon, and moving southwards we can now see that the cliffs around Cromer Point are less daunting.

Scarborough Castle Ahead

From here there are more signs of human activity: fishing boats ply up and down the coast seeking prized catches: periodically there is the whiff of diesel fuel carried on the wind. Gazing south, the skyline buildings of Scarborough gleam in the noon-day sun: a warm invitation to the delights of Scarborough. South of Burniston we are now in farming country, and green fields go right to the coast on our left. The line used to loop through Scalby, where a viaduct used to carry us high over the River Derwent, and passed the golf course. It is just a mile from here to the Castle, perched on the elevated promontory that shields the beach from winter 'Nor-Easters'. The poster shows the sweep of South Bay, with the aquamarine-blue jewel of the lido clearly visible in the centre of the bay. Again, Mason's detail is exquisite; a painting produced nearly 40 years after his work on the previous page.

Coming into the town from the north, we turn eastwards towards the castle and the subject of the next poster. This was painted by the great Frank Newbould in 1934, one of his many LNER commissions. Situated on top of a triangular cliff some 300 feet (91m) above the town, this 12th century structure was built on the site of an old Roman signal and lookout post. The natural lay of the land gives 360^{0} vision and is an easy place to defend. It is almost the perfect fortress site, and archaeological evidence suggests there have been a number of fortresses here for at least 2500 years. Newbould's striking poster shows what is left; much of the central keep, with sections of the original walls, most of the Barbican and a few remains of some of the outer buildings.

The extensive damage was caused by two main events: protracted fighting to hold it during the English Civil War, and prolonged shelling by two German warships during WWI. William Le Gros built the first stone structures here around 1130 during King Stephen's reign. But Henry II seized the site on becoming King and proceeded to strengthen the defences. The gate tower was replaced by the central keep shown here, and the inner walls were enlarged.

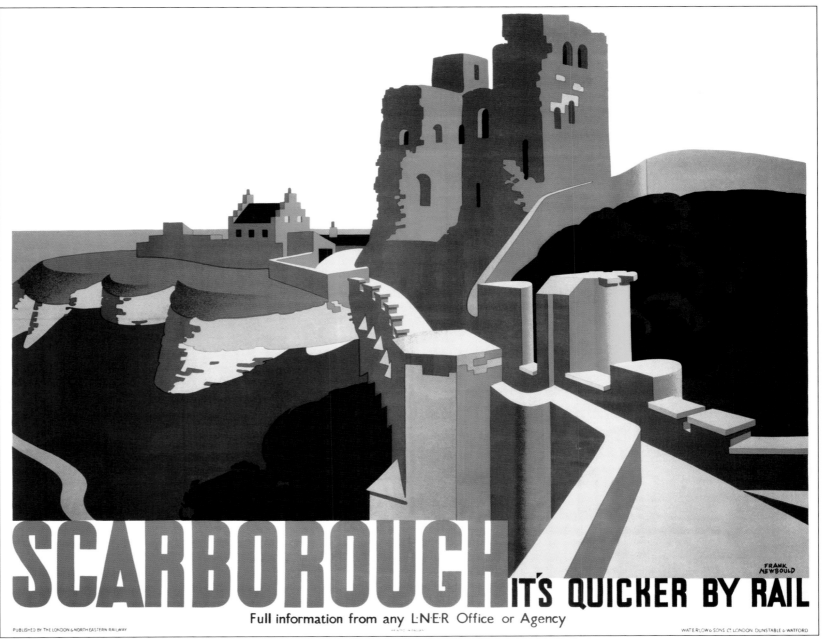

1934 LNER Quad Royal of Scarborough Castle, North Yorkshire: Artist Frank Newbould (1887-1950)

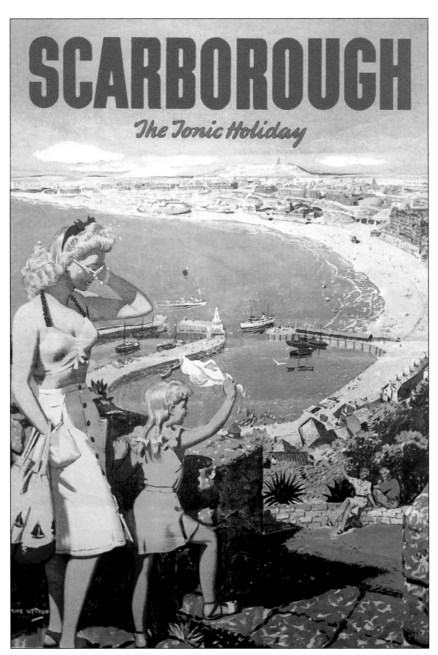

View from the Castle Ramparts: Poster from 1950s: Artist Clive Uptton

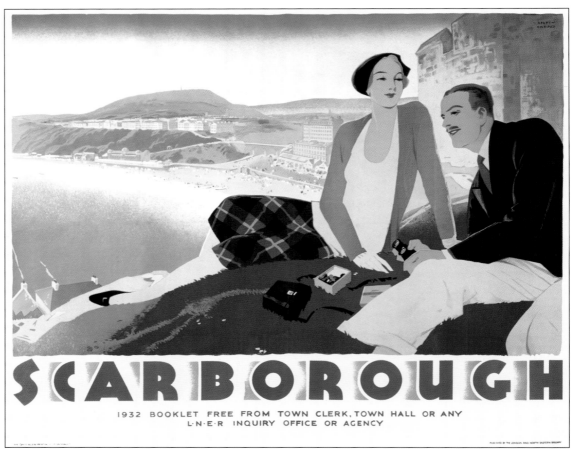

Romance at the Castle: LNER 1932 Poster by Austin Cooper (1890-1964)

Newbould's poster shows the many levels of the central keep. Visitors can see fireplaces at first and second levels, but it rises to 40 feet (12m), and in its day must have been quite a place to stay. Once Henry II had finished building, this castle was virtually impregnable, and so it proved until the English Civil War. Here prolonged cannon fire caused widespread damage. It changed hands seven times during the bitter Royalist-Roundhead conflict, and was to stand proud again during the Jacobite Rebellion and other conflicts. It took the German navy to finally cause mass destruction during a hail of some 500 shells on the castle and the town in December 1914. Our two posters here show the wonderful view from the south ramparts, looking over the harbour and bay. Now we can see its strategic importance. The poster above by Austin Cooper is one of his lesser-known works, with both foreground and background interest: a great poster.

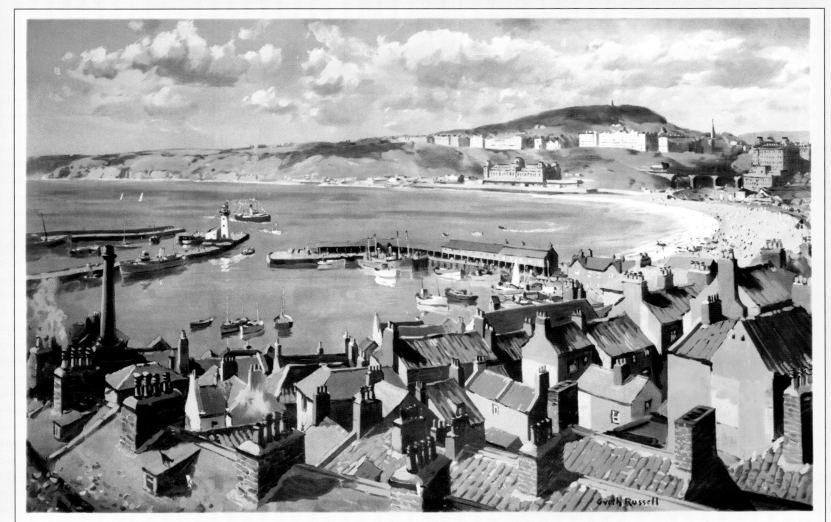

SCARBOROUGH

BOOKLET FROM PUBLICITY DEPARTMENT. SCARBOROUGH

Train services and fares from 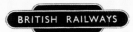 stations. offices and agencies

A Quite Fabulous Railway Poster: Scarborough's South Bay from Below the Castle, Issued by British Railways in 1950: Artist Gyrth Russell (1892-1970)

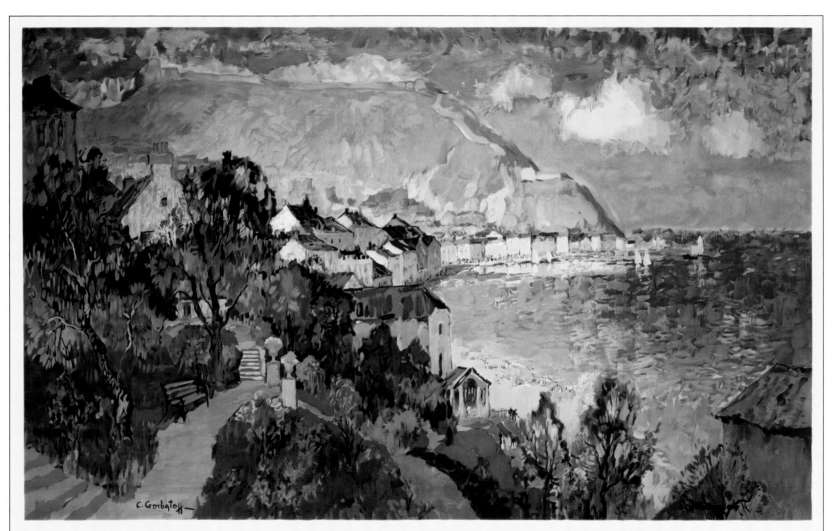

The Castle and Harbour from South Bay Scarborough: Artist Konstantin Ivanovic Gorbatoff (1876-1945)

Down Towards the Beach

The poster on page 99 shows the view as we walk down from the castle area towards the small harbour, through narrow streets of red-roofed houses. This superb poster is a great advert for 'Old Scarborough'. The harbour and fisherman's cottages were built in the lee of the castle, for natural protection of course, but Russell's painting of the old part of the town is wonderfully composed.

We walk along through the streets and towards the beach, but then stop and turn around to gaze at the vista of Scarborough Castle from the south. This is Gorbatoff's painting alongside, produced more in the *'Impressionist Style'* of Van Gogh than a railway poster. It is, however, a wonderful piece of art from a Russian artist, who in 1922, fled the aftermath of the 1917 Revolution. He then spent his life in Western Europe (first in Italy and then in Berlin), picking up commissions in several countries. How he came to paint this for the LNER is a mystery, and why Scarborough? Maybe it reminded him of Capri, his first home after Moscow. Whatever the reason, it is a refreshing departure from the usual style of BR railway posters.

Walking briskly along the front in an easterly breeze, it is time to look at the two open-air swimming facilities that used to be important parts of the towns attractions. We retrace our steps, and go first to the North Bay and see the new sea-water pool. The date of this poster is the mid-30s and it shows the facility that eventually became the Atlantis. It was demolished in 2007 to make way for the multi-million pound Sands Development scheme, but as the poster shows it was a fine facility. The headland, with the castle prominent, is clearly seen as we look south.

To the South Bay Lido Area

It is time to go south to see the famous the South Bay lido. In the two posters that follow, we see the architecturally superb high-level diving boards that have sadly been demolished. The whole complex was a wonderful example of the philosophy of healthy urban living that existed during the inter-war years. This was actually started as the pool was started just before WWI and completed in 1915 – maybe this was the real target of the German Navy in 1914, to stop the locals having fun in wartime! Throughout this series we will see other railway posters of such pools, many built in the inter-war years, when the Art-Deco architectural style naturally lent itself to their design. They also say something about the British spirit, as who in their right minds would swim (or sunbathe) outdoors in a country whose average temperature, for a good part of the year, is a mere 18^0C!

The construction of this pool, one of the largest ever built in Europe, began in the summer of 1914 when war clouds gathered. Harry Smith, Borough Engineer from 1893 to the 1930s, oversaw the design and construction. The pool was 330ft (101m) long and more than 65 feet (20m) wide. Some of the surrounding buildings were completed in a second phase construction in the 1930s. Though closed in 1989, and under constant threat of development, it was one of the finest surviving examples and moves were made to give it Grade-listed status. However, there is a more interesting reason why the lido should be protected and enhanced, and this has roots in the tidal behaviour in the Bay. Harry Smith realised that such a structure might help stem coastal erosion. It was built at the point where the highest flood tides strike the coast. The idea was that its volume could help deflect the tidal currents south-eastwards. The pool complex held two million gallons (over 8,000 m^3) of water, and together with the concrete used in the construction, this reinforced the central defences by taking energy from the highest tidal waves. Such ideas have been used in other places and are a viable means of coastal defence. Anyway, aside from the engineering, it made super railway posters, as we now see.

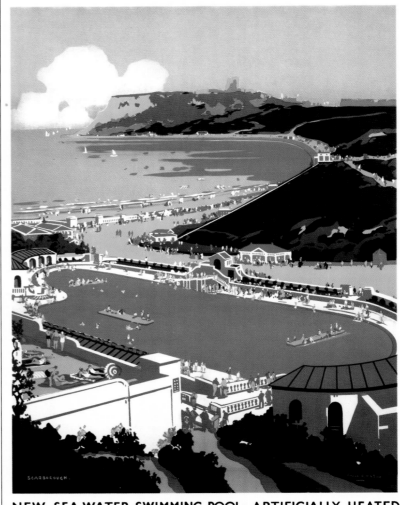

NEW SEA-WATER SWIMMING POOL- ARTIFICIALLY HEATED

SCARBOROUGH
IT'S QUICKER BY RAIL
FULL INFORMATION FROM ANY L·N·E·R OFFICE OR AGENCY

PUBLISHED BY THE LONDON AND NORTH EASTERN RAILWAY PRINTED IN GREAT BRITAIN 1939 S C ALLEN & COMPANY LTD. 20, GERRARD ST, LONDON W1.

Scarborough's North Bay Pool: Artist Frank Henry Mason (1875-1965)

Now we move magically back to the twenties and thirties for the next two posters. Just appreciate the style and elegance of the sea-water pool in Edmund Oakdale's 1936 poster. Here we see the Union Jack flying, the pool is thronged and people are using the complex as the social place to meet and greet. This must have been a great time in the pool's history. The new buildings had just been completed, and the country was in a general period of relative prosperity, so elegant dresses, sporty jackets and summer hats were the order of the day.

Today we take leisure time and standard working hours for granted, but a reduced working week and paid holidays only first appeared in the 1930s. This poster is a classic example of how style, tastes and appearances changed at a time when the LNER was pushing the message *'Its Quicker by Rail'* very hard. It is one of a series that Oakdale was commissioned to paint to show the elegance of Yorkshire. What is so good about this poster is the perspective, all the way round the bay to the castle. One can imagine Oakdale sketching the complete scene, and then spotting subjects for the foreground, which he cleverly placed afterwards.

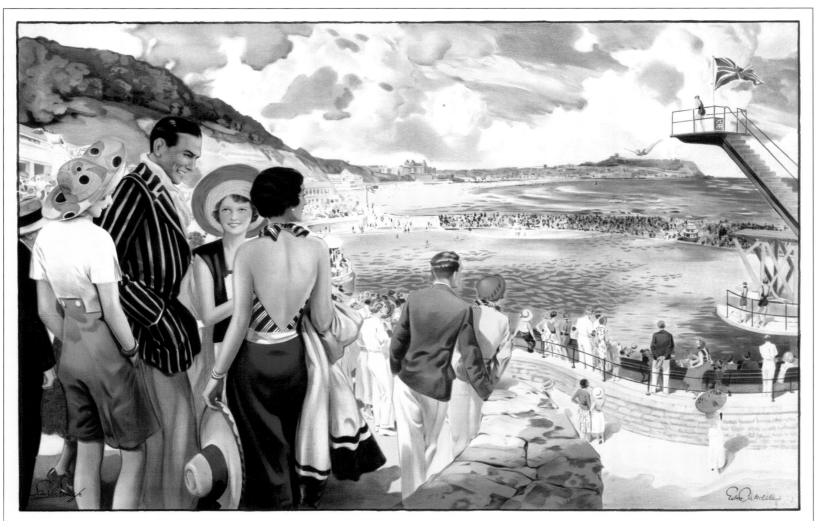

SCARBOROUGH
IT'S QUICKER BY RAIL
Full Information from any L·N·E·R Office or Agency

The Scarborough South Bay Lido at its Height: LNER Poster from 1936: Artist Edmund Oakdale

Here we go back another decade to 1925 for a poster from a lesser known artist, William Barribal. The fashions may have changed but the popularity of the Lido is evident in this unusual poster, where the lady sitting on the wall partially obscures the resort title. This is harking back to some of the early Caledonian Railway Company posters of the Edwardian era.

Barribal was a London-born artist, who specialized in painting people, especially beautiful women, and some of his pictures are prized today. He was one of the first of the 'art deco' artists who painted for the LNER, and he also created memorable images for Schweppes advertising posters and of women that were used on Waddingtons playing cards. Such work is highly collectible. He was trained in his early career as a lithographer and went to study art at the Academie Julien in Paris. From here he then undertook work for fashion-leader Vogue, and his eye for good composition of groups of people showing fashions was well known. Note in this poster how you gradually move from the foreground and up onto the diving board. The poster may be a little 'retro-looking' but the overall balance and colour is first class.

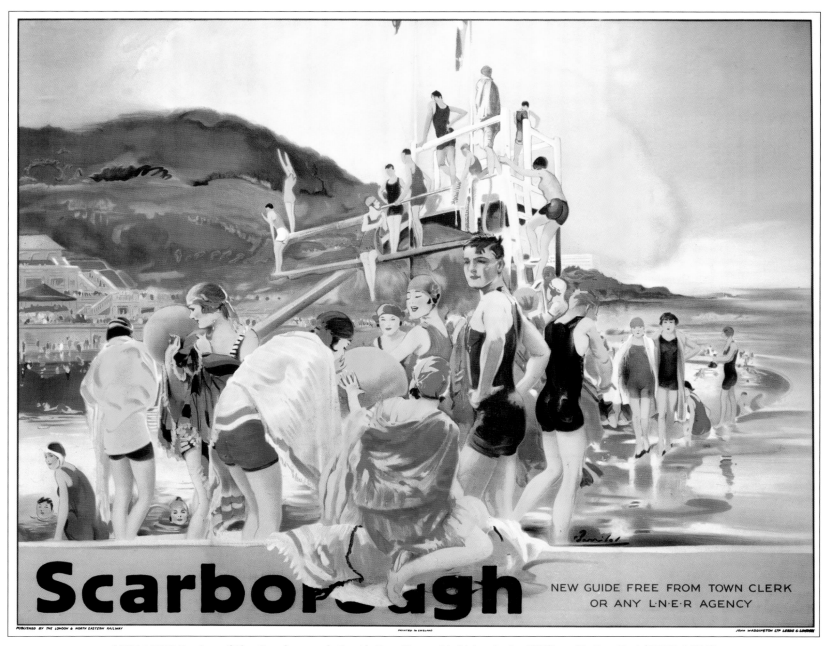

1925 LNER Poster of the Scarborough South Bay Open-Air Lido: Artist William H. Barribal (1873-1956)

It is a short walk from the Lido down onto the beach, where we can slowly turn and look from south to north to appreciate the sea-front panorama in its entirety. This 1933 poster from Andrew Johnson shows the delights of Scarborough on a summer's day.

As well as our shoe-conscious bathing belle, we can see part of the famous Scarborough Grand Hotel far right. (We will shortly be going inside in another poster). This iconic hotel is now Grade II Listed, and has recently undergone a major £7 million refurbishment.

Below her left knee on the foreshore is the equally famous Scarborough Spa. Waters with supposed minor ailment healing properties were discovered here in the 17th century. Word spread quickly, and soon people flocked to the area to be cured. In the 1820s, the area was developed, and the Spa area was leased from Scarborough Corporation. A bridge was built to link beach to town, and also a cliff railway. The bridge was widened and this promenade now became a popular place to stroll and be seen.

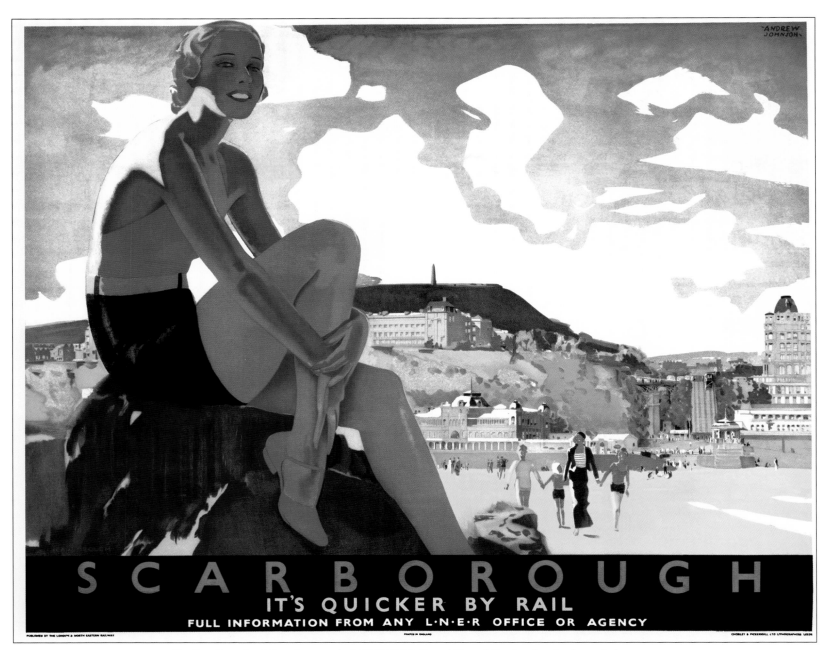

On the Beach at Scarborough: LNER 1933 Quad Royal Poster by Andrew Johnson

GNR Poster from 1920 by Frank Henry Algernon Mason (1875-1965)

These two posters give more perspective of the South Bay beach and the Spa area. The Scarborough sands are wide and safe, and the cartoon poster from Frank Mason shows two of the *Alice in Wonderland* characters extolling the virtues of the sandy beach. This post WWI poster would certainly appeal to children and families, and is clever poster marketing. It is one of prolific Frank Mason's more unusual and unexpected works.

We come up to the Spa and climb the steps to see the beach from a higher level. Our late 1950s couple are sporting the latest fashions, in true Scarborough tradition. At this time, British Railways was carrying on the practice of colourful and eye-catching posters, some from known and others from unknown artists, as in this case. This was probably supplied by one of the many of the artists' studios that supported marketing activities. This one is also rarely seen in auctions.

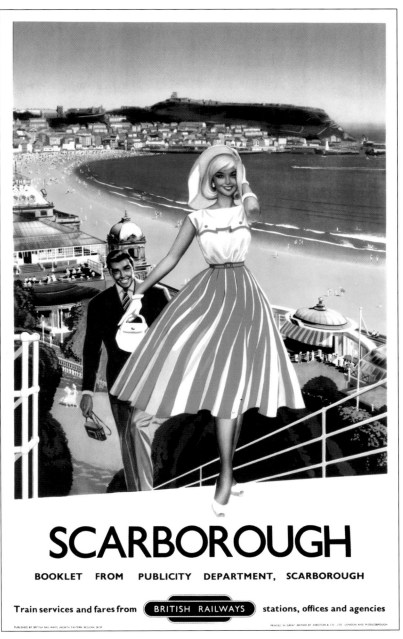

1958 BR (NER) Poster of Scarborough Spa Area: Artist is Unknown

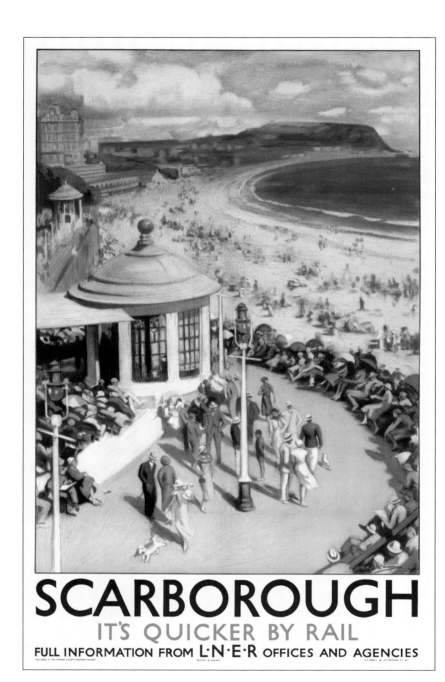

Scarborough Spa in 1935: Artist Arthur C. Michael

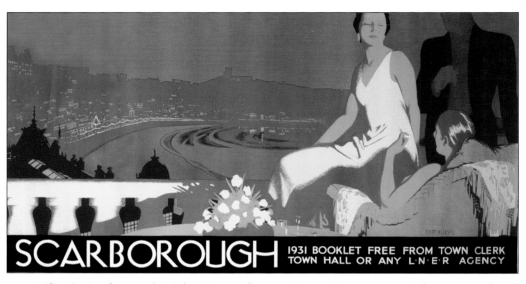

A Classic Scarborough Nights Poster from 1931: Artist Tom Purvis (1888-1959)

Time to Socialize

These two posters follow on from the previous pair in showing the Spa and the elegance that was always found in the town. In Michael's 1935 poster the Spa, the seafront and beach area are all busy, showing the real popularity of Scarborough. The Spa complex has many amenities, including the 600-seater theatre for shows and pantomimes, a 2,000 seat conference room, the Ocean room for dances and other events, and of course the large promenade linked to the nearby cliff railway. This travels up the 200 feet (70m) cliffs and into the town. The poster shown above and the one depicted on the opposite page, show people socialising in the Spa. When the Spa and Lido facilities were upgraded, there was a renewed interest, and during the 20th century, the second heyday was certainly when all these lovely posters appeared.

The other favourite place to socialize was the Grand Hotel. When completed in 1867, it was one of the largest hotels anywhere in the world. This is superbly designed and reputed to be based on the theme of time, spanning one year. This comes from the four towers (the seasons), 12 floors (the months), 52 chimneys (weeks) and 365 rooms (the days). Along with the castle, the hotel suffered severe damage from the Germans, but it was restored, and in 1978, was purchased by Sir Billy Butlin. Today it is now owned and recently further restored by Britannia Hotels. The heyday was probably in late Victorian times, when Yorkshire's elite and wealthy holidaymakers made up the clientele.

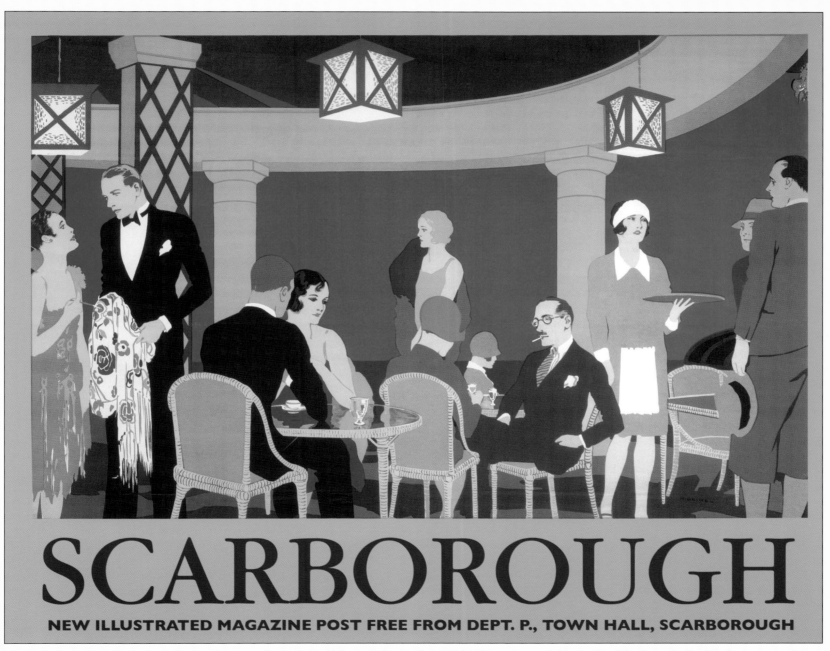

Socializing at the Spa: Left Hand Poster from a Double Quad Royal published in 1929: Artist Reginald Edward Higgins (1877-1933)

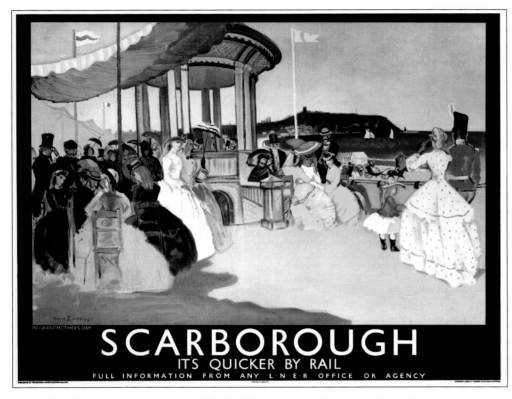

***'In Grandmothers Day'*; 1935 LNER Poster: Artist Doris Clare Zinkeisen**

These two posters show Scarborough in the olden times. The Zinkeisen poster above was painted in 1935, when Doris placed Victorian ladies in the setting of central Scarborough, around the Spa. Her trademark was the splashes of colour dotted around the posters she painted, and most of them had many people within the frame. As with many other Scarborough posters, there are loads of people on view, testament to the resort's popularity for the past two centuries.

Alongside is a double royal poster, which was issued by the North Eastern Railway in early Edwardian times. Although the artist is not known, it is based on the work of John Hassall, who had immortalised the Skegness 'Jolly Fisherman' in 1908. The style and poster colouring is very reminiscent of Hassall, but is more likely to be a copy of the successful image. This poster is rarely seen in auction, and it is considered unlikely that many still survive today.

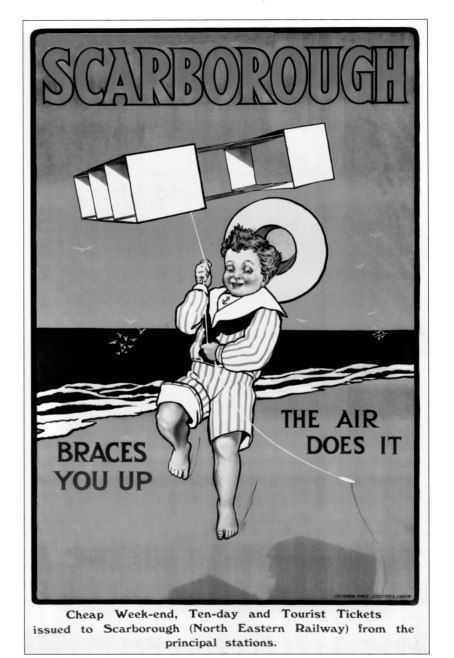

NER Poster from 1909: Artist is Unknown

Here we have another famous poster. The LNER issued holiday guides and handbooks to boost tourism to key destinations. It goes without saying that Scarborough was one of these. The guide usually had a miniature version of a railway poster on the front and here we have the 1929 guide by Laura Knight. The scene could actually be for Saltburn, Scarborough or Bridlington, but placing it here fits with the two on the opposite page.

Laura Knight was born into a poor environment, but was always encouraged in art, especially in early life, by her mother. She enrolled at Nottingham School of Art, where she was to meet her future husband, Harold Knight. She experimented with many mediums: etchings, lithographs, linocuts and ceramic painting to name but four). Based on her reputation and adaptability, the railway companies (plus London Transport) used her for a limited number of posters, of which this is probably the best known. She received many Government commissions during WWII, and afterwards painted for the Coronation of 1953 and other high profile events in the 1950s. She painted right up to her death at age 93.

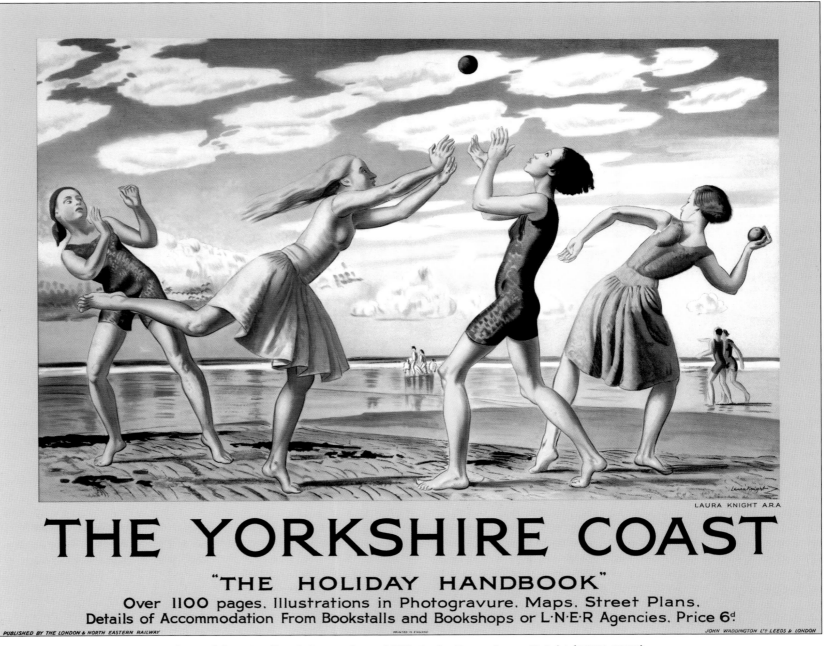

The Holiday Handbook Poster from 1929: Artist Dame Laura Knight (1877-1970)

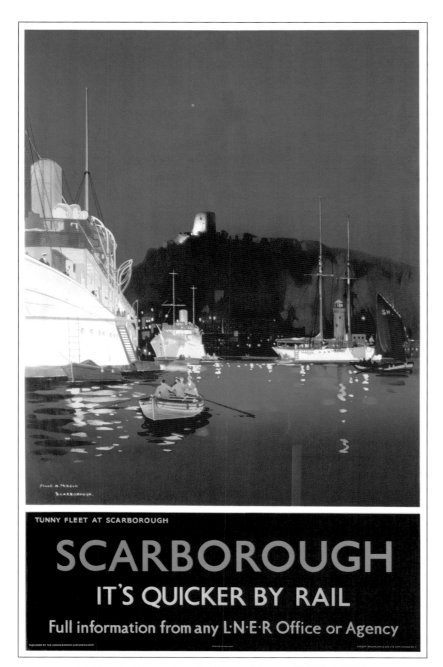

1930s Poster by Frank Henry Mason (1875-1965)

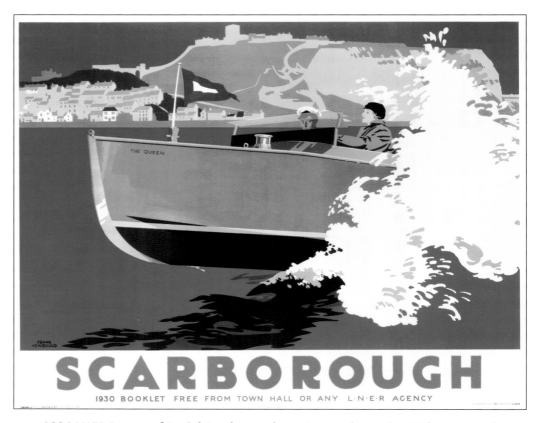

1934 LNER Poster of Social Scarborough: Artist Frank Newbould (1887-1950)

Scarborough at Work and Play

As well as beaches that were usually busy, Scarborough had a rich socialite reputation. It was the place that the richer people used to visit and the two posters here show 'messing about on the water'. Newbould's poster above is well known, and shows a couple speeding around the bay. Newbould used minimalist colouring, with no details at all in the water or the spray from the boat. The outline of wave and water is used to convey speed. Alongside is an evening scene of large ships in the bay. The caption says the 'Tunny Fleet at Scarborough', but they look more like visiting cruise ships than fishing vessels. There used to be a large and active fishing fleet here, but WWI losses sounded the death knell, from which the industry has never recovered. The harbour was always too small and most vessels remained outside until others had unloaded.

The Mason poster mentions tunny, but the last one was caught off the coast in the mid 1950s. This was a bad omen for the fishing industry generally, as tuna used to swim and feed off the huge shoals of herring. When herring started to decline, the tuna went elsewhere. The visits of Scottish fisher lasses, who used to come to support the local industry, also declined, and by 1970, they were not seen any more in Scarborough harbour. Very soon afterwards the herring fleet, which had been a part of the Scarborough economy for more than 150 years, had died. The fishermen had done themselves out of a living, taking too much fish too quickly.

However, the town still had its tourism and days out at the seaside were as popular as ever. The lure of Spanish package holidays was starting to eat into tourist numbers, and posters such as those below stopped appearing on our stations up and down the country. The glory days were over. The poster alongside shows Scarborough on a balmy summer's evening in 1961, but this is real artist's licence' as we are looking north -unless it is dawn after a long night out!

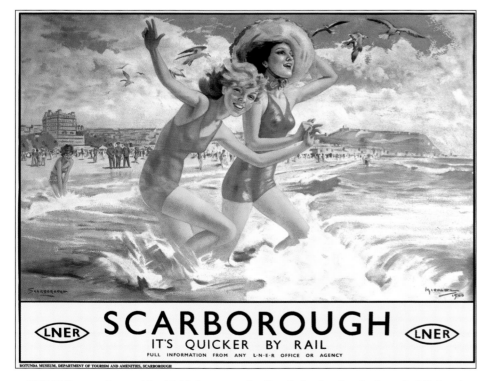

WWII Poster Issued in 1940 from an Earlier Painting by Arthur C. Michael

1961 Poster Issued by British Railways: Artist is Unknown

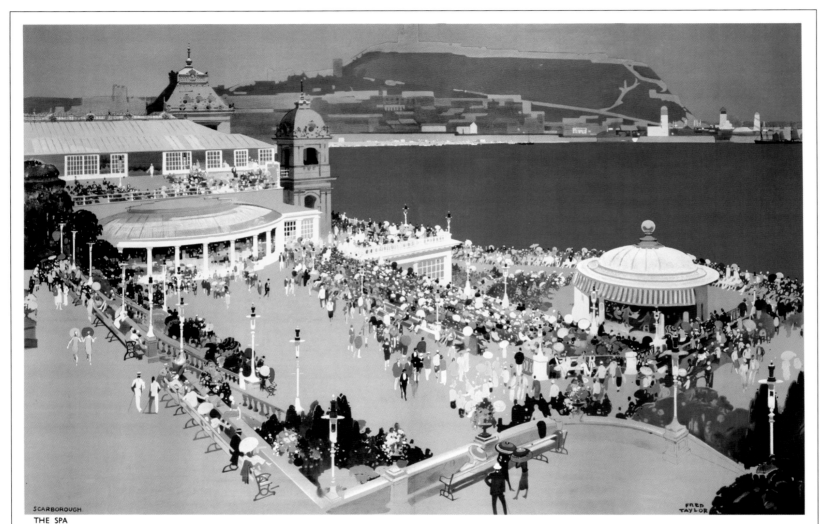

SCARBOROUGH
THE SPA

FRED
TAYLOR

SCARBOROUGH

IT'S QUICKER BY RAIL

FULL INFORMATION FROM ANY L·N·E·R OFFICE OR AGENCY

PUBLISHED BY THE LONDON AND NORTH EASTERN RAILWAY

JOHN WADDINGTON LTD. LEEDS & LONDON

A Classic LNER Scarborough Poster from 1939 of the Famous Spa: Artist Fred Taylor (1875-1963)

The storm clouds of war were beginning to grow when this poster was issued in 1939. No sign of gloom and dismay here, as the Spa area in South Bay is packed. Fred Taylor possibly painted this a year or so earlier and the LNER issued the poster ahead of the breakout of war in a final effort to promote tourism and fill their trains.

The town has always been at the forefront of tourism and promotion, and had already issued small books about how to get there and listing all the amenities and attractions to see. The Town Council has always been progressive to ensure that the resort is always visited and that guests go home happy.

This is not another plug to go to Scarborough (they do not need one from me), because in 2008/2009 they won awards for entrepreneurship, and in 2008, it was voted the most enterprising town in Britain. It is no wonder, given the past history of railway advertising, that their tourist tradition is still alive and well today. However, this poster also shows the relative prosperity and style of the clientele in the late 1930s: happy times for the town.

Scarborough is the first seafront in England to be totally '*Wi-Fi*', and they have installed one of the fastest broadband networks, a testament to the vision of the town's planners.

This unusual poster shows what Scarborough is really all about. How many of us can remember rock-pooling during days out at the beach? Scarborough has numerous rock pools at low tide, especially at the southern end of the bay. Stephen Bone painted this relatively early in his career. Born in London, he lived part of his childhood in Italy in an artist's environment. His parents were both artists, and his father was a very eminent draughtsman and famous engraver. This work has the lovely subtitle of '*A summer visitor among the coastal residents*'. It is quite unlike any poster before or since – a poster beneath the waves and very imaginative.

This was Stephen Bone all over. He was a Naval Reservist. and during WWII was a Lieutenant and also worked for the War Artists Commission, recording the images of battle. His time at sea produced a striking series of naval paintings, but he sadly died at the height of his profession.

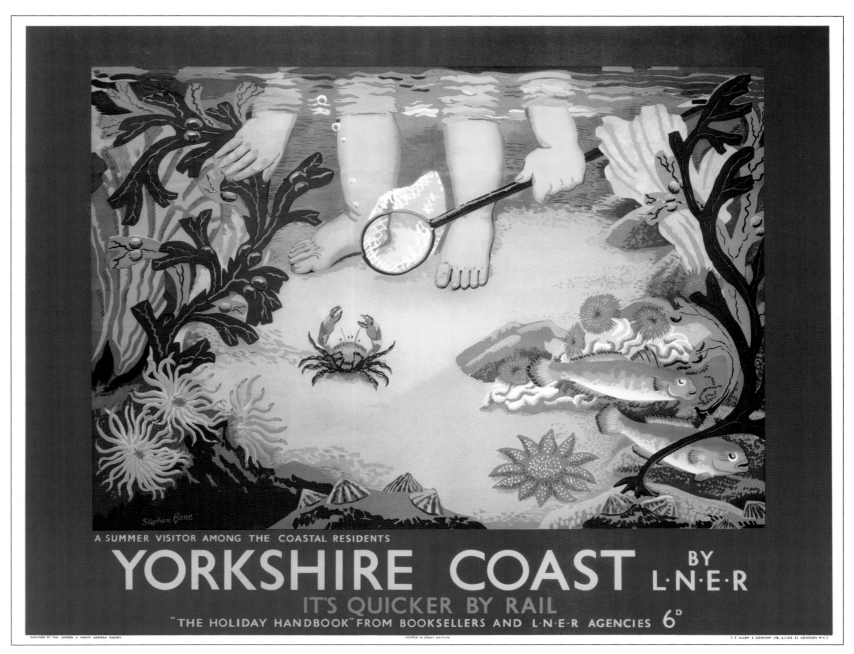

1933 LNER Poster of Summer Days in Rock Pools: Artist Stephen Bone (1904-1958)

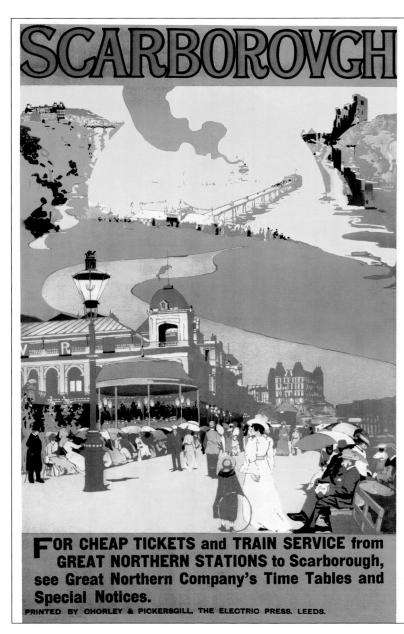

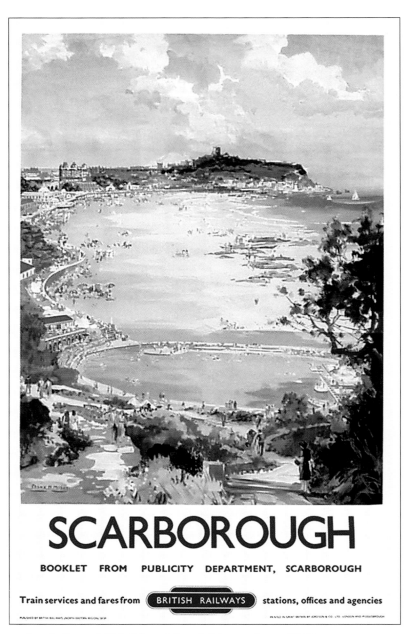

We close our visit to 'Bracing Scarborough' with a quartet of posters that span 40 years. The oldest and the most recent are shown here. The poster issued by the GNR in 1910, shows very clearly how far poster art advanced in the first decade of the 20th century. The clever collage shows castle, pavilion, prom, and elegant people of the late Victorian era. I have it on good authority that the pier is at North Bay and this was demolished after WWI. Alongside, Mason's expansive painting shows how his style and peoples' tastes had changed from the double royal shown here. Those posters from immediately before WWI somehow seem more dated, when compared to some produced around 1910; the lettering maybe?.

Our finale on page 116 is an absolute stunner, and for me one of the top five railway posters of the 20th century. This shows a couple possibly deciding whether to have a martini or a gin & tonic (champagne even) on a partly shaded balcony, with the warm summer sun breaking through the leaves to highlight their elegant dress. Broadhead has painted something quite magical here and its use as a railway poster was down to the vision of Cecil Dandridge; anybody ready to go to Scarborough?

Two Scarborough Posters Almost 40 Years Apart: Baumer Lewis from 1910 (L) and Frank Mason from 1948.

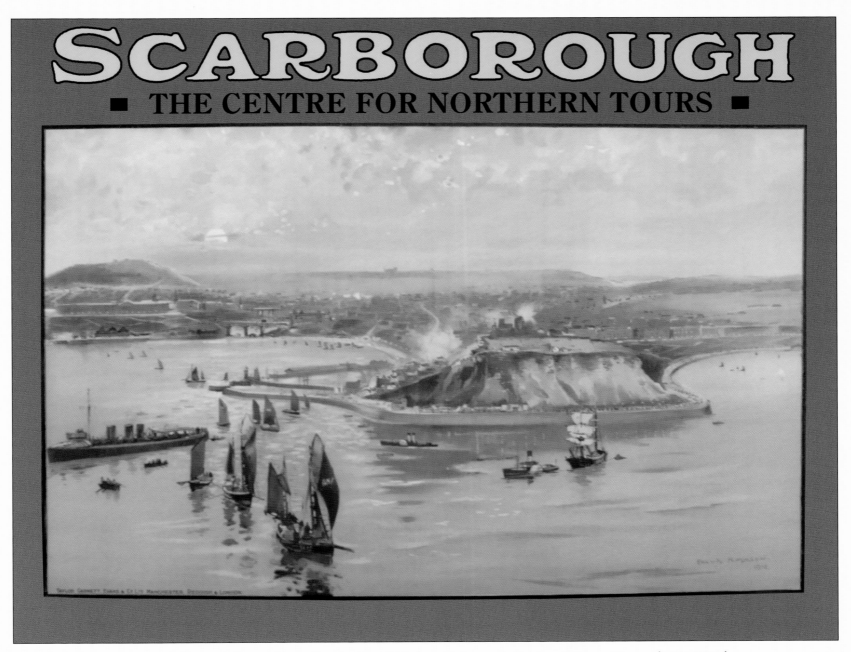

1914 Scarborough Poster Issued by the North Eastern Railway: Artist Frank Henry Mason (1875-1965)

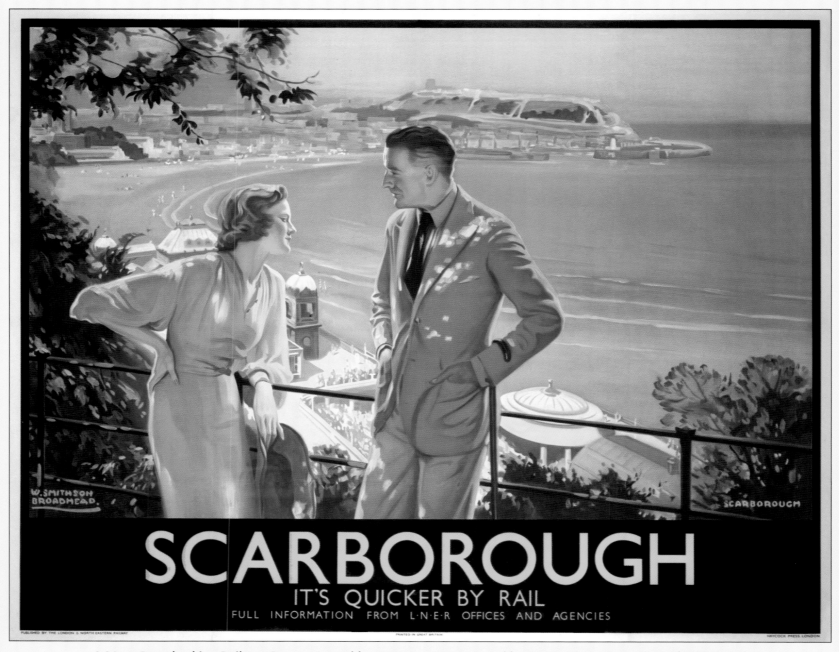

A Most Breathtaking Railway Poster: Issued by LNER in 1935: Painted by W. Smithson Broadhead (1888-1960)

Chapter 5 Beside the Seaside
Filey-Flamborough-Bridlington

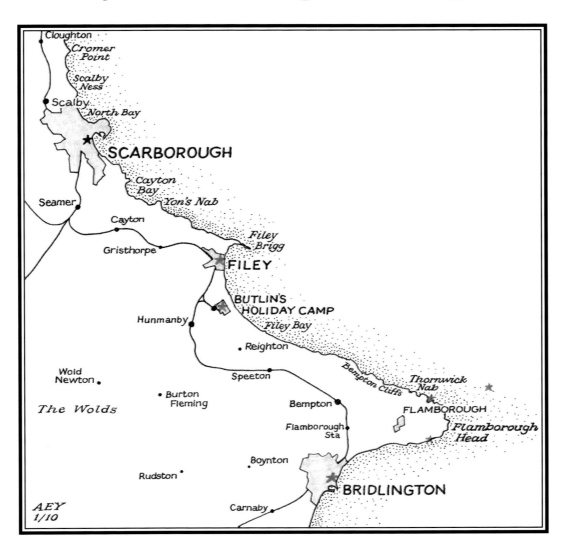

Chapter 5 Beside the Seaside

1935 LNER Poster by an Unknown Artist

The Short Journey to Filey

This chapter unashamedly features a wealth of seaside holiday posters. Our journey will take us south from Scarborough, through Filey and around Flamborough Head to finish at Scarborough's great seaside rival, Bridlington. This fine alternative Yorkshire resort features on many posters and as with the last chapter, we end this one with another classic. Unlike the last chapter, you can still take the trip in this chapter by rail today, but we will magically jump on and off the train, as the posters show life 'Beside the Seaside'.

Filey is a mere eight miles (14km) south of Scarborough. For the more adventurous, the Cleveland Way makes a wonderful walk on a fine summer's day. The footworn-track runs from Scarborough's South Bay to Filey Brigg, the site of another Roman signal station. Fires from here could be seen from Scarborough Castle: data transmission in double quick time and the Roman equivalent of the Internet today. Two miles (3 kms) from Scarborough we find Cornelian Bay, where over the years there have been finds of some semi-precious stones. Maybe this is what the children in our first poster are looking for: no crabs and small fish for them – where are the diamonds!?

Past Cayton Bay and Castle Rocks below Gristhorpe Cliff, we soon see Filey, where this poster by an unknown artist begins the journey. The town may have derived its name from the old English word 'File', meaning a thin finger of land protruding into the sea. This is almost certainly a reference to Filey Brigg. From below the North Cliff, the foreshore rock platform extends a long way out at low tide, and almost certainly is the real location of the poster depicted here. It is a rich area for fossils, mainly plants and small bi-valves, rather than the large dinosaur remains that appear off the Dorset Coast.

Filey is an Edwardian resort, with a large sandy bay that sweeps south-eastwards, from the Brigg, to the King and Queen Rocks near Smeeton. It has always been a family resort and all the posters shown in the first part of this chapter all highlight this. Filey's tourist industry has never had the glamour of more up-market Scarborough, but the friendly atmosphere and safe bathing areas, with miles of rock pools to explore, are ideal for families with smaller children. This is the market sector the railway posters targeted. For a century it has been a relaxing place to visit, even if the surrounding area had holiday camps and several large caravan parks, which blotted the landscape. Day-trippers tended towards Bridlington and Scarborough, but families went to Filey.

The poster nearside shows the view looking northwards towards the Brigg, but at high tide. Alongside is a view from further south, so the whole sweep of the bay with the cliffs at Filey Brigg in the distance, give a good appreciation of the area's panorama.

Filey was initially a fishing village, but the location and the wonderful sandy bay soon turned it towards tourism. The Ellis Silas poster shows that the coat of arms shown below for Filey Council is a perfect representation. Here we have rocks, sun sand and sea: everything to make the family holiday perfect for younger children. This is one Town Council who made the best of the assets available. The Silas poster is also one of the few BR posters which were commissioned in the 1950s, though we will see the famous Butlins poster for all their camps a little later.

Filey Town Council Coats of Arms

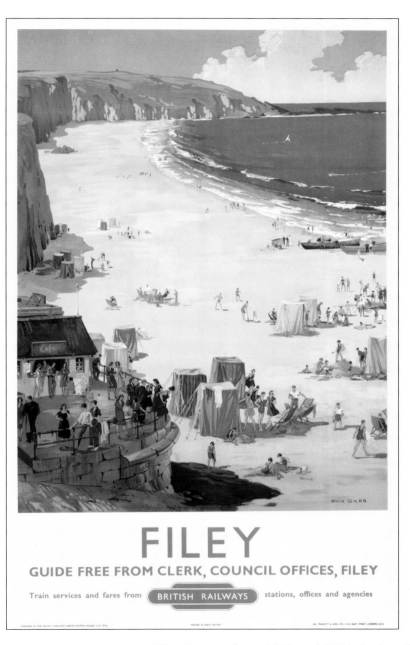

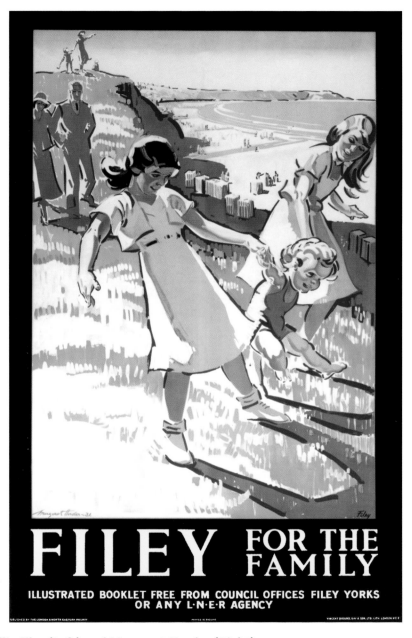

Filey Posters from 1952 and 1931: Artists Ellis Silas (Left) and Margaret Horder (Right)

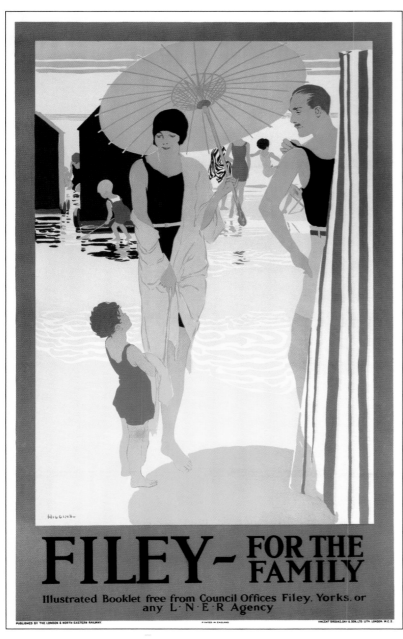

1925 LNER Filey Poster: Artist Reginald Higgins (1877-1933)

What is noticeable in all the Filey posters is the presence of children: very clearly the intended market. Rail links to the town were good and the Butlins holiday camp to the south of the town even had its own railway station, to ensure that families had the easiest of transfers from their home to their holiday chalet. The posters here are unashamedly aimed at summer holidays, but both are rarely seen today. The Higgins poster appeared in 1925, and a decade later the styling may have changed, but the message had not. The parasol, colours and overall style is reminiscent of Chinese art, but the subject is distinctly British. Michael Foley's poster has children enjoying the expansive sands and inviting us all to join them.

Around 1750, people started to notice the peace and solitude the village offered compared to Scarborough, but it was not until the 1830s that John Unnett, a West Midlands solicitor, saw the potential, bought some land and built a crescent of elegant houses (later named the Royal Crescent) that were to change the fishing image forever. It quickly became **the** seaside address to have and Filey was 'on the map'.

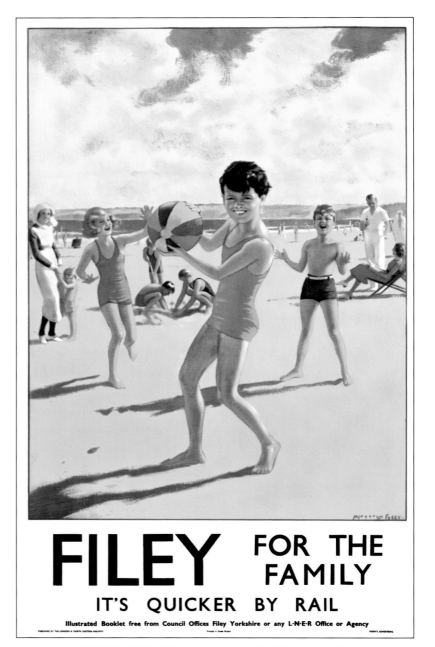

1934 LNER Holiday Poster: Artist Michael Foley

I Do Like to be Beside the Seaside

For centuries, the fishing community had lived around what is today Queen Street. This street also has the oldest existing building that now accommodates the town's museum. This is dated 1696 and is Grade-II listed. When Foord's Hotel (and yes, it is spelt this way) opened in the early 1800s, the town began its proud history of welcoming visitors. But like so many seaside towns throughout Britain, it was the building of the railways that made the economy strong from Victorian times onwards.

Construction of the town's station began in 1845 and it was opened in October 1846, enabling the many visitors who first went to Scarborough by train and then on to Filey by road, to make the whole journey from industrial West Yorkshire by rail. A year later, the line was extended down to Bridlington, via Hunmanby and Bempton, to join with the line up from Hull to Bridlington, which was also completed in 1846. In the space of just 18 months, therefore, the fast-rising resort of Filey had good transportation connections. Remember at this time there was no poster advertising, so the resort's qualities spread by word of mouth. The town used to have a second railway station, just to the south, that served the main Butlin's holiday camp, but this is now no more. The Margaret Horder poster on page 119 shows families walking along the cliffs, close to where this was later built.

The poster shown here was issued in the early days of the LNER, and carries one of the early logos used by that railway company. The poster is more of a social painting than an eye-catching poster, and yet follows on from the legacy that the NER gave to the LNER in publicity terms. The NER always had an artistic streak to support the commercialism, and more than a decade before this 'arty' poster appeared, the policy from the York office was *'to be keenly alive to the value and necessity for advertising their wares in an attractive and alluring manner as possible'*. This is an extract from a 1914 article 'Railways and Art'. It is the first such article I came across in the NRM records, where the true value of poster art was to become mainstream railway policy.

What I have not able to determine is the exact location of this poster: I suspected Filey Brigg and this has since been confirmed (but with artists' licence!). In this part of the bay there are cliffs, which over the years have been eroded to form a shelf from which fisherman and children alike can occupy the hours. Chas Pears' pastel-like painting shows designer fishing in a poster rarely seen. The town today is still small (population less than 10,000), but go onto Google Earth and notice how many photographs are posted. This is still a popular area today, more than 80 years after this timeless poster appeared.

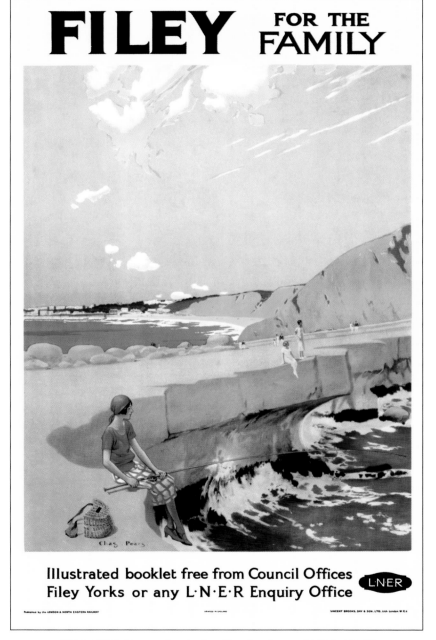

1924 LNER Poster by Artist Charles Pears (1873-1958)

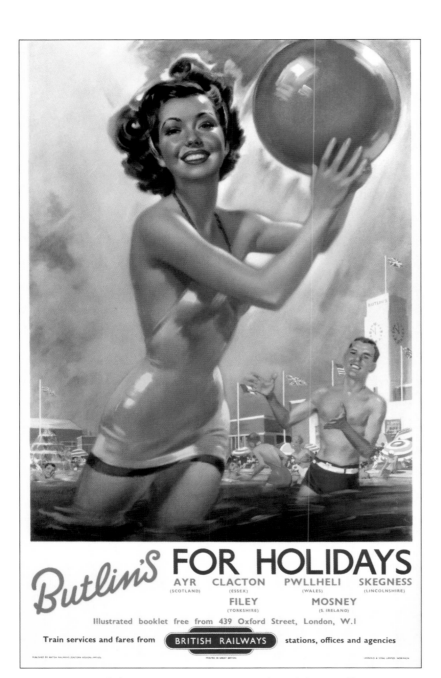

Mervyn Scarfe's Famous 1962 Poster Advertising Butlins Camps

For our next poster, we travel a short distance south of the town, to the site of the famous Butlin's Holiday camp. For more than 40 years this was a central pillar in the local economy, and when it finally closed in 1984, it caused a huge dent in local finances. Its history involves the saving of my favourite class of steam locomotive – the Princess Coronation – two of which were preserved for posterity by entrepreneur Billy Butlin. He built holiday camps at various key locations in Great Britain, some of which are listed on the poster here. Filey began life as a land purchase of 120 acres for £100 per acre. Construction began just before the start of WWII and, shrewd businessman that he was, Butlin did a deal with the Government to accelerate development as RAF Hunmanby Moor, in exchange for more money after the war to finish the camp to his original vision. More than 6,000 military personnel were stationed here at any one time during the war. The RAF even helped him finish the development in 1945. With the purchase of land to take the whole site up to 400 acres, the camp turned into one of Britain's largest and, at its height, was able to cope with almost 11,000 visitors each week. Just imagine the logistics necessary at summer season weekends, when people finished and started their holidays.

Such mass transportation of people meant Filey station was no longer practical, and a second dedicated station appeared in May 1947, almost two years after the first visitors started to use the camp. Butlin even had the Filey camp open for the last two weeks of the 1945 season. The station actually closed six years before the announcement that the camp itself was to close, along with Clacton, at the end of 1984. As it was one of the major UK camps, filling it became increasing difficult, as sunshine holidays to Spain progressively took away the clientele. When the site was sold, it was held by a succession of people, who tried to carry on the Butlin's tradition. However, all failed and eventually the site was split in two. The northern section is now still a holiday camp (owned & managed by Haven and marketed as Primrose Valley), whilst the other half is being developed with private homes, a leisure centre and a purpose-built, smaller hotel.

The poster here is one of a series that British Railways commissioned in 1960 in another joint venture with UK 'Holiday King' Butlin. It was this closeness with BR that enabled Billy to purchase two magnificent engines, *Duchess of Hamilton* and *Duchess of Sutherland,* which he had cosmetically restored and sent to his Minehead and Heads-of-Ayr camps. If this had not happened, only *City of Birmingham* would have survived from the entire class (and today this is incarcerated inside the City Museum in its home city). Therefore, Billy Butlin has allowed us all to see the sight of Stanier's best in full flight today. The NRM has recently put *'Hamilton'* back into red and gold streamlined livery, and this is now on view in the Great Hall, York: it is simply fabulous! We owe Butlin's vision a huge thank you.

Boating Events at Flamborough

Now we feature an unusual and historic poster that depicts a strange event off the Yorkshire Coast. The sub-caption says *'Paul Jones fight off Scarborough'*, but it is actually John Paul Jones' battle off Flamborough Head. The unusual angle is that the battle involved a continental squadron of the US navy who were battling the UK for independence.

Mason's dramatic quad royal shows the height of the battle, where his flagship (*Bonnehomme Richard*) engaged *HMS Serapis*. The *Serapis* and the *Countess of Scarborough* were escorting a larger convoy of merchant ships, when Jones' small squadron of his flagship plus frigates *Alliance* and *Pallas*, decided to make trouble. *Scarborough* took charge of the merchant fleet, whilst *Serapis* took on Jones' squadron. The two ships had a broadside duel and immense damage was caused to both ships. Jones' flagship was eventually holed below the waterline and started taking on water. The *Alliance* joined the *Bonnehomme Richard* in attacking *HMS Serapis*, which eventually was overwhelmed. As his flagship was sinking, he took charge of the damaged *Serapis* and sailed away victorious.

1920s LNER Historic Poster Uniquely Displaying Yorkshire's Naval Battle With the USA: Artist Frank Henry Mason (1875-1965)

BR (NER) Poster from 1960s: Artist Edward Wesson (1910-1984)

John Paul Jones (1747-1792) is considered by many to be the Father of the US Navy. His name was as hated in England as it is glorified in the USA. Scottish born, there is no doubt that he was a clever, bold and fearless sailor, but he was always considered by the English to be a renegade, a traitor and a ruffian. After his Flamborough Head encounter, he lived his life on the Continent and died aged 45 in Paris, forgotten and laid to rest in an obscure cemetery. His remains were exhumed in 1905, and with great ceremony, the same number of Americans who had accompanied him on his raids (508) escorted the body back for internment at the Naval Academy at Annapolis, Maryland. Mason's poster is therefore the story of a Scot fighting for the Americans and beating the English off the Yorkshire Coast: a really great poster story with an image to match!

The poster shown here is one of Edward Wesson's loveliest paintings. It shows the small bay called North Landing some four miles (six km) along the coast from Bridlington. The area today is designated a Site of Special Scientific Interest (SSSI) for its wonderful geological, botanical and ornithological aspects. The whole of Flamborough Head has a real draw for those readers interested in nature, and, not surprisingly, tourist posters exist to encourage visitors: but today fewer people do.

It also has a more romantic side, being used by smugglers, whilst coastal erosion means that wonderful arches, coves, stacks and caves all carved by the waves, are waiting to be explored. It was also the site of the old RNLI lighthouse, and where many Yorkshire cobles used to be launched for fishing, but today they carry tourists to view the magnificent cliffs from the sea. Our trio of posters on these two pages show two views of the natural harbour (left and far right), whilst in the middle is another of the *'East Coast Craft'* series that features the Yorkshire coble. This is the boat traditionally found here (and all the way up the coast to Whitby).

The two posters opposite come from the prolific Frank Mason, and it is interesting to compare his treatment of the natural harbour with Wesson's. Mason loved seascapes, and he shows boats being launched during a North Sea storm, with wave after wave rolling landwards. During one storm in 1871, some 20 ships were driven ashore here, with the loss of more than 70 souls. It led the RNLI to establish the brick lighthouse shown in Wesson's painting. The cliffs are limestone and over 200 ft (70m) high in places. Natural streams flow down to the sea, punctuating the cliffs and adding to the grandeur of the place. I can image Wesson sitting and taking in the beauty of the bay whilst he produced his own masterpiece. This is a favourite Yorkshire poster of mine, and one that takes it rightful place in this chapter.

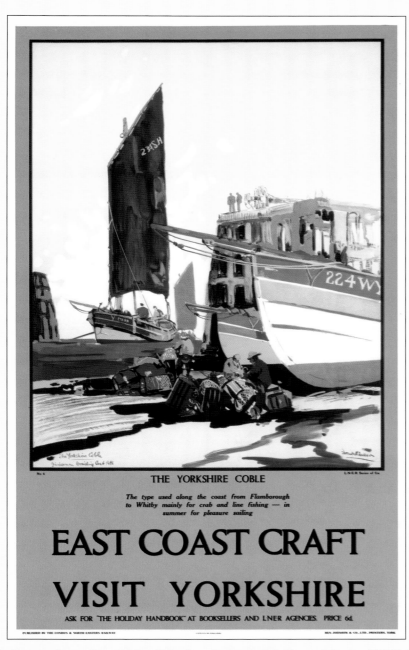

1930s Poster from Coastal Craft Series: Artist Frank Henry Mason (1875-1965)

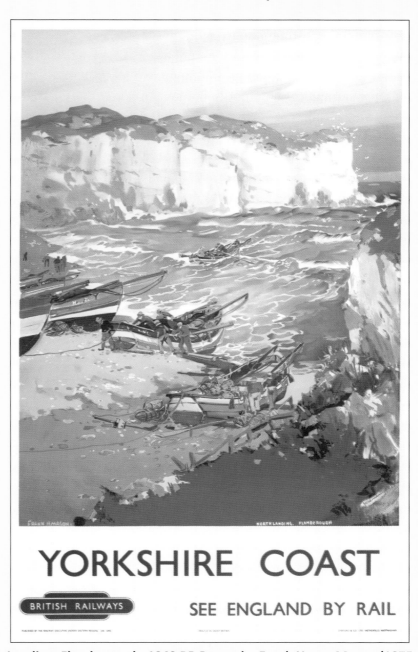

North Landing, Flamborough: 1949 BR Poster by Frank Henry Mason (1875-1965)

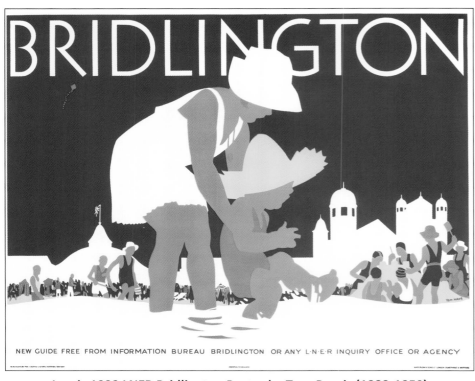

Iconic 1932 LNER Bridlington Poster by Tom Purvis (1888-1959)

And So on to Bridlington

Taking the train out of Filey and past the spur to the Butlin's camp, we are soon well into open country for the short trip to Bridlington. This was another major resort that played host to millions of people from the West Riding (and elsewhere) over hundreds of years. After passing through Bempton, the line turns south and we soon arrive into Sewerby, with the sea to the left. This is the northern part of the town, and minutes later, we pull into the station on time. This was built in 1846, but had a complete makeover in 1912, when the Edwardian Baroque style was used, and the new roof in lightweight NER-style was installed. The concourse is spacious to cope with the large numbers of people who came for their holidays. When the station was built, Bridlington was actually two places separated by some open country. To the northern end was Bridlington Quay, where the fishing fleet and tourist areas were located, and about a mile inland was the Old Town (once known as Burlington). Here we find the old Priory church of St. Mary, and the site of the old market.

Once the railway arrived, building quickly devoured the open land and Bridlington became the town we know today. The first hotel actually preceded the coming of the railways by 40 years, but it was the 1850s onwards when the resort's reputation was made. Not surprisingly, being such a holiday destination, the town had a plethora of posters appearing from the end of Victoria's reign right up to modern times. The rest of this chapter presents a selection of these, and we have some 'real crackers'.

We begin with an iconic poster by the great Tom Purvis. This simple eye-catching poster is the epitome of commercial art. It is bold bright and clear, everything you need in a holiday poster. There is no need for words, the image says everything. Contrast this with the Taylor image below. This is bold, yet cluttered, with an ambiguous message. As a poster, it gives no real clue as to what is being advertised.

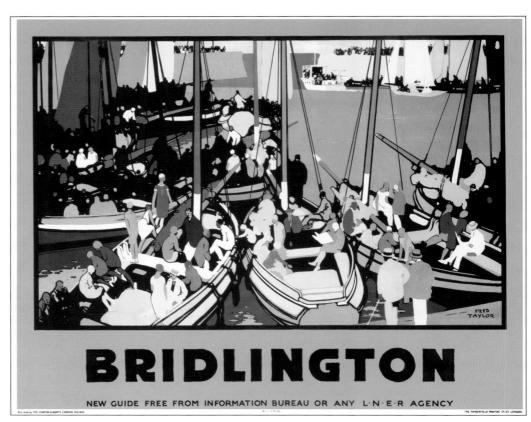

1928 LNER Poster by Fred Taylor (1875-1963)

This is a real Bridlington classic. Painted by the great poster artist Frank Newbould, it shows a smartly dressed couple gazing out to sea, while more elegant people stroll on the promenade below. This period was the heyday of the town, when the more affluent seemed to go to Scarborough; but judging by this painting, equally well-dressed people apparently also went to Bridlington.

Now the long sweep of the bay can be appreciated. The harbour and tourist area is shown by the red houses in the centre of the poster, and beyond is the northerly continuation, ending at Flamborough Head on the horizon. The beach has many changing huts and the whole place appears neat and tidy. It was to stay this way until the 1970s, when like many British seaside towns, the standards slipped and adverse tourist comments were voiced. I am happy to report that this was taken on board by the local council, and today a real effort has been made to bring the town back to former, more affluent times. This poster is well composed and is a real collectors' piece. It does not appear that often in auction, but when it does, bidding is always keen.

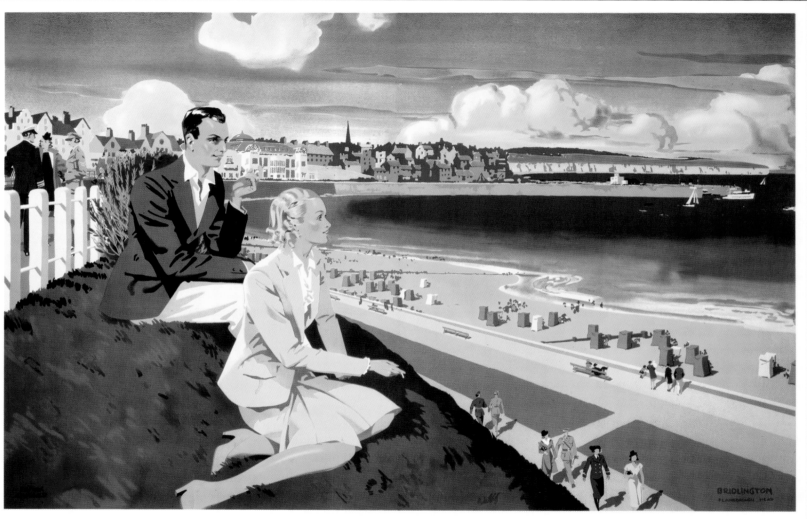

Classical LNER Poster for Bridlington Issued in 1935: Artist Frank Newbould (1887-1950)

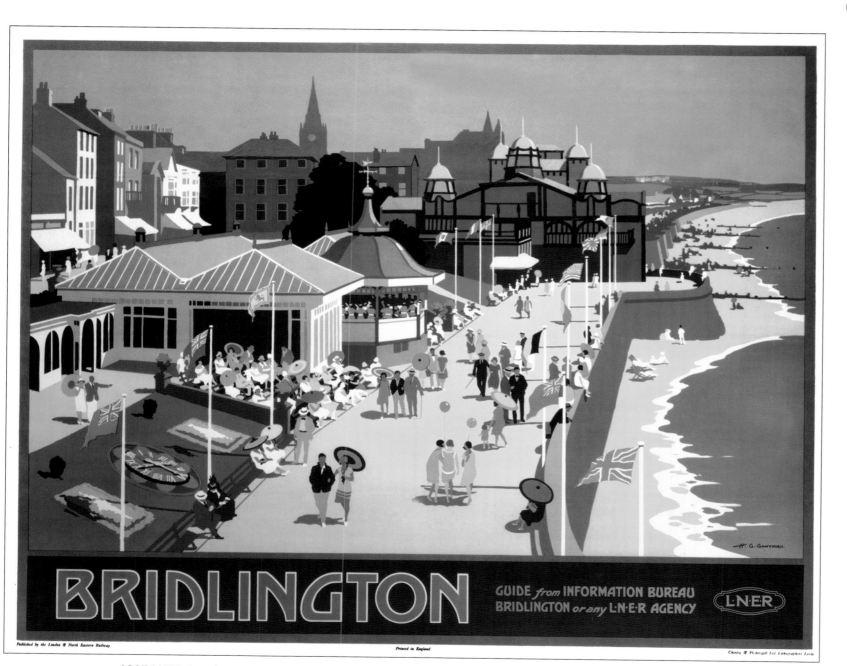

1927 LNER Quad Royal of the Promenade, Bridlington: Artist Henry George Gawthorn (1879-1941)

We see here one of a pair of LNER posters from the wonderful poster artist H.G. Gawthorn (the second is at the end of the chapter). He was active in the first decade of the LNER, and was a favoured artist of William Teasdale (LNER Advertising Manager), though not signed exclusively to the LNER. As a result, he also produced a few posters for the Southern Railway.

This gives us a great insight of the seafront almost a decade after the end of the Great War. The elegance is clear, with manicured gardens, smartly dressed people, ladies carrying umbrellas to guard against the sun and a general impression of well-being and affluence.

Here we are near the Spa Theatre in Central Bridlington. The first theatre here was destroyed in a fire in 1906, and W.S. Walker was commissioned to design the replacement, which opened in 1907. The whole five-acre complex included a bandstand, concert hall, as well as the theatre, and just before this poster appeared the whole complex was given a facelift with an investment of £50,000; a tidy sum in those days.

Anything that the LNER could do when producing exquisite quad royal Bridlington posters, BR showed they could match. This superb piece of art was commissioned in 1949, and appeared as a poster in 1950. The artist Frederick Donald Blake painted many views of the east and north east area, of which this is one. (Others we will see in Volume 4).

He has set up his easel about half a mile south of the harbour, and is looking north-east in this view. As with the poster on page 127, similar features are present, and little seems to have changed for 15 years. The beach is crowded; the blue beach huts are there, even the same fluffy white clouds sit over the white limestone cliffs of Flamborough Head. Newbould's poster had few children: Blake's poster has them everywhere. The summer social mobility had the workers from the industrial centres taking their holidays here and at other resorts all along the Yorkshire Coast. Workers from Manchester went to Blackpool; Yorkshire workers came to the fashionable Yorkshire resorts and throughout the 1950s, times were good. However, tastes were to soon change, and the British tradition of family holidays at Bridlington or Filey slowly fell away, as people went south to the Costa del Sol.

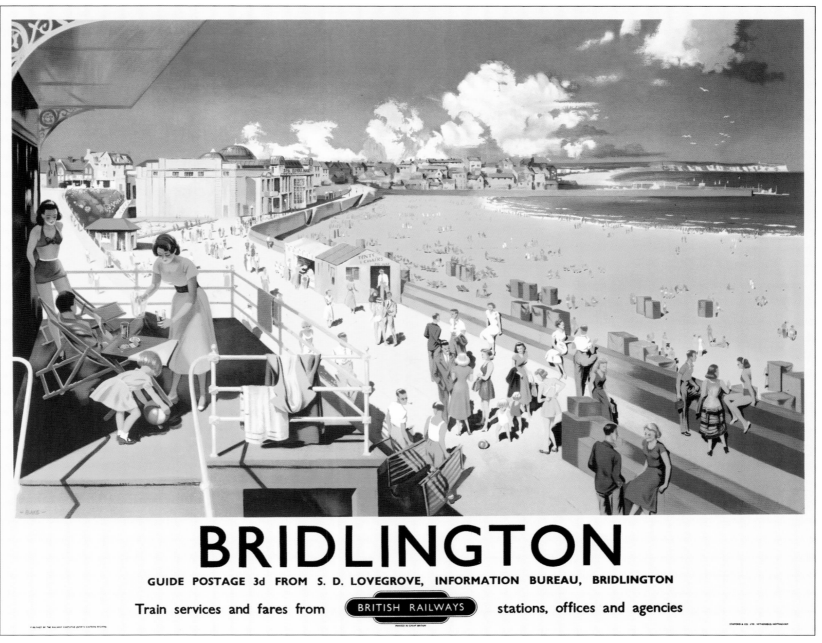

BRIDLINGTON

GUIDE POSTAGE 3d FROM S. D. LOVEGROVE, INFORMATION BUREAU, BRIDLINGTON

Train services and fares from BRITISH RAILWAYS stations, offices and agencies

1950 British Railway Poster for Fashionable Bridlington: Artist Frederick Donald Blake (1908-1997)

Here we have a rarely seen poster. The best tourist promotion for the town was 1925-1935, when many of the really classic posters actually appeared. This one is towards the end of that decade, and it is interesting to compare this poster with Gawthorn's painting of the same area a decade earlier (and shown on page 128).

The sun must have really shone in that era, judging by the number of coloured umbrellas visible. But what is interesting about this poster is the number of people on the promenade to see the passing of the Prince's Parade.

I also noted that the Cross of St. George is proudly flying, along with the Union Jack and other flags. This for me, is one area where we have lost a lot today. The sense of pride in the country then compared to now is quite different. It shows in the artwork of posters and it most certainly shows in behavioural patterns today. This poster and many others in this Volume show the English seaside at its best.

Clearly seen is the new 'art deco' design of the Grand Pavilion. This theatre, which was refurbished in 1926, burned down in 1932. It was hastily rebuilt in 'double-quick' time by the design shown here.

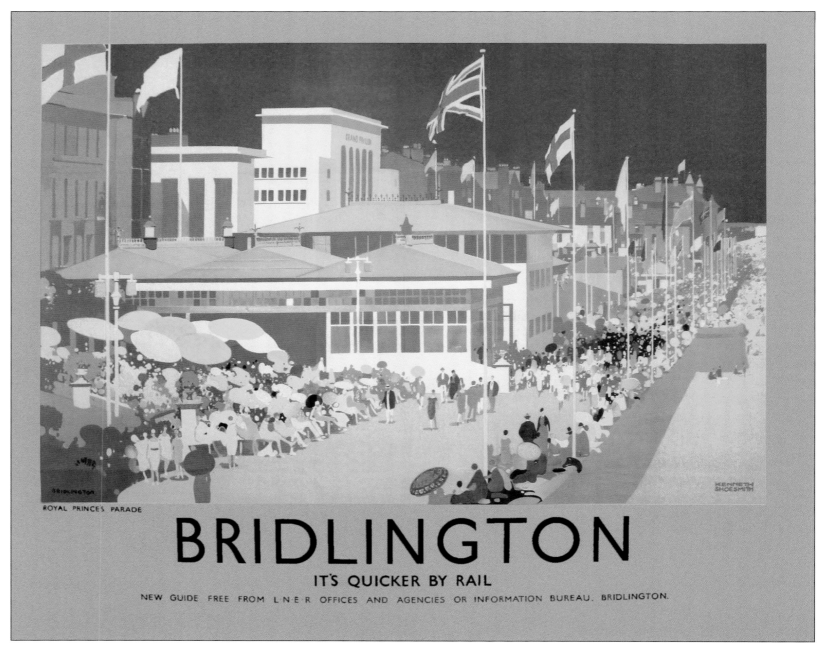

1936 LNER Poster Issue of the Princes Parade, Bridlington: Artist Kenneth Denton Shoesmith (1890-1939)

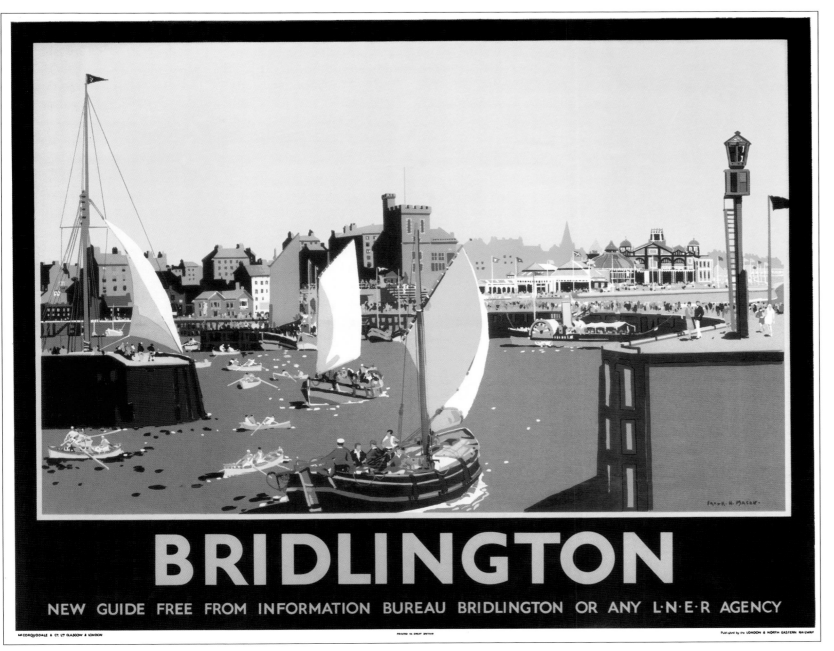

1930s LNER Poster of the Harbour at Bridlington: Artist Frank Henry Mason (1875-1965)

For me this is a superb poster. Anything where blocks of colour replace the detail shows commercial art at its best. Here traditional blue skies and clouds are replaced by a yellow dustsheet, and this sets the red and pink buildings off quite beautifully. The artist is Frank Mason, who has broken with his traditional detail here (as in his Scarborough poster on page 96), to produce an unusual image. We have moved north along the parade and onto the harbour breakwater, to then look back towards the theatre complex, with the flags still flying.

Interest is brought to the foreground by Yorkshire cobles plying to and fro through the harbour entrance. Notice how the white sail is set against the dark block of the building in shadow, to give prominence to the smaller boat and a deeper sense of perspective. Mason has not put any detail in the waves or sea as he normally does. This is a real artist's eye at work.

Records are unclear as to exactly when this was produced. Some say 1936, but from the style, the lettering and the lack of LNER logos, I am more inclined to think this is earlier, maybe 1930-1931. I therefore leave it as early 1930s.

1935 LNER Poster Showing Social Bridlington: Artist Fred Taylor (1875-1963)

This next group of posters focuses on people, fashions and socializing. Sparkling seas and golden sands are the reasons why the resort has always drawn thousands of visitors. This is as true today as it was in the mid-19th century, when the railways truly transformed the town. But to say that this is the only reason for socializing in the town would not do it justice. Old Bridlington is steeped in history, but this has not appeared on any posters, so the impression of the town is of a family resort, with all its attractions – and that is it. These next few posters add to the 'beach-style' reputation, but if you do visit the town, go to the old part to the north, and you will be in a different world.

The original village is inland and was clustered in the form of a series of narrow streets around the Augustinian Priory, founded in 1113. This was a wealthy priory and naturally attracted a lot of attention from outside. One of the former priors (John of Thwing) was canonised, and his shrine became a place of pilgrimage. After the English victory at Agincourt, Henry V came here to pray and give thanks. At that time Bridlington was held in high reverence.

Along came Henry VIII, took all the treasures and destroyed the Shrine and much of the priory. Only the Nave survives, and today this is the Parish Church of St. Mary. The Priory gatehouse also survived, and today we can enter the Bayle Gate (which dates from 1388), and see the historic side of Bridlington. Contrast the two images here with the narrow and curved High Street. Here the tourist will find 17th and 18th century bow-fronted buildings leading into the spacious 13th century Market Place, where the Priory used to hold its weekly sales; and where the village fair would have been held.

St. Mary's church has one of the finest concert organs in the world, and is larger than many cathedral organs. As I love to hear JS Bach (BWV 582) played on a full cathedral organ, Bridlington for me is far more than the tourist side alone would suggest.

Fred Taylor's poster opposite and the Septimus Scott poster here are LNER's vision of social Bridlington. The railways were into mass transportation, and always wanted to show the glamorous and not necessarily the historic side of this Yorkshire town. Other cities such as York, Edinburgh, Chester or London had the reverse policy, so there history prevailed.

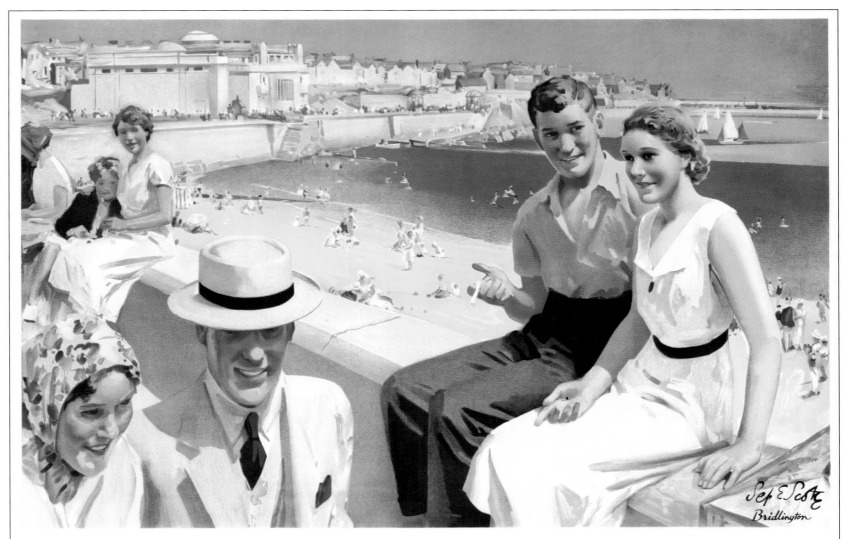

Famous 1935 LNER Poster by Septimus Edwin Scott (1879-1962)

In the 50 years after the building of the railways, the population more than doubled, as the historical side was overwhelmed by the *'having a good time'* side. People came from all parts of Yorkshire, as these two posters show. One of the earliest visitors to the resort by rail was Charlotte Bronte, making her first ever visit to the seaside, aged 23. The first of the seawalls was constructed in the 1860s, northwards from the small fishing harbour, and around the same time, the ornate (but now demolished) Alexandra Hotel was also built. The first parade with gardens was laid out, and ten years later, the seafront 'stuccoed' terraces were finished. By the end of the 19th century, all the seawalls, the Spa complex and the 'posing promenades' were ready, and 'Social Bridlington' was on the map. Now the railway advertising could really begin. The classic posters already presented are supplemented here by a British Railways and a lively LNER poster that mimics the scene from a railway carriage. Of course the station was not alongside the beach, but the intent is clear.

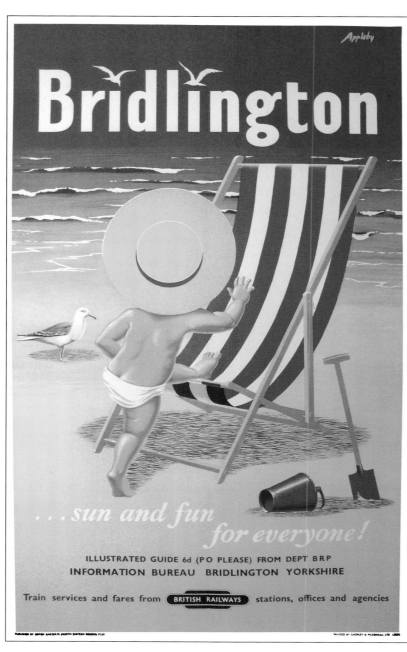

1964 British Railways (NER) Poster: Artist signed as Appleby

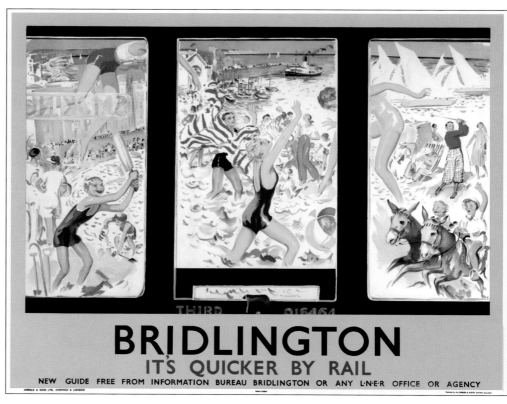

Mid 1930s LNER Poster by Thomas Cantrell Dugdale (1880-1952)

Once the seafront development was complete, scenes like this were commonplace, though maybe looking at the characters depicted here, it is more at home in a comic. Here we have the bearded fisherman, stylish dressers, a naval officer looking for his ship, the little girl and her dog who should be on the beach, and a young man racing to sail his model yacht. The Spa complex with its glass dome is on the far side of the harbour.

This has recently undergone yet another multi-million pound refurbishment, and contains all the state-of-the art facilities necessary to meet the entertainment needs of a more astute public. The Royal Hall is exquisitely adorned in 1930s 'art deco' style, and is capable of holding up to 3,500 people, so that concerts, plays, sports, dancing and exhibitions are now easily catered for.

Today, modern shops and attractions co-exist happily with the treasures of the past – there is literally something here for everybody - and is why the town won *'Visitor Destination of the Year'* in Yorkshire's 2007 Tourist Board award scheme.

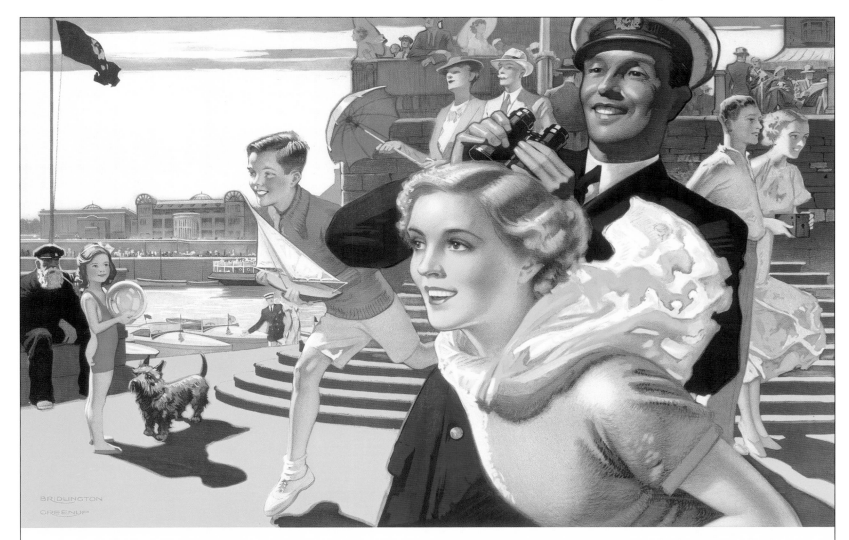

1936 LNER Quad Royal: Lively Bridlington by Artist Joseph Greenup (1891-1946)

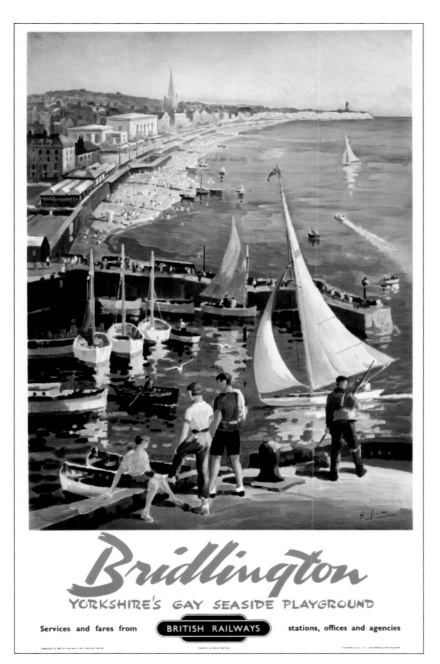

Great Caption on 1958 BR Poster: Artist George Ayling (1887-1960)

Messing About With Boats

This next group of posters sees us in the harbour area of the town. As our first poster, issued in 1958 from artist George Ayling shows, the harbour is at the southern end of the beach. This also has a caption, which at the time the poster was painted had a quite different meaning. Today, it is highly unlikely that a railway poster would carry such a slogan even at the risk of me being politically incorrect. However, the poster rises above all this PC stuff, and gives a wonderful panorama of Bridlington, with Flamborough Head in the distance. The poster shows many boats, both around the harbour and along the coast. Contrast this with the LNER poster by John Littlejohns from a generation before. We have changed position and stand behind visitors taking in the business of the harbour in the late afternoon. The large pleasure boat shown arriving was a Bridlington landmark, as the next two posters also show. The colour contrast between the two works is striking.

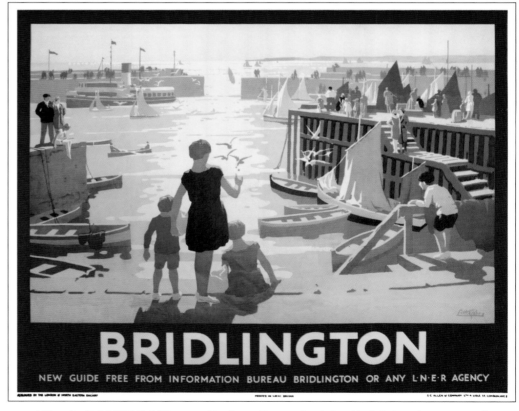

Wonderful 1930 Bridlington Harbour Poster by John Littlejohns (1874-19xx)

The contrast between the previous two posters is repeated with our next two. Again, one is pure LNER, and the double royal is far more vibrant and colourful BR. Our pleasure boat is now moored against the quay and excited day-trippers are watching or embarking for a trip. We can only imagine what the two old fishermen are saying as they put the world to rights. What is striking about this rather unusual Newbould poster is how the colour of the rather prominent funnel is repeated in the large resort lettering. The artist's position is also unusual, with the foreground harbour wall more of a focus then the myriad of town roofs beyond. Considering Newbould normal style, this poster is unusual, but it is rare.

The Wootton poster alongside was one of many he painted for various parts of British Railways in the 1950s. His work is being re-evaluated and more appreciated today. The scene is full of movement and colour, but I perceive the sea to be rather viscous and oily!

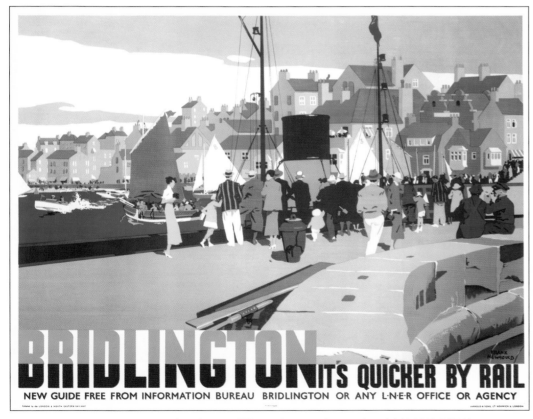

1935 LNER Poster by the Prolific Artist Frank Newbould (1887-1950)

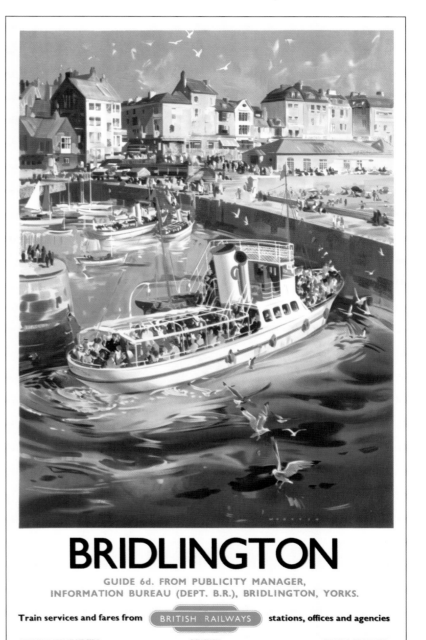

1953 BR Poster of Bridlington Harbour: Artist Frank Wootton (1914-1998)

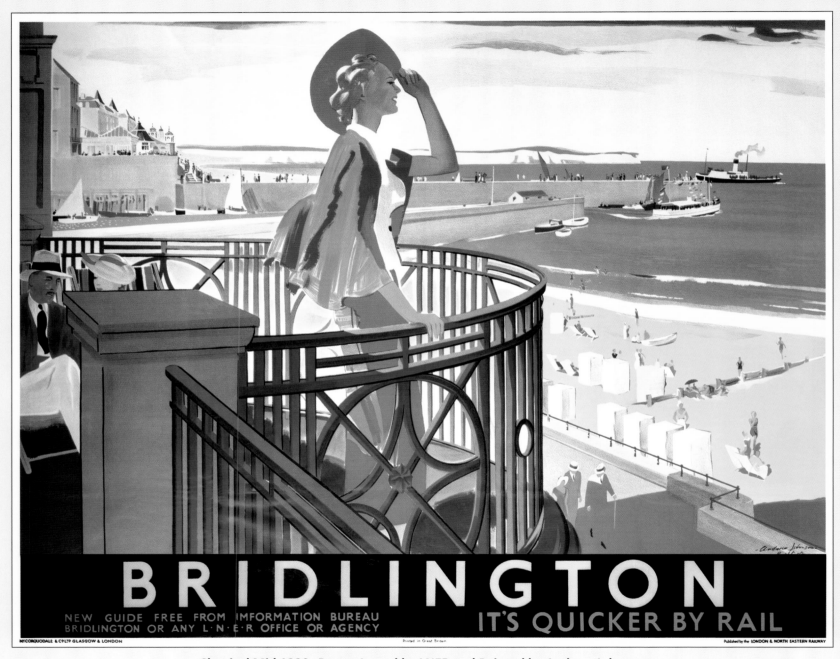

Classical Mid 1930s Poster Issued by LNER and Painted by Andrew Johnson

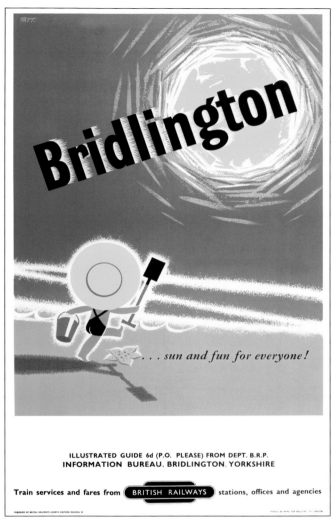

1957 BR Poster by Artist 'Tatt'

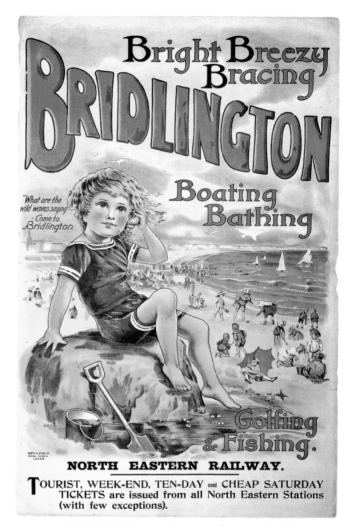

1913 NER Poster by an Unknown Artist

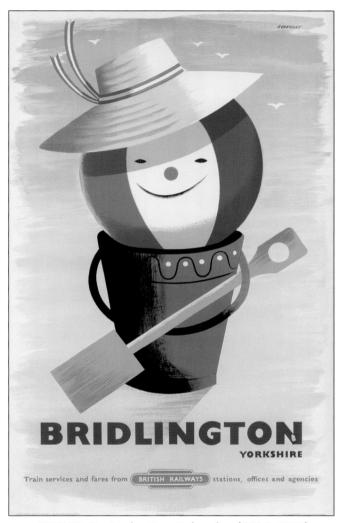

1955 BR Poster by Tom Eckersley (1914-1996)

Here we have three posters of real contrast that span over 40 years. In the centre is a vintage Edwardian example that set the scene for many that followed. For its time this was cutting-edge and is a poster that rarely surfaces. Above, is a typical 'Agency' type piece of artwork that is more art-deco than late 1950s. It carries a simple but effective message, the essence of a commercial poster.

Over to the right is a really eye-catching poster by the great commercial artist Tom Eckersley. He (like his Christian namesake Tom Purvis many years before) had a great talent for putting a commercial message down on canvas simply and colourfully. This is one of the most iconic posters that BR produced for any of the Yorkshire resorts in the 1950s, and it too is rarely seen today.

I finish our Bridlington sojourns with a stunner. The next page sees the second of the Bridlington pair by Henry Gawthorn in the mid-1920s. Just admire his composition, colour choices, style and movement in this super poster: it actually ranks in my top ten of all time. There is interest and vibrancy everywhere: when seeing this on your station, who wouldn't wish to visit such a trendy place?

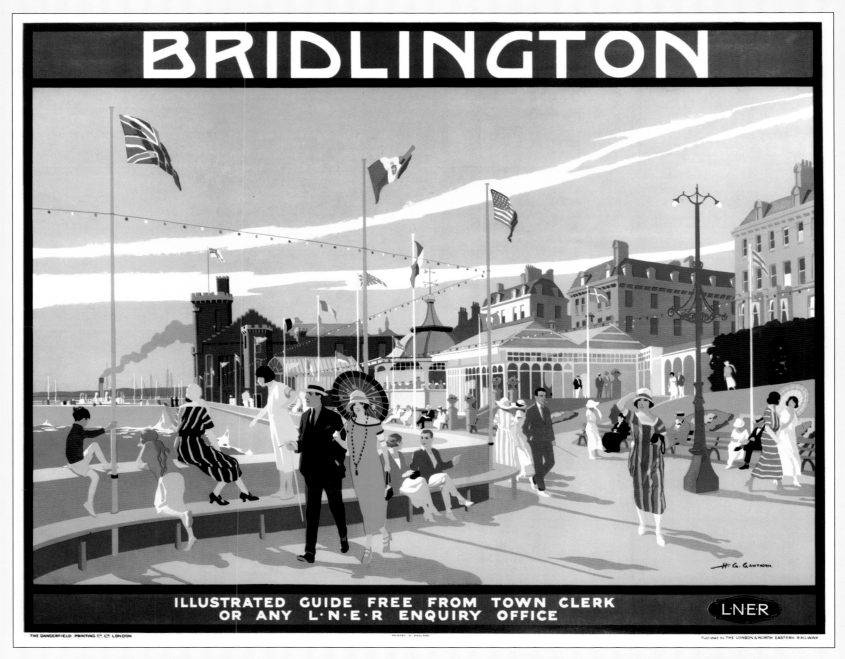

A Truly Fabulous Piece of Railway Art: The Elegance of Bridlington in 1927: Artist Henry George Gawthorn (1879-1941)

Chapter 6 Touring Eastern Yorkshire

Bridlington Bay – Hornsea – Hull – Goole – Doncaster

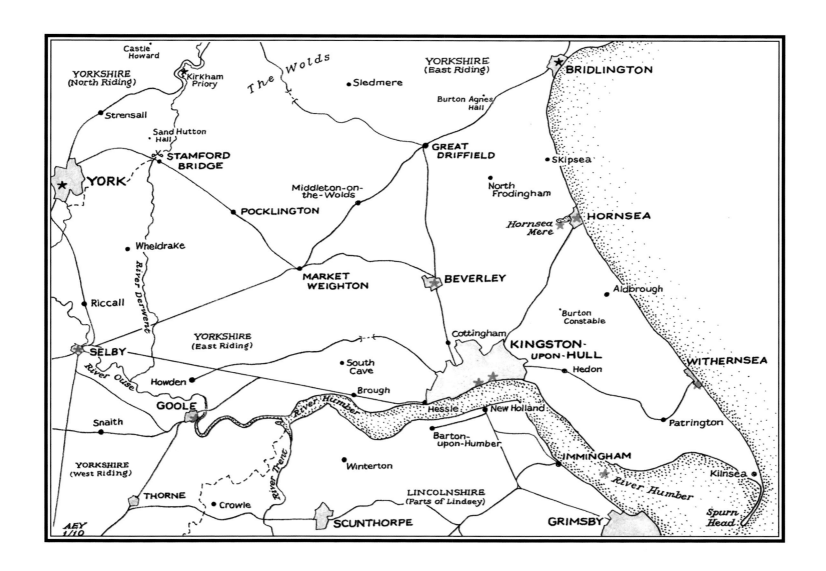

Chapter 6 Touring Eastern Yorkshire

Towards the Magnificent Gothic Parish Church

Bridlington is the last of the large seaside towns north of the Humber. Since leaving Redcar we have never been far away from rocky cliffs and spectacular panoramic views. All this changes as the long sweep of Bridlington Bay, composed of sandy beaches and clay 'cliffs', takes us almost 40 miles (65 km) down to Spurn Head. These 'cliffs' are mere mounds of soft brown boulder clay deposited here towards the end of the last period of glaciation, and naturally do not offer much resistance to the lashings of the North Sea tides twice a day. The whole coastline is unstable, and some areas are lost to the sea at the rate of more than four to five feet (around 1.5m) per year. This equates to the sea moving almost two million tonnes of material a year! History shows us many settlements and villages that have been lost. Villages such as Ravenser, which sent representatives to the parliament of Edward I, have totally disappeared: the Holderness coastline has moved about three miles (five kms) since Roman times. The whole coastline is rather unremarkable, but trying to walk the coastal route means the intrepid walker has punctuations in his journey to wait for the tide to ebb. There are two smaller resorts, Hornsea and Withernsea along this coast, but getting to them by train was never easy. Nature saw to it that trains were kept away from the sea here, and instead the two resorts were at the end of separate branch lines from Hull. (Both branches are now closed). Our train journey takes us from Bridlington towards Driffield, and then south through Beverley. Here is the magnificent Gothic Minster, built over two centuries and depicted in a carriage print that shows the sumptuous exterior, and one poster showing us a portion of the majestic interior.

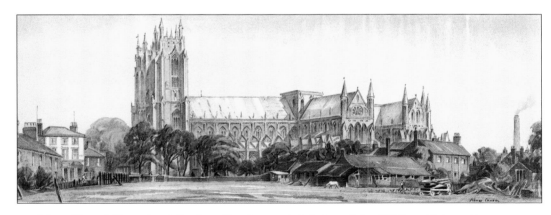

Magnificent Beverley Minster: Carriage print Artwork by William Sidney Causer

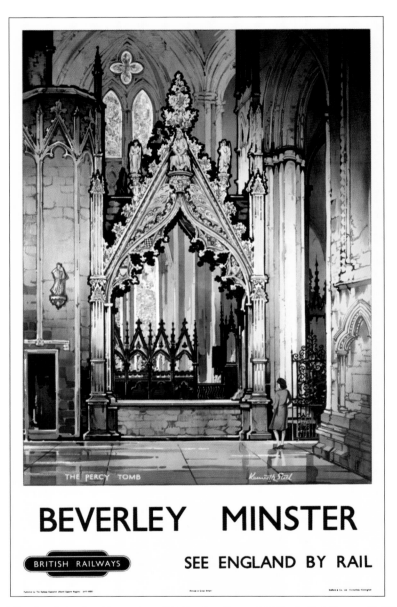

The Minster Interior Beverley; BR Poster from 1960: Artist Kenneth Steel

Architecturally speaking, it is generally regarded as the most impressive church in England that is not a cathedral. Originally a collegiate church, it was not selected as a bishop's seat during the Dissolution of the Monasteries, so today it is actually the Parish Church of St. John and St. Martin. The building we see today was begun in 1220 and completed around 1430. It is a supreme example of the Perpendicular style. It contains elements of three Gothic styles - Early English, Decorated and Perpendicular, all combined into a harmonious whole. It is the superb internal vaulting that ties everything together so beautifully. The Minster is 333 feet (102m) in length; larger than a number of English cathedrals. The Nave is from the Decorated Period and the main Transept is Early English.

The West Front, with the superb twin towers, is pure Perpendicular, and this alone is worth the detour from the train. What is surprising is that with so many railway posters of churches and cathedrals, this did not fare so well in the tourism stakes. The interior has columns of Purbeck marble, some wonderful stone carving and the elaborate tomb of Lady Eleanor Percy, with its richly decorated canopy. No wonder it was chosen by Steel for his poster; it is almost certainly the finest surviving example of Gothic Art that we have. It is the work of five skilled masons and took almost nine years to complete. The tomb bears the arms of Edward III, which includes the fleur-de-lys, adopted after 1340. Until 1820 a tomb chest rested on the ledge beneath the canopy. It escaped the destruction which took place after the Reformation (and by the Puritans in the 17th century), and remains almost intact. Today we can admire its intricacy and beauty.

Beverley itself is over 1300 years old, and was once the 10th largest town in England. It also used to be among the richest in the land. The railway arrived here in 1846 and enabled people to visit the numerous religious buildings in the town. But it is time to catch our train for the short nine-mile (15 km) journey into Hull.

South to the Fishing City

Hull is by far the most important conurbation in East Yorkshire and has the distinction in railway terms of having three termini and numerous other stations within its boundaries. The main station has gone through some interesting times. The original three-bay trainshed was enlarged by the NER into a grand five-bay structure, creating the last of Britain's great barrel-vaulted glass and iron railway stations. This is easy to find in Percy Home's poster alongside. There are also other railways lines running all round Hull to serve all the industry and the city docks. It is to the docks on the north side of the Humber that we next travel.

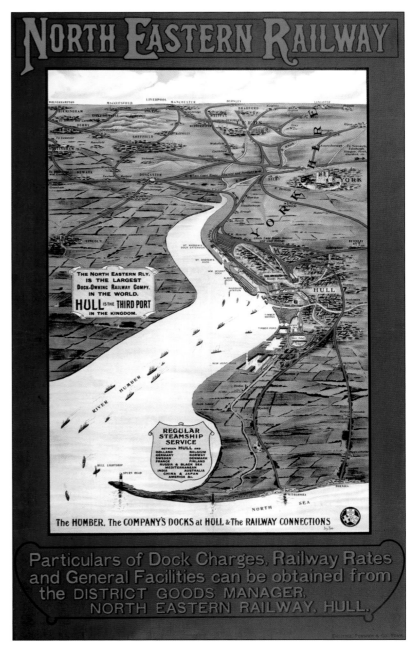

1910 NER Poster of the Environs of the Humber: Artist Percy Home

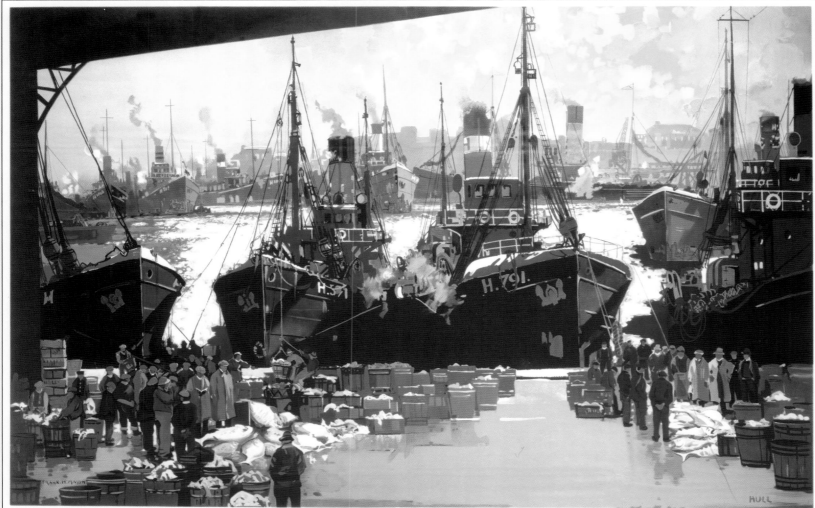

ST. ANDREW'S FISH DOCK, HULL

EAST COAST INDUSTRIES
SERVED BY THE L·N·E·R

PUBLISHED BY THE LONDON & NORTH EASTERN RAILWAY

PRINTED IN GREAT BRITAIN

HAYCOCK PRESS, LONDON

Magnificent 1938 LNER Industrial Poster of a By-Gone Era: Artist Frank Henry Mason (1875-1965)

Many people do not care for industrial-type posters, but coming from an engineering background, I find them truly fascinating. During the past 25 years, we have lost a way of life that many today admire. These were the days when the UK lived from its own hard work, and our industries were home-based and goods home-made. Sadly today, we have little of this left. This wonderful poster of the St. Andrews Dock in Hull shows a scene full of vim and vitality, as trawlers unload their catches in wooden crates, watched by many buyers eager to obtain the best fish.

Just look at the number of boats in the docks, and the early morning sun setting the sky to gold. St. Andrew's Dock was originally designed for the coal trade, but when opened in 1883, it was earmarked solely for the fishing industry. Steam-powered trawlers had appeared, together with full rail connections, before the main dock extension was built in 1897. By the 1930s, road transport was challenging rail, and the last fish train ran in 1965.

The last boom period in the industry was in the early 1970s, but by this time the fish market buildings were in need of repair. With the expansion of the freezer trawler fleet, it was decided to move the fish docks to new buildings at Albert Dock in 1975, and St. Andrew's Dock was closed.

The Docks at Hull have always been a significant employer and a mainstay of the local economy. Through the years, the various railway companies developed sizeable fleets and in 1935, five of them were combined to form the Associated Humber Lines Ltd. Their function was originally as managers, not owners, but this changed in the late 1950s. They ceased their own operations in 1971 but continued as managers for another decade. Once formed, this company produced a lot of railway posters using both well-known and lesser-known artists. Below we have one of Montague Black's wonderful aerial maps showing the route operated out of Hull. The poster alongside is one of a series showing dock activity, but also route information. Hull docks possessed a well integrated series of railway quays and freight handling equipment; exactly what would have been expected of a shipping line with a railway heritage. Rather interestingly however, there is no BR Totem logo on this poster, even though it was issued by the British Transport Commission. The artwork, however, is exquisite for such a poster.

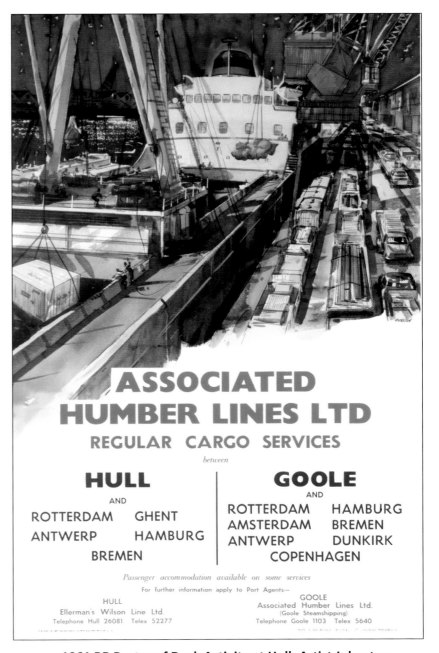

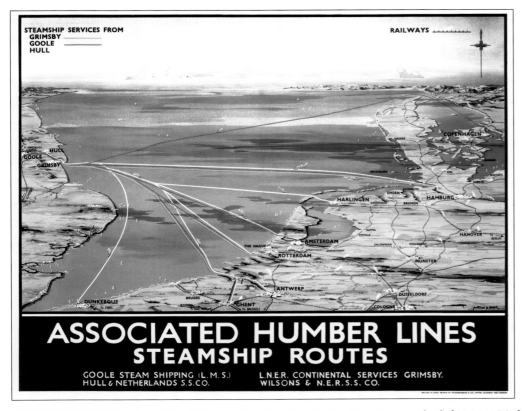

1936 LNER/LMS Poster of Hull Steamship Routes: Artist Montague Black (1884-1961)

1961 BR Poster of Dock Activity at Hull: Artist Johnston

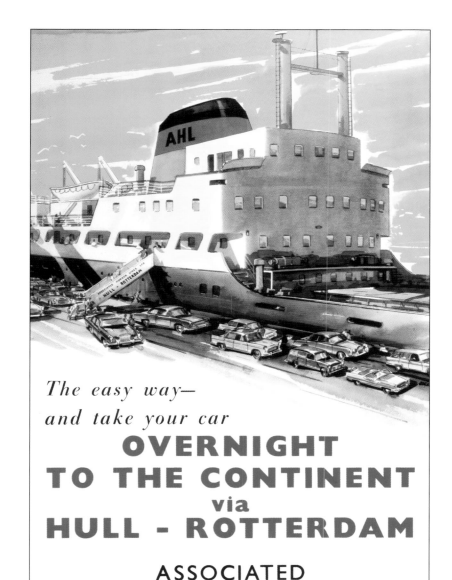

1961 BR Poster of the Overnight Car Ferry from Hull: Artist Johnston

This second poster from the artist simply signed as 'Johnston' (we know nothing more about him at this stage), shows either *MV Bolton Abbey* or *MV Melrose Abbey,* both built in 1958. This poster again appeared in 1961, so either vessel was a little over two years old. The 'two abbeys' were sister ships of 2740 tonnes each, and were capable of carrying cars and 88 passengers, plying the Hull-Rotterdam route as the poster shows.

The funnel depicted here shows the heritage of Associated Humber Lines (AHL). These were the company colours of the Goole Steamship Company founded in 1846. It was taken over by the Lancashire and Yorkshire Railway (LYR) in 1905, but the company identity was retained. Even when the LYR was itself absorbed into the LMS in 1923, the same identity was retained. Humber shipping interests of the LMS and London & North Eastern Railway (LNER) were combined into the Associated Humber Lines (AHL) in 1935, although individual companies retained their titles. Also included in the merger were The Goole Steam Shipping Company, The Hull and Netherlands Steam Ship Company and Wilson's & NER Shipping Company (The Wilson Line). The combined fleet was considerable and for many years held a very strong position for cross-North Sea services to Holland, Germany, France and Denmark. As well as operating out of Hull, ferries ran from both Goole and Grimsby.

The Hull & Netherlands Steam Ship Company was formed in 1894 to run services between Hull and Dutch ports. In 1908 they were taken over by the North Eastern Railway (NER). NER became part of the London & North Eastern Railway in 1923. Shipping interests were managed by Associated Humber Lines in 1935. The Goole Shipping Company operated routes from the Humber ports of Goole, Hull and Grimsby to a wide range of European destinations including Amsterdam, Antwerp, Dunkirk, Gent, Zeebrugge, Vlissingen, Hamburg and Rotterdam. They mainly operated small cargo/passenger steamers, but in 1906, the LYR started a summer service from Hull to Zeebrugge with the Fleetwood steamer *Duke of Clarence*.

It can be seen from this short potted history that the railways of the time were already starting to think about an integrated transport system. History shows the LNER carried fewer passengers but more freight than the LMS-based shipping interests, so when amalgamation occurred, the newly formed AHL was strong with a good customer base. Some of their ships were old but slowly these were replaced. When in 1948 British Railways was formed, the shipping interests fell under the auspices of the British Transport Commission, who also inherited hotels, docks and inland waterways, plus road haulage services. AHL eventually became part of the Road Haulage Executive (curious decision) and in the mid 50s began ordering their own ships to serve on several routes.

This poster shows three of the 12 ships that used to sail from the Humber ports. At the bottom we have *MV Fountains Abbey*, in the centre is *Whitby Abbey* but at the top one is of the trio of ships named after Yorkshire cities (the *Wakefield*, *Leeds* or the *York* dating from 1958/9 – Rodmell chose the *Wakefield*.). However it was two other vessels that became celebrities. These were *Byland* and *Kirkham Abbey*, built in 1956 to replace the aging Goole ships. They were of 1,372 gross tonnes each and sailed the Goole-Copenhagen route. Each vessel had refrigerated holds enabling butter, bacon and eggs to be shipped from Denmark (on the Humber they became the "butter boats"). Notice again that there is no reference to British Railways, even though this was the issuing authority, and here we now have reference to Ellerman's Wilson Line. The Wilson's and North Eastern Railway Shipping Co was formed in 1906 to operate services to Hamburg, Antwerp, Ghent and Dunkirk. In 1916 the Wilson Line was bought, and became Ellerman's Wilson Line Ltd in 1917. In 1973 all Wilson Line services, except the North Sea services, were merged into Ellerman Liners: by 1978, Wilson ships were gone.

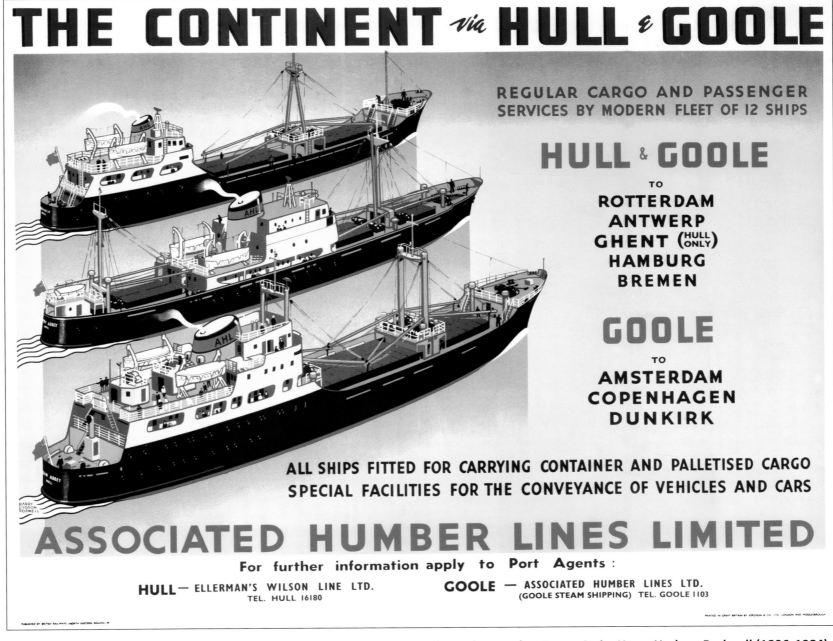

1960 AHL/BR (NER) Quad Royal Poster Showing the Main Fleet Sailing from the Humber Ports: Artist Harry Hudson Rodmell (1896-1984)

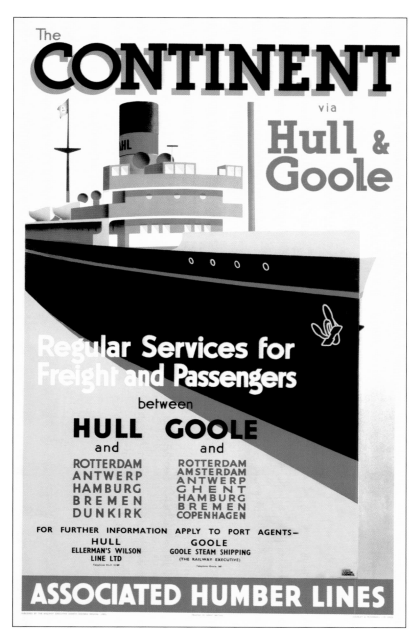

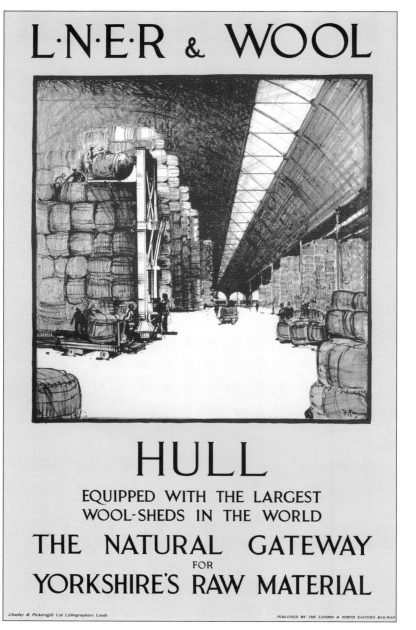

Poster from 1952 by Harry H. Rodmell (left) & a 1930s Lithographic Poster by Frank Henry Mason (right): Both Advertising the Port of Hull

During the late 12th century, the monks of Meaux needed a port to export wool from their estates. They chose a spot at the junction of the rivers Hull and Humber to build a shipping quay which they called Wyke on Hull. In the late 13th century, when Edward I looked for a port in the north-east of England, he acquired Hull and promptly renamed it as Kingston (King's Town) on Hull.

With the advance of the railways linking Hull with Selby and Leeds, more trade came to the port and, again, it was decided another dock was needed and extensions opened in 1846. The railways were able to link the wool mills of West Yorkshire directly to the ships, to help export the goods. Hull developed links with many parts of the world, and not just the traditional Scandinavian, German and Benelux connections.

Victoria Dock was next to be built; the first one to the east of the River Hull. It opened on 3rd July 1850. The original entrance was from the River Hull via lock-pits, but later an extension called the 'Half-tide Basin' was constructed on the south side of the dock, with a 60 foot (19m) entrance from the Humber. In 1964 the entrance to the Victoria Dock from the River Hull was closed and remodelled. The dock was finally closed in February 1970.

By 1860, more space was needed and the Albert & William Wright Docks were constructed on the western bank of the Humber. St. Andrews Dock followed in 1883, and the operations of the fishing fleet were transferred completely to this dock. The Albert and William Wright Docks were joined together in 1910. In the late 1950s, Albert Dock was redeveloped, and by 1959, half of the south side had been reconstructed.

In October 1972 the docks were closed to commercial traffic. Due to the changing needs of the fishing industry, they were refurbished, and in November 1975, transferred back to the Fishing Industry.

Many goods came through the port, but historically wool was regarded as the premier product. When the Yorkshire wool industry declined, wool was imported from Australia and New Zealand. The facilities at Hull for this commodity were excellent, as shown in the poster alongside (left). The poster shown on this page advertises Hull as Britain's cheapest port and to this day it still retains its important position in the UK's infrastructure. None of the posters shown on these two pages are that common, but this vibrant image documents dock developments well.

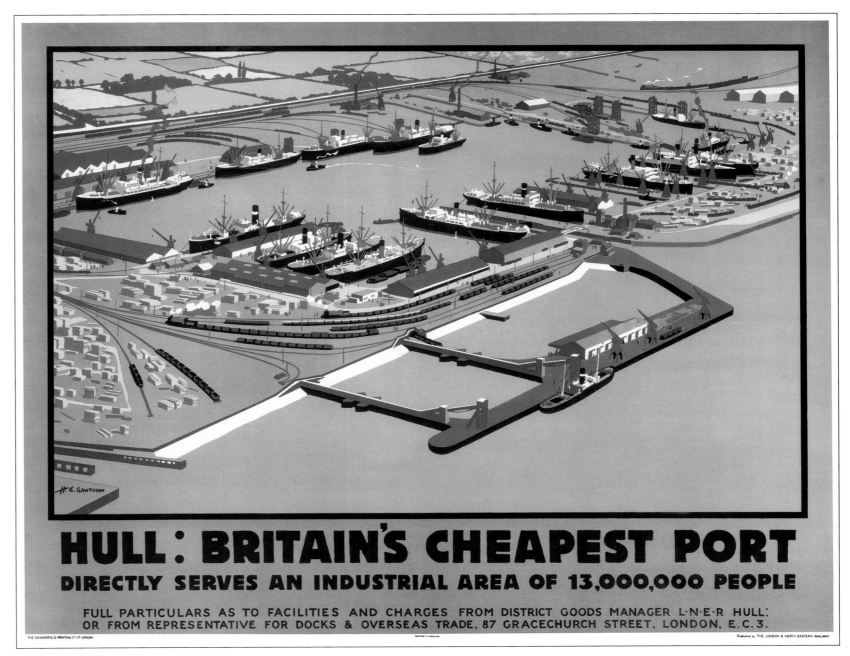

1929 Aerial Poster View of the Main Docks at Hull: Artist Henry George Gawthorn (1879-1941)

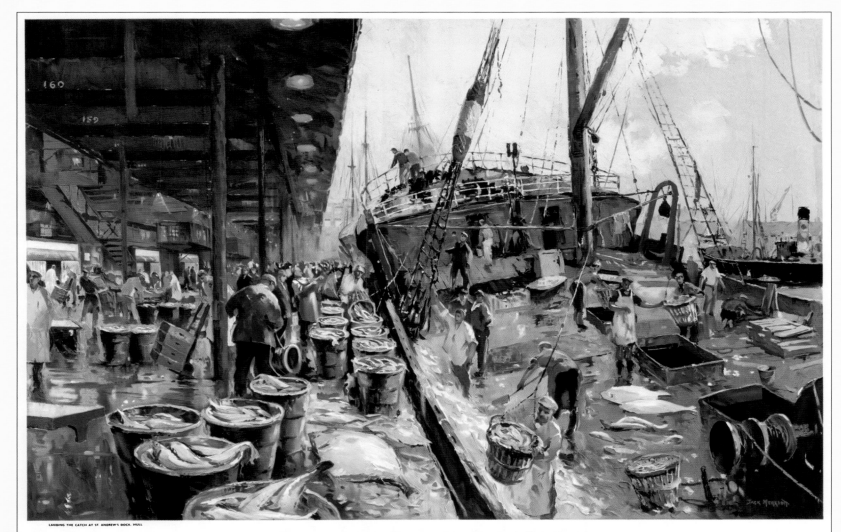

1950s BR Poster of St. Andrews Fishing Dock Hull: Artist Jack Merriott (1901-1968)

Today, St. Andrews Dock is now the site of a multi-million pound development, but in former times it was a hive of activity, and the home of the Hull fishing fleet. At the end of the 19th century there were more than 6,000 trawler visits per year, as the dock became one of the major landing sites for North Sea fish. Jack Merriott's early 1950s painting of the landing of the catch shows what it must have been like.

Contrast this painting with Frank Mason's on page 143. Here, the noise, the activity and the atmosphere of the period is more evident, and Merriott chose to showcase the catch, rather than the whole scene. It was a bustling place, with the UK's busiest telegraph office, large repair shops, fishing support services, massive cranes and extensive railway sidings, all to help speed the many catches on their way to markets all over Britain.

The decline of fishing stocks, beginning around this time, signalled huge changes for Hull. Years of over-fishing eventually caused the docks to close and move to a smaller facility. When built in 1883, it cost over £400,000 but on closing, to develop the new St. Andrews Quay leisure complex, many times this figure was needed to revitalise the area.

Entrance to Victoria Dock, Hull: Artist Edgar Thomas Holding (1876-1952)

The role of Hull docks has changed in recent years. It is now used by more than one million passengers per year and more than ten million tonnes of cargo enters and leaves the port. There is now a 10,000 sq m (40,000 sq ft) all weather freight terminal that handles dry bulk materials (fertilizers, cement, cocoa and grain), paper products, large quantities of timber and steel. The Queen Elizabeth Docks are home to the container traffic, with over 250,000 containers coming in and out of the port each year. All this is a far cry from the serenity shown in Holding's carriage print artwork above of the Victoria Dock entrance in the 1940s. But enough of docks and industry: it is time to leave for the coast again.

Off to the East Coast Again

Two short branch lines ran north-east and east out of Hull to take us to the twin seaside towns of Hornsea and Withernsea. These developed as the places to relax, once the railway arrived in 1854 at Withernsea (and ten years later at Hornsea). When Dr. Beeching came on the scene to study the financial plight of our railways, these two lines felt the axe, and both closed in 1964. Considering the relative size of both these resorts, a surprising number of railway posters were produced. Our first poster here shows the excitement as two young children and their mother approach the town in the 1930s. The station was not planned to run right to the coast (because of the boggy ground), but this decision was reversed and facilities were built at double the original estimate, as piling supported the station and the trackbed. Commercially, the route was never a success, and within 20 years had been taken over by the NER and then by the LNER in 1923.

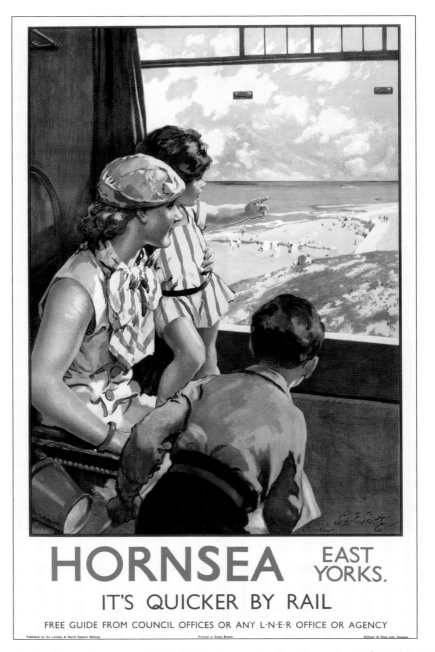

Our Arrival into Hornsea: LNER 1930s Poster by Septimus Scott (1879-1962)

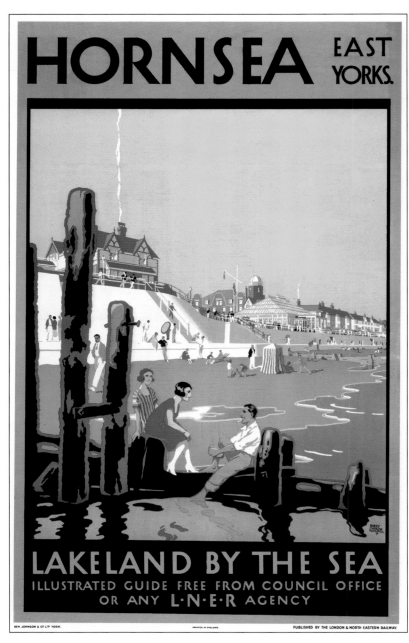
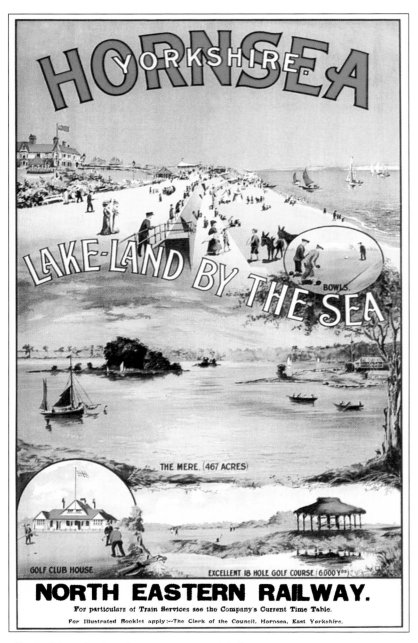

Once we left Hull, the old railway line used to run in virtually a straight line north-eastwards to the coast. From the air, the flat Wolds of East Yorkshire are a patchwork of fields, and the railway journey was swift. When the Hornsea 'day-tripper' appeared, tourists soon replaced smugglers as the most popular visitors. The colourful quintet of posters that follow shows that the railways advertised the resort from Edwardian times. However, British Railways sadly neglected to feature this attractive resort in any of its advertising campaigns.

It has always been advertised as 'Lakeland by the Sea', due to the large lake (Hornsea Mere) just inland from the coast. We would have passed this on our left during the train journey from Hull. It is the largest freshwater lake in Yorkshire, covering an area of around 470 acres (1.9 km^2). It is, however, relatively shallow (around 12 ft deep (3.7m)) and is ideal for boating, rowing and fishing. It is also a Special Protection Area (due to its shallowness that results in a diverse range of swamp and fen plants.) It hosts many species of birds throughout the year, and is of international importance for migrating birds. Today, any 'twitchers' have to visit by car or bus.

Hornsea Posters from 1926 (Harry Rodmell – Left) and 1911 (C.W. Loten – Right)

The Mere was formed at the end of our last ice age. The Loten poster from 1911 shows clearly how this area was marketed by the NER to bolster the tourist trade. It is also the only poster featured here that shows the main seafront panorama. The Rodmell poster opposite and the two shown on this page really do not do justice to the resort, though our obligatory seaside dogs are still there! However, when displayed together, as here, the colours are complimentary and the quartet makes a nice display.

The seafront today is a wonderful place to visit in the winter, when winds roar on from the north-east and the many groynes and breakwaters take a real 'bashing'. The resort also sees walkers throughout the year, as the seafront is home to a marker for the end of the Trans-Pennine Walk. The last section of this uses the now-defunct trackbed that thousands of holidaymakers travelled on in former times. As with many seaside towns in Great Britain, time has brought some decay, but it was never always so, as the 20s and 30s saw the hey-day for visitors as the next poster shows. Here elegance is displayed on a poster that is rarely seen. This image has been heavily restored to show its real beauty to befit that 'golden' time.

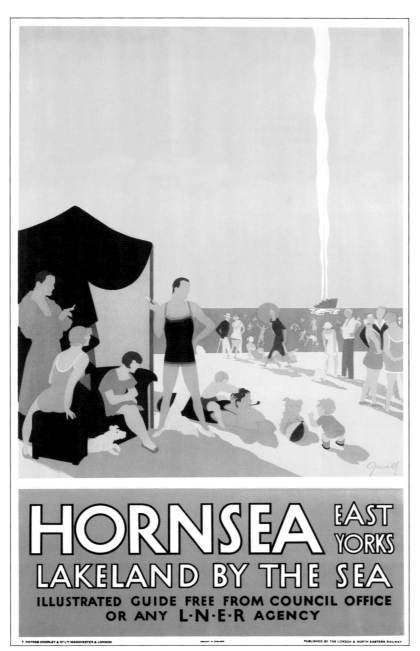

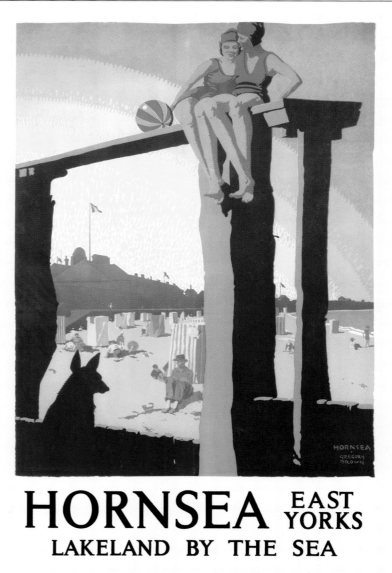

LNER Posters for Hornsea from 1923 (Freiwirth – Left) and the Early 1920s (F. Gregory Brown – Right)

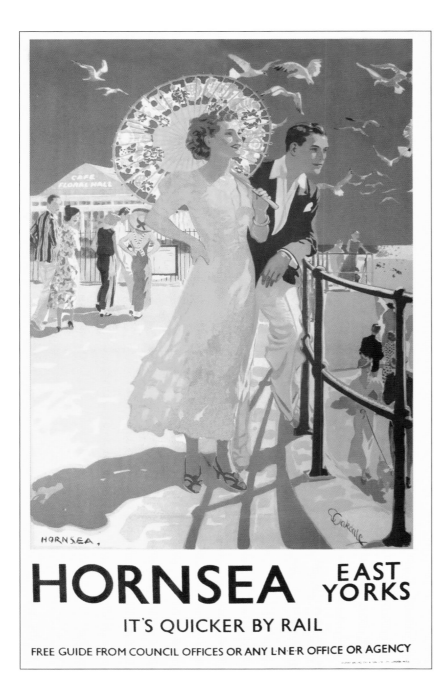

Mid 1930s Elegance in Hornsea: Artist Edmund Oakdale

This poster could be mistaken for fashionable Brighton, or any of the warmer southern resorts, but this is bracing East Yorkshire. The picture is beautifully composed with an eye-catching palette, and I for one can imagine it doing its job in the 1930s. Hornsea has never been a large resort (population today around 8,500), but it is known worldwide for its pottery and ceramics industry. This only began after the end of WWII, but the local factory did establish its name through posy vases and character jugs, which had attached animal figures. They were the brainchild of local designer Colin Rawson who, along with his brother Desmond, began making plaster of Paris models to sell to tourists on the seafront as visitor souvenirs. Neither had formal training, but they quickly developed a reputation and their work sold well.

It was during this period that the son of one of their backers began to experiment with contemporary tableware, and soon diversification into this line occurred. As they grew, they moved to nearby Edenfield. The site developed into a theme park, one of the very first to appear in the 1950s. Here, people could go along and 'throw clay' to try to make their own pots, and family days out were supported by a model village, a car museum and other attractions/distractions. But this was not to last, and by 1984 the company was in financial difficulties as tastes changed and the tourist numbers fell. Further attempts to keep the town's largest employer afloat followed, but by 2000 its demise occurred, and the famous Hornsea Pottery went into receivership. In late 2008, a permanent museum was established in Newbegin, the main street in the town, and we can go back to see the contemporary tableware that caused so much interest when it appeared.

Tourists today are catered for with a large shopping centre called 'Hornsea Freeport' on the southern edge of the town, and close to where the former pottery stood. It was the first of its type in the area, adapting the original UK theme park set up by Hornsea Pottery in its heyday. But the heart of the town had gone and so too had the elegance shown here. This poster in the NRM collection is heavily damaged, but after Photoshop attention and some digital repair work, you would never know: it is too rare to leave out.

But it is now time to move down the coast to the other resort in the area, Withernsea. Today we drive, but in railway times it was back to Hull and back out again on the other branch line that ran east. Withernsea is just east of the Greenwich Meridian and was approached by rail from Patrington, which sits virtually on longitude zero. There were a few railway posters produced for local tourism, but as with Hornsea these did not feature in BR advertising policy for the Yorkshire coast, and it was left to the LNER to do their best. However, the three that follow are classic 1930s posters.

The near-side poster shows one of the real landmarks of this small seaside town. These are the twin towers of the pier entrance, which when built in 1877, was a staggering 1200 feet (364m) in length. Sadly this is all that remains; as one ship after another decided they wanted a piece of it! The first vessel collided only three years after it was finished. By the time the maritime 'drivers' had finished, it end up a mere 50 feet (15 m) long.

The two grand towers were refurbished, and today the site of the old pier is obliterated by sea defences designed to 'do a King Canute' and hold back the relentless march of the waves. Frank Mason's muted-palette painting of the wide promenade, dominated by the towers that could have been stolen from a large castle, is one that rarely appears and is easily one of his lesser-known works.

The poster on the far side is advertising the local weather. Both mother and daughter look as though they have been 'pulled through a hedge backwards', but this is the appearance you could gain after a good day on the beach at the height of summer.

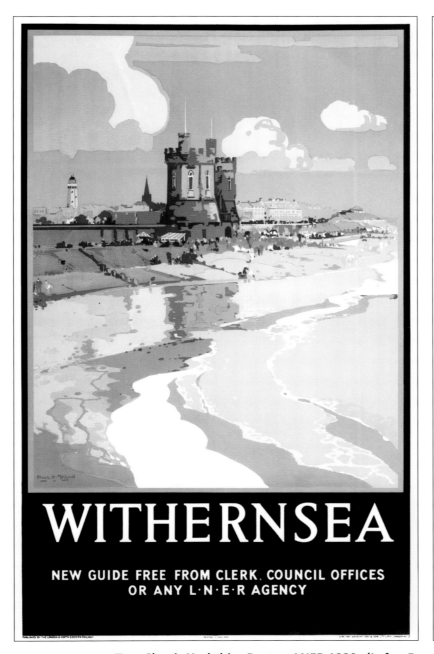

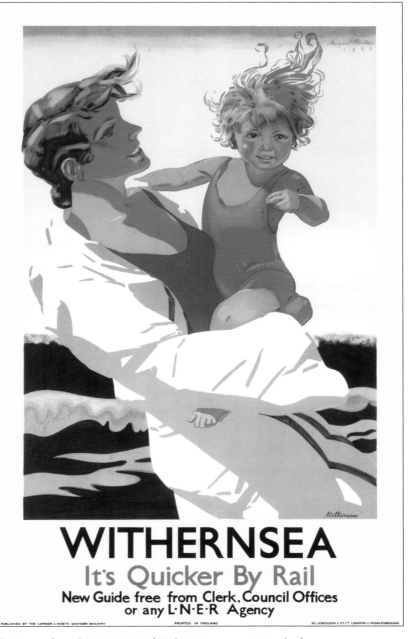

Two Classic Yorkshire Posters LNER 1920s (Left – Frank Mason) and LNER 1933 (Right - Margaret Horder)

Withernsea is the most isolated of the Coastal Yorkshire resorts and, like many already described, saw a huge boom in tourism when the railway arrived in the mid-Victorian years. The station opened in 1854, and eventually passed to the North Eastern Railway and then to the LNER. They were responsible for the four posters we found for the town and after WWII, travel here by rail seems to have been little advertised. This classic seaside poster of the 1930s comes from an artist about whom little is known (indeed, this is the lone work of hers to have entered the large poster database). As with the previous two posters, it is rarely seen, which is a great shame for a classic Yorkshire seaside poster. This poster might be dedicated to the British actress Kay Kendall who was born in the town, and those of you who liked 1960s British jazz probably already know the great trumpeter Kenny Baker was also born here. Withernsea station closed in 1964 and all that remains of the trackbed is an overgrown footpath used by walkers. The closure marked a period of slow decline, and today Withernsea makes most of its money in the summer months when resilient tourists still visit. Anybody visiting in winter is likely to go home with the same hairstyle as that shown in the previous poster. Stepping back in time we catch our train back to Hull, and change trains to visit Selby.

Inland to Selby

Once we pass North Ferriby, the track runs dead straight for 20 miles (32kms), until it reaches the outskirts of this once prosperous town that historically was part of the West Riding. The first piece of artwork shows the River Ouse running through the town, with the magnificent Selby Abbey behind. This is one of the many carriage prints produced by Kenneth Steel. In former times this river supported a shipbuilding industry and a thriving port, being also on the canal connection to the Industrial West Riding and Leeds.

Carriage Print Artwork by Kenneth Steel of the Abbey Town of Selby, Yorkshire

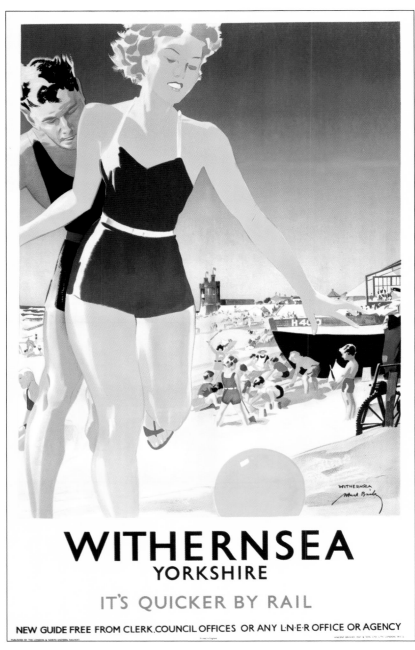

1933 LNER Withernsea Poster by Artist Maud Briby

There are several strong similarities here with Beverley. Selby Abbey is one of England's largest parish churches and, like Beverley, it is larger than some cathedrals. Naturally, being an important religious building, it features on our next two posters.

It was founded by Benedict of Auxerre in 1069 and developed by the de Lacy family. The first poster refers to the Decorated Style of the 13th and 14th century, which characterizes part of the building. However, the tower is Norman. I would encourage any visitors to see the wonderful Washington window featuring the arms of George Washington, America's first president. The design is said to be the basis for the famous *Stars and Stripes*. But the interior is superb, as Kenneth Steel shows us. Henry VIII closed the Abbey in 1539 and many outbuildings were demolished, but the central nave survived, and shortly after the turn of the 17th century, it again became a place of worship. Like York Minster its foundations are on sand, so over the years subsidence has been a problem.

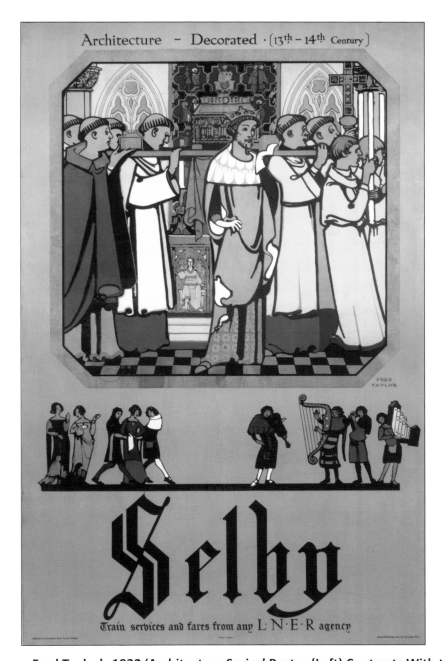

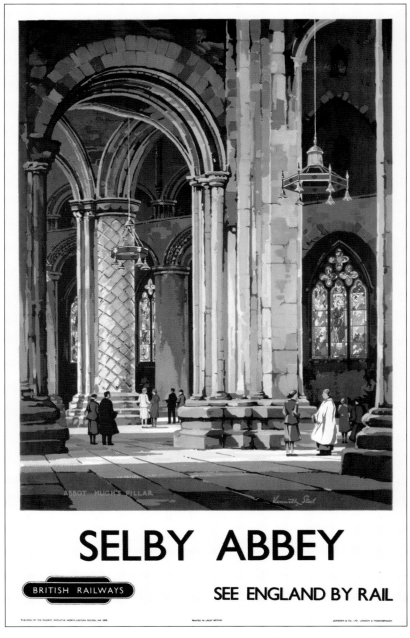

Fred Taylor's 1932 'Architecture Series' Poster (Left) Contrasts With the 1950 BR Poster of Selby Abbey Interior by Kenneth Steel (Right)

It is not long before we are back on the banks of the Humber, a hugely important river to the economy of the East Coast. The poster shown here is another from the 'Rivers Series' of the 1920s, commissioned by the LNER to promote business and commerce, and the supporting role of the railways. The artist is that mainstay of early LNER artwork, Frank Henry Mason.

The Humber and On to Goole

We have travelled down the Ouse past Goole (where we return shortly), to the confluence of the Trent and the Ouse. From here seawards the river becomes the Humber. It is hardly a river. being entirely a tidal estuary. In former times (before the last ice age) it was far longer, running much further out into the North Sea, and at that time contained freshwater. The sepia-toned poster sums up everything about the river very succinctly, and together with the docks at Goole, the Humber carried a great deal of marine traffic from the three ports mentioned. For me, this subject would have been far better painted in full colours. The superb Humber Suspension Bridge was not even dreamt of when this poster appeared, but today, it dominates the area. It was the longest in the world, but is now just in the top five.

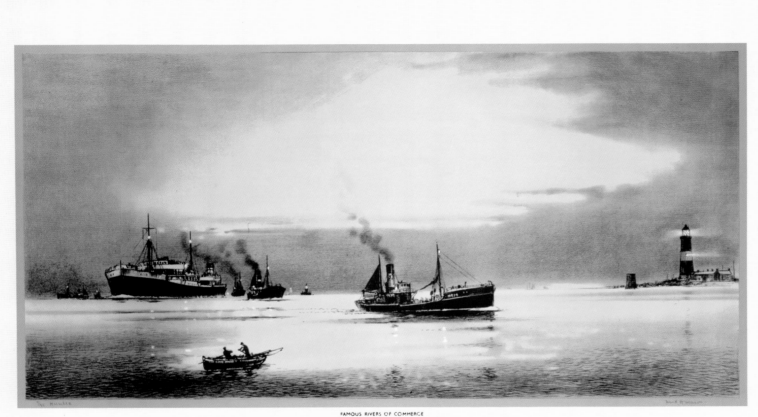

FAMOUS RIVERS OF COMMERCE

THE HUMBER
SAILINGS TO AND FROM ALL PARTS OF THE WORLD
HULL – BRITAIN'S THIRD AND CHEAPEST PORT
GRIMSBY – WORLD'S PREMIER FISHING PORT
IMMINGHAM – DEEPEST DOCK ON EAST COAST
ADJACENT HOLIDAY RESORTS – CLEETHORPES AND WITHERNSEA
LONDON AND NORTH EASTERN RAILWAY

1920s LNER Poster Extolling the Virtues of the River Humber: Artist Frank Henry Mason (1875-1965)

Up-river from the confluence of the Ouse and Trent lies Goole. Some of the earlier posters tie Hull and Goole together as 'Humber ports', but Goole lies on the banks of the Ouse. In terms of the railways, its history comes from the LMS side, and during the formation of Associated Humber Lines, this heritage was used to show the blending of the two main railway companies.

This 1928 poster, before the merger, is pure LMS. It was produced by McCorquodale Studios, a firm of artists who undertook work for about 35 years for various railway companies. This one is signed 'JP', attributable to one of the registered artists. What is lovely about this work is the choice of colours for an industrial poster. In the early years, the LMS used professional artists, but once they turned to commercial sources, their posters had (for me) more appeal. Pink quaysides and roofs would never have appeared in 'proper paintings'. Here, we can clearly see the funnel colours that became the house colours of Associated Humber Lines. This rather uncommon poster would have looked great in the AHL Offices (and maybe did once hang there). The lower reaches of the Ouse allowed reasonable sized ships to enter port, and many goods from Yorkshire factories were exported from here.

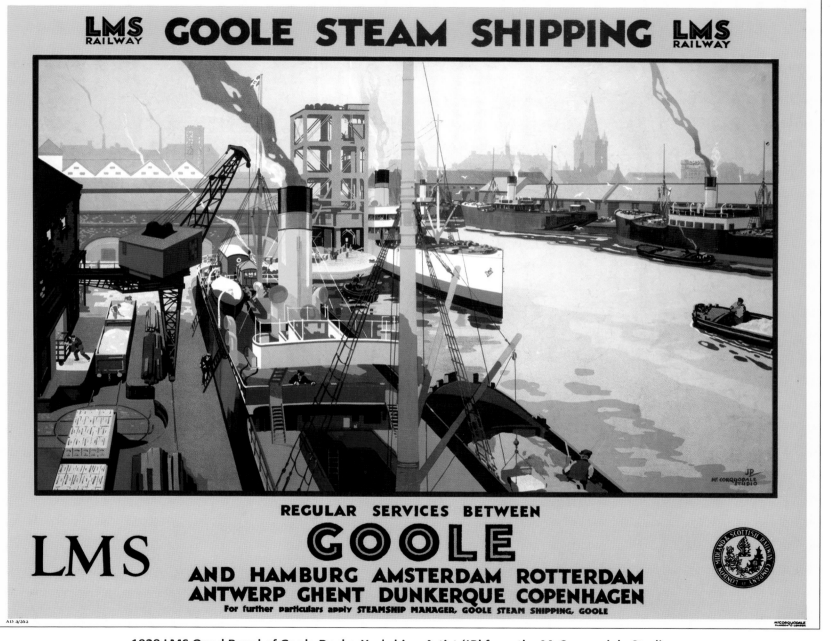

1928 LMS Quad Royal of Goole Docks, Yorkshire: Artist 'JP' from the McCorquodale Studios.

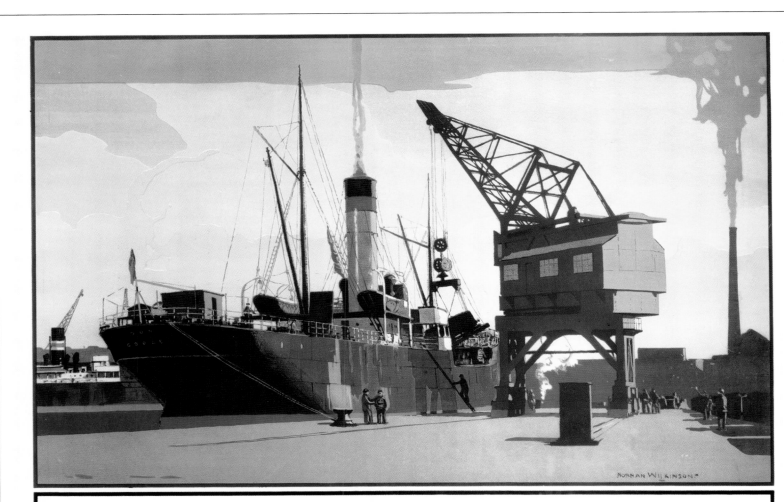

GOOLE

s.s. "DON" Coaling at the 40-ton Crane

By NORMAN WILKINSON, R.I.

LMS

Goole on the River Ouse is the Humber Port from which the LMS fleet of cargo steamers sail for the principal Continental Ports including Amsterdam,

Antwerp, Copenhagen, Dunkerque, Ghent, Hamburg and Rotterdam. It is the most inland port in England and carries on a large trade in the export of coal

A Circa 1930 Poster of Goole Docks; A Classic LMS Railway Company Shipping Poster by Norman Wilkinson (1878-1971)

Staying in the Docks, we move to the quayside and watch one of the freighters being coaled. The SS Don was one of ten sister ships, named after northern rivers, being built in 1924. She was scrapped in 1958. This was the second vessel to carry this name (the first was built in 1892, but was lost in 1915 during WWI hostilities).

Rather interestingly, *'You Tube'* carries footage of her being loaded with wool in the 1930s at a time when Goole Docks was busy. What is also most interesting is that today's infrastructure connections are a shadow of former times (the Aire and Calder navigation system, the Dutch River plus rail links from the South and West), but nevertheless Goole Docks is active and thriving.

The best connection today is the M62 (less than two miles away), but the canal system and extensive railway links were the former way of getting goods to the docks for export and to remove the imports. There is still a rail link, but this is reduced to a single track. Here, Wilkinson has captured a still winter's morning with the ship being prepared for sea. The cargo is probably already loaded, as there is no evidence of quayside materials awaiting loading. The early morning sunlight highlights the crane and ship: it makes a lovely poster.

We finish the shipping part of this chapter with two more AHL posters. The Goole Shipping Company was formed in 1864, and started carrying passengers in 1879. The first ships were named after directors of the company, of which only the *Robert Crake* of 1879 survived when they were taken over by the Lancashire & Yorkshire Railway (LYR) in 1905.

The nearside poster dates from the early 1950s, before the 'Abbey' series of ships appeared, and when the *Duke of Connaught* was being used. The far-side poster dates from the latter part of the 1950s, when the newer 'Abbey' series of ships appeared, and this may be a poster to advertise the new vessel, MV *Fountains Abbey*.

We end our East Yorkshire travels with a wonderful railway poster. Terence Cuneo painted two of the 'East Coast Racehorses' being serviced in Doncaster works. What is amazing to me is that the LNER and BR never made more use of this most famous of railway locations in their promotional work. This was always referred to as 'the Plant' and was established in the town in 1853. Just let's savour a most sought-after poster showing true railway history.

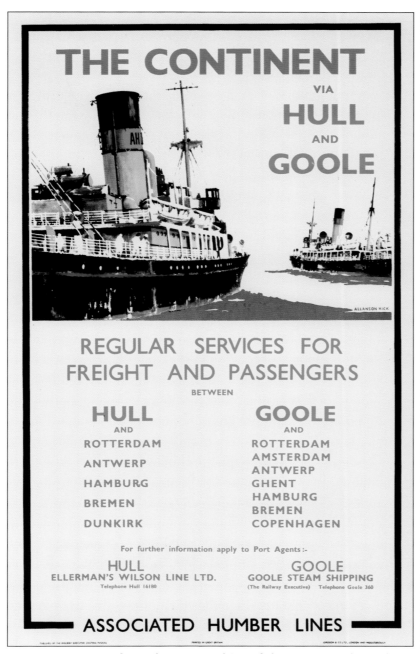

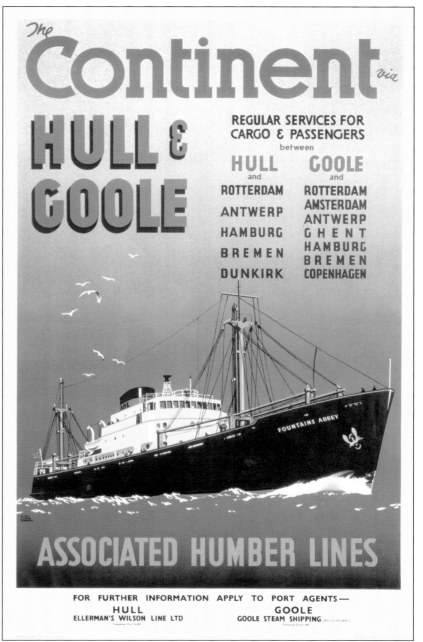

Posters from the 1950s: Ships of the Associated Humber Lines: Allanson Hick (Left) and Harry Hudson Rodmell (Right)

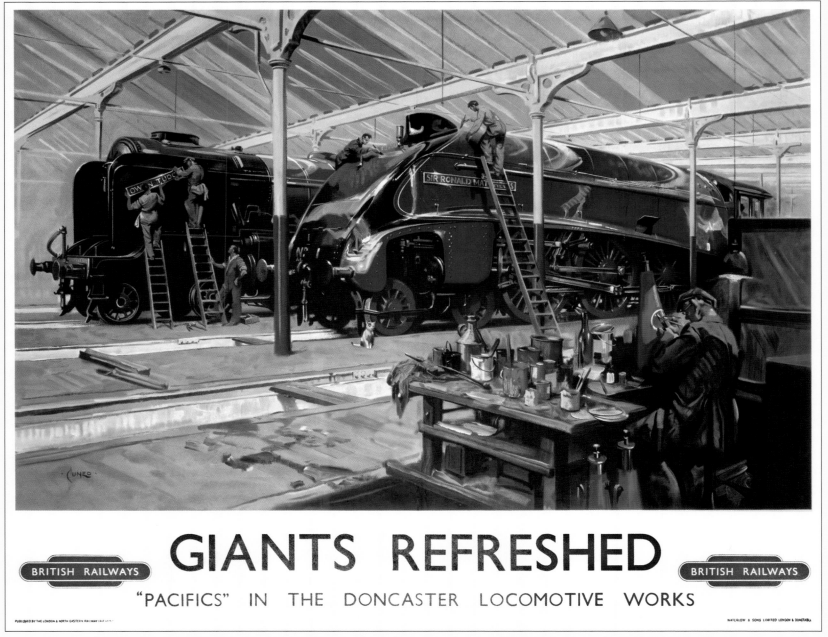

Classic 1950s Reprint of an LNER 1930s Poster: Gresley's Thoroughbreds Inside Doncaster Works: Artist Terence Tenison Cuneo (1907-1996)

Chapter 7 Beautiful Dales and Moors
The Yorkshire Dales & the North York Moors

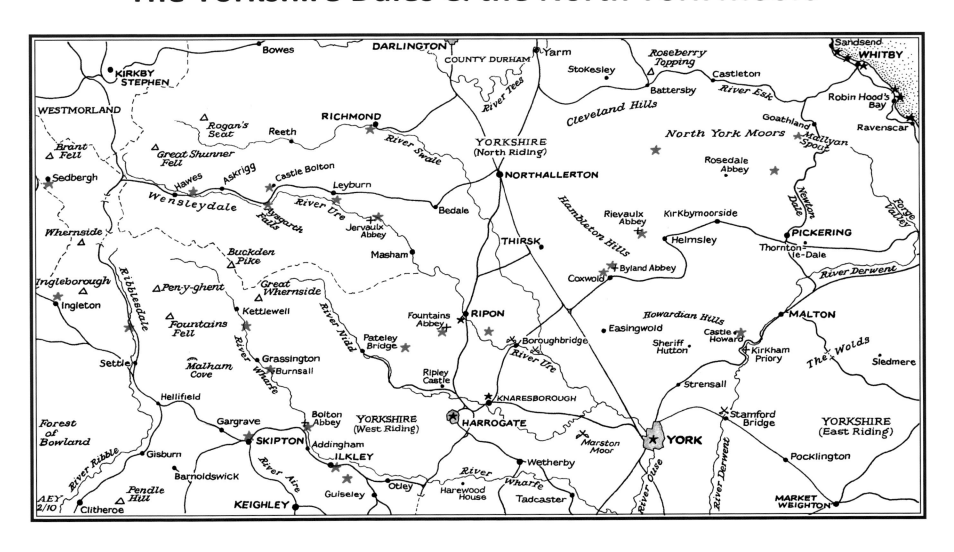

Chapter 7

Beautiful Dales and Moors

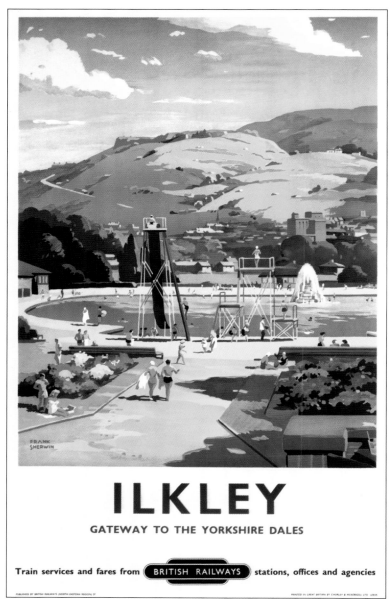

1957 BR (NER) Poster of the Dales Gateway: Artist Frank Sherwin (1896-1986)

At the Southern Gateway to the Dales

From Doncaster we magically fly over industrial West Yorkshire (which is covered in Chapter 10 - with some superb artwork), and come to a part of Yorkshire that many consider to be some of the finest open scenery in England. This was endorsed by the railway companies who over the years have produced some really cracking posters. For the Dales part of our tour, we will enter through the southern front gate (Ilkley), and leave from the northern back gate (via Richmond) to end the Dales part at Fountains Abbey. Next is the North York Moors with some lovely LNER posters advertising the delights of the area. The end of the chapter has a distinctly spiritual feeling, with visits to some of Yorkshire's ruined abbeys. The LNER had a surprising number of 'Abbey' posters produced, though they were sadly neglected by British Railways. We end at Jervaulx Abbey near Ripon, in preparation for the start of the next chapter. The Yorkshire Dales is one of our National Parks, created more than 50 years ago. It falls within the historic borders of Yorkshire, though sections are in today's Cumbria and in both West and North Yorkshire. The whole National Park is a collection of 21 river valleys that link and intertwine. Most of the valleys are named after the river within, the most well known exception is Wensleydale (home to Wallace and Gromit's favourite cheese), and named after the village of Wensley at the eastern end of the valley. (The River Ure runs through the village and Uredale does not sound right: however, the olden-day name of Yoredale still appears occasionally).

We begin in Ilkley with a quite lovely poster from the great Frank Sherwin. The town is located in the lower reaches of Wharfedale, mostly on the southern bank of the River Wharfe. Its location really does make it the 'Gateway to the Yorkshire Dales' as this poster shows. Its history and heritage go back thousands of years, and evidence shows this area has been inhabited since before the early Bronze Age (around 2,000 BC). Relic hunters and archaeologists are just some of the people who have visited for many years. And today we are greeted by Victorian architecture, expansive streets and during the summer months there are flowers everywhere (as Sherwin's poster illustrates). The open-air swimming pool was part of the town's attractions. During the late 17th and early 18th centuries, the waters around the town were said to have healing properties, so hydrotherapy and other health centres sprang up to cater for those wishing to partake. It was during this period that Ilkley gained the reputation as one of Yorkshire's Spa towns. The health facility at nearby Ben-Rhydding was a favoured place to visit until it was demolished. People from all over England came to bathe in the cold spring waters.

The town is well laid out with plenty of opportunity for promenading and 'people-watching'. Its location is shown to great effect in the next poster. Ilkley is surrounded by hills, and here three ladies are taking in the expansive panorama on a warm summer's afternoon. The ladies are on the outskirts of Ilkley Moor (home of the well known Yorkshire song). Reginald Brundrit was a well known local artist (he actually lived further up the valley near Grassington), so in keeping with the LMS policy of the time, he was asked to paint a scene from his area, and produced this lovely poster in 1926. It is an image rarely seen, and I think this is the first time it has ever appeared in such a book.

The Otley and Ilkley Railway built a station here in 1865, but it was not until the Midland Railway arrived in 1888 that a station befitting the town was constructed. Sadly, it closed in 1965. Even further back in time, the Romans were here (local fort remains exist), and the town is listed in the Domesday Book as being in the estate of William de Percy. Ilkley was laid out by William Middleton in Victorian times and contains some wonderful buildings. Visitors to the Victorian Church are also treated to the sight of Anglo-Saxon crosses and other medieval artefacts. Throughout every summer, many walkers and hikers throng the town.

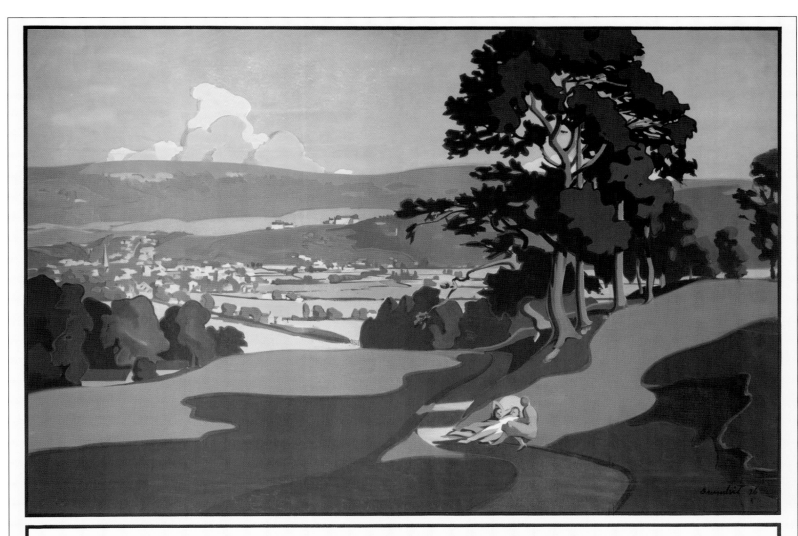

Classic 1926 LMS Poster for Ilkley: Artist Reginald Grange Brundrit (1883-1960)

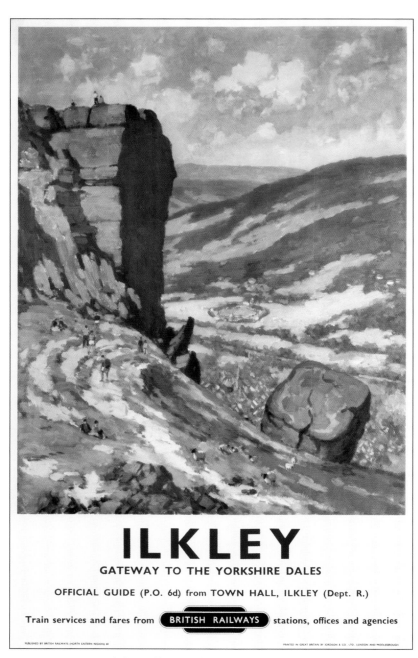

1960 BR Poster of the Hills Overlooking Ilkley by an Unknown Artist

The town is known for the wide range of independent and specialist shops, and it really should be praised for trying to keep the 'older way' of shopping alive. The town Lido, shown at the start of the chapter, was built in 1935, and is one of only a handful of open-air pools in Yorkshire. Visitors cannot fail to be amazed by the openness and beauty of Ilkley during the summer, and one place I do recommend is Darwin Gardens, which features a large maze (the Millennium Maze). The gardens are named after Charles Darwin, who was a frequent visitor to the town and surrounding area. He was actually there when his ground-breaking *'Origin of the Species'* was finally published.

Residents of Ilkley are termed 'Olicanians' because in 79 AD the Romans built the fort of Olicana near the River Wharfe. A portion of the west wall can still be seen at the site, now occupied partly by the Elizabethan Manor House Art Gallery and Museum, and partly by All Saints' Church. Nearby is the Old Bridge over the river, which dates from 1675 and is the subject of a lovely carriage print by Frank Sherwin (an extremely good artist who was favoured by the railway companies). The Dales Way, a long-distance walk all the way to the Lake District, begins nearby.

As we move out and above the town, we come to our next poster. This depicts the Cow and Calf rocks on Ilkley Moor. These are found at the eastern end of the valley and south of the town. The view from here is spectacular and this poster really does not do real justice to the panorama from Burley in Wharfedale to our right up towards Addingham further up the valley. It is also surprising that no other artists decided to paint this part of Wharfedale. Also on the moor is White Wells which reputedly is built on the site of a Roman Bath. Maybe a reader can confirm whether this is fact or tourism? Ilkley Moor itself stretches between the town and Keighley to the south-west. Walkers can cross the peat bogs that rise to over 1300 ft (400m) above sea level on their journey from Wharfedale to Airedale.

Through trains used to run up Wharfedale as far as Bolton Abbey before the line turned west to Skipton, but this section closed in 1965, so today Ilkley is a terminus on the line to Leeds and Bradford. However, it is electrified, so walkers can start their exercise after a comfortable short train journey from the industrial centres. Visitors today can also marvel at the stone-built station that has lovingly been restored and modernized during recent times. Ilkley is also notable in that it was the last British Rail station to be lit by gas. The gas lights were finally extinguished in the late 1980s. The famous tangerine-coloured totems used to take on an extra glow when visitors arrived in the town around the time this poster was painted, and station totems from here and nearby Ben-Rhydding are highly prized.

Our next poster sums up what many people feel about this area. This Edwardian poster lists some of the main Dales, but strangely misses out Wharfedale and Ribblesdale, two of the largest. People had been visiting and walking these lovely Dales for very many years before the National Park was established in 1954. This covers an area of 680 square miles (1760 sq km) and in summer, especially on warm sunny days, is thronged with people from Leeds, Bradford, Manchester, Newcastle, Sunderland and Sheffield, all nearby cities.

The four Dales listed here cover the eastern and northern areas. Nidderdale runs south towards Pateley Bridge and Harrogate, while the other three run west to east; Wensleydale towards Leyburn, Swaledale towards Richmond and Teesdale towards Barnard Castle. The curious rock formations depicted in this poster are found at Brimham in Nidderdale. They are scattered over some 50 acres on Brimham Moor, and provide a great variety of weird and wonderful shapes. Everybody sees a different animal from a different direction – the Magic of the Dales perhaps? At night when all the humans have gone, it looks like the real magic begins. This is a rarely seen poster and, therefore, well worth inclusion.

1914 North Eastern Railway Poster by an Unnamed Artist Showing Yorkshire Dales Twilight Delights

Beautiful Wharfedale

We begin the tour proper in Wharfedale. Bolton Abbey, just a short distance north of Ilkley, is the next stopping place. In summer it is a tourist hotspot and these two pieces of art show why. The photographic image (left) was one of the first British Railways published as *'proper art'* was beginning to be phased out. Alfred Kersting's photograph shows the beauty of the ruined abbey reflected in the tranquil Wharfe. The carriage print artwork below, by Frank Sherwin, shows almost the same view. The railway line used to be one of the finest of the cross-Dales routes, but when it closed in 1965, enthusiasts refused to let it die (see page 231). Today you can again travel from the 1888 Embsay station to the new (and recent award-winning) station at Bolton Abbey. This new station is about 1.5 miles (2.3kms) from the 12th century priory shown in these two pieces of art. The Augustinian Priory dates from around 1150, and was established some 30 years after the smaller Embsay priory.

Bolton Abbey lies within the Bolton Estate, a 30,000 acre (120 km^2) park that used to belong to the Dukes of Devonshire. The eleventh Duke of Devonshire set up a Trust, and it is the Chatsworth Settlement Trustees who now own the Estate. The magnificent 30,000-acre Estate has five areas designated as English Sites of Special Scientific Interest, including Strid Wood, an ancient oak woodland, and a supreme example of what large areas of England used to look like. Building work was still going on at the abbey when the Dissolution of the Monasteries resulted in the termination of the priory in 1539. The east end remains in ruins but the famous Victorian architect August Pugin performed some conservation work on the lovely windows. When I was studying away at college in Yorkshire, this was a favourite place to go during the weekends that I stayed, instead of hitch-hiking back to Shropshire.

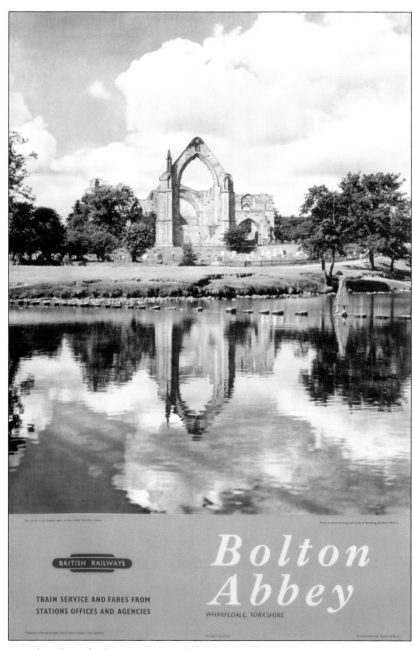

1959 (BR (NER) Photo-Poster of Beautiful Bolton Abbey: A.F. Kersting

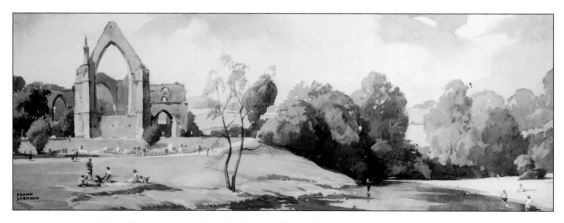

Carriage Print Artwork of Bolton Abbey by Frank Sherwin (1896-1986)

The mention of Strid Wood on the previous page brings us to a section of the river that narrows considerably, and where the current flows fast. I looked up the definition and found *"A narrow passage between precipitous rocks or banks, which looks as if it might be crossed at a stride"*. But beware; this section of the river is far more dangerous than it looks! We are only a few miles up the Dale from Bolton Abbey, and already peace and tranquillity fill the air.

Bolton Abbey is usually thought of as being in Upper Wharfedale, the section from the source to around Addingham (between Bolton Abbey and Ilkley). This 1948 poster by Gyrth Russell shows the expansive beauty of the area, with the Wharfe well below us in the valley. Farms dot the landscape and in summer, walkers can enjoy such a view across miles of unspoilt countryside. This valley is green and lush; a far cry from the old mills and industry of Leeds and Bradford to the south.

The Wharfe rises near Camm Fell and flows almost 60 miles (100 kms) into the Ouse near Cawood, south-east of Tadcaster. The word Wharfe is Celtic, meaning 'winding' or 'twisting', and in the lower reaches, it describes the behaviour well.

The Expansive Beauty of the Yorkshire Dales Portrayed in this 1948 BR Poster by Gyrth Russell (1892-1970)

 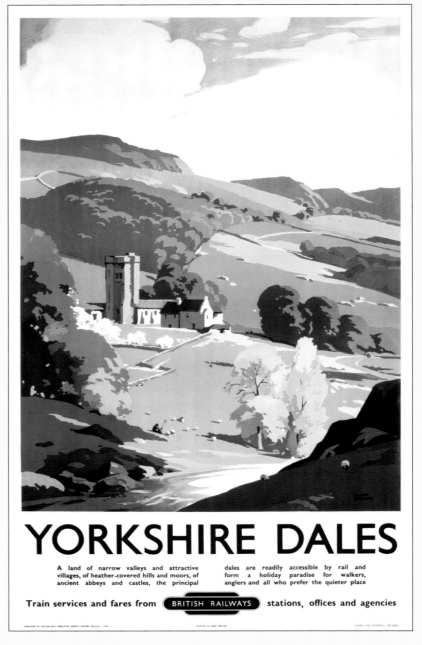

Two Wonderful British Railways Posters of the Yorkshire Dales: Artists: Ronald Lampitt (Left – published 1961) and Frank Sherwin (Right – published 1963)

To Skipton and Beyond

Access to the beautiful areas shown in the two posters alongside is best undertaken on foot. (NOTE: I am informed the left hand picture is Muker, in Swaledale to the north, but the placing here seems to fit the posters better). The railway swung westwards from Bolton Abbey and Upper Wharfedale, and passed through Embsay to Skipton in Airedale, and to the subject of our next poster, Skipton Castle.

This magnificent and medieval structure is one of the most complete and best preserved castles in England. John Greene's poster shows the sandstone structure sitting high over Eller Beck. Attacking from this side, therefore, was useless. The frontal side was heavily fortified with an enormous gatehouse and very thick walls. The site was also high on the rock ridge, with the ground sloping away from the castle walls. This meant that the 900-year old Skipton Castle was always going to be a problem for any troublemaking invaders. Its history is intimately entwined with the Clifford family, who were given the property in 1310 by Edward II. (GWR fans may already realise there was a *Castle Class* engine - 5071 and later 5098 *Clifford Castle* - named after the family's other castle in Herefordshire). Robert Clifford was made first Lord of Skipton, but he was killed at Bannockburn before he could see the completion of his building work.

The only time the castle was ever taken was during the English Civil War, and only then after a three-year siege. Afterwards, Cromwell ordered Lady Anne Clifford to restore it, so even he must have recognized the importance. Even today it is a residence (Lord Clifford of Chudleigh), but as we descend from the train and walk up the gradual slope, the imposing Norman gatehouse greets us. Passing through, we are confronted by six interconnecting towers surrounding the central courtyard. You can almost feel the history here. The poster really does not do this fine place justice and if we had more time, we could spend all day exploring dungeons to ramparts – a wonderful building indeed.

Skipton also sells itself as the 'Gateway to the Dales', only this time it is Malhamdale and Ribblesdale. The town is mentioned in the Domesday Book of 1086 and, as we have seen at the castle, was a major location of Civil War fighting in 1643 onwards. The Midland Railway built the first station here in 1847, but this was replaced by a better structure in 1876. The station spandrels are just wonderful on the line that was electrified in 1994. (A second major refurbishment was also carried out in 1998). It is time now to get back on the train and head north-east towards the Dales. This time the line runs up beautiful Ribblesdale and eventually all the way to Carlisle over the famous S+C line. However we magically alight at Stainforth and take in the next poster.

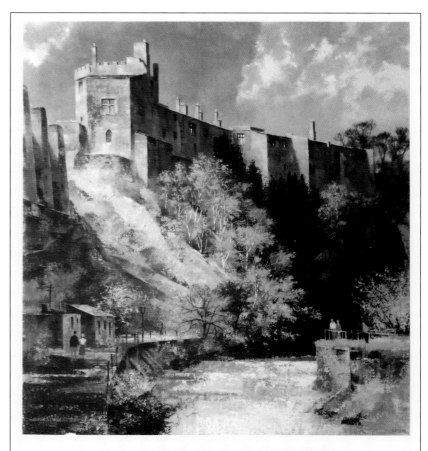

1958 BR (NER) Poster of Skipton Castle: Artist John Greene

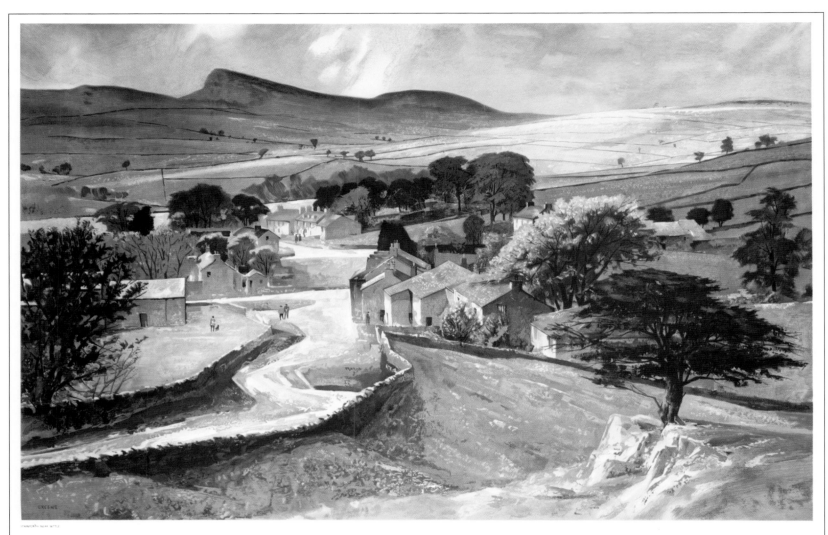

Ribblesdale

NORTH WEST YORKSHIRE

Ribblesdale, among the Pennine Fells, is remarkable for the beauty of its moorland and mountain scenery, its waterfalls and its interesting caves and potholes.

Go in comfort by train to Settle, Giggleswick or Horton-in-Ribblesdale stations

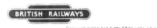

Evocative 1959 British Railways Poster of Stainforth-in-Ribblesdale, Near Settle by John Greene

Greene's evocative poster shows the tiny hamlet of Stainforth basking in the afternoon sunshine. This wonderful poster is in my own collection, and I love the way the artist has chosen his colours to match the beauty and openness of the countryside. Nearby, walkers can find Malham Tarn (to the east) and the three major peaks of Ingleborough, Penyghent and Whernside are not that far away for the more athletically inclined.

Because of the moorlands and the fells, this area is one of the more popular spots in the whole of the Dales National Park. The area is limestone country, so caves, waterfalls and other natural delights are to be easily found, and potholing is a major attraction for visitors, all eager to explore the underground delights.

The railway line crosses and re-crosses the Ribble as we steadily gain height. A journey on the Settle to Carlisle Railway is one of life's greatest pleasures. It is superb in the winter sunshine, when snow-covered fells appear on both sides. Stainforth is not quite so hospitable when the winter snows set in, but whatever the season, the Yorkshire welcome is always friendly. Building the railway here was not so easy!

This pair of posters was issued at a time when the LMS and LNER were going head-to-head to attract passengers. Both, however, are superb examples of how the railway companies used art in their marketing campaigns. Both posters deserve a special place in this trip and are rarely seen. The Schabelsky poster could actually be anywhere in this chapter (and is more likely to be further north), but it just seemed right to place it in Ribblesdale alongside Whatley's early LMS poster, to show rival advertising of that time.

Ingleton is well to the west of Ribblesdale, and to get here we crossed the unique Ribblehead viaduct, flew from the train and came down the River Doe valley to what is for many, the centre of caving, potholing and waterfall-watching. Here we find White Scar Cave, Ingleborough Cave, Skirwith Cave and a whole labyrinth of challenging activities underground; more than enough for anybody.

Over a 300 million year period, the water has carved its way through the limestone. If you are squeamish about crawling into confined spaces, go and marvel at Gaping Gil, a 360 ft (110m) high cathedral-like cavern. Winches lower the curious into the wonderful cavern.

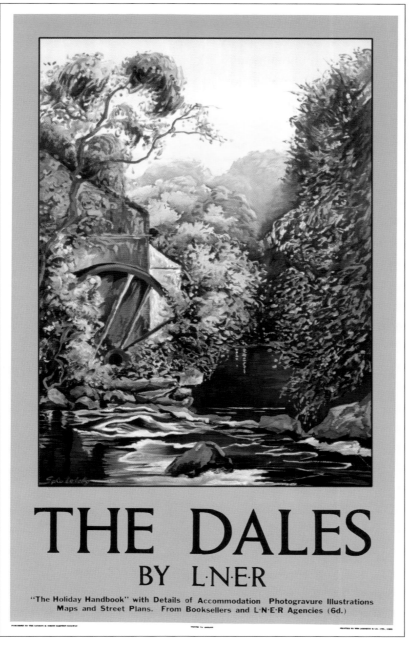

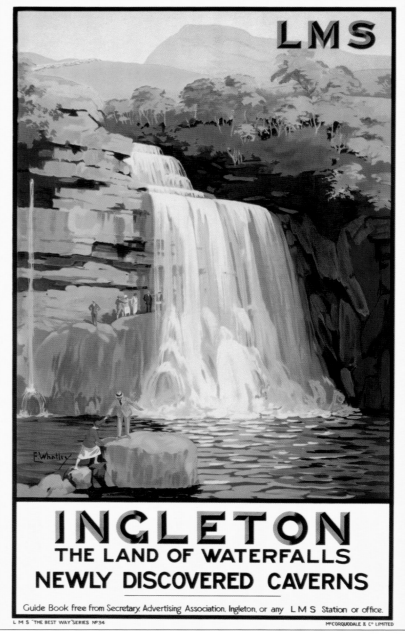

The Old Rivals Advertise the Yorkshire Dales: Schabelsky from Around 1930 for the LNER (Left) and Whatley 1924 (Right) for the LMS

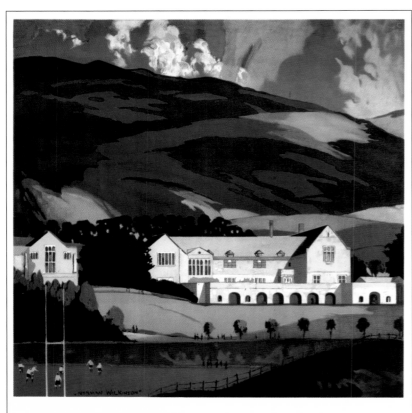

SEDBERGH SCHOOL

By NORMAN WILKINSON P.R.I.

 Sedbergh School was founded in 1525 by Roger Lupton, Provost of Eton and "native of the paroche of Sedber in the countie of York." Although the Foundation included a Chantry, it escaped suppression under the Chantries Act, thanks to the exertions of the Master of S. John's College, Cambridge. By the end of the 17th century the School was already of more than local importance, having 120 boys, in spite of its remote position. It lies amongst the fells, near the borders of Westmorland, where the Rawthey joins the Lune. The buildings shown here date from 1874, except for the Cloisters, which are a War Memorial.

For Information and Literature apply: Associated British and Irish Railways, Inc., 9 Rockefeller Plaza (14 W. 49th St.) New York, or Your Own Tourist Agent.

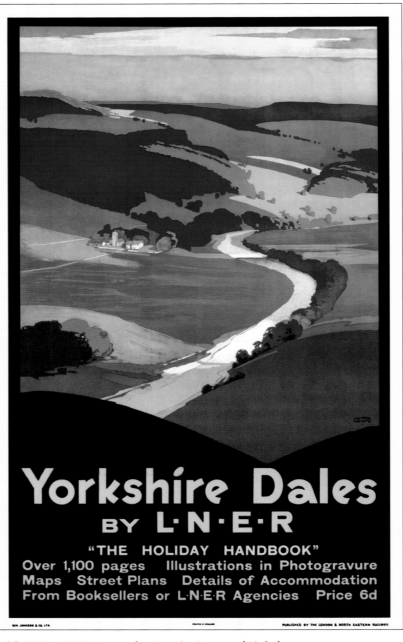

1929 LMS Poster by Norman Wilkinson (Left) and mid 1920s LNER Poster by Austin Cooper (Right)

The line from Settle heads northwards past Dent over Ribblehead and on into Westmorland, just south of Kirkby Stephen. It is a magical journey. I have ridden it twice, once behind the *Duchess of Hamilton* and again behind *Union of South Africa*. It is a simply fabulous journey, and we will see some of the rather insipid posters advertising this treasure in Chapter 10.

Along the route, and just inside Yorkshire, we find Sedbergh and its famous school. Norman Wilkinson captured this and 14 others throughout the LMS network in the *"Schools Series"* from 1929. The poster here is beautiful. Look at the moodiness of the fells and the sun picking out the school buildings – really great art. Alongside is an LNER rival; I am not sure of the exact location but no doubt somebody will know. Again we have pastel shades, blues and greens to show the beauty of our landscape. This is Austin Cooper at his best, expansive and precise, almost too good for advertising a simple holiday book, but Teasdale expected his top artists to paint everything and anything!

The Northern Dales

Now we have come to a real contrast. This is the LNER advertising the North East Dales; maybe Wensleydale or Swaledale. Byatt's lovely painting from around 1936 is bound to make you want to return. A railway line used to run down the valley from north of Dent, down past Hawes and Bedale to join the main line at Northallerton. Amazingly, this was closed even before Dr. Beeching had a chance to look at it, and today it would make a wonderful tourist trip.

As well as its famous cheese, Wensleydale is known for its wool, its weather and its walkers. Go after a rainstorm and just watch the river and the waterfalls, as sunlight plays on them. Thousands throng the valley during the tourist season, whether on foot or travelling by car. Swaledale may have fewer towns and settlements, but not fewer tourists in the summer. Like all these Dales, this is limestone country and in summer is a mass of wild flowers. There are many large limestone barns, similar to the one depicted in Byatt's poster.

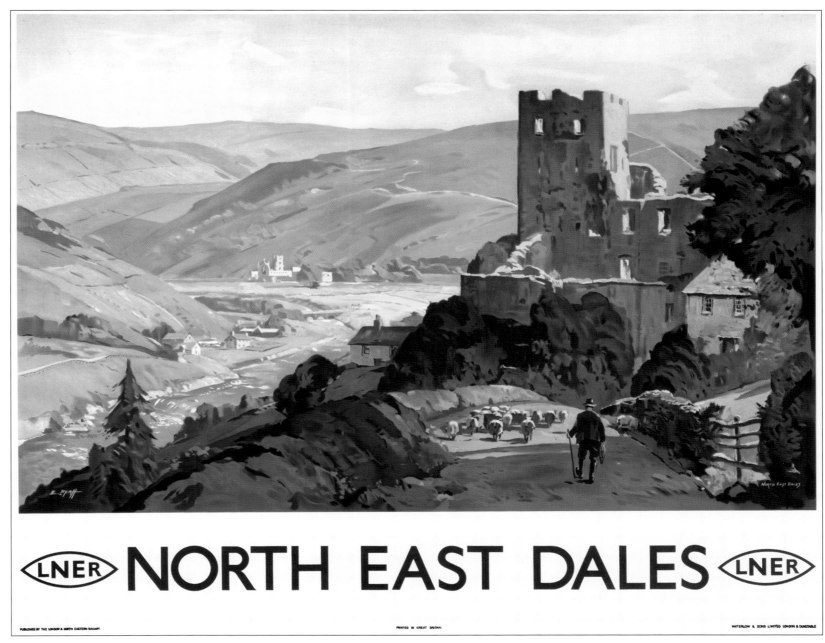

Magnificent LNER Quad Royal from Circa 1936: Artist Edwin Byatt (1888-1948)

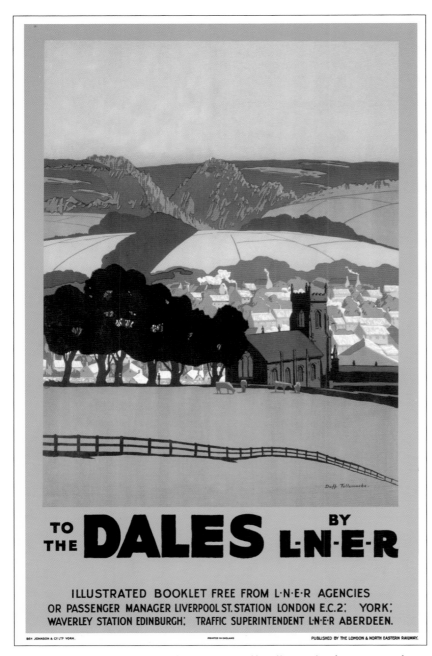

1930 LNER Double Royal by Hon. Duff Tollemache (1859-1936)

YORKSHIRE DALES

IT'S QUICKER BY RAIL

FULL INFORMATION FROM L·N·E·R OFFICES AND AGENCIES

LNER Quad Royal from 1940: Artist Edwin Byatt (1888-1948)

The poster above is also probably Swaledale, and likely painted at the same time as the one earlier, but records show it was a strange wartime issue. It does not have the expansive feel of the previous poster, (and maybe this was the effect of the war). Nevertheless it is a rarely seen poster. To our left is one of the few posters attributable to the Hon. Duff Tollemache. This member of the aristocracy was an active painter in the 1920s and today his work is sought after. The location is Pateley Bridge in Nidderdale and home to England's oldest sweet shop. The contrast in the greens used in both these posters made them ideal 'page-mates' to show poster art development within the LNER over about a decade span. The next poster is magnificent and rightfully has a page to itself. Aysgarth is found in mid-Wensleydale, and Haslehust presented the LNER with a masterpiece to savour. The limestone steps accentuate the falls, which are actually not that high, but are spectacular after winter rains.

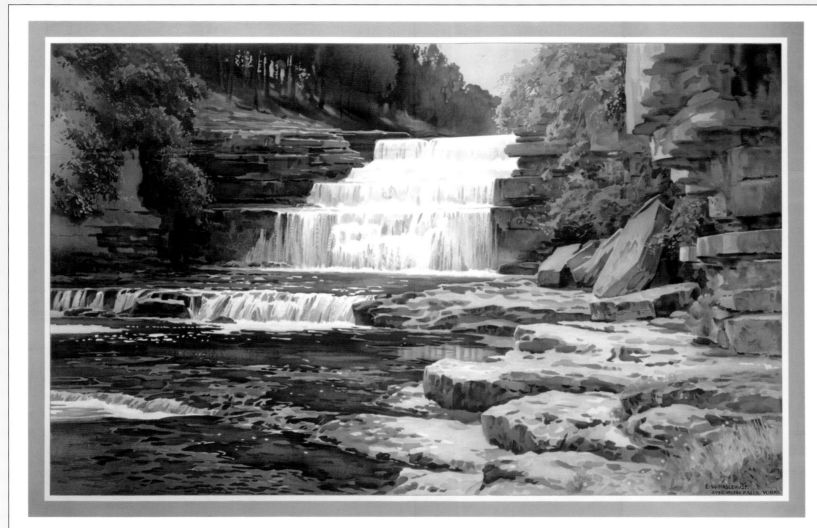

AYSGARTH FALLS, YORKS.
IT'S QUICKER BY RAIL
FULL INFORMATION FROM ANY L·N·E·R OFFICE OR AGENCY

PUBLISHED BY THE LONDON & NORTH EASTERN RAILWAY PRINTED IN ENGLAND HAYCOCK PRESS, LONDON

Another Wonderful Poster from Ernest William Haslehust (1866-1949): LNER Quad Royal from the Mid 1930s

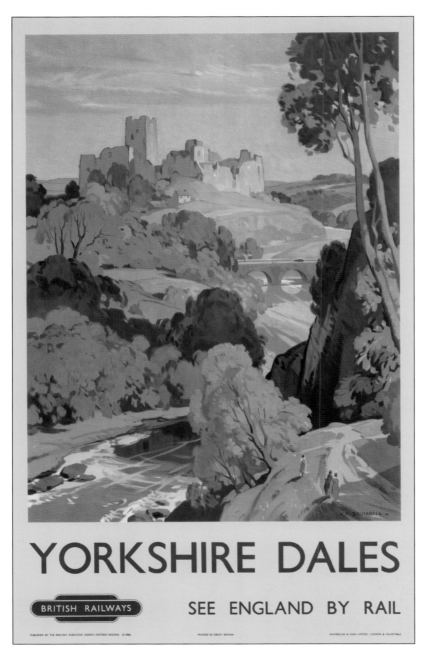

1948 BR Poster by Leonard Squirrell (1893-1979)

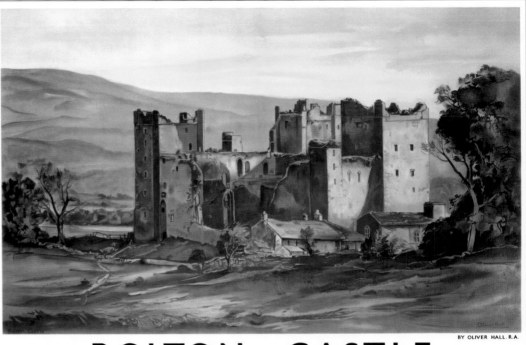

Mid 1930s LNER Poster of a Famous Castle: Artist Oliver Hall R.A. (1869-1957)

We are now in the far northern Dales, almost at the end of this part of the Yorkshire journey. Here we have two contrasting images, one from the BR era and the other from the height of the LNER years. To the left is Leonard Squirrell's early BR poster of what appears to be Richmond Castle from a distance. Above is the moody poster of Bolton Castle from Royal Academician Oliver Hall. This castle was completed around 1400, and more than 600 years of history has left it with scars of a sometimes violent past. It was besieged in the English Civil War in 1645, and was the prison for Mary Queen of Scots in 1569. It was built by Sir Richard le Scrope, King Richard II's Lord Chancellor of England in the late 14th century, and has never passed out of the Scrope family ownership since construction. The current castle owner is Lord Bolton, a direct descendant of Sir Richard. It has been used in many films and TV programmes (*Heartbeat, Elizabeth* and *Ivanhoe*).

Richmond and Fountains Abbey

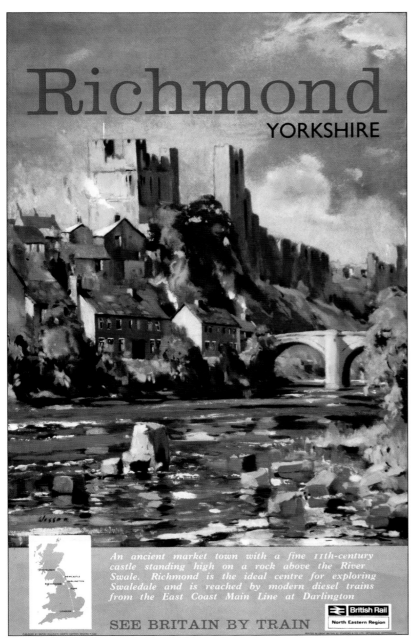

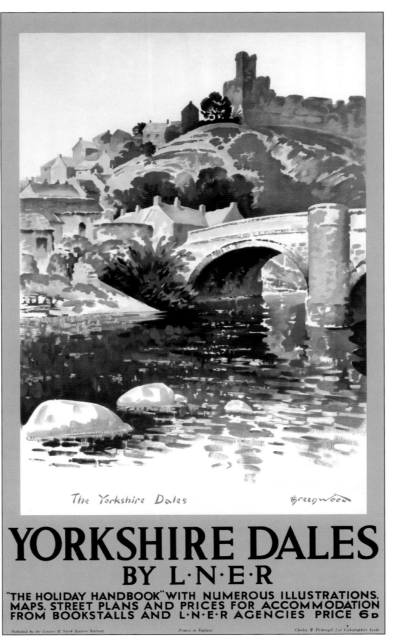

Contrasting Views of Richmond North Yorkshire: Edward Wesson (Left) in 1962 and Orlando Greenwood (Right) in the 1920s

Bolton Castle is in Swaledale, and as the river slows and widens, we come to the Yorkshire town of Richmond (or as the locals say the Capital of Richmondshire). The town was founded after the Norman Conquest of 1066, and the castle was built from 1071 onwards (completed around 1086). The origin of the name seems to come from *Richemont* in Normandy, and the first owners were the Dukes of Brittany. Eventually the castle and surrounding lands were willed to Henry VII, whose grandson, Henry Fitzroy, became the first Duke of Richmond. The railway arrived here in 1846 with the construction of a short branch line from nearby Catterick Bridge; it closed in 1969.

Richmond has been the subject of a surprising number of posters, due almost certainly to it being at the entrance to Swaledale. Space has restricted me to just two posters. The Wesson from 1962 illustrates his bold rendition of the castle's position above the town to perfection, while the softer 1920s painting from Orlando Greenwood gives the castle far less prominence, concentrating instead on the River Swale. The town was prosperous in the 17th and 18th centuries, due to the local wool trade and fine Georgian buildings appeared.

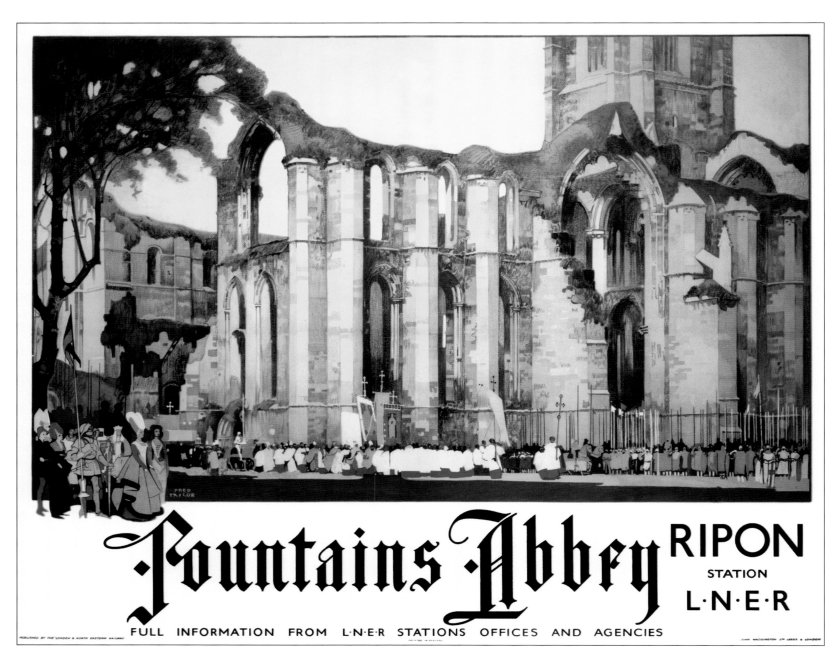

Classic 1927 LNER Poster of Fountains Abbey, North Yorkshire by Fred Taylor (1875-1963)

From Richmond it is a short journey to nearby Fountains Abbey. As with Richmond, I have included just two from the half dozen produced, but what a fine duo! I have chosen two LNER Posters, though the Rushbury shown opposite was later re-issued by British Railways. (A copy of this hangs proudly in my home as a first-class example of BR's early decision to re-issue classic posters).

This lovely 1927 poster by Fred Taylor shows an open-air service amidst the ruins. These are Grade I listed, and along with the nearby Studley Royal Water Garden, they form part of a UNESCO-listed World Heritage site. This is because these wonderful ruins are our best example of a large Cistercian Abbey. It was built around 1125 and functioned well for 400 years, until arch-demolition expert Henry VIII ordered the dissolution of all the monasteries in 1539.

The abbey buildings and over 500 acres (2 km²) of land were then sold by the Crown, on 1 October 1540 to Sir Richard Gresham. Locally-quarried stone forms this ethereal structure. The Cistercian code of architecture and building was strict, but Fountains Abbey ended up more decorated and with more additions than the standard design called for. Taylor's poster shows the beauty of the stonework.

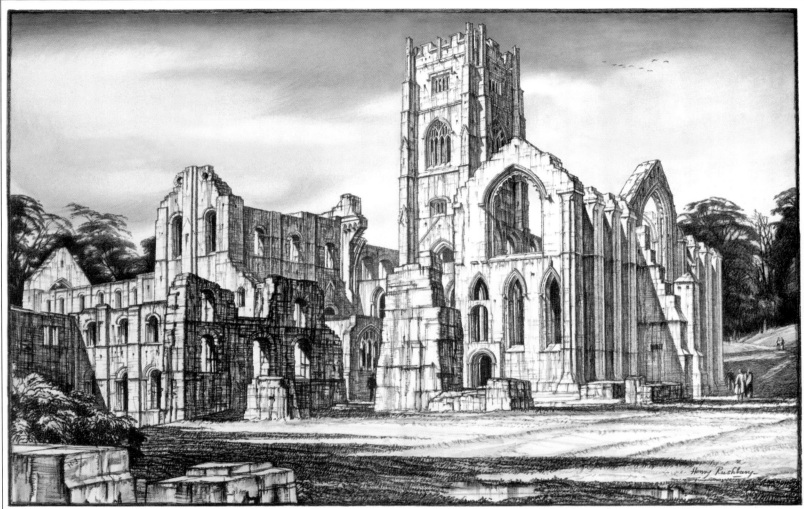

LITHOGRAPHED BY HENRY RUSHBURY, R.A.

 FOUNTAINS ABBEY

TRAVEL BY RAIL TO RIPON STATION

Magnificent Lithograph Poster Issued by the LNER in 1934: Artist Sir Henry George Rushbury RA (1889-1968)

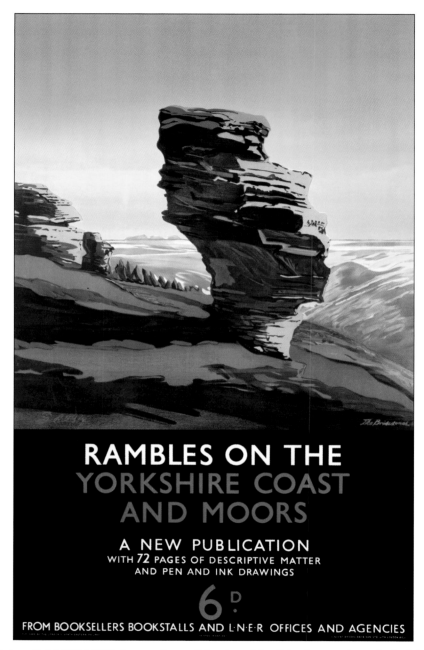

Colourful 1932 LNER Poster from "The Rambles" Series: Artist Schabelsky

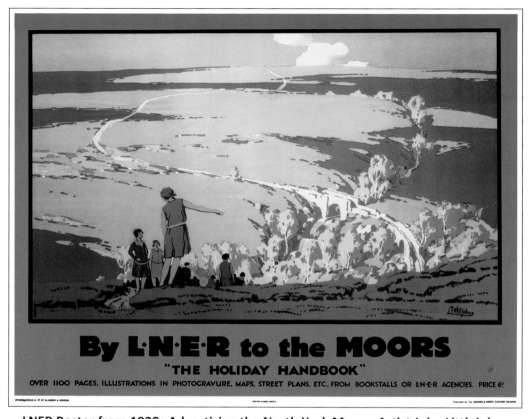

LNER Poster from 1920s Advertising the North York Moors: Artist John Littlejohns

Time to Walk on the Moors

Fountains Abbey is close to Ripon, but it is not yet time to visit the town and instead we head north again to the wild and wonderful North Yorkshire Moors (NYM). As with the Dales, this was a favoured tourist destination and the LNER targeted the area as a means to fill their trains. This colourful pair of posters gives hints of the moorland colours, when the heather is in full bloom. The NYM is the largest continuous expanse of heather in the United Kingdom, covering an area of 550 square miles (1430 km^2). It stretches from Thirsk in the south-east corner, up to Guisborough near Middlesbrough, and almost to the coast. The southern parts are limestone, then a band of Oxford clay that separates the limestone from the sandstone to the north. Shale and ironstone make up the most northerly parts. These bands were laid down in warm seas around 150-200 million years ago (the Jurassic period). The whole area tilted southwards, exposing the ends of these various bands.

Walking on the Moors through seas of heather is one of the great joys when visiting Yorkshire. The LNER certainly recognised this pleasure, and in 1930 commissioned a famous poster. Tom Purvis's bold style and wonderful eye for colour produced this classic. He even had the audacity to put in his own logo on the poster, and for a time the LNER did use it. The poster is devoid of detail, and yet has vibrancy. Seeing the full sized version of this really does make you appreciate his genius.

The North York Moors are drained by two main river systems. The northern section is drained by the River Esk and its tributaries. The Esk flows from west to east and empties into the North Sea at Whitby. To the south the moors are drained by the Rye, Rical, Dove and Seven that all feed into the Yorkshire Derwent in the Vale of Pickering. The Esk Valley is home to a not-to-be missed railway journey (Middlesbrough-Whitby). Passengers (like today) could alight at Grosmont and take the North York Moors Railway down to Pickering. These two lines were built in the 1840s onwards and opened in sections. Dr Beeching closed the Grosmont-Pickering line, but true railway enthusiasts have had the last word!

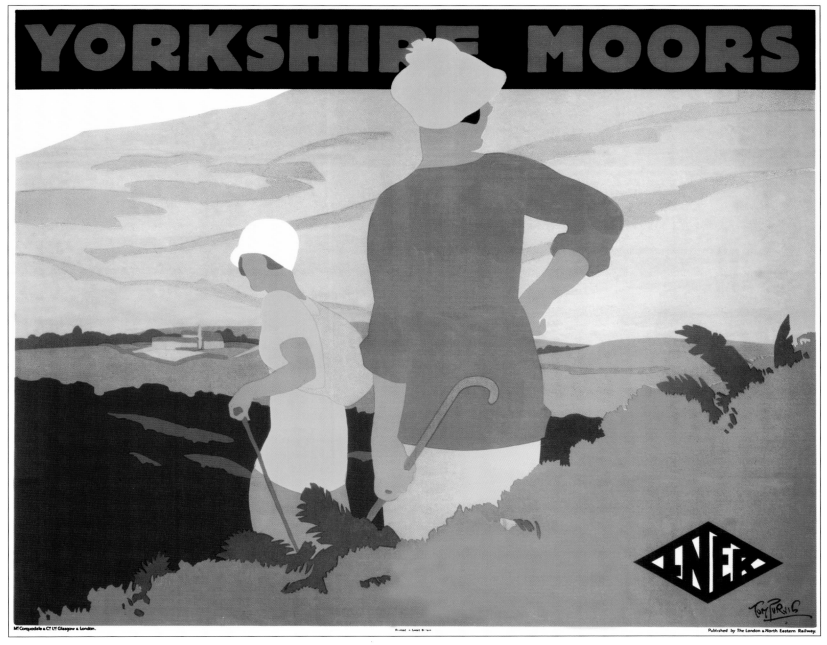

The Classic York Moors Poster from 1930 Using an LNER Logo Designed by the Artist Tom Purvis (1888-1959)

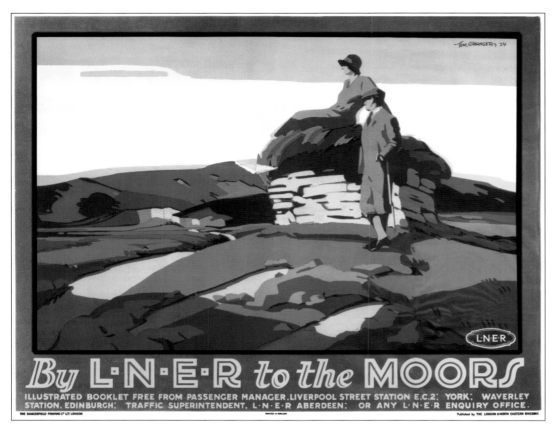

Tom Grainger's Colourful LNER North Yorkshire Moors Poster from 1924

all over England with a concerted campaign from 1924 onwards. Many of the posters were quad royals, chosen so they could show the space and beauty on offer.

The poster below, again by Tom Purvis, is one of his most unusual images. At more than 65 feet (20m) Mallyan Spout is the highest waterfall in the NYM National Park. It is best approached from Goathland. Purvis chose a monochromatic approach, which, for me, does not show the real beauty. After heavy rain it can be a most impressive sight. It is best seen when the leaves are gone from surrounding trees and maybe this influenced Purvis's thinking. It is possible to get really close to the water, as the walker's silhouette shows. Across the centuries, pilgrims found peace and settled on the Moors; hence you will find a wealth of important ruined abbeys, historic churches and priories across the area. To finish this chapter we will take a slow journey through some of them. The LNER produced many in the 1924-1934 decade, and some of the more evocative are shown here for the first time.

The North York Moors Railway runs through Newton Dale; a succession of narrow and twisting gorges that alternate with swathes of colour, as the railway winds north from Pickering. Tom Grainger's early LNER poster also depicts swathes of colour, as our walkers take in the expansiveness and look down on the railway below. In addition to the many posters for the area, the railway companies also commissioned several carriage prints from the same artists. These feature the moorland villages of Lastingham and Hutton-Le-Hole. The former has a church, parts of which date back to the times of William the Conqueror, and the latter has a wonderful green, ideal for picnics while relaxing in the summer sun.

As well as the moorlands there are lush green fields, atmospheric woodlands and crosses and cairns everywhere, helping to point the way on a multitude of footpaths. Our walkers above are resting and gazing from one of these. The LNER bombarded potential travellers

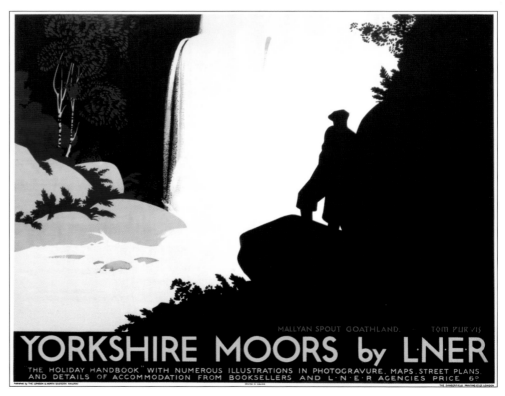

1930s Monochromatic Poster of Mallyan Spout by Tom Purvis (1888-1959)

The Famous Ruined Abbeys of Yorkshire

One of the most beautiful of the ruined moorland abbeys is Rievaulx. This is located in the south-western part of the Moorlands National Park and, as shown in this pair of posters, is accessed from nearby Helmsley station. The picture below was found in the NRM archives in an album of black and white photographs taken of the rarer LNER posters. I personally have not seen this poster, nor do I have records of it appearing in auction. Throughout this Volume several of Haslehust's paintings have appeared, and I have no reason to believe that this one is anything but a beautiful picture. I would love to see a colour photograph, if any readers could oblige. Like Fountains Abbey on the edge of the Yorkshire Dales, Rievaulx is Cistercian. The remote location was ideal for the monks' way of life: their desire was to follow a strict life of prayer and self-sufficiency with little contact with the outside world.

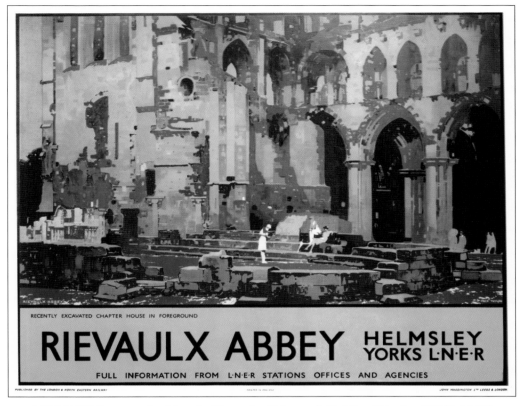

1933 LNER Poster of a Moody Rievaulx Abbey: Artist Fred Taylor (1875-1963)

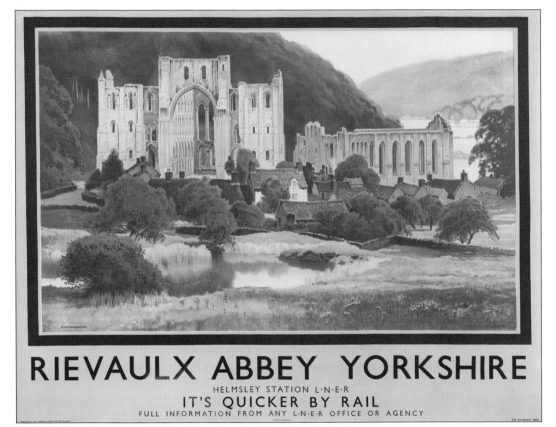

B+W Picture of Another Ernest Haslehust Masterpiece: Rievaulx Abbey in the 1930's

The abbey was founded in 1132 by monks from Clairvaulx, the famous abbey in northern France (founded by St. Bernard in 1115). The names of many of the Yorkshire abbeys are therefore French in origin. You can judge the size of the structure from these two posters, and in time the abbey grew to become second in stature to Fountains Abbey. The river shown behind in Haslehust's painting is the Rye, and wooded hills surround Rievaulx in a sheltered part of Ryedale. In order to create enough flat land to build the substantial abbey, the first job the monks undertook was to move the River Rye! In fact they did this three times in the first 100 years of the abbey's existence, and the Rye is now many metres west of its former course. Traces of the old river banks can be seen in the abbey grounds today. Two hundred years of decline followed in the 13th and 14th centuries, when our favourite demolition expert, Henry VIII appeared in 1538; he signed the death knell, when the abbey was dissolved. Anything of value was stripped away, and the buildings made uninhabitable. The two posters give us a glimpse of what might have been.

Our second abbey is Byland, located near the village of Coxwold. Again the LNER placed the nearest station on the poster for pilgrims and tourists alike. This too is Cistercian and founded by Abbot Serlo of Savigny, whose congregation became Cistercians around 1150. Some of Serlo's followers were resident in the Furness area of Lancashire, and it was a community from here that founded the Byland village and abbey. The abbey was long (as evidenced by the ruins) and became the third richest in the area (after the two previously discussed). Just look at the size of the surviving pillars in Fred Taylor's 1934 painting, and imagine how grand this abbey must have been.

Once the community had settled towards the end of the 12th century, it prospered from sheep-rearing and wool production. This prosperity led to the cloisters being enlarged and glazed: at their height they were one of the largest in England. The people in this poster are standing in the centre of the cloister green and are dwarfed by the abbey ruins. The altar from here is now at Ampleforth Abbey.

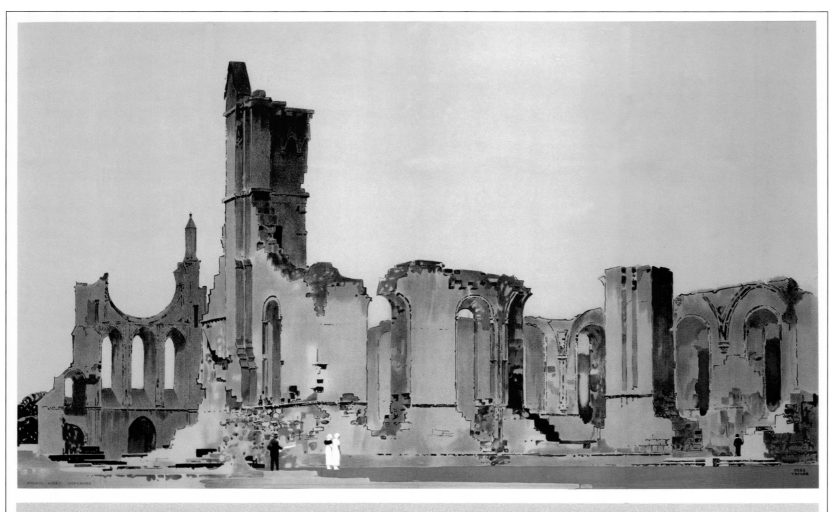

BYLAND ABBEY YORKS

COXWOLD STATION

IT'S QUICKER BY RAIL

FULL INFORMATION FROM L·N·E·R OFFICES AND AGENCIES

Unusual Quad Royal from 1934 from the Prolific Artist Fred Taylor (1875-1963)

Coxwold village also featured in one of the 'Booklover's Britain' series of posters issued in 1933. The Rev Laurence Sterne lived at Shandy Hall in the village, and here he wrote *Sentimental Journey* and *Tristram Shandy* (shown in this colourful first poster). Alongside we have a poster from Freda Marston, of Kirkham Abbey and issued a few years after her death. The abbey is further south nearer to Malton and until 1930, the village had its own railway station. The river shown in this poster is the Derwent. This abbey was Augustinian and many of the buildings date from the 12th and 13th centuries. It was founded by Walter L'Espec, who lived at Helmsley Castle and who also helped with the establishment at Rievaulx.

We end the chapter with another evocative abbey image by Fred Taylor. This is Jervaulx situated at East Witton, near to the City of Ripon. Originally established at Fors in Wensleydale, it was moved eastwards and overall administration came under Byland Abbey. Taylor portrays it in springtime – wonderful! We can only stay a short time as nearby Ripon beckons. It is time to look at some elegant posters.

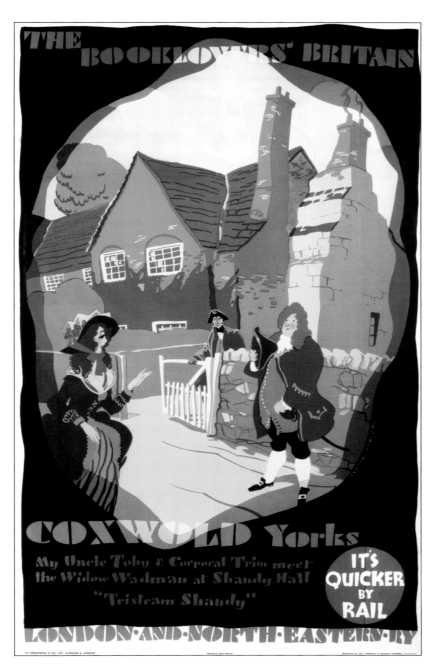
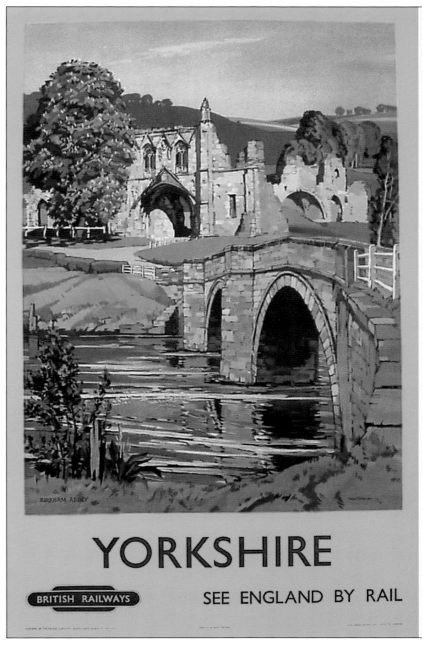

Two Colourful Yorkshire Posters: Coxwold from 1933 by Austin Cooper (Left) and Kirkham Abbey from 1960 by Freda Marston (Right)

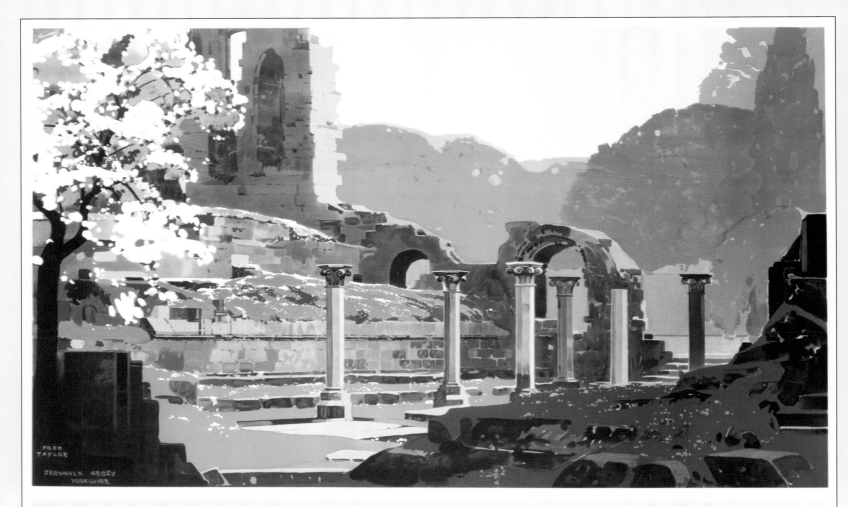

Wonderful 1933 LNER Poster of Ruined Jervaulx Abbey, North Yorkshire: Artist Fred Taylor (1875-1963)

Chapter 8 Yorkshire Elegance

Posters from Ripon, Knaresborough and Harrogate

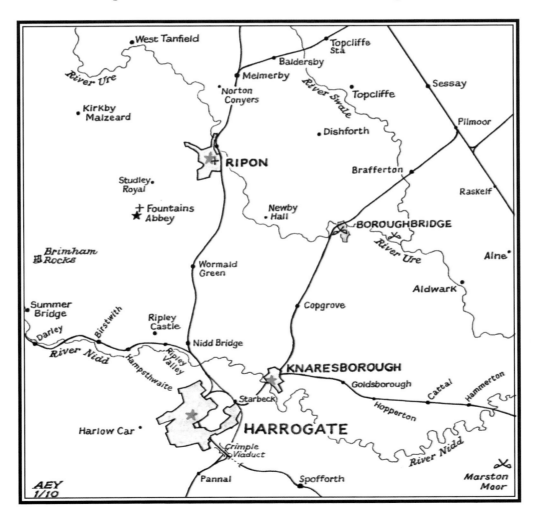

Chapter 8 Yorkshire Elegance

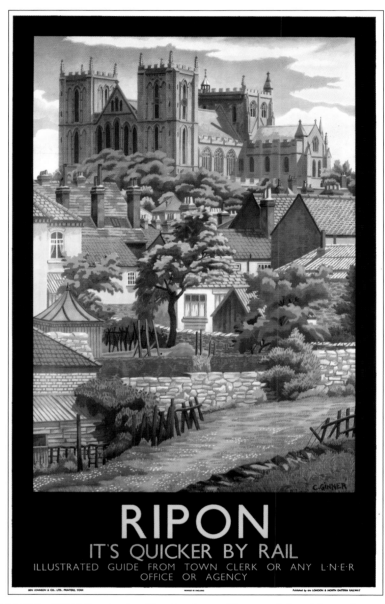

Mid 1930s LNER Poster by Charles Isaac Ginner of Our Ripon Approach

Small is Beautiful

After the scenery and serenity of the Dales and Moors, this part of our journey returns us to elegant cities and towns, and features some of the finest railway 'people posters' of the 20th century. We will begin in Ripon, and then visit Knaresborough and the fashionable Yorkshire Spa of Harrogate. There was an LNER engine named *Irish Elegance*; I have taken this and adapted it to the contents of this part of our journey.

We begin in Ripon and with a colourful work from Charles Ginner. He was born in France in 1878 and died in London in 1952. After flirting with architecture and drawing, he decided in 1904 to become an artist and enrolled at the Academie Vitti. He loved Van Gogh; the colourful style of the Dutch master greatly influenced his style and eye. His tutors hated his works and he left the Academie under a cloud. However, undeterred he joined the Camden Group in London and was a founder of the Cumberland Market Group of Artists. His paintings caught the eye of the LNER who were looking for freshness in the 1930s, and he undertook a commission to paint some of the cities served by the LNER. This poster is from that series. It is really eye-catching and detailed; an ideal beginning to this chapter. Ripon is one of England's smallest cities but has a rich history going back 1,300 years. It is dominated by its lovely cathedral (featured on many railway posters), but has a culture and tradition that also features, as we see later, on a lovely Claude Buckle poster. However, today it has no railway station, as 1967 saw the axing of the ex-NER site that opened in 1848. Its tangerine totems used to be a welcome sight to those visitors who used to come by train. One of these is in my own collection; they are not that common. When it was open, Ripon station was at Ure Bank, a mile north of the city centre.

It is the cathedral that towers over the small city, just as the posters on this pair of pages shows. The first place of worship was built on the site by St. Wilfred in the 7th century, and over the years it is has been redeveloped, added to and upgraded. The present building is actually the fourth complete structure to have stood on this site. The first crypt built in 672 AD does survive, but this is amazing considering that the whole place was razed to the ground in 948 AD, when the King and the Archbishop of York fell out! The first minster was destroyed by William the Conqueror, but over the years the existing building has become a symbol of grace and stability in the area. Ripon Minster was consecrated as Ripon Cathedral in 1836, when the first new diocese was established in England since the reformation and Ripon had its own bishop. The railway arrived at the same time; fancy a Cathedral and a railway station appearing in a decade!

This poster by Fred Taylor shows Ripon Cathedral from above. It is unusual in many respects. There is no real recognized style, being a mixture of Norman sections, mainly unfinished Perpendicular and Early English, with bits of other eras tacked on. It is one of England's smallest cathedrals but at the same time one of the tallest, making it feel more like some of the lofty cathedrals of France. Small it may be, but inside it is quite superb. Stand at the central crossing and simply turn full circle: just wonderful!

Equally impressive is the West Front, added in 1220 in the Early English style. Both these posters show the twin towers, started before the Wars of the Roses and finally completed when the nave and central tower were remodelled. (The central tower had collapsed in 1450). The final series of perpendicular arches were never completed, as the Crown and finance got in the way. Apart from its obvious height, Ripon Cathedral is well proportioned, but is dwarfed by Selby Abbey and Beverley Minster visited earlier in this Volume. The 1878 Lewis organ of 3,400 pipes in its superb Gilbert Scott case sounds rather fine in such an open nave.

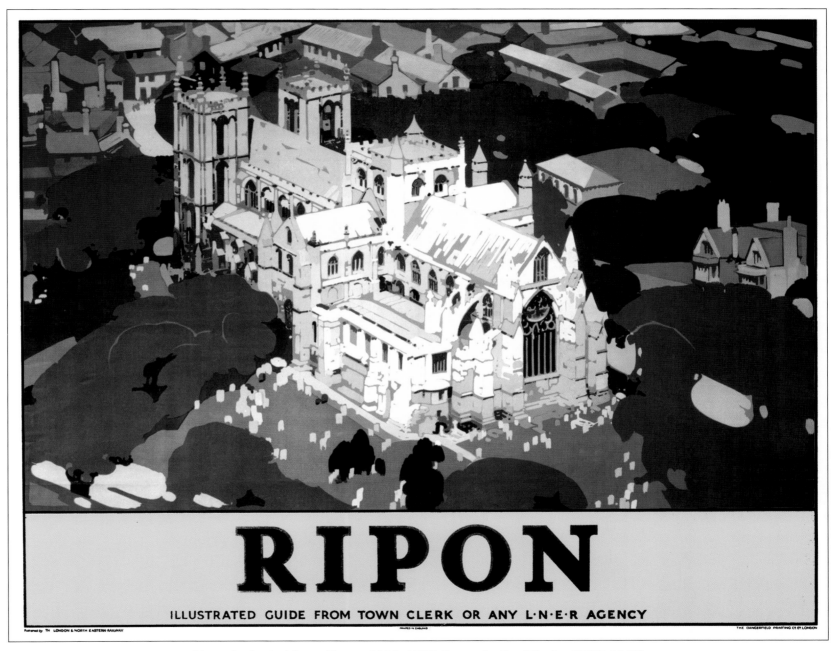

Ripon Cathedral from Above: 1930s LNER Poster by Fred Taylor (1875-1963)

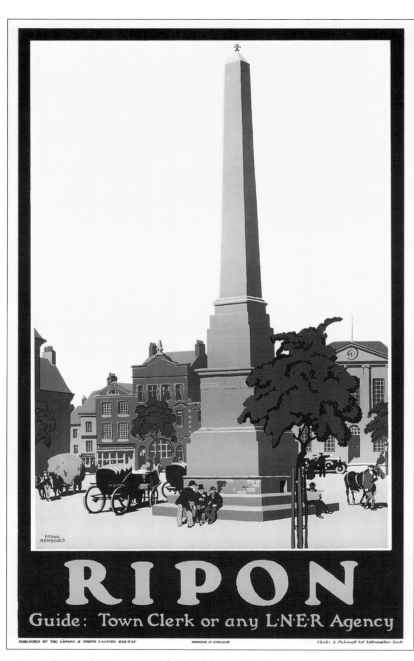

Far left, we come to one of the most interesting paintings from Claude Buckle of the Wakeman of Ripon. This is one of England's oldest traditions, stretching back more than 1100 years to Saxon times. This 1960 BR poster commemorates the tradition that warns the city of Viking raids. King Alfred the Great was on the throne and when he visited the settlement of Ripon in 886, he granted a Royal Charter, with the gift of a horn to help warn of invaders. This is still sounded every evening at 9pm, from all four corners of the Market Square, to tell everybody that the Wakeman is on duty and the watch is set. The wonderful horn is shown to perfection in this historic poster. One of the horns held in the city is a gift from the people of Ripon, Wisconsin. Made from Buffalo horns this cements the close ties between the two cities. (Google Earth also shows there is also a Ripon in California).

The 300-year old obelisk, where the Wakeman performs the nightly ritual, is shown in Frank Newbould's 1930 poster. The fine buildings that surround the square are depicted with horses, carriages and dress from Edwardian days. Sadly, neither of these posters appears that often.

Ripon City: Claude Buckle (Left) from 1960 Contrasts with Frank Newbould (Right) from 1930

As a market town, the market day is central to Ripon's culture. It is held on a Thursday, with stalls run by traders from the surrounding area. In celebration of the city's founder (St. Wilfrid), the *Wilfrid Procession* is held every year. It originated in the year 1108 when King Henry I granted the privilege of holding a day-long fair for him.

Wherever you are in Ripon, the cathedral is visible. This final pair of posters for the city shows two views. Spradbery chose the River Ure as his main focus, with the misty religious silhouette behind, whilst Schabelsky took a far more colourful approach for his poster advertising one of the guides issued by the LNER in the 1930s. This shows the side elevation in detail, and I think this lovely building would be almost perfect with a central spire instead of the rather squat tower. The poster artwork, however, is exquisite.

When the railway ran here, we could have caught the local train down to Harrogate, but despite fierce local protests, the BR axe meant an English city was severed from all but road connections. Magically, therefore, we will have to fly to our next destination, Knaresborough.

LNER Advertising Posters from the 1920s and 1930s: Spradbery from 1924 (Left) and Schabelsky from 1934 (Right)

Knaresborough

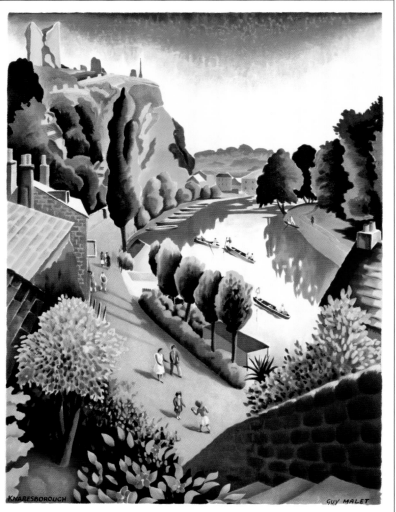

Before ending the chapter in Harrogate, we first make a brief visit to the Yorkshire Spa and Market Town of Knaresborough. The railway from Harrogate enters the town from the west, over the Nidd viaduct. As we enter, the Gawthorn poster shows us the superb view from the carriage window.

The elegant four-arch bridge was completed in 1851, to carry a branch of the new Leeds and Thirsk railway over the River Nidd. As much of this fashionable town is built in stone, engineer Thomas Grainger wanted the huge structure to blend in to the environment: it does so very well.

As we sit in the carriage, we are nearly 80 feet (25m) above the river. The viaduct is 250 feet (80m) long making each arch around 60 feet (19m). Looking in the other direction, the second poster shows us the depth of the Nidd Gorge at Knaresborough. The colourful poster by Guy Malet is a rarely seen work, and both posters show the river as a hive of boating activity. These posters appeared within a year of each other, as the Spa town was one of the focuses for railway travel. Advertising for this lovely spot is rarely seen today.

Two LNER Posters from the Mid-1930s: Henry George Gawthorn (1879-1941) (Left) and Guy Seymour Warre Malet (1900-1973) (Right)

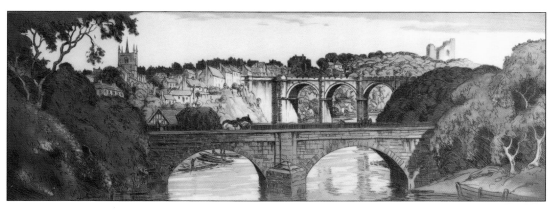

Carriage Print Artwork of the Nidd Gorge, Knaresborough by Cyril Barraud

These two lovely examples of railway art give us a better perspective of the Nidd Gorge. In Barraud's unusual carriage print, the bridge in the foreground is also seen in Gawthorn's poster. The town was built in a location where defending it was easy. Like Skipton, it has the river on one side, and rising ground on the other. In the distance in Barraud's picture, atop the highest hill in the town, is the ruin of Knaresborough Castle, which dates from Norman times. This was the refuge in 1170 for Hugh de Morville and his fellow assassins who, after murdering Thomas A Becket in Canterbury Cathedral, 'high-tailed' it northwards hoping to escape the wrath of the King. However, they were found and dealt with! The castle was extensively rebuilt and strengthened by Edward I, and as a Royalist stronghold, it came under Roundhead attack in 1644. Once taken, it was ordered to be dismantled and many of the buildings in the town are said to be built of castle stone.

Jack Merriott chose to look up to the viaduct from a boat on the river just as the train crosses. This popular poster is one of the very few that British Railways produced for this town. Merriott used colour scattered along the river bank to give the simple bridge some added interest. The reflection in the water is masterfully accomplished. The theme of the lady with the parasol relaxing as she is taken along the river is picked out in the first poster on the next page.

Knaresborough was mentioned in the Domesday Book (as Chenaresburg), but was not granted a Royal Charter until 1310 (by Edward II). Markets, however, had been held for more than a century before that, so it was a natural choice for Austin Cooper's poster. Mineral waters were an attraction long before the railway came in 1851, but once built, this enabled day visitors to come more easily from Leeds and Bradford.

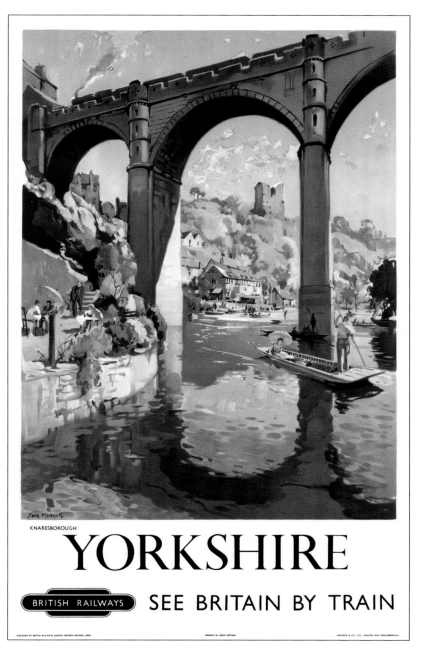

View of Knaresborough in 1953: Artist; Jack Merriott (1901-1968)

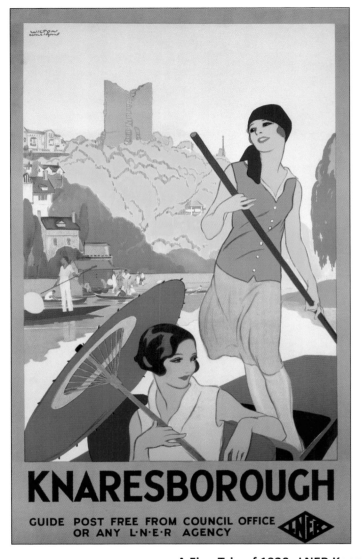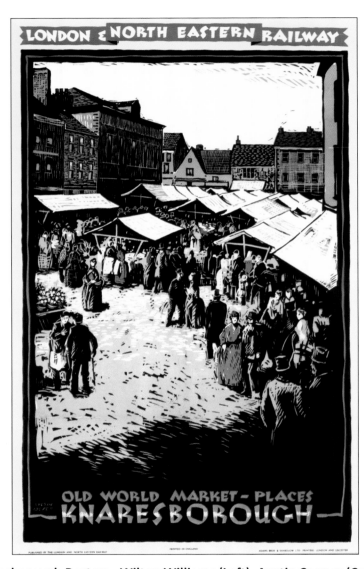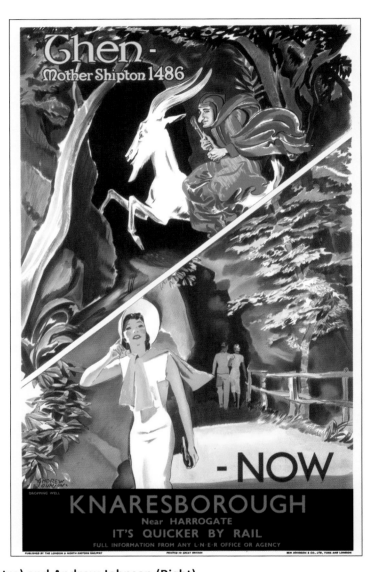

A Fine Trio of 1930s LNER Knaresborough Posters: Wilton Williams (Left), Austin Cooper (Centre) and Andrew Johnson (Right)

This trio shows how concentrated the LNER's marketing approach was for Knaresborough in the 1930s. It also shows the diversity the artists took in portraying the town. Wilton Williams produced an almost oriental style image; quite a contrast from the darker Austin Cooper poster of the town's market, which formed part of the series commissioned in 1932. Near Knaresborough is Mother Shipton's cave, where legend has it that the soothsayer and prophetess Ursula Southseil (Mother Shipton) was reputedly born in 1488. It has been a tourist attraction since 1630, and Andrew Johnson used the legend in his poster, issued as part of the *'Then and Now'* series. This poster contains some imaginative artwork.

This final Knaresborough poster is arguably the most famous. It was painted by Sir Frank Brangwyn. It was one of the earliest LNER commissions, and appeared a year later in 1924. At that time Brangwyn was at the height of his popularity, and Teasdale gave him several Yorkshire and north-eastern subjects, all of which were painted in the same style. (His Durham poster is the rear cover and the atmospheric North East Industries is found on page 64).

This poster gives the best impression of the rock bluff that protected the town from the south and west. A similar, though larger, viaduct was found on the line northwards from nearby Starbeck towards Ripon, but this was closed in 1967 when the line was dismantled. That viaduct was twice the length of the one depicted here, and crossed the Nidd further down the gorge at more than 100 feet (30m) above the river. Today passengers can travel only east-west, but in former times Ripon to Knaresborough must have been a wonderful train journey. It is just a short four-mile train trip today to take us westwards to Harrogate, to visit Yorkshire's most renowned Spa town.

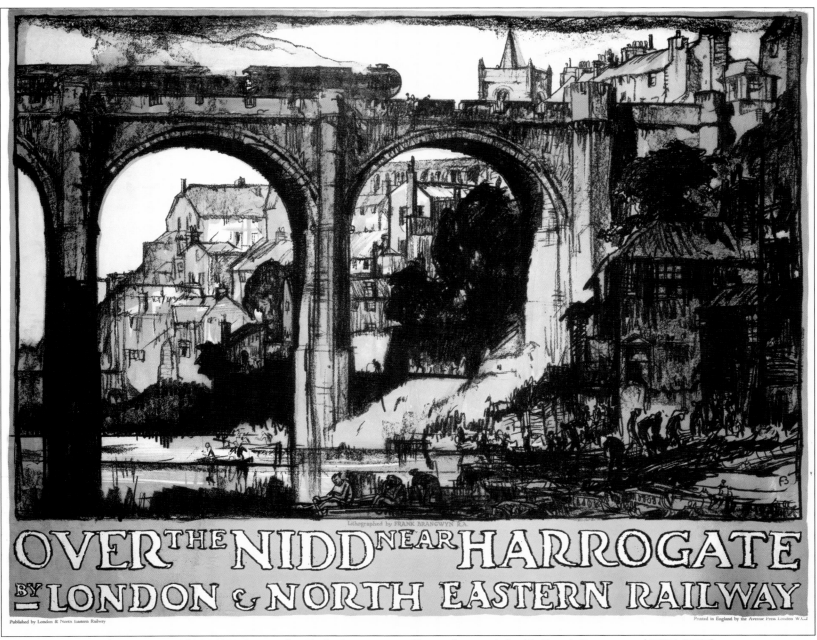

The Famous 1924 LNER Poster for Train Journeys to Knaresborough by Sir Frank Brangwyn (1867-1956)

The Spa Town of Harrogate

Harrogate is one of the most pleasing and refined of the English Spa towns. Located as it is in the Nidd valley on the edge of the Dales and Moors, it could be a natural centre to visit all those places described in the previous chapter, as well as having superb local amenities within the borough boundaries. Harrogate is famous for its parks, tea shops, antique bargains, Turkish baths and best of all (according to my wife Judi), its shoe shops! It has always been a place of elegance, once the mineral spas had been founded and developed. The spa water contains iron, sulphur and salt, so that in the 17th and 18th centuries, a string of affluent but sickly people began to use the health spas, and the wealth of the town was established.

Walking here is a pleasure, especially when summer sunshine abounds. Our first poster sets the scene nicely. Having arrived by train from Knaresborough, what better way is there than to go and 'people watch' in the Valley Gardens. This has been the subject of several great posters, but the one shown here is more expansive, to give a wider feel to the town. British Railways followed the LNER lead and issued this in 1950. I can't help feeling though that Moody did not make the most of what is a potentially great British scene.

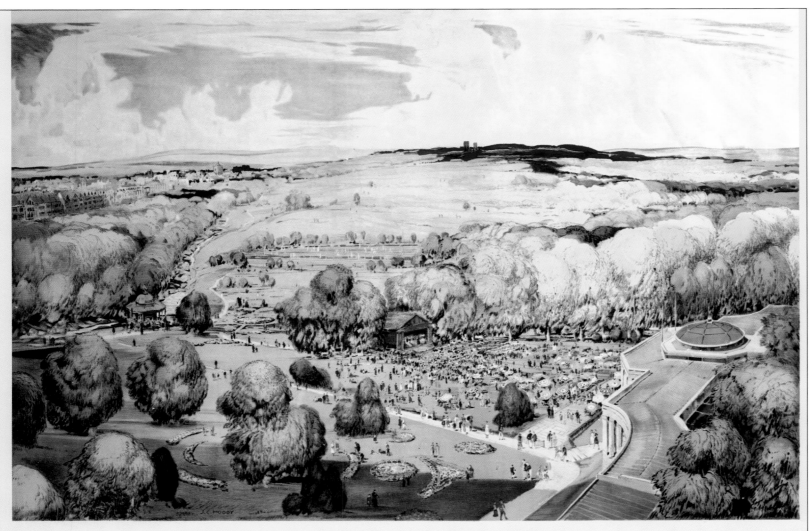

Panorama of the Valley Gardens and Sun Pavilion Harrogate: BR (NER) Poster from 1950 by John Charles Moody (1884-1962)

In order to emphasize this, just look at Henry Tittensor's portrayal of the Royal Baths in nearby Crescent Road in 1941. This was painted at the height of the Battle of Britain. This is beautifully painted and composed, and is the first glimpse of why I chose the title for this chapter. Here we see all the attributes that attracts visitors to Harrogate. Notice the colouring and warmth of the buildings, the Yorkstone soaking up the summer sun. WWII has seen key military departments moved up from London to Harrogate for security reasons, but individual hats and sporty blazers are still the order of the day.

Located in the centre of Harrogate, the 17-acre Valley Gardens lives up to its international reputation with a staggering variety of seasonally planted formal and informal displays. It is a lovely dell, full of Rhododendrons and contrived woodlands that take the visitor today to the nearby RHS's Harlow Carr Gardens. Within the early development years, almost half of 80+ mineral wells in Harrogate had been found within the boundaries of the gardens.

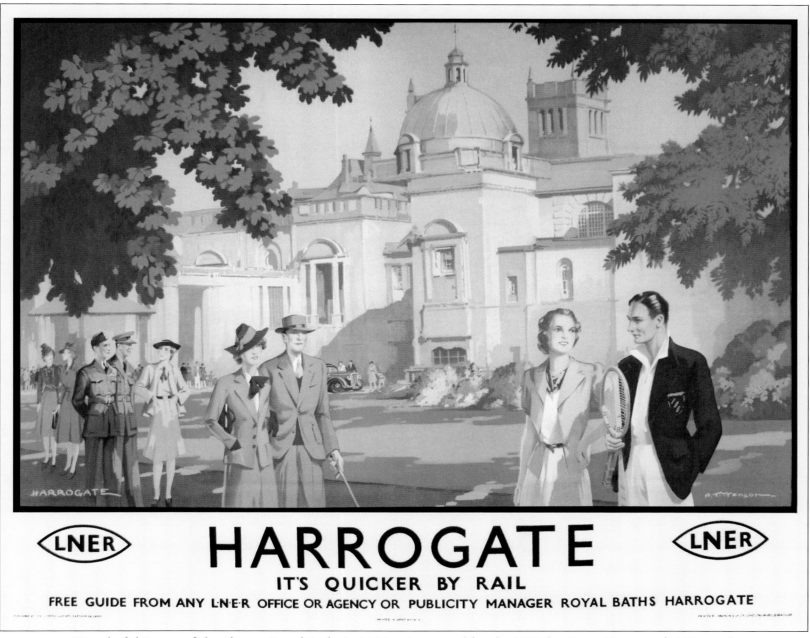

Wonderful Poster of the Elegant Royal Baths in 1941 as Portrayed for the LNER by Henry Tittensor (1887-1942)

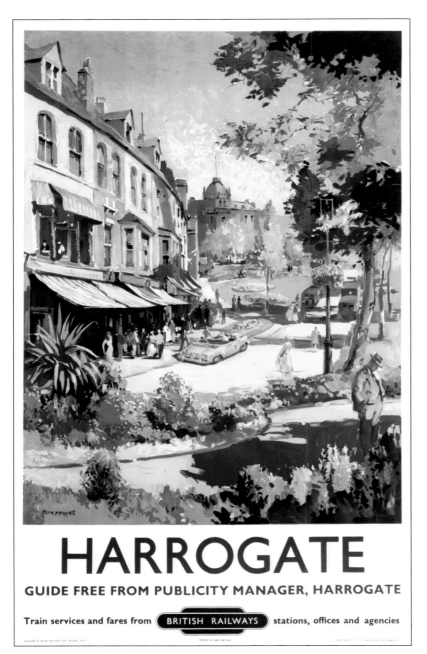

Wonderful 1957 Poster of Floral Harrogate: Artist Jack Merriott (1901-1968)

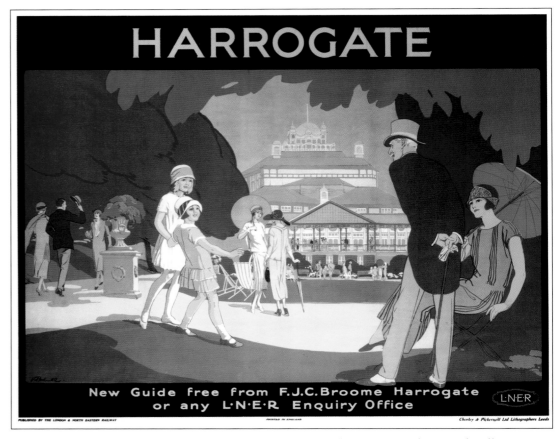

Classical 1925 View of Harrogate Pavilion Gardens: Artist Lilian Hocknell

The floral theme is continued in this pair of posters as we wander aimlessly though the gardens, and take in more summer sun. Harrogate has always been big on flowers and Steel's classic Coronation year poster shows this well. During the summer, visitors can take in the scent of thousands of blooms, as a myriad of bees and insects fly everywhere gathering pollen. Formal elegance returns in Lilian Hocknell's poster that appeared in 1925. Now here we see elegance in abundance. Contrast the style of dress with that on Tittensor's poster on the previous page some 15 years later.

The gardens began around 1778 when mineral springs were exploited, but it was not until the late Victorian years that formal designs and planting appeared. The present-day Sun Pavilion appeared in 1933, and the pergolas, walkways and exotic plants appeared in the late 1950s, when gifts of New Zealand plants were made.

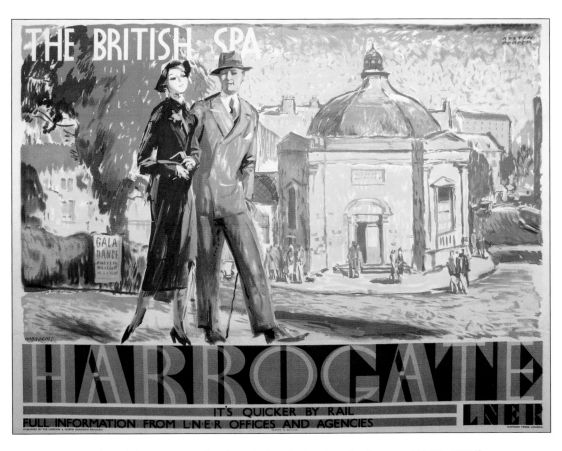

Colourful Harrogate in the 1930s: Artist Austin Cooper (1890-1964)

This second pair of posters provides further evidence of the changing style of advertising for this lovely area of Harrogate. The early Edwardian poster would not really induce me to travel here, but Cooper's colourful rendition above almost certainly would. This poster is unusual for Austin Cooper, and not instantly recognized as his. The buildings are poorly painted compared to the poster alongside, but the colour more than compensates.

The GNR poster is a rarity, and is included in response to comments on Volume 1, when more pre-grouping images were requested. This would have benefitted from anything but a black sky. If Britannia had been colourful against a blue sky, this would have made a most elegant poster. The Royal Baths are prominent again here. This quartet spans two generations and are contrasting examples of advertising in the first half of the 20th century.

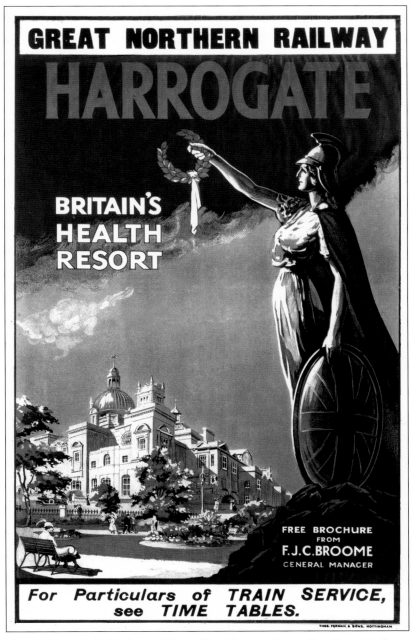

Poster by Unknown Artist from Edwardian Times: Great Northern Railway 1910

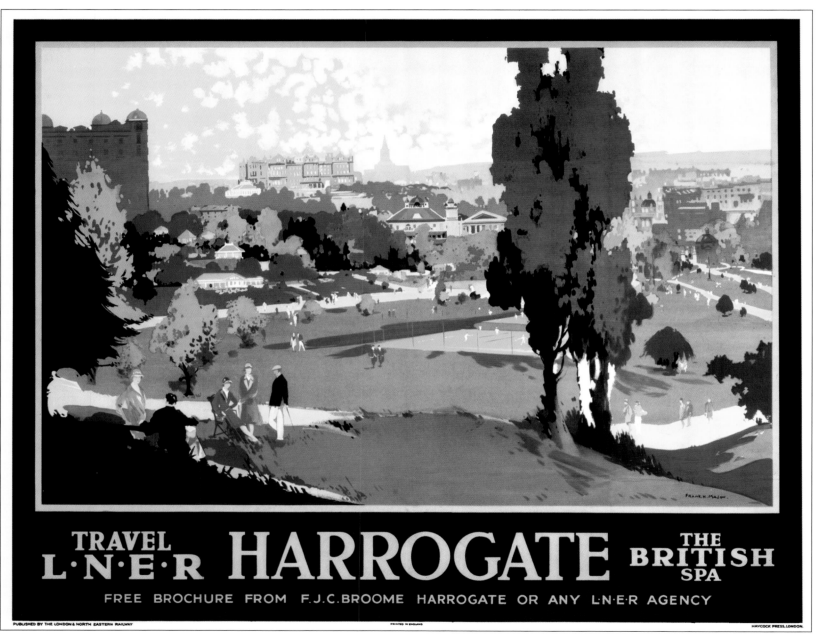

Frank Mason's View of the Harrogate Gardens, Yorkshire: Issued by the LNER in 1930

This next poster is in complete contrast to the previous four, and is for me, one of the great Frank Mason's least attractive posters. I included it here because it is a rare poster, and is different to how most of the other artists portrayed central Harrogate. In late Victorian times, and up to WWI, Harrogate was extremely popular amongst the English elite and European Nobility. After the war there was a decline in visitors. Therefore, from 1926 onwards, the LNER decided to do something about this, and many posters were commissioned. Why this one was published is not clear, as it would hardly invoke rail travel.

However, the poster campaign did work, and the number of visitors started to increase again, as WWII loomed. What helped the wartime economy is that several Government departments were evacuated from London to Harrogate, so that military personnel were a common sight (as in Tittensor's poster). This meant many meetings and battle conferences were staged, leading to the foundation of Harrogate as a major UK Conference centre. Its transportation links, (road, rail and the nearby Leeds/Bradford airport) are added bonuses for business travellers. The town's railway station was built in 1862, following on from the 1848 station at nearby Starbeck. We will see posters for the Harrogate Pullman a little later.

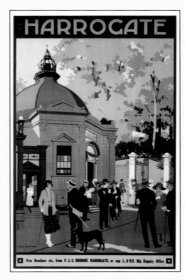
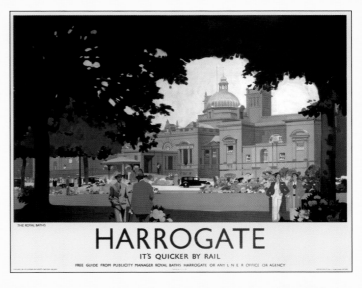

A Fine Selection of Harrogate Railway Posters from the 1920s to the 1950s (See page viii numbers 296-301 for details)

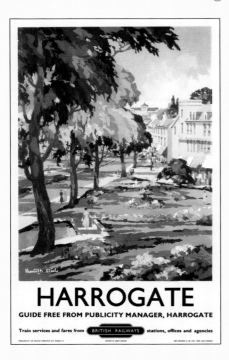
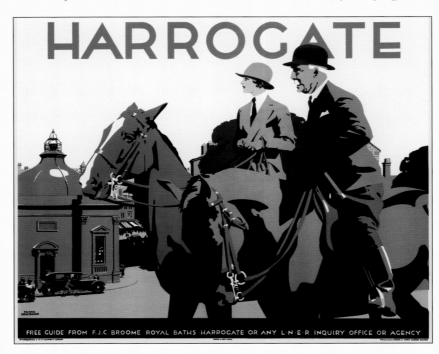
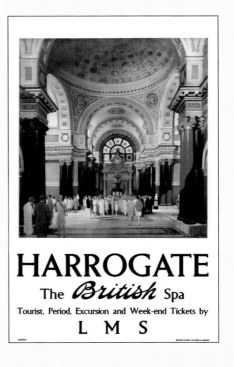

Formal and Informal Socializing

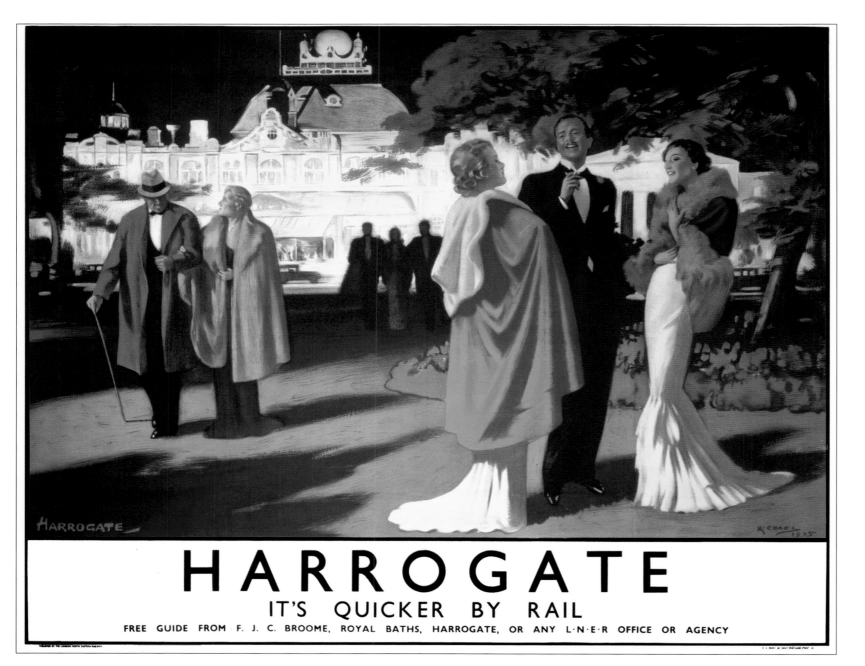

A Formal Evening in Harrogate: Arthur C. Michael's Classical 1935 Image

As you may imagine, there were very many Harrogate posters issued, far too many to include all of them here, so a small selection is given on the previous page. These include works from Fred Taylor (top right), Kenneth Steel (bottom left) and Christopher Clark (bottom right). The Clark poster is unusual, being from the LMS. Harrogate is firmly in LNER country, so when the town was being promoted, it was unusual to see a rival company making the promotion. The poster shows the interior of the Royal Baths, a quite magnificent building. The buildings in Valley Gardens feature in posters from Gawthorn and Newbould (top centre and bottom centre), but all the posters depict style and affluence. The poster alongside shows us the end of a formal evening in Harrogate. People have been to the theatre and are now socializing on an early autumn evening. The fur coats and wraps guard against chill winds, but Michael's poster clearly shows us elegant Harrogate. This was issued in 1935, when the LNER was making its major marketing effort. When this was painted, the town had come a long way from the discovery of the first health spring in 1571. The waters were similar in composition to those at the Belgian resort of Spa, hence the usage here.

Over the years, people came from far and wide to partake of this inland resort, and some of these visitors are shown in the colourful quad royal by Anna Zinkeisen. The backdrop is the Sun Pavilion, but in front are people of all ages visiting the town.

The start of the real growth can be traced back to around 1631, when a second well (the Sweet Well) was discovered by Dr. Michael Stanhope. The town grew steadily in the 17th century, and the first inns appeared from around 1670 for the visitors. The land was divided up between the local gentry, but some 200 acres were left for public use. This is why there are so many parks, gardens and pavilions around central Harrogate today.

A Georgian theatre was built around 1788 and other facilities appeared too, so that by 1800, the population had grown to around 4,000. By the end of Queen Victoria's reign it was more than 25,000. The arrival of the railways in 1848, as with many towns throughout Britain, signalled the start of modern-day Harrogate. From 1900 to 1950, the population had doubled again. But time was not kind. The Royal Baths closed in 1969, The Royal Pump Room became a museum and many of the wells were sealed.

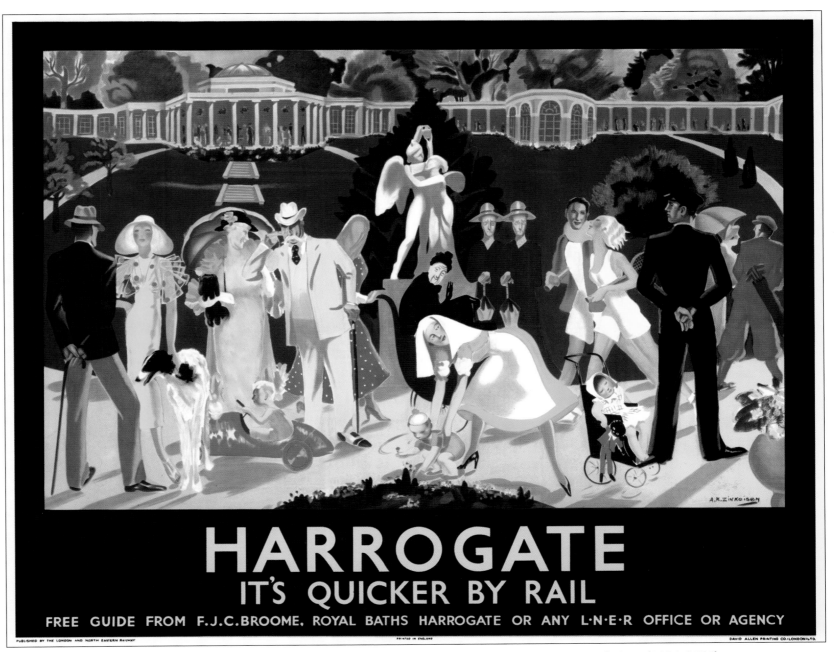

Unusual LNER Quad Royal from 1934: The People of Harrogate by Anna Katrina Zinkeisen (1901-1976)

1936 Socializing in Harrogate by an Unknown Artist

This is an unusual poster and for botanists, a great study in trees. It appeared around 1933, when the LNER was pushing hard to promote the Spa using the new *'Its Quicker by Rail'* slogan. The majority of the classical Harrogate posters seemed to appear between 1930 and 1936, but this poster is one of those rarely used. I am sure this is the first time this has featured in any book. It is unusual for such a distinctive poster not to carry the artist's signature, so if readers can help to identify the painter, I would be most grateful.

It shows one of the many social gatherings that took place during the summer months, and could be an event linked to the Yorkshire Show. Clearly this event is in central Harrogate and, judging by the crowd gathered around, some type of performance is taking place. As with most of the posters from here, everybody is well-dressed and apparently well-behaved – attributes that would be most welcome today!

As well as the facilities in and around the town centre the nearby 250-acre (100 hectare) showground stages the major events, such as the Harrogate Flower Show and the Great Yorkshire Agricultural Show, when some of the joys of yesteryear re-appear.

Theatre and Holidays

The Royal Hall is a magnificent Edwardian theatre, which was built in 1903. It was originally called the Kursaal, but after WWI, the name was changed to Royal Hall to reflect the mood of patriotism that swept the country. The building was designed by architects Robert Beale and Frank Matcham, and is thought to be loosely based on Ostend Kursaal in Belgium.

The origin of the word Kursaal is German, meaning literally a 'Cure Hall'. However, this has come to mean a hall for grand events and special occasions. Such buildings were popular throughout the Spa resorts of Europe, but being British, they never caught on here! Matcham in particular was a leader in this field, being responsible for many landmark theatre buildings in late Victorian times. Two of the most well-known, when the Royal Hall was commissioned, were the London Coliseum and the Hackney Empire. Taylor's late 20s poster shows the sumptuous interior. Major refurbishments over the years have maintained the character of this great theatre.

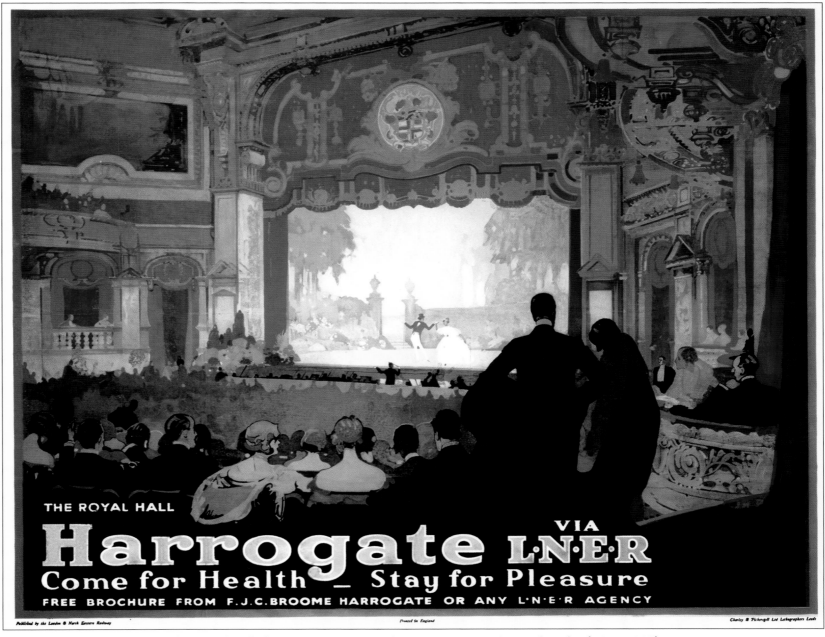

The Royal Hall Theatre Harrogate in the Late 1920s: Artist Fred Taylor (1875-1963)

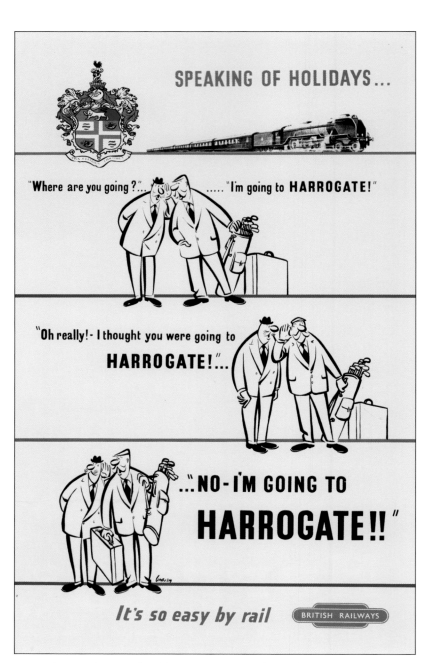

British Railways Advertising for Harrogate in 1960: Artwork is Unknown (Left) and by Carney (Right)

British Railways began to move away from classical art around 1960. Photography had rapidly developed, so that excellent images could be reproduced in full colour and in high resolution. The first poster here is typical of the collages produced from 1960 onwards. Gone is the elegance and the panache of the decade earlier. Would this make you want to visit Harrogate – in my case, no. The town and its attractions had not changed, but the advertising style to induce us to go there most certainly had.

Alongside is the other style – caricatures. This most certainly might catch the eye, but as a means of promoting the town, it does fall short of what I would expect from an advertising poster for this Spa. Harrogate is a 'gold shoe shop' town with wealth, influence and style. It is interesting to contrast this pair of posters with the two opposite.

In order to attract the 'right clientele', you have to get them there in style. The Harrogate Pullman ran from Kings Cross to the Spa Town via Leeds. It ran at convenient times – late morning to mid-afternoon.

The British Medical Journal of 19th July 1919 carried an article about the new Pullman to Harrogate that started running the following Monday. Strange place for a railway advert, I hear you say', but the BMA was extolling the virtues the 87 different health-giving waters that the Spa offered.

The new service offered travelling in comfort and dining in style and all this for 7/6d First Class! In later years it became the Harrogate Sunday Pullman, leaving Kings Cross at 09.40. It must be the right way to travel 200 miles or so in Britain, and if we had high speed lines offering a similar service today, I am sure it would be successful.

Harrison's 1923 poster shows the dining car as we speed northwards to take in that 'Yorkshire Elegance'. A few hours later we are sitting in the park telling a young couple how superb the Pullman is. Septimus Scott's superb poster rounds off the chapter very nicely!

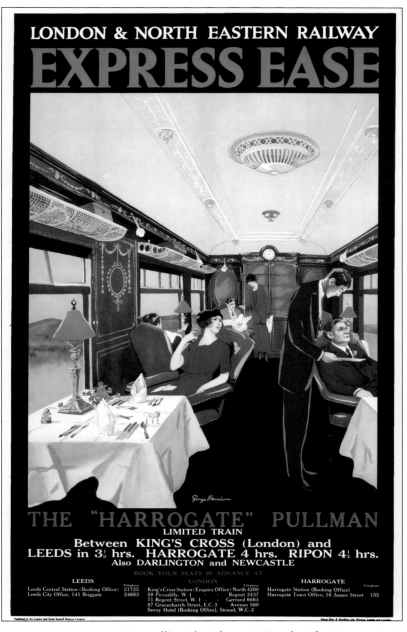

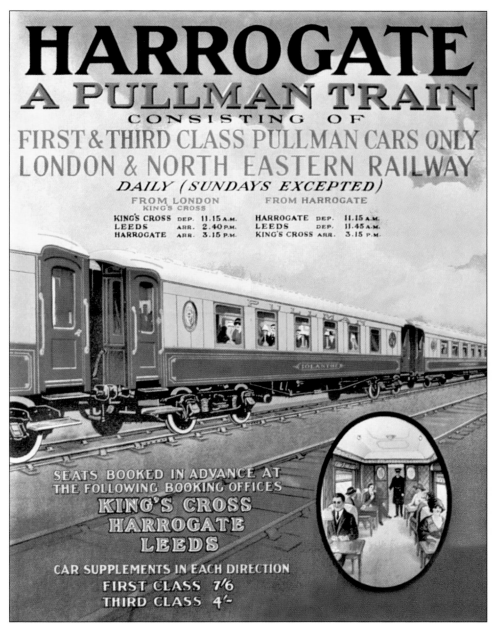

Travelling the Elegant Way by The Harrogate Pullman: George Harrison (Left) and an Unknown Artist (Right)

HARROGATE

LNER 1933: A Wonderful Summer's Afternoon in Harrogate: Artist Septimus Edwin Scott (1879-1962)

Chapter 9 Eboracum: The City of York

Posters from the City of History and Railways

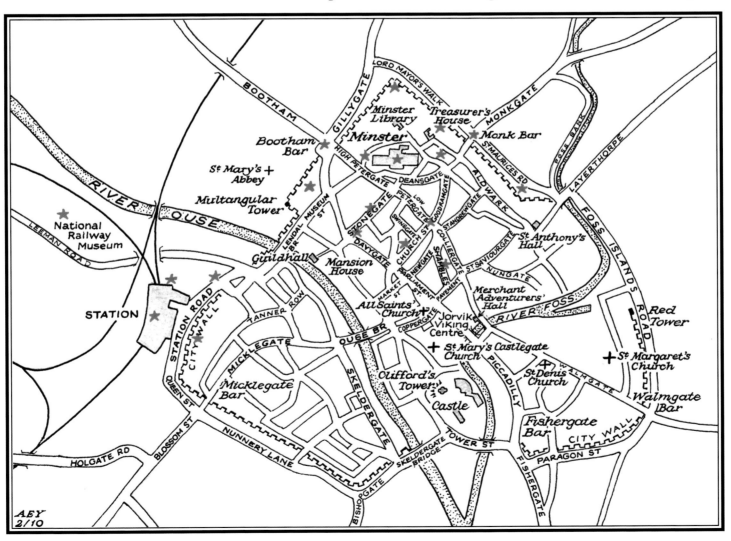

Chapter 9 — Eboracum: The City of York

Superb British Railways Heraldic Poster from 1956 for the Ancient City of York: Artist E.H. Spencer

The Crown Jewel in Yorkshire

For the visit to a city with such a rich history, we must start with a wonderful painting, and there is none that shows the richness of York more so than E.H. Spencer's 1956 poster. All the history, architecture and pageantry of the City of York are depicted in full colour. Down through the ages this city has seen it all. Some of the famous characters of the past grace the poster, along with probably the best group of heraldic shields on any railway work of art. Spencer was a master of such subjects, but what is especially pleasing is his composition, faced with such a vast array of information to work from.

BR commissioned this, showing that at least one person in the National Railway Company had a desire to propagate the city's past. In this poster Spencer's treatment of the Minster and city walls is superb, with the two coats of arms of the City of York and the See of York, placed in the centre. This chapter marks journey's end for this Volume, but we have in York the epitome of English history. Not surprisingly, posters from here go back to the early days of railways, and it is poignant that the home of the greatest collection of British railway posters (the NRM) is also here.

Before we start the tour proper, the poster shown alongside deserves a special place. This is the first poster that the LNER produced, appearing at the start of the summer season in 1923. The LNER turned out to be the 'fastest out of the blocks' of the newly formed 'Big Four' companies, when their publicity departments began work in the early months of 1923. The General Manager, Ralph Wedgwood, had appointed W.M. Teasdale as his Publicity Manager, and this turned out to be an inspired choice. Teasdale had come to the LNER from the NER, one of the most progressive of the pre-grouping companies in publicity terms. He also recognized the visual image, and was very much in favour of modern art and the use of colour and style to give a strong corporate image. His vision and drive became the cornerstone of the LNER, enabling them to produce some wonderful posters in the early years.

What is intriguing is the choice of subject for their first poster. Tourism was all about holidays, travel, scenery and places of interest. Who but Teasdale would have decided HIS place of interest was the interior of one of England's greatest cathedrals. It also set the seal on why Fred Taylor was then asked to paint so many of York's architectural masterpieces. Taylor looked at the other classical British cities in the same terms; Lincoln, Durham, Edinburgh, Norwich and Ely were given similar treatment.

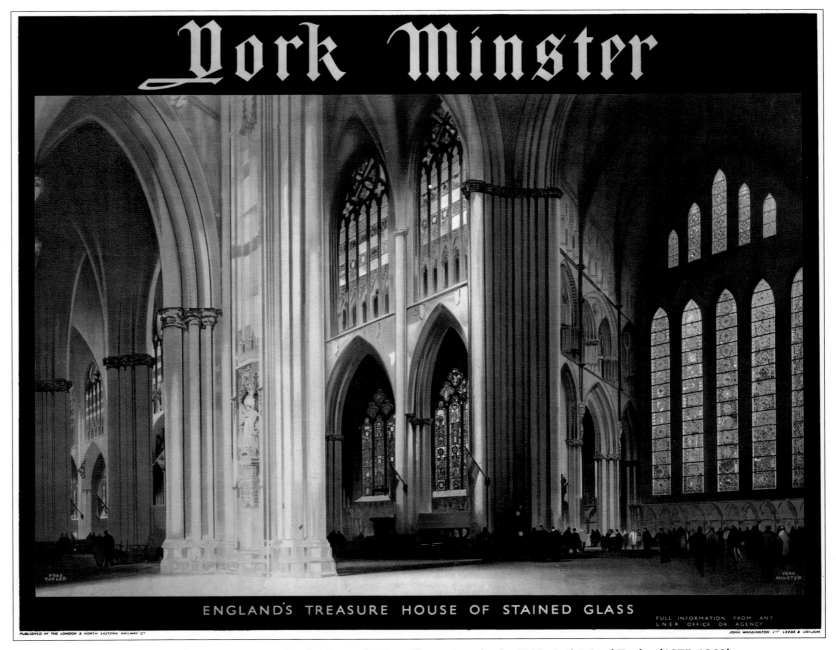

The Very First LNER Poster: York Minster's Magnificent Interior in 1923: Artist Fred Taylor (1875-1963)

York
From an original painting by Brendan Neiland to celebrate the launch of the InterCity 225 from London to Edinburgh.

INTERCITY

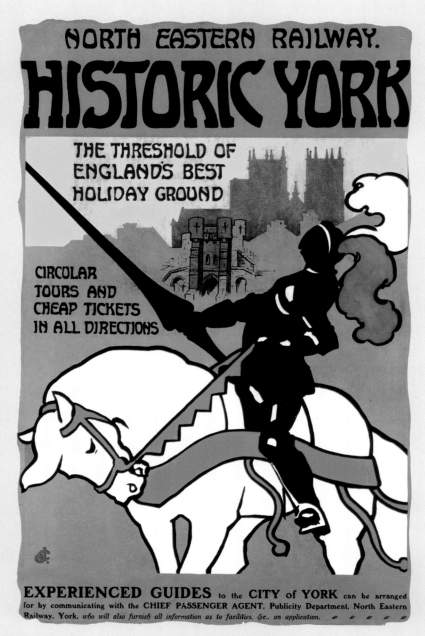

Today we arrive in York from the north or south on a gleaming white charger. Seven hundred years ago we would have arrived in York on – er – a gleaming white charger! Only the speed and technology has changed. York's fabulous railway station (recently spoilt by the wires), is shown far left, with the reason we are here alongside. For me both of these represent the best of British poster art. The Neiland poster from 1991 is instantly recognized (though some people might say Newcastle), but look at the style and direct message in the NER poster from around 1910. This is the design heritage where Teasdale learned his craft, and it is actually not that surprising he did so well so quickly.

The railways came to York as early as 1839, when the York and North Midland built the first small platforms on Queen Street, inside the city walls. These lasted less than two years as the North Eastern built the first of their stations. The 1841 station was the first to contain a travellers' hotel within its structure. A new station appeared in 1877, designed by Prosser and Peachey. With 13 platforms, it was the largest in the world when new. Its curved layout was stunning and its beauty is still appreciated by passengers today.

Arrival into York in the 1990s and the 1290s: Artists Brendan Neiland (Left) and Unknown (Right)

Walking Through Historical Streets

Walking from the station, the first port of call is for a pot of Yorkshire tea in the Royal Station Hotel. Gazing from the Rose Restaurant, the Minster is seen towering over the city in the distance. As we take our tea, the waiter brings us a city guidebook and lo and behold on the cover is a railway poster painting by Kenneth Steel of the joys that this city affords (right).

This was York's second Royal Station Hotel; the first had been built adjacent to the first station, and was demolished when the station was redeveloped. It opened a year after the second station, and being built of Scarborough yellow bricks, the elegant five floors had a better overall appearance than the hotel it replaced. It featured elegant, high-ceilinged banqueting rooms (as shown in our poster alongside), and 100 large bedrooms for anyone who could afford 14 shillings a night. I bet the cost has gone up 'a few bob' since those times!

Our 1965 city guide book cover has us standing in Gilly Gate, looking through Bootham Bar towards the west front of the Minster. Steel painted two posters for this location (the other is found on page 223), and this is the lesser known: how wonderful that it has featured on our guide.

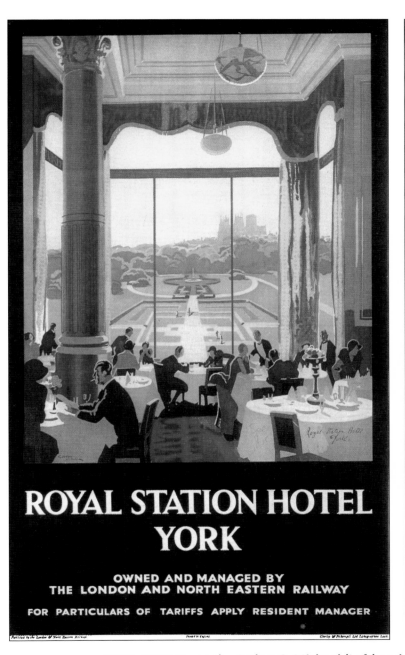

1930s LNER Poster by Arthur C. Michael (Left) and Bootham Bar in 1965: Painting by Kenneth Steel (Right)

Low Petergate York: 1952 BR (NER) Poster: Artist Claude Buckle (1906-1973)

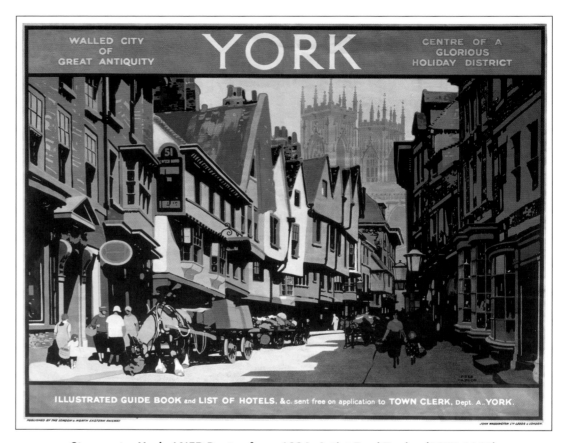

Stonegate, York: LNER Poster from 1924: Artist Fred Taylor (1875-1963)

York within the fortified walls is a wonderful place to visit. Walking around the wall from Bootham Bar to Monk Bar affords us some superb views across a multitude of roof-tops, with the Minster as the backdrop. If we move into the old streets, we see why these made ideal subjects for great paintings. The four on these pages are just *'the starters for 10'* to use Bamber Gascoigne's famous phrase. To the left is (for me) the best of the York street scenes; Claude Buckle's atmospheric painting of Low Petergate. In all the times I have stood here, I have yet to see a tree! Buckle's buildings in this poster are wonderfully painted. An earlier poster is depicted above: this is Fred Taylor's 1924 representation of Stonegate. He painted this again from a slightly different position (poster near right), and used dress from the 18th century to show us that nothing had really changed in 150 years. In both paintings the wonderful towering outline of the Minster is a central focal point.

Petergate and Stonegate merge right in front of the Minster, so this is why the outlines of the central tower look so similar. In his poster below, Taylor concentrates on Stonegate and the people. It shows Stonegate as one of the main shopping streets in the old city. Indeed, records show this name as early as 1188, even though it was built on top of the Roman road Via Praetoria (after Emperor Praetorius), and accessed through the old Roman gate Port Praetoria in the area around St. Helen's Square. It was most likely named as the road along which the stones for the various churches and then the Minster would have been taken. (The present Minster appeared after the name Stonegate was first used). As you move from Stonegate south-eastwards towards one of the small market squares, an example of the many narrow streets that existed is shown in the Danvers double royal poster. This is Little Shambles. The style and colour palette are modernistic; exactly what W. M. Teasdale, the LNER's Publicity Manager wanted to portray as <u>his</u> face of the LNER.

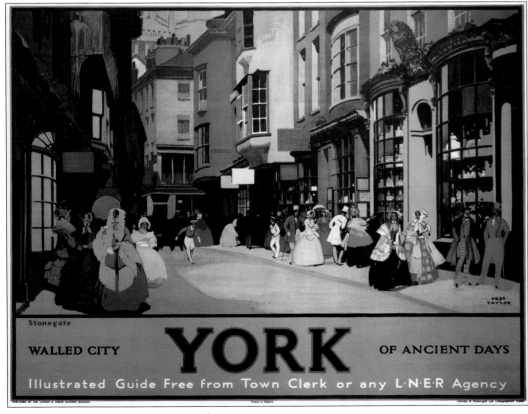

Stonegate in the 18th Century: Artist Fred Taylor (1875-1963)

1924 LNER Poster of York's Little Shambles: Artist Verney L. Danvers

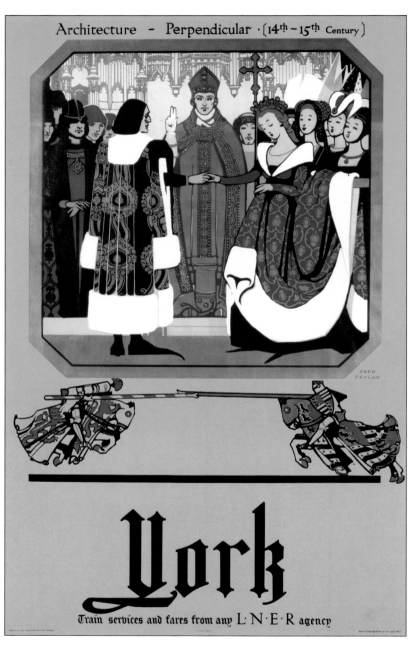

As we roam the narrow and historical streets, it is not difficult to appreciate the grandeur of this fine English city. This pair of double royal posters shows this perfectly, even though they were produced 30 years apart. British Railways commissioned some incredibly good posters, and far left is a true classic. Again it is one of Spencer's superb colour palettes; imagine seeing this on a busy London station and wishing you could be there. Even today, this modern looking poster needs no words to tell you what is being conveyed. The nearer poster is one of a series of posters commissioned by the LNER about periods of architecture. Part of York Minster is a superb example of Perpendicular, but here Fred Taylor has introduced the colour of a marriage ceremony and the past history of jousting. The series title is almost buried right at the top.

While we are in the vicinity of the Minster, wandering through narrow streets, maybe now would be a good time to visit the Minster, as a ceremonial procession is about to take place through the city, after a service of thanksgiving. We are now back in 1935. Taylor's poster shows the long procession headed by the Mayor of York, city Aldermen, local dignitaries and other important pillars of the community.

The Colourful Grandeur of York: History, Architecture and Religion: E. H. Spencer 1955 (Left) and Fred Taylor 1932 (Right)

The Magnificent Minster

This is the York Centenary Procession, celebrating 100 years of local officialdom. The magnificent West Front is the backdrop to fine robes, regalia and a colourful event. As well as a place of colour and splendour, over the centuries this has been a city of conflict, bloodshed and barbarity. First the Romans, then Vikings and then the 'tribes of England' fought amongst each other. And let us not forget the Scots who contributed well to a violent past. A great part of York's tourism pull is to see Roman ruins, Viking buildings, haunted houses, the famous castle museum and a whole host of other treasures. The railways have brought people here in their millions over the years, and today over four million people make at least one trip a year to the city. (I have been going for years and never tire of the sights and sounds of one of my favourite places: the NRM isn't bad either!). Japanese cameramen, American tourists, Spanish and Italian students, Uncle Tom Cobbley and all are to be seen here in high summer. But let's take in the splendour of the procession from our Fred Taylor classic.

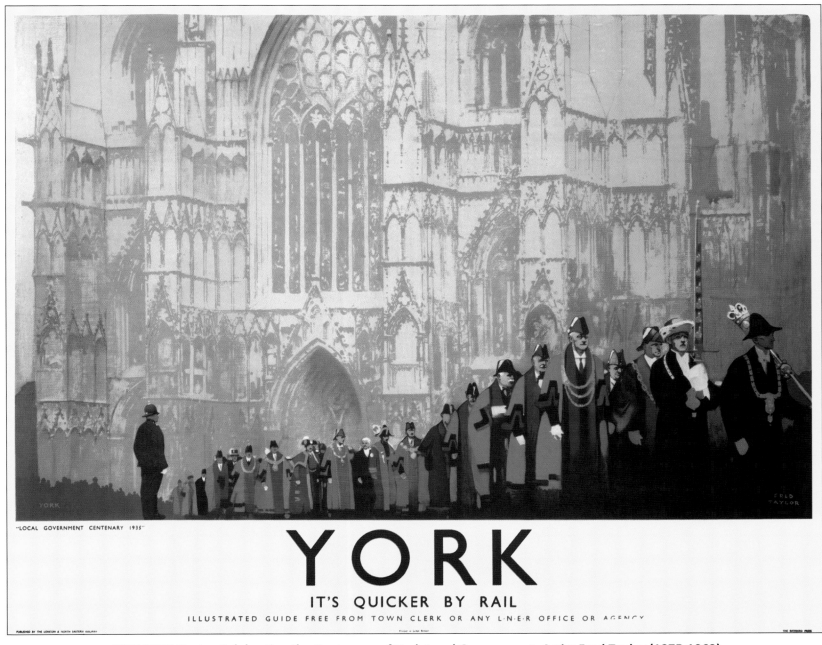

1935 LNER Poster Celebrating the Centenary of York Local Government: Artist Fred Taylor (1875-1963)

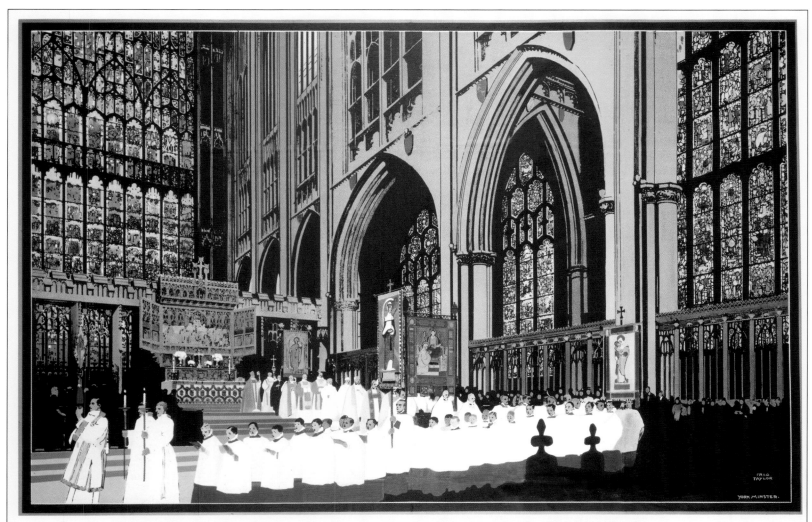

YORK MINSTER

IT'S QUICKER BY RAIL

FULL INFORMATION FROM ANY L·N·E·R OFFICE OR AGENCY

Sunday Service Surrounded by Wonderful Stained Glass in York Minster: 1933 LNER Poster by Fred Taylor (1875-1963)

A typical sight within the Minster was depicted in yet another of Taylor's wonderful quad royals. This one dates from 1933. Taylor probably had a season ticket for the nave of York Minster, as he painted so many parts of the cathedral. What this poster shows so beautifully is the rich array of stained glass. The collection of stained glass in York is unique, and it is also the world's largest collection of medieval cathedral glass. Some panes date from 1250. The magnificent Great East window is currently being renovated and cleaned, but the two transept windows and the Great West window are joys to behold. Taylor's painting shows some of this truly magnificent stained glass to perfection. It is little wonder the LNER chose to commission so many posters, most from Fred Taylor.

The guide book we are using shows us that the Minster has 128 separate windows composed of an amazing two million panes of glass. Cleaning is a continuous job, and we read that each window is attended to every 125 years. Of particular beauty are the Rose Window in the South Transept, the Five Sisters in the North Transept and the Chapter House, with its wonderful ornate vaulted ceiling. I have spent many hours in this fabulous place, and this intricate poster reminds me of all my visits.

I make no apology for including two more of Taylor's posters, produced at a time when Teasdale had decided York Minster was a big tourist draw. Below we are looking towards the North Transept window. The Minster has the widest and one of the highest naves in Europe, ranking right up there with the great cathedral at Cologne, which is slightly larger. This poster was one of a set of six the LNER published (Durham appears on page 52): all show Taylor's skill as an architectural artist. The Minster is Gothic, but from different periods. The Nave is Decorated Gothic, the North and South Transepts are Early English, with the choir and east end being Perpendicular Gothic. The Lady Chapel (shown right) was completed in 1343, at the eastern end. The seamless blending of styles is far less noticeable than at Gloucester, for example. I have a small piece of carved stone that formed part of the original fabric of the Minster for at least 500 years. This was bought to help fund the 1984 restoration, after a major fire destroyed the South Transept roof.

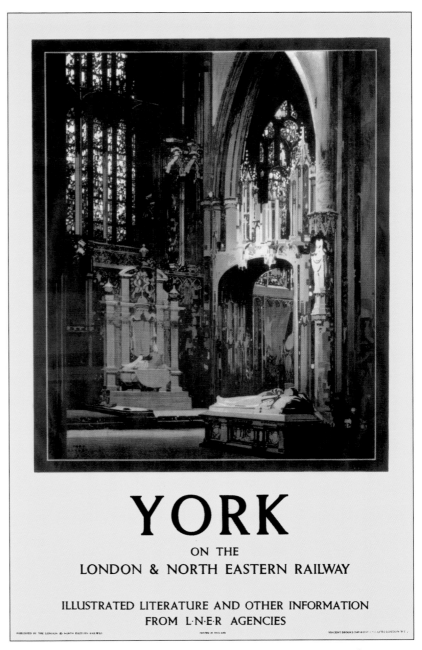

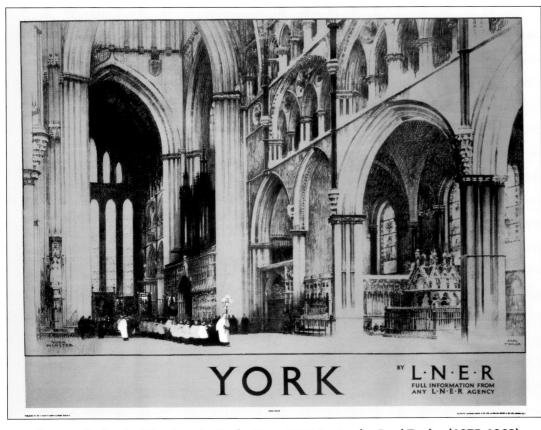

Perpendicular Architecture to Perfection: 1924 Poster by Fred Taylor (1875-1963)

The Lady Chapel at York Minster: LNER 1920s by Fred Taylor (1875-1963)

This poster (alongside left) is somewhat of a rarity, showing the West Front of the Minster in 1941 during WWII. Some army officers have just been to visit the Minster, and the huge bulk of the West Front is clearly shown in this detailed painting. This poster also shows virtually the final house style of the LNER, with their 'winking eye' logo and Gill Sans lettering prominent. It was issued in 1946, five years after the artwork was completed.

The building programme was begun during the tenure of Roger of Pont L'Eveque, who was appointed in 1157. Gothic cathedrals were appearing all over Europe, coinciding with the start of the greatest period of construction in the Minster's history. Over the centuries, various buildings have stood here: new sections were built and then rebuilt over 250 years, resulting in today's magnificent building. In his first project, Roger gave the cathedral its Choir (the richness of its decoration being quite extraordinary) before replacing areas around the transept chapels and a new West Front (now lost). It was Walter de Gray who then rebuilt the transepts again and put in a central tower. He persuaded the Minster Treasurer to fund the work, and so began a tradition of architectural patronage. This allowed the West Front we see today to be completed in 1345.

The Minster Painted in 1917 by Ernest William Haslehust (1866-1949)

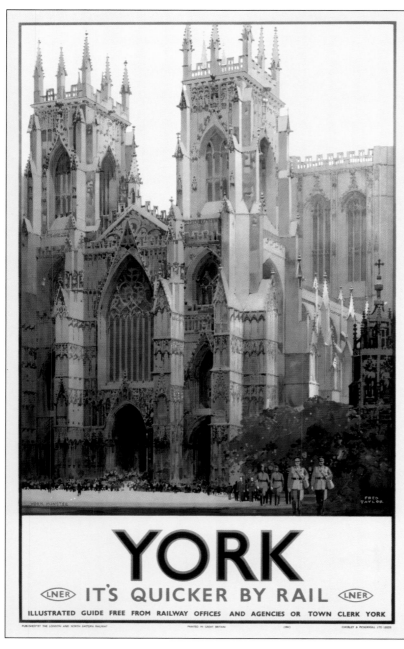

West Front of York Minster in 1941: Artist Fred Taylor (1875-1963): Issued 1946

The early 20th century painting by Haslehust sadly did not make it as a railway poster (which I cannot understand), but was used for promoting York as a centre to visit. The wealth of the Treasurer's House is, however, shown in two railway posters. The house, completed in the early 15th century, allowed a grand style of living until around 1547, when it then passed through a succession of private owners, being altered, cut in half and modernised many times over. It was a local industrialist, Frank Green, who restored it to the condition shown here, over a 30-year period. Taylor's painting (below) shows us the interior at completion. Shortly afterwards, it passed to the National Trust, who cares for it today. Notice in the BR poster from 1954, the large painting has been moved and Shepherd's poster gives us more detail and colour than the LNER poster from a generation before. It is supposed to be haunted, and apparitions of Roman Legionnaires have been reported at various times. Records show us the old Roman Road ran right through the cellars, before any structures (including churches) were ever erected.

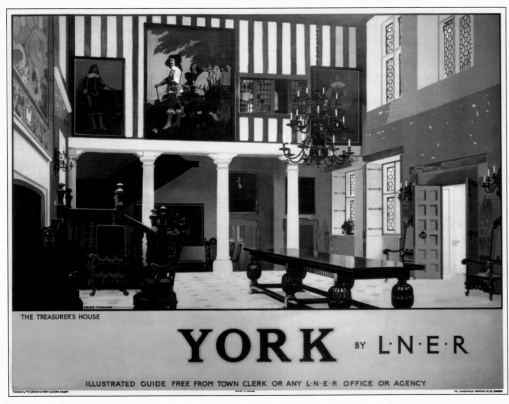

The Treasurer's House, City of York in 1930: Artist Fred Taylor (1875-1963)

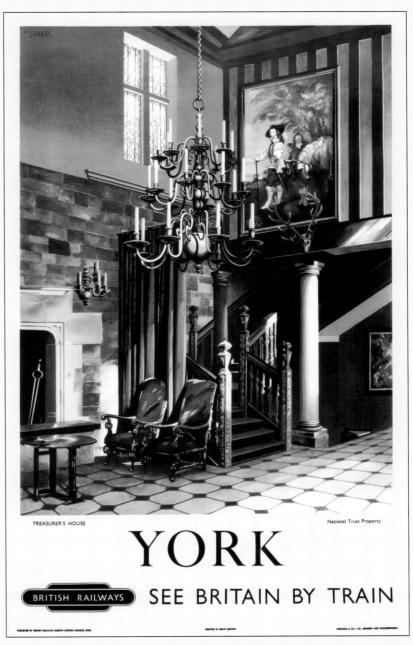

BR Poster from 1954: The Treasurer's House York: Charles (Shep) Shepherd

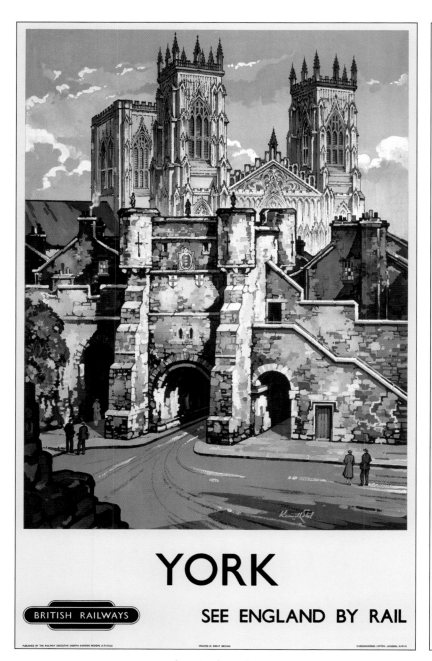

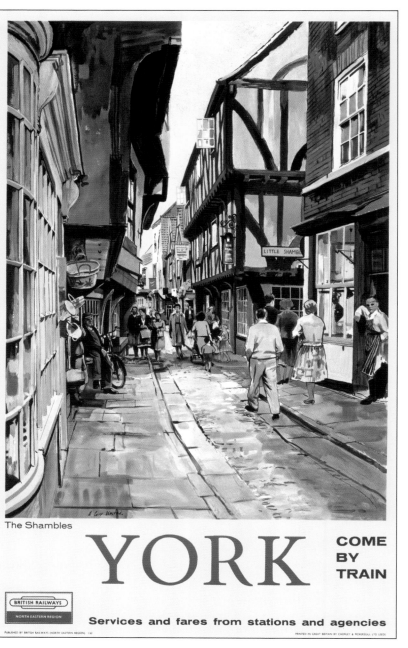

Two Superb British Railways Posters of Medieval York: Kenneth Steel (Left) and Alan Carr Linford (Right)

Views of Medieval York

A short walk from the Minster we are back in medieval York. This period, running from the Norman Conquest, was the time of perhaps the greatest importance in York's history. William was struggling to hold southern Britain, and York became the site of many rebellions in the first few years of Norman rule. William garrisoned troops there, and built many of the walls; not to defend the city, but to show the rebel's that he was here to stay. Following a combined assault by English and Danish forces in 1069, he burned several areas of the city, including parts of the Minster.

Rebuilding and brute force brought the city back to prosperity, and today the legacy of those troubled times is reflected in many railway posters. These two show the famous Shambles area and Bootham Bar, but on BR posters from the 1960s. At this time British Railways was focusing on history, and advertised some of Europe's most fascinating places. These two are typical of the brilliant artwork produced during that campaign. On the far side is Bootham Bar (that leads into High Petergate and the Minster West Front) by Kenneth Steel, and alongside is the Shambles, superbly painted by Alan Carr Linford.

In medieval times, York was a dangerous, intriguing, smelly and yet colourful place to be. Many of the buildings date from this time. Its strategic and political importance grew until, for a short time, it became the capital and second home of a number of Kings from Edward I onwards. Some of these past links are shown in the Minster's stained glass.

Henry II had the wooden Norman castle keep rebuilt in stone around 1244, and also ordered strengthening of the walls. As a result of the castle works, the York City elders undertook more work on the walls from around 1250. By 1315 the whole circuit was completed, and to pay for it, a tax was levied on anybody entering one of the four main gates. One of these gates (Monk Bar) is depicted in another of Taylor's posters (nearside), and far right we have Kenneth Steel's impressive 1965 view of the Minster from an area where the walls were punctured when the railways first arrived in May 1839. (George Hudson was persuaded to have the railways come through York, so he made a statement by building the first station <u>inside</u> the walls).

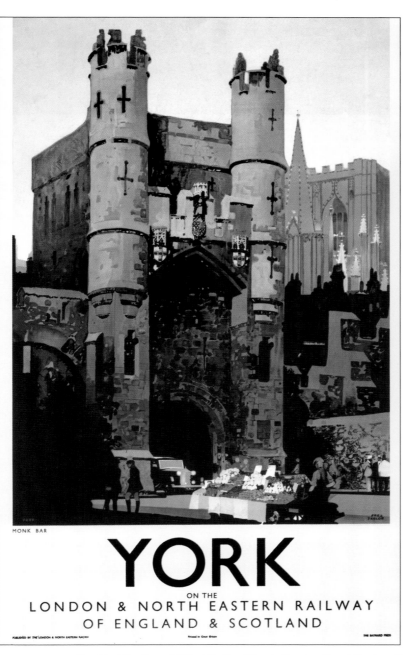

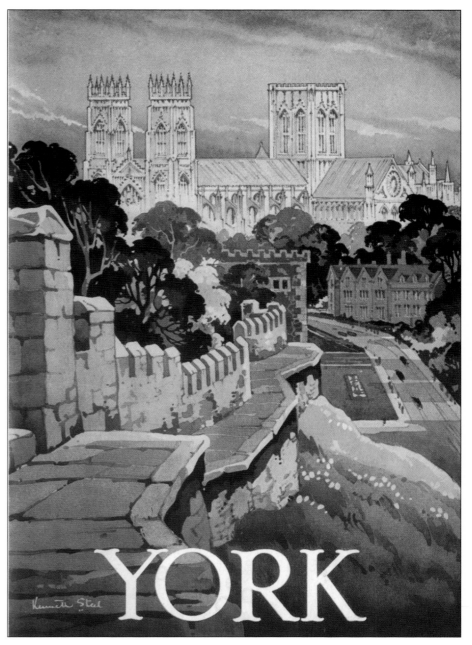

York's Medieval City Walls: Monk Bar by Fred Taylor (Left) and the Minster from Station Road by Kenneth Steel (Right)

ST. WILLIAM'S COLLEGE

ARCHITECTURE OF YORK 13 CENTURIES

GUIDE FREE FROM TOWN CLERK OR ANY L·N·E·R AGENCY

The Wonderful Inner Courtyard of St. William's College, York: LNER 1928 Poster by Fred Taylor (1875-1963)

College Street is located behind the eastern end of the Minster. It takes its name from the building shown on our next poster. This is yet another from Taylor's York odyssey, being painted in 1927 and issued a year later. St William's College is named after Archbishop William Fitzherbert, the nephew of King Stephen, and great grandson of William the Conqueror. He was appointed in 1153 and he was so well liked that the crowds made the old wooden Ouse bridge collapse during his procession. However, this building was not finished until 1467, after taking two years to build, and was the home to the Minster priests.

It is a superb example of a medieval building and, as a sign of our times, it is now a conference/wedding venue. For this, they use some beautifully panelled rooms on the upper floor. The good news, I suppose, is that it is saved, and still used. When there are no conferences and events, a walk around the interior is well recommended – just ask. It has a wealth of interesting features. Twelve carved oak figures symbolize the year's labour required to decorate the roof of the inner courtyard. Taylor's poster is a little dark for my taste, and probably painting from the Minster side would have produced a more pleasing image.

The medieval streets of Old York are said to be home to more ghosts per square mile than most other places in England. Another feature of medieval York is its penchant for mystery plays down the years. This is a cycle of 48 plays that cover sacred subjects from the Creation to the Last Judgement. After being forgotten in the 18th and 19th centuries, they were revived for the Festival of Britain, and are now enshrined in modern day city events. One would think this would be an unusual basis for a railway poster, but British Railways was having none of that, and commissioned Edward Bawden to depict three scenes (The Risen Christ, The Adoration and Satan at Hell's Mouth) shown in this most unusual piece of railway art. What is pleasing to the eye is the overall composition, and the beautiful architectural artwork.

The plays are first recorded celebrating the festival of Corpus Christi in York in 1376, and this lasted until around 1569. A manuscript of the current York plays, probably dating from around 1465, survives at the British Library. If one sees this poster full size (50" x 40"), it does make a huge visual impact, the clear intent for publishing it.

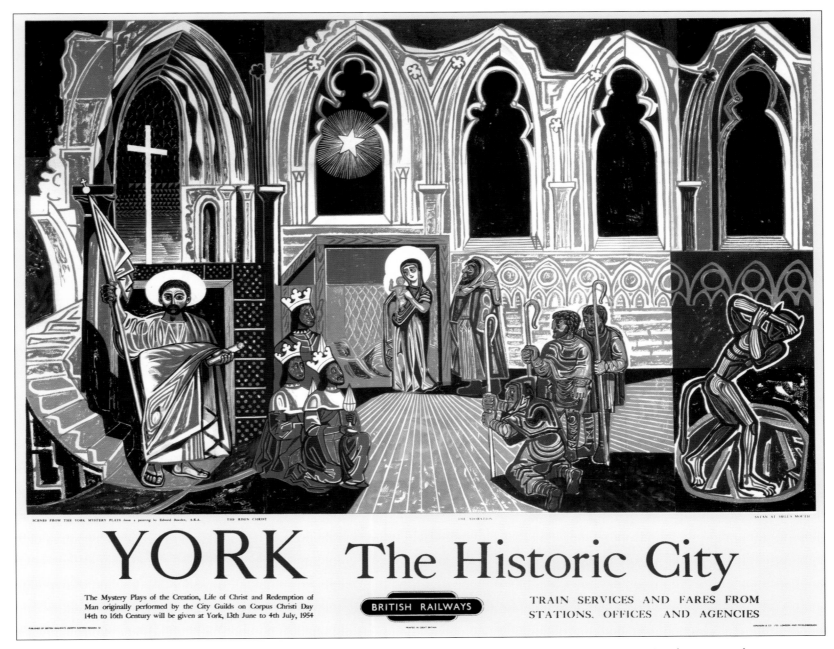

British Railways Poster from 1954 Depicting Mystery Play Scenes: Artist Edward Bawden (1903-1989)

Colourful Past and Present

There is no denying York's heritage. Wonderful buildings (such as Kings Manor – left) and colourful people (such as Dick Turpin – below) have only added to the city's reputation. You can spend (as I do) hours just walking the old city, watching, photographing and reflecting on Yorkshire's Crown Jewel. Dick Turpin was an 18th century highwayman who was executed in York in 1739 for horse theft. He turned out to be a burglar, poacher, thief and all-round 'bad-guy', but even his past did not stop his famous fictional ride from London to York on his steed Black Bess becoming a tale of English folklore. His legend came from a story by the Victorian novelist William Harrison Ainsworth almost 100 years after Turpin's death. Doris Zinkeisen chose to portray this journey as he approached York. Another famous person from olden-day York was Guy Fawkes, but no posters were made about him!

Kings Manor House Exterior in 1931: Artist Fred Taylor (1875-1963)

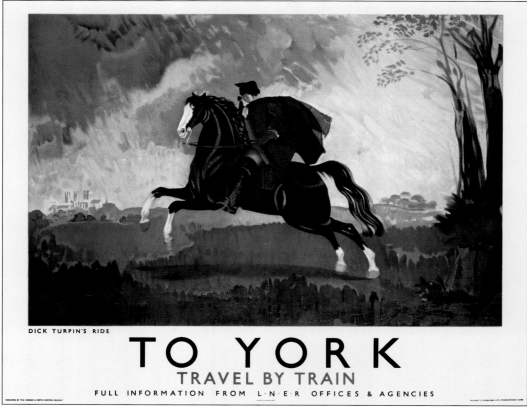

The Famous Doris Zinkeisen Poster from 1934 of Local 'Hero' Dick Turpin

York has provided some really great people from the arts, especially in the past 100 years. The great actress Dame Judi Dench, composer John Barry and poet W.H. Auden (which is one reason why Paul Atterbury chose his poem in the Foreword), were all born in the city in the 20th century. But York is also the home of railway history and the NRM, where the world's largest collection of engines, ephemera and millions of artefacts associated with railways from Victorian times until today, can be found. Now, this is a place I have spent hundreds of hours in, including when the old roundhouse was the base. I have seen it develop into <u>the</u> place to study railway transportation, and have been most fortunate to have browsed many of the drawers that house the images contained in this whole series. I will include some more NRM posters in the next chapter, but alongside is one of the good contemporary images that shows York in pictures: religion, Viking ships, railways and a family coming to see the sights. Our last two posters show the Minster: Rushbury's unusual view contrasts with Taylor's classical view. Our travels could not end in a better place!

Wonderful 1947 Panorama of York Minster from the North-East: Artist Henry Rushbury

British Railways 1987 Poster for Fabulous York: Artist Unknown

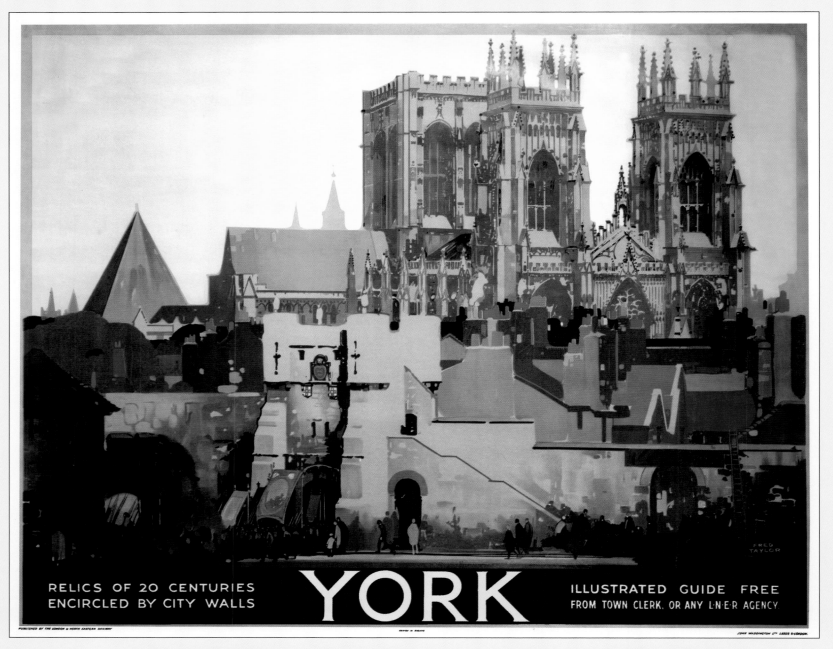

RELICS OF 20 CENTURIES
ENCIRCLED BY CITY WALLS

YORK

ILLUSTRATED GUIDE FREE
FROM TOWN CLERK, OR ANY L·N·E·R AGENCY.

Fred Taylor's Timeless View of the City and Minster at York: Issued Circa 1924 by LNER

Chapter 10 Marketing Yorkshire & the North East

The Impact of Railway Advertising on the Region

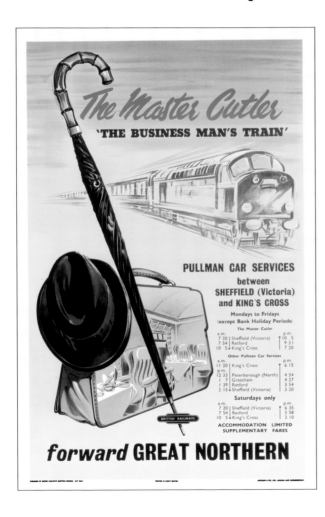

Chapter 10 Marketing Yorkshire and the North-East

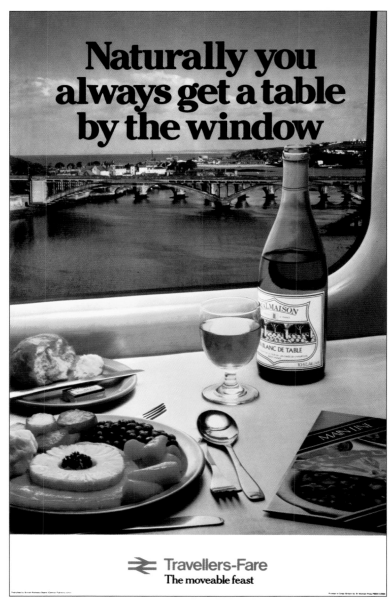

BR Travellers-Fare Poster from 1980: Powerful Modern Advertising

Opening Remarks

Railways began in this area, and not surprisingly the number of posters produced is high. Strangely, however, it is not the railways that the majority are focused on: it is scenery, seaside towns and the area history where time and money were invested. This part of England was one of the powerhouses that drove the Victorian economy: iron, steel, wool and coal were to generate enormous wealth. The Durham, Northumberland and Yorkshire coalfields provided the first stimulus for mechanised transportation, but once the key towns were linked for goods movement, mass people-carrying quickly followed. We have toured the region with artistic posters, but now it is time to look a little more deeply at the impact of posters down the years, and to present some of the more modern images. There is no doubt that in the future, a modern rail network is going to be a key component of this area's future, and they will reduce carbon footprints if used efficiently. To emphasize modernism we begin with two contemporary images.

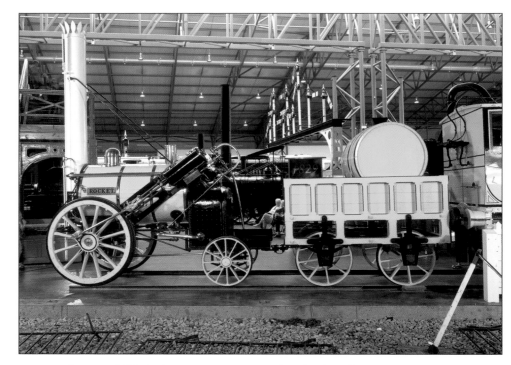

A Star Railway Exhibit in its Museum Home: 'Rocket' in the NRM Great Hall in 1999

Our first poster is typical of the style of photographic images used around 1980. It shows us entering Berwick-upon-Tweed aboard a southbound express, whilst enjoying a good lunch. What is interesting is the poster was issued by the catering arm of BR. The only photograph in the book is taken from the extensive NRM collection and shows a replica of the engine that started it all inside the Great Hall at York in 1999.

Railways have been a significant cornerstone in the development of the whole region. This quartet demonstrates that the best way to travel long distances in this country has been via the railways. For me, it is surprising that we do not have high speed links, and that investment generally throughout the whole of the 20th century has been minimal. Indeed, records show that the 1990s Heathrow link and the new Channel tunnel link are really the only major projects to supplement what is largely a Victorian railway system.

The GNR and NER were always the two most enthusiastic companies when it came to railway posters. E. M. Horsley (Advertising Manager of the NER) gave a lecture in 1912 on the ideal characteristics of posters, and how they should look; attractive but informative (see references).

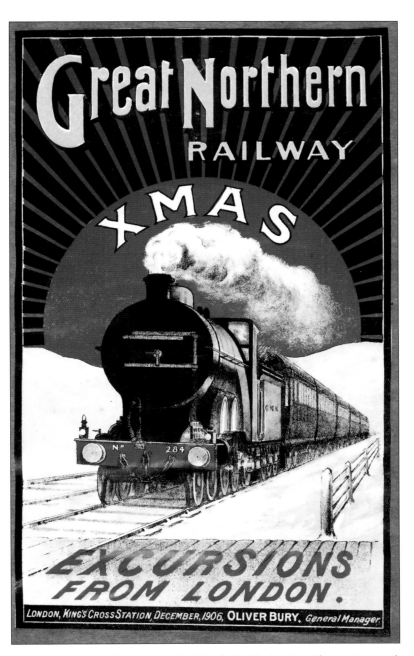

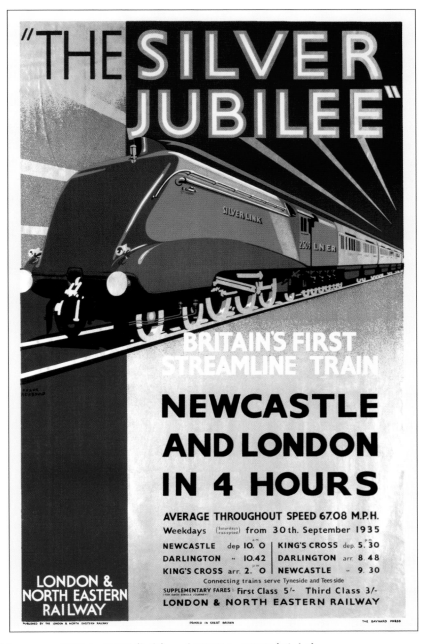

Travel to the North by Train Has Always Been the Message: GNR in 1905 (left) and LNER in 1935 (Right)

Setting the Scene

The reign of Edward VII saw the railways in Britain at their zenith. At a time when colourful posters adorned stations, the railways dominated all facets of transportation in our islands. They had quickly decimated canals for the transportation of goods, people did not have cars and the industrial centres had to have places for people to go to for holidays. For the region featured in this Volume, holidays were taken on the Yorkshire Coast, the beaches around the Tees estuary and the county of Northumberland. Posters fell into three groups: letterpress, ones to advertise holidays and places to see, and the third group aimed at industrial customers and the carriage of freight. The poster below fell into the second category: it is one of a set produced around 1910 for the different parts of the NER's area.

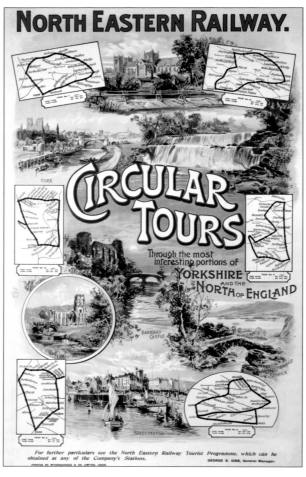

The Circular Tour: Market Creation by the NER in 1920: Artist is Unknown

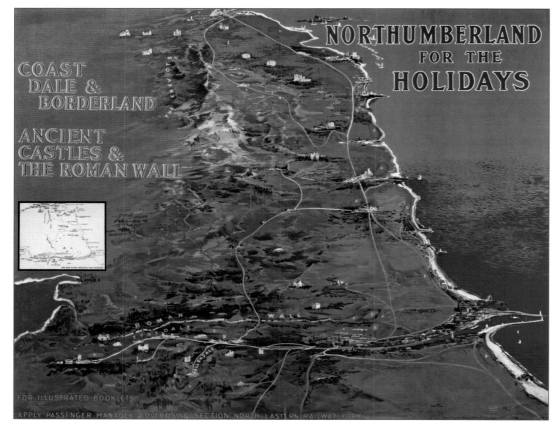

Edwardian Poster from Circa 1910 Advertising Northumberland Holidays: Artist Unknown

Just prior to WWI, the railways were responsible for a three-fold increase in freight tonnage carried, and a four-fold increase in passenger numbers. The NER set the pace both in promotion and execution, introducing cheap day travel, weekend savers, tourist tickets and other rates that we think of as new today. It was their desire that railways should be the province of everybody. Bradshaw's railway guide was the first of the tourist books, and the first to decipher the nightmare of the timetable maze, allowing anybody to plan trips more easily. The poster above appeared just after WWI to promote the whole area. Vignettes show York, Ripon Cathedral, Aysgarth Falls, Bridlington, Barnard Castle and Fountains Abbey. The circular tour was a campaign designed to get people moving again.

The NER had a sound base with its coal transportation operations that accounted for more than 60% of their revenues (around £23M) in 1921. By comparison, their passenger miles were well down compared to the GWR, LNWR, MR, GER and LYR. They made a concerted effort to improve this. However, they did have advertising flair, and for a time, this worked. All this was to change in 1921, when it was obvious that railway economics had come to the fore, and many of the smaller companies were going under. The Railways Act of 1921 amalgamated companies, large and small, all over Great Britain into four main groupings. They began operations in 1923, with the LNER inheriting the NER, GNR and GER publicity groups as the main ingredients of a vibrant Advertising Department. They used a three-pronged policy of general letterpress, pictorial and industrial posters, and even the greatest artists they contracted had to turn their hand to all areas. An example of each area of corporate advertising is given alongside. These were painted by Newbould, Purvis and Austin Cooper respectively. This was to remain the central theme of LNER marketing, which the other three main companies soon followed.

 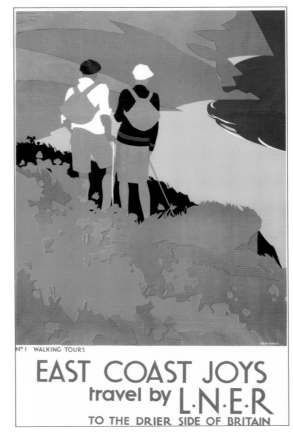 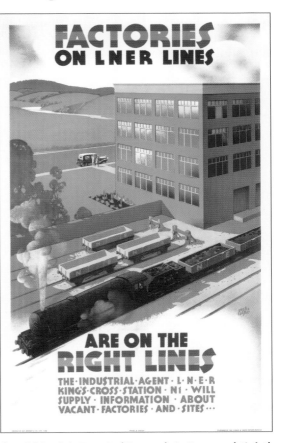

The LNER's Three-Pronged Advertising Campaign: General, Pictorial and Industrial: Artists are Newbould (Left), Purvis (Centre) & Cooper (Right)

The three posters here are meant to represent Whitby, walking on the Moors, and ensuring business has full railway support for the LNER lines. The central poster is part of a set of six that fit together to form a larger panorama, and Purvis was to do this again with resorts all down the East Coast. We will see one of these a little later. The factories poster by Austin Cooper was part of a concerted campaign to build up their far from healthy freight business in the late 1920s and early 1930s. All three of these artists were loyal to the LNER, and largely responsible for the great reputation that the LNER built up. Throughout this book we have seen a plethora of wonderful images, and a high proportion came from the LNER era. At inception, the LNER had 6.590 route miles (more than 10,000 kms) stretching from London up to northern Scotland and across to Cheshire and the Wirral. Consequently, it is not surprising that they issued more posters in the early years than the others. Their first season's posters numbered 45 major works of art, and this increased steadily As early as 1925, some 180 staff were employed in the main Advertising Department and a count of all their station hoardings revealed in excess of 70,000 spaces needing to be filled. As if to flaunt their position, the LNER mounted a poster exhibition at Kings Cross to celebrate their first year, and this proved extremely popular. Teasdale knew that he had a winning formula. This continued annually until they went 'up-market' by using the New Burlington Gallery in the West End in 1928: this was an even bigger success.

But it was the passenger traffic that the LNER wanted, so they devised a careful campaign of the beautiful images we have seen thus far, plus some inducements using the stylistic images of the *'Big Five Artists'* and their contemporaries. The image shown left was an attempt to fill their trains to the whole of the coastline covered in this journey as the storm clouds of WWII began to gather. In many respects it is an unusual poster for 1939, but Cecil Dandridge, who was then LNER Publicity Manager, would not be deflected from his advertising, even if a certain 'Mr. Hitler' was looming large. Bossfield Studios was a commercial group led by Messrs Boss and Stansfield, who acted as administrators and managers for several artists.

Below is a very collectible poster. It is one of a large series of county and area views commissioned by Dandridge to show stylised images of parts of the LNER domain. We will see several throughout this poster book series, but this is quite a well-known and very eye-catching work. It shows clearly how the LNER approached regional marketing.

A Classic Mid-1930s LNER Poster for Yorkshire: Artist Tom Purvis (1888-1959)

Inducement to the Seaside in 1939: Artwork by Bossfield Studios

The LNER had realised they had the lead, and so began a series of public poster exhibitions. They were held in London and became very popular right from the word go. First Teasdale and then Dandridge took great delight in promoting their artistic bias, and this also spilled over into letterpress, handbills and other more mundane publications. The LNER took great delight in marketing Yorkshire and the North-East in as colourful a manner as they could, and all through this Volume there are wonderful examples of colour, style and boldness to catch the eye (and the LNER hoped to fill their trains of course!).

Below, a slightly later LNER poster from 1938 is shown. This poster, when seen full size, really catches the eye. It depicts the North-East Coast, between Sandsend and Whitby, but what is so noticeable is the colour palette that Mason used. I am sure the North Sea rarely looks like a tropical location, but here it could be a rocky Greek island or southern Spain!

Classic LNER 1938 Poster of Yorkshire's East Coast by Frank Henry Mason (1875-1965)

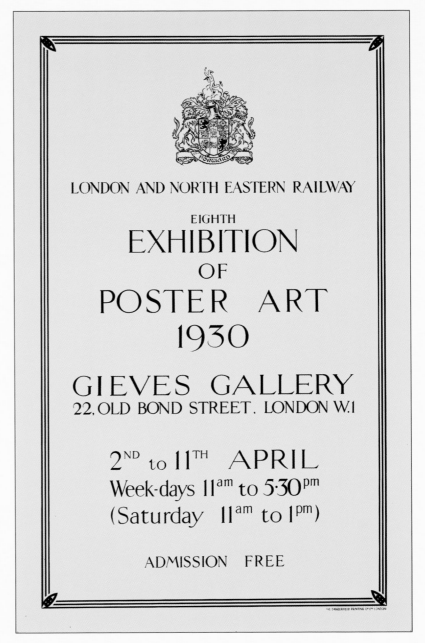

Poster to Advertise a Poster Exhibition: LNER Issue from 1930

West Yorkshire

Up to now I have neglected West Yorkshire, and the time has come to set the West Riding into context, so we can then look at marketing the whole area in BR and modern times. The railway had a captive market in taking the people from the industrial areas of Yorkshire to either the coast or to the Dales and Moors. Consequently there was hardly any advertising featuring the cities of Bradford, Leeds, and Sheffield. After all, who would want to go and look at mills and steelworks, when Scarborough, Bridlington and Wensleydale beckoned? The railways, however, could not ignore the industrial bases, as their business customers contributed hugely to the Company coffers. As they did not issue many posters, they did commission paintings, and some of these are quite superb.

Below is an early painting of the interior of the main signal box at Brighouse East, where the cross-Pennine route through Sowerby Bridge and the line into Bradford, diverge. The signalman here has quite a few levers to operate, on what was a busy junction. The artwork is superb – and notice the signal box is spotless!

Victorian Lithograph of Whiteley's Viaduct, Hebden Bridge: Arthur Tait (1819-1905)

L&YR Painting of Brighouse East Signal Box in 1917: Artist Frank Prince

The coloured lithograph, from the American artist Arthur Tait, was typical of the artistic work commissioned before railway posters were perfected. This shows the important route through West Yorkshire and across to Manchester. The river is the Calder, and this has been included as a thank you to the superb support I have received from Amadeus Press in Cleckheaton. Their printing presses are very close to the Calder, and as my research has not yet revealed any Cleckheaton, Dewsbury or Huddersfield railway posters, this is the nearest railway painting I could find to where this Volume was created. Tait's work does however show the skill in lithography that existed in England in Victorian times, and this is the reason so many eminent foreign poster artists (Jules Cheret for example) came here to study. The crossing of the Pennines was a major feat of engineering (51 miles – 82 kms), including the mile-long Summit Tunnel, which was dug by hand. The line opened in 1939, and this 1845 lithograph shows the new viaduct.

Sheffield has always relied heavily on the railways, and here we have two paintings commissioned by shipbuilder Cammell Laird, which appeared during WWI. The area was the mainstay for metallic products of all types, right up until steel prices collapsed in the UK, when foreign producers significantly undercut UK industry. The top picture shows the rolling mills at the Penistone Steelworks, north-west of Sheffield, and the bottom picture depicts the forging shop at the Cyclops Iron and Steel works in the city itself.

Sheffield has been an industrial centre since the 14th century, and by 1600, was well known for its cutlery and metal products. The Hallamshire Company of Cutlers, formed in 1624, was the guarantee of quality. (Our first poster for this chapter on page 231 shows the advert for the Master Cutler, an express for businessmen between Sheffield Victoria and London Kings Cross). In 1740, local engineer Benjamin Huntsman perfected the crucible steel process, where quality improved as carbon content was reduced. Around the same time, silver plating was discovered, and these two industrial developments were responsible for Sheffield's prowess being extended and the town's rapid development. By 1843, Sheffield was a borough, and in 1893 it was granted a city charter. It was not until 1856 that the Bessemer steel-making process made the Huntsman crucible process obsolete, but Sheffield embraced new technology quicker than anybody, and soon the new process converters appeared in the town. One is preserved today at the Kelham Island Museum, alongside the River Don. For people of an engineering and industrial background, this is a most interesting place to visit. Stainless steel was invented in the Sheffield laboratories of Brown Firth by Harry Brearley in 1912, and today the world can thank the innovativeness and engineering excellence of the city as the basis of modern metallurgy.

The two paintings here are typical of industrial facilities all over this part of West Yorkshire (now South Yorkshire, of course, after more boundary tinkering). I spent many summers here with an Aunt, who was a school mistress at nearby Grindleford. One of the delights of the summer holidays was a visit to Redgates model shop along the Moor, where Airfix kits lined the walls from floor to ceiling. Those were happy times indeed! But there is another city claim to fame that many may not be aware of. Sheffield FC was the first formal football club in the world (1857), but it was not until they had played an exhibition match in London, that our own Football Association was formed.

The poster on the next page is one of the truly superb engineering posters. Railways had arrived in Sheffield in 1838, when the Midland Railway Company opened the first station. The GCR opened Sheffield Victoria in 1851, and battle lines were drawn, as the steelmakers now had two serious competitors to choose from. This continued after the 1923 grouping, when the LMS and LNER continued fighting for Sheffield passengers and steel freight.

Two Paintings from the Sheffield Area Produced During WWI: Artist E.F. Skinner

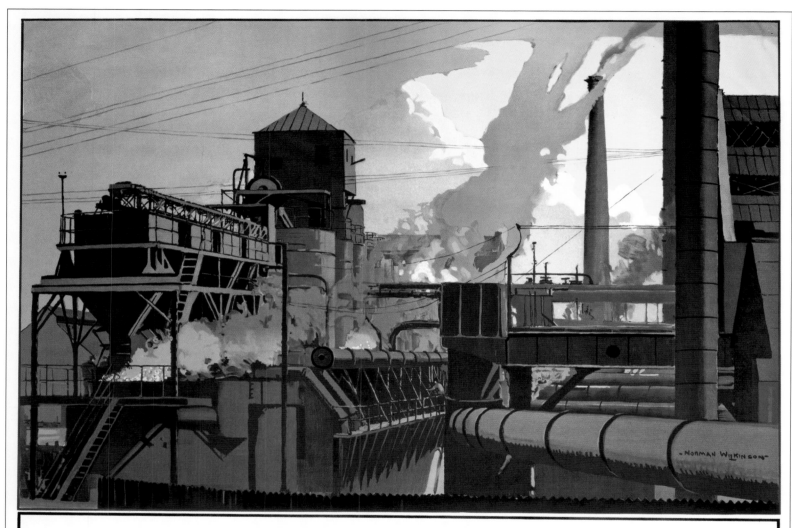

A SHEFFIELD STEEL WORKS
MAIN LINE ST. PANCRAS TO THE NORTH
BY NORMAN WILKINSON R.I.

Super LMS Industrial Yorkshire Poster from 1935: Artist Norman Wilkinson (1878-1971)

This poster comes from the LMS, who right through railway history, seemed to capture industrial business (and steel business in particular) rather well. It was issued in 1935 and then re-issued by British Railways in May 1949, with the revised title *"Service to Industry – Steel"*. This was at a time when the UK was still shaking off the effects of WWII, and BR saw industrial business as something to advertise and grow. As Wilkinson's 1930s image was so good, they just used it without change.

But it was shortly after this time that Britain's industrial might really started to decline. West Yorkshire was one of the places to really suffer. Steel mills in Sheffield, textile mills in Bradford, Wakefield, Halifax and Keighley, and the demise of the Yorkshire coal industry under very acrimonious circumstances, all saw the bulldozers visit more than the railways. West Yorkshire had changed forever. Along with the Lancashire textile and the West Midlands car industries, the demise of our manufacturing base, almost two generations ago, is partly responsible for our predicament now. Railway poster production is actually an excellent barometer for this. As peoples' social lives and livelihoods all changed, the poster advertising styles reflected this. Our Nation has not recovered from the time when road transportation decimated railway freight movements, and people preferred Benidorm to Bridlington.

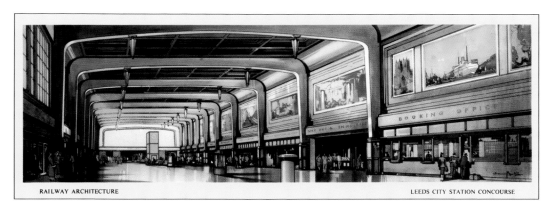

Carriage Print of the Grand Concourse at Leeds Station: Artist Claude Buckle

The affluence of Victorian times resulted in the centres of Leeds Bradford, Sheffield and Huddersfield having grand buildings and a fine culture. Just go to Huddersfield and marvel at the station façade. Leeds is also very grand, and is depicted above in one of Claude Buckle's many carriage prints. Its Victorian shopping arcades are supreme examples of great architecture. Bradford, Halifax and Huddersfield all grew because of the woollen industry; Leeds grew based on cloth manufacture, whilst heavy engineering was found in Wakefield, Castleford, and Pontefract. All the way across to Knottingley there were coal mines, though only Kellingley and a few opencast mines still remain.

Today, the finance and retail sectors are some of the main providers, with two leading supermarket chains being based here (Asda in Leeds and Morrisons in Bradford). Railways have always played a significant part in the area's growth, and when Gresley designed his streamlined A4's, they were quickly used to link West Yorkshire's industry with London's finance. The iconic poster alongside shows the *"West Riding Limited"*: an express service which was introduced by the LNER to link Bradford and Leeds to Kings Cross. This service first ran on 27th September 1937, so the poster was produced a few weeks beforehand to advertise and promote the new link. The first two engines used were 4496 *Golden Shuttle* and 4495 *Golden Fleece,* which were both painted into Coronation blue livery to reflect the status of the new express. Indeed, records show 4495 was named at Leeds Central station only two days before the inaugural run: it had originally been named *Great Snipe*. This poster is very collectible, as is anything now by the artist Charles Shepherd (Shep).

We will now return to the general aspects of Yorkshire and North-East marketing, but this is not the end of West Riding posters, because the 70s and 80s saw several more issued to promote the NRM, the City of York and other aspects of the region.

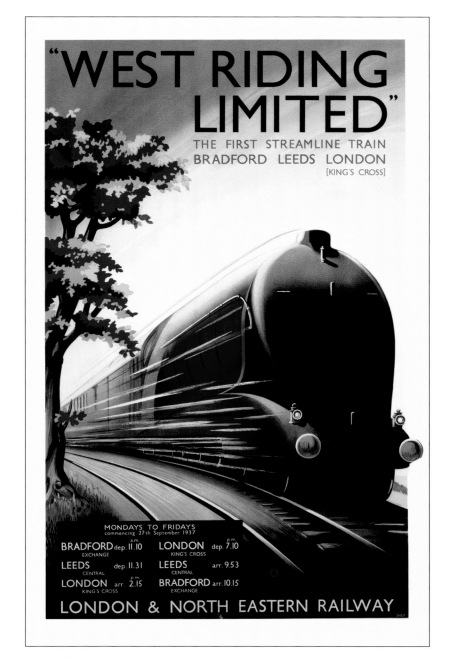

Iconic 1937 Poster for the New Train: Artist Charles Shepherd (Shep)

BR and Modern Marketing for the Area

Having set the historical and industrial perspective, it is now time to look at how British Railways and their contemporaries treated the marketing of Yorkshire and the North-East. The poster alongside is almost the reference for the LNER, against which we can measure the success of BR poster investments. Here, I have very many to choose from, so I will use a collage at the end to show trends and styles during the 20th century. Throughout this Volume there are examples of the changes in style matching changing market conditions. This area was hit as hard as any in the UK, so rail usage has fluctuated from good to bad, back to good, and now the ECML is again under usage and financial pressure.

Probably the best place to start is again with the region's past. These two posters below show how railway history and a stately house received attention in the 1960s and 70s.

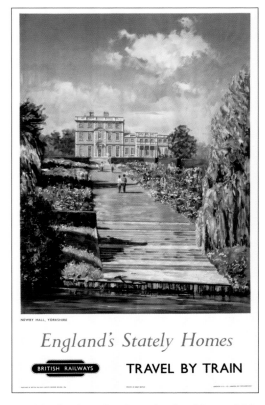

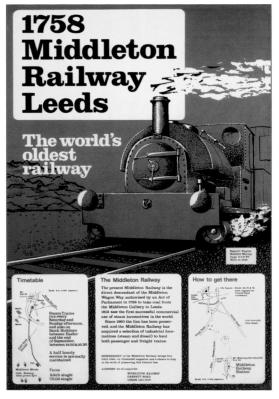

1927 Industrial Marketing in the North East: Artist H.G. Gawthorn

Marketing the Area in the 60s and 70s: Grand Homes and Railways in Abundance

The 60s saw mainly a classical treatment, but modern styles and thinking became more evident as the 70s approached. Indeed, Leeds resident and former Radio 1 DJ Jimmy Savile figured heavily in the *'Age of the Train'* series of posters and TV ads. This was an attempt by BR to counter failing passenger revenues, at a time when the motor car and road transportation were winning out. But there were some good contemporary poster adverts, and two are shown below. They show that the change from the Transport Commission controlling the marketing, to the 1962 formation of the British Railways Board, had an immediate impact. Fresh thinking, modern artists and the removal of some traditional methods produced a new wave of posters. Both of these are clever, and also show a great deal pictorially about Northumberland and the Durham twin resorts. Reginald Lander became a major source of 1960s posters. Laurence Fish, who only died last year, was also used extensively in all the BR regions. Their artwork is still fresh today.

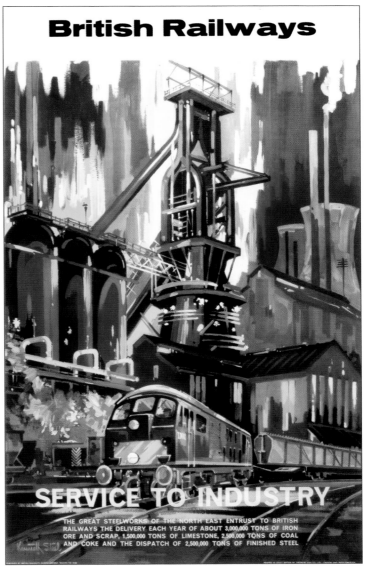

Industrial Marketing in 1963: Artist Kenneth Steel

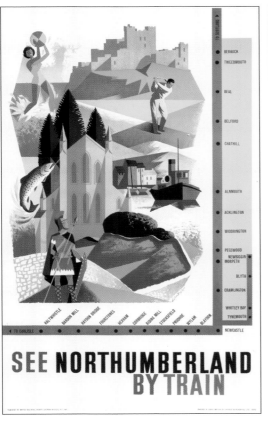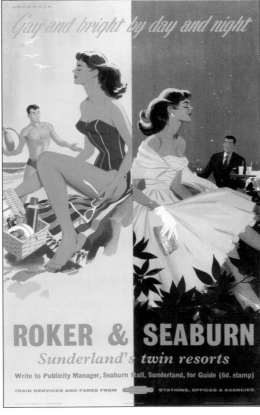

Contemporary 1962 Posters for the North-East: Lander (Left) and Fish (Right)

Industry too was treated in a modern way. We saw Cuneo's wonderful painting of ICI Billingham on page 65, but just look at this quite superb painting of steel blast furnaces from Kenneth Steel around the same time. This is a great poster, industrial or not.

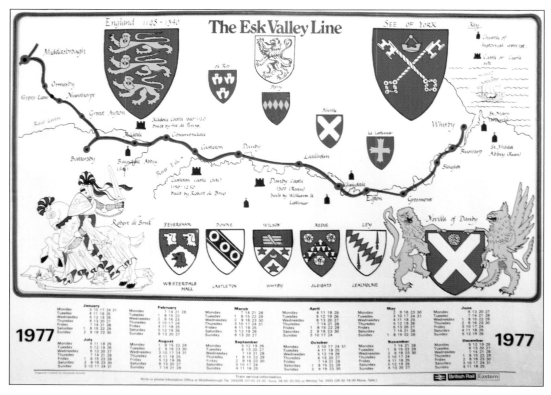

Reverting to History in 1977 to Market the Line to Whitby: Artist Unknown

It was built in the 1870s, and is regarded by historians as representing the pinnacle of Victorian railway engineering and enterprise. It should be remembered that almost our entire railway network today is Victorian, and our failure throughout the 20th century to modernize and upgrade, now has financial and business implications. Putting new trains on old tracks is not the answer; it is our usual 'fudge'. The nation's efficiency and carbon footprint removal would both gain if we had a modern railway network. The Victorians recognized this, but we have forgotten it. Like today, the Settle-Carlisle railway construction in 1870 was driven by politics. The Midland Railway Company could not gain a suitable access to Scotland using LNWR lines. So, it built its own route, right through one of the most inhospitable parts of northern England. The legacy is sheer beauty, but was built in appalling weather conditions by more than 6,000 navvies, with a terrible loss of life. The left-hand poster below shows some of the many features, whilst the right-hand poster is encouraging the city dwellers to take in the magnificent scenery. It is amazing to think that during the Thatcher years we were thinking of closing it. Thank goodness that the Transport Secretary at the time (Michael Portillo) was a friend of the railways.

The 1970s saw no real corporate style, so posters appeared in a variety of images and messages. One of the more unusual is shown above from 1977. This seems a rather incongruous poster for the time, but maybe the Queen's Silver Jubilee in June of that year had a bearing. The mixture of heraldry and a local railway line route makes this one of the more unusual posters that British Rail (as they now branded themselves) put out. It does show however that railways and history are closely intertwined, and that tourism is driven by both elements. Unusually, this poster comes from the Eastern Region of BR.

The two posters alongside show two facets of the marketing of one of Britain's greatest journeys. This is a 73 mile (117 km) line that links the industrial centres of West Yorkshire and Lancashire with the beauty of the Lake District area, via the border city of Carlisle. The line runs through the western part of the area covered in this Volume, touching the Yorkshire Dales and the North Pennines, and is without doubt one of the top two scenic lines in the British Isles, (the other being the West Highland in Scotland).

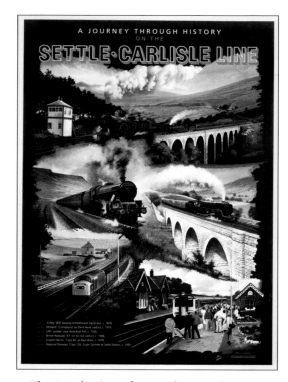

The Marketing of One of Britain's Greatest Railway Journeys: The Settle to Carlisle

There is no doubt that an integrated and efficient railway system is at the heart of local infrastructure. In the middle of the 20th century, trams and trolleybuses were taken out of service, but today 'light railways' are appearing in most of our cities. Sheffield is a case in point. I remember travelling on the old trams as a boy. It was obvious, even then, what a great way this was to travel around a city centre. They were removed in a fit of madness, and a few years ago put back at enormous cost (Edinburgh is going through the same painful exercise today). Just why is it that stations and lines are removed or threatened with closure, and then sometime later the decision is reversed? Just why are we so poor at infrastructure planning and execution? West Yorkshire has had to reinvent and regenerate itself following the collapse of former industries, and these three images show that the modern poster gives information on transport, the Meadowhall shopping centre and the complete transformation over time of the centre of Leeds. Here, the posters are informative but also have a clean and contemporary look.

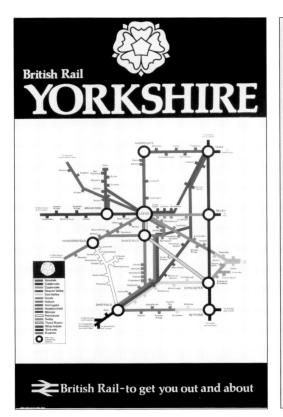

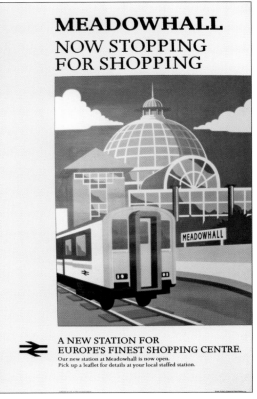

Railway Advertising in the late 20th Century: Posters from the National Collection

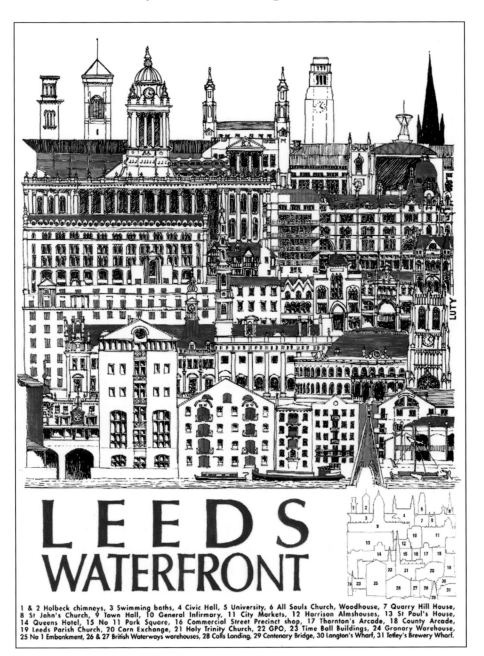

Poster Usage in Metropolitan Regeneration During the 20th Century

The final development occurred in the 1990s, when art and photography were combined by Brendan Neiland in his treatment of Leeds station (alongside right). When studying this poster in detail, one can appreciate the artistic vision it contains. It was produced in 1991 to publicize the new Intercity 225 service that began with new rolling stock. Both Leeds and Sheffield have undergone huge change in the last 40 years, whilst York continues to trade on its history and beauty. The contrast could not be greater.

The final two posters below show how a combination of posters can produce an effective message. Here, I show the power of the railways (right) and the value they can represent (left). Driving and parking in city centres today is a pain, and it really does make more sense to take the train. What is interesting here is the diversity in the style, and yet the message is very similar. By using the power of the poster and varying the image, the message is picked up by more people. Good marketing is about catching the eye.

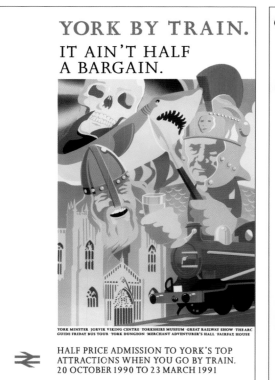
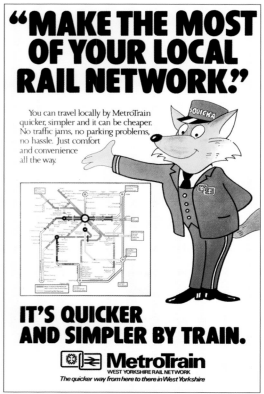

Advertising Yorkshire and Railways in the Late 20ᵗʰ Century

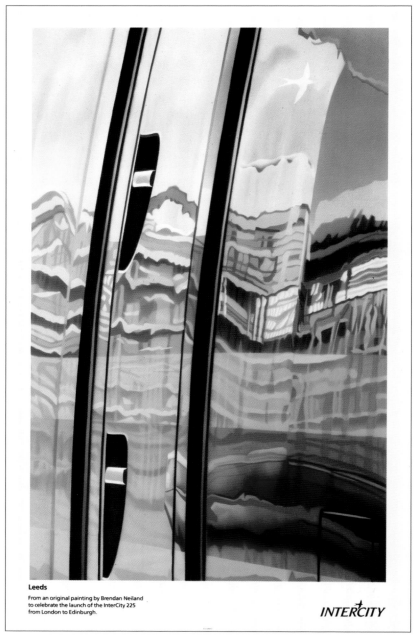

Contemporary Leeds Railways in 1991: Artist Brendan Neiland

Closing Remarks

This has been a lovely book to research and write and as the study progressed I realised the closeness of advertising, railways and the region's fortunes. In terms of railway art, the area has been blessed with a great deal of attention. Railways have had more impact on the social and economic development of the region than is realised. They have allowed seaside towns to grow, industry to boom and exports from the hard-working towns of the region to be sent to all parts of the world. The six posters here are almost a potted history of poster development over the whole of the 20th century. Today, steam excursions are an important part of the local economy. We are most fortunate that the majority of the materials I have used can be seen at the NRM in York. If you are interested in railways and railway posters, the new facilities put together since the building of the Great Hall allow both interested and serious parties alike to study the region closely.

By far the biggest problem I faced was how to use the wealth of information contained in the National Collection in a unique way. I did not want to create just another poster picture book, and looking at past texts, modern works have received scant attention. As well as taking the in-depth railway journey in art, the aim of this final chapter has been to show how posters developed at a time when the region was changing rapidly. I sincerely hope that the result of many years work stimulates more visitors to the area, and emulates the original intent of all 389 images contained herein: namely to go to and see some of these evocative places. Enjoy Yorkshire and the North-East everybody!

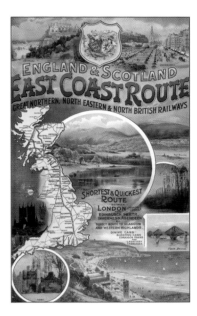

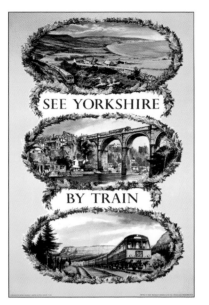
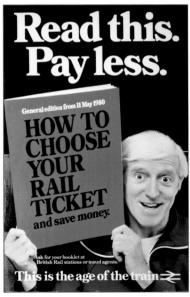
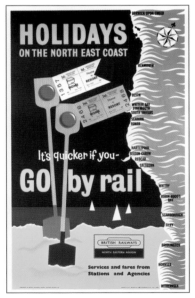
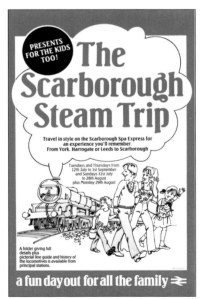

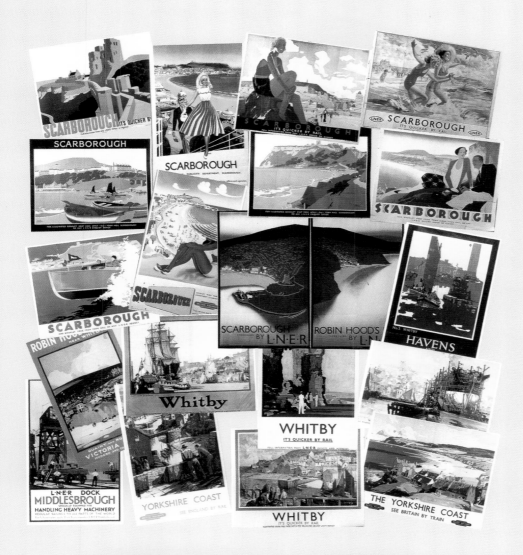

Copyright Scarborough Borough Council 1990 (Both Pictures)

Reproduced by Kind Permission from 1990 Book "Railway Posters of the Yorkshire Coast"

ARTIST PORTRAITS

Thumbnail sketches of the lives of the more prominent and influential poster artists, who will appear throughout this series of books, are given in this section. Greg Norden has been of great help in assisting with this. Data from his definitive book on carriage prints *"Landscapes Under the Luggage Rack"* forms part of the information presented here (see Appendix D). Other information was received from many sources, via research at the NRM and on the Internet.

Adrian Paul Allinson (1890-1959)

He was born in London 9/1/1890, the son of a doctor. He was educated Wycliffe & Wrekin College, Wellington, and studied art at the Slade School under Tonks, Steer, Brown and Russell from 1910-12, and won the Slade scholarship. Allinson worked for a time in Munich and then Paris. He was a teacher of painting and drawing at Westminster School of Art. Whilst living in London, he became a notable landscape painter, sculptor and poster designer. He died on 20/2/1959, having produced posters for GWR, SR & BR.

Bruce Angrave (1914-1983)

Born in Leicester, Angrave studied at the Chiswick School of Art and London's Central School of Art. He worked as a freelance illustrator, designer and sculptor. Heavily influenced by both Eckersley and Games, his poster work is distinctive and sometimes a little bizarre. His concept was *'follow or discard'* after two seconds! He felt a good poster could be looked at time and time again, thus almost forcing the message home. After WWII, he undertook many commissions and his work was displayed at the 1951 Exhibition.

Stanley Roy Badmin (1906-1989)

Badmin was noted as a detailed landscape watercolour artist, a lithographer and an illustrator & engraver. He was born Sydenham, London 18/4/1906, the son of a schoolmaster, and studied art at Camberwell School of Art and at RCA. He was art teacher and lecturer at Central School of Arts and Crafts, and was elected to the Royal Water Colour Society in 1939. He illustrated several books including 'British Countryside in Colour', 'The Seasons', 'Shell Guide to Trees and Shrubs' etc. Very elaborate in style. He lived in Bognor, Sussex for some time, and produced posters and carriage prints.

William H. Barribal (1873 - 1956)

Barribal was a London artist who began his career as a lithographer, before going on to study at the Paris Academie Julien. Becoming an accomplished painter and designer by the first quarter of the 20th century, Barribal created such memorable images as posters for the Schweppes advertising campaign, and the Waddingtons playing cards series, which are avidly collected today. He is also well-known for the bold Art Deco posters designed in the 1920s and 1930s for the London North Eastern Railway.

John Francis Bee (1895-19xx)

Designer of stage settings, posters and show-cards. Born in Wolverhampton. Studied art for four years in Europe and the Near East. Exhibited in Manchester and worked at Loughborough and Liverpool. His work was illustrated in 'Commercial Art' and 'Posters and Publicity'. His posters bore a distinctive capital 'B' monogram (as in Chapter 3), but his carriage panel artwork carried his normal signature. Painted for the LNER and GWR. Little is known about his later life, and no data has been found about his place or date of death.

Samuel John 'Lamorna' Birch (1869-1955)

Samuel Birch was born in Egremont, and educated at the Academie Colarrossi in Paris from 1896. His mother encouraged his art from an early age, and at 15 he exhibited at the Manchester City Art Gallery. He had moved to Cornwall in 1892 and, despite no formal training at that time, he became a professional artist. He was a keen fisherman, and his love of water always inspired his work. His nickname came from the fact that he lived at Newlyn in the Lamorna Valley. He is known for his expansive painting.

Montague Birrell Black (1884-1961)

Poster artist & illustrator, he was born Stockwell, London 29/3/1884. Educated Stockwell College, he first produced military and naval artwork, and was artist war correspondent for Toronto Star 1939-45. Black lived West Derby, Liverpool and Harrow, Middlesex. Was a White Star Line artist, and was renowned for his map posters for the railways over many years. He produced posters for LNWR, M&GN, LNER, LMS, SR & BR.

Stephen Bone (1904–1958)

Painter, born in Chiswick, London, on 13 November 1904. His father, Sir Muirhead (1876–1953), was a prestigious draughtsman and engraver. He trained from 1922-24 at the Slade School of Art under Henry Tonks. He was awarded a gold medal at the International Exhibition in Paris. In 1929 he married the artist Mary Adshead. By the time of the Second World War he was serving as a lieutenant in the Royal Naval Volunteer Reserve. He also worked for the War Artists' Commission. Many of his images were published in the *Illustrated London News*. His talent was recognised by his appointment as director of Hornsey College of Art in 1957. Sadly, he died only a year later in London, on 15 September 1958.

Sir Frank William Brangwyn (1867-1956)

Brangwyn was a Welsh artist, virtuoso engraver, water colour specialist and a truly progressive designer. Born in Bruges, where his father had been commissioned to decorate the Basilica, he returned to England in 1875 and received artistic guidance from both his father and the architect William Morris. With no formal training, his work was accepted for an RA summer Exhibition and he was determined to become an artist. Initially he used limited palettes in his posters, so they appeared dark and gloomy: later this changed as 'Orientalism' swept the art world. His work softened and brightened in his later years. Brangwyn received commissions from the East and from Africa. His work is very collectible.

F. Gregory Brown (1887-1948)

Began his artistic career as a metal worker, but turned to magazine illustration. He undertook work for all four of the main railway companies in addition to ICI, the Empire Marketing Board and MacFisheries. Gold Medal winner at 1925 Paris Exhibition of Art for textile design. Produced many posters for the London Underground.

Pieter Irwin Brown (1903-19XX)

Born in Rotterdam and grew up in Holland. He then travelled widely in Europe and Africa working as an artist. When he moved to London, he worked for Leigh Breton Studio and set up a design business with partner Rickman Ralph. He designed posters for the London Midland & Scottish Railway, Great Western Railway, London Transport and London County Council Tramways. In the 1930s he travelled to Indonesia, Japan and China, where he produced Japanese style woodblock prints. He moved to America in 1940, and worked under the name Pieter van Oort. In 1946 he settled in New York and little is known of his later life. He appears in the database as P Irwin Brown.

Claude Buckle (1905-1973)

Painter in oils & watercolour, particularly marine subjects, poster designer. Born London 10/10/1905. Trained as an architect, specialising in industrial drawings, but turned to art in 1928. Was a member of Savages Art Club in Bristol. Produced commissioned artwork for the new nuclear power stations around the country. Close friend of Terence Cuneo. Achieved a prolific output of artwork for the railways. Painted many of his later subjects around the coast in France. Lived near Andover, Hampshire. Died in 1973. LMS, GWR and BR Posters.

Sir David Young Cameron (1865-1945)

Born in Glasgow and trained at both Glasgow and Edinburgh Schools of Art in the 1880s. Became known for his church interior drawings, and for his detailed etching work. Made Royal Academician in 1920, and was sought after until his work dried up in the Great Crash of 1929. Undertook poster work for the LMS.

Lance Harry Mosse Cattermole (ROI 1898-1992)

Painter in oils & watercolour. Born 19/7/1898, son of Sydney Cattermole, an artist, and grandson of George Cattermole (1800-68) - illustrator of 'The Old Curiosity Shop' and other Charles Dickens works. Educated Worthing, Sussex and Odiham, Hants. Studied at Central School of Arts & Crafts 1922-23 and at the Slade School 1923-26. Lived near Worthing for many years. Represented in many museums and collections.

Christopher Clark (1875-1942)

Lived in London and better known initially as a historical and military subject painter. He worked for the LNER and LMS and several posters were reissued by BR. Famous for ceremonial posters, such as Trooping the Colour and Changing of the Guard.

Austin Cooper (1890-1964)

Born in Canada he trained and practised in Britain. He studied at the Cardiff School of Art from the age of 13, before winning a scholarship to the Allan-Frazer Art College, Arbroath from 1906 until 1910. In 1910 he moved to London, studying in the evenings at the City and Guilds School. He returned to Canada as a commercial artist, although this was interrupted by war service during the First World War in Europe. In 1922 he settled in London and received the first of many poster commissions from London Underground. Over the next two decades he established his reputation as a top poster designer. After the 1920s his work became increasingly pictorial, and he produced work for the Empire Marketing Board, LNER as well as the London Underground. In 1943 he turned from his career as a poster artist to become a full time painter.

Charles Ernest Cundall (1890-1971)

He was born in Stretford, Lancashire and studied at the Manchester School of Art, and then the Royal College of Art 1912-14. His studies were interrupted by WWI but he returned to RCA in 1918. Further studies at Slade Fine Art School and in Paris followed. He travelled widely; cityscapes and portraiture characterized his work, though he strayed into poster art and produced some good 'Big Four' and London Transport items. During WWII he was in Quebec as an official War Artist.

Terence Tenison Cuneo OBE (1907-1996)

One of the most famous of all poster artists, Cuneo was the son of Cyrus and Nell Cuneo, well respected artists. He studied at Chelsea and Slade Art Schools. Known for railway subjects, he was also an accomplished portrait painter (including Royal and VIP subjects). Some of his engineering and technical work is also excellent. He was

appointed as official painter to Queen Elizabeth II for her Coronation in 1953.

Laurence Fish (1919-2009)

He was born in London, and trained as an illustrator in Max Miller's studio at publishers Iliffe & Son, specialising in technical subjects - aircraft, yachts, motor cars - and acquiring the meticulous draughtsmanship required for publications like Yachting World, Autocar etc. During war service with the RAF he was seconded to MI5 as a specialist in explosive devices. After the war he was a founder member of the Society of Industrial Artists and Designers, and became internationally known as a painter/illustrator. His work was commissioned and owned by most large industrial companies, (e.g. Shell, BP, Dunlop, Bristol Aeroplane Company, Hawker Siddeley, BOAC, MG Cars, British Rail and the Indian Air Force. His covers for Flight International and posters for British Rail Posters, are already collectors' items.

Francis Murray Russell Flint (1915-1977)

Landscape & coastal painter in oils & watercolour. Born 3/6/1915, son of Sir William Russell Flint, the famous artist (who also produced posters for the railways). Educated at Cheltenham College and *HMS Conway*. Studied art at Grosvenor School of Modern Art, at the RA Schools and in Paris. Was art master at Lancing College. Lived in Burgess Hill, Sussex and Coffinswell, South Devon and London W8. Was Vice President of RWS. Died accidentally in Spain in 1977. Produced artwork for LNER Post-War, W Region series.

Abram Games (1914-1996)

Games learned his art at evening classes from 1932 onwards. He went to St. Martins School London, but left after two terms to pursue art. Worked in photography for his father, and then in a commercial design studio. In 1936 he won the London Olympic Games poster competition, and became a freelance artist full-time, securing commissions from Shell, London Transport and the Post Office. He was official War Office Designer during WWII. He had a 60-year career as an influential poster artist.

Konstantin Ivanovic Gorbatoff (1876-1945)

A Russian-born artist who fled the aftermath of the 1917 Revolution, going first to Italy, and then to Berlin in 1926. Commissioned by LNER to paint his famous poster of Scarborough (see page 100). He died just two weeks after the end of WWII.

Henry George Gawthorn (1879-1941)

He was born in Northampton and studied at Regent Street Polytechnic. He trained as an architect, but later turned to painting and art. He was a prominent LNER poster artist and wrote widely about poster design. He used to include himself in his posters, and 20 of his works are found at the NRM in York. Some of his seaside posters are absolute classics, (see page 139).

Charles Isaac Ginner (1878-1952)

He was born in Cannes, France and left school at 16 to go to sea. On his return he was briefly employed in an engineer's office before leaving for Paris, to work in an architect's office. In 1904 he left to study art at the Academie Vitti under Paul Gervais. His style of painting was not popular at the Academie and he left to go to the Ecole des Beaux-Arts and then to pursue his own career. Greatly influence by Van Gogh's bright style. Produced railway posters for the LNER.

John A Greene (ARCA)

Artist in oil and watercolour and lecturer. Studied art at the RCA. Lecturer at the Architectural Association School

from 1946. Produced work for I.C.I. and the British Transport Commission. The detail in some of his posters was astonishing. Lived at Bordon, Hants.

Norman Hepple (1908-1994)

Born in London, Robert Norman Hepple produced posters for both BR and London Transport. He was educated at Goldsmiths College and the Royal Academy. His father and uncle were both well-known artists of their day. His work is owned by the Royal Family, and during WWII he was attached as artist to the National Fire Service. Suffering ill health during his later life, he was killed in a road accident shortly after undertaking his commissions for London Transport.

Ernest William Haslehust (1866-1949)

Landscape painter chiefly in watercolour, illustrator. Born in Walthamstow 12/11/1866. Educated Manor House, Hastings and Felsted. Studied art at Slade School under Legros. Represented in several public collections. Principal works include *The Bridge nr Arundel* and *A Devon Estuary*. He illustrated the *'Beautiful Britain'* series of books. President of Midland Sketch Club and Vice President of Kent County Chess Association. Lived in South London for many years. Died 3/7/1949. Produced posters for LMS & LNER in a most detailed and wonderful style of painting (see page 58, 62 and 177).

Rowland Hilder (1905-1993)

American-born landscape & marine painter, illustrator, author. (Born 28/6/1905 at Great Neck, Long Island, USA of British parents). Educated at Morristown, New Jersey. Settled in England 1915 and studied at Goldsmiths College School of Art under E.J.Sullivan 1922-25. His work was first selected for RA in 1923 when only 18. He married Edith Blenkiron, also a painter. Represented in several public collections here and abroad, and is

renowned for his paintings of Kentish oast houses. Was President of RI 1964-74. He illustrated many books incl. 'Moby Dick' 1926, 'Treasure Island' 1930, 'The Shell Guide to Flowers of the Countryside' etc. Designed National Savings and Shell Oil posters. Hilder wrote books on watercolour technique and an autobiography 'Rowland Hilder, Painter & Illustrator'. He lived in Blackheath, London and died April 1993.

Ludwig Holhwein (1874-1949)

Born in Wiesbaden, Holhwein also lived in London, Paris, Munich and Berchtesgaden. He trained as an architect, but began producing posters as early as 1906. Some of his early works are quite superb (restaurants, pavement cafes and buildings) and he was asked by the LNER to undertake some commissions. He worked as an illustrator for the Third Reich during WWII, where his bold style was suited to the messages required.

Eric Hesketh Hubbard (1892-1957)

Landscape & architectural painter, etcher & furniture designer. Born 16/11/1892 in London. Educated at Felsted School. Studied art at Heatherleys, Croydon School of Art and Chelsea Polytechnic. Member of many art societies. Represented in many public collections, home and abroad. Published a number of books including 'Colour Block Print Making' and 'Architectural Painting in Oils'. Founder and director of Forest Press. Lived Croydon, Surrey; Salisbury, Hants and later in London. Died 16/4/1957. Produced posters for LMS, SR & GWR.

Edward McKnight Kauffer (1890-1954)

Born in Great Falls Montana, Kauffer became a most prolific and well known poster artist in Europe after studying first in San Francisco and then in Paris in 1913. WWI saw him move to London, becoming a London Transport artist for over 25 years. One of the most influential poster artists, he used surrealism, cubism and futurism in his work. Significant posters were produced for the GWR, Shell, Empire Marketing Board and the Post Office. His posters are instantly recognizable.

Ronald Lampitt (1906-19xx)

Painter of landscapes in oils & watercolour, poster designer, book illustrator (including children's books). Worked for Artists Partners Agency in London. Lived In Hampstead, London. Produced posters for GWR, LMS and SR, as well as many for BR.

William Lee-Hankey (1869-1952)

Painter and etcher of landscapes and portraits. Born 28/3/1869 in Chester. Studied at Chester School of Art under Walter Schroeder, at the RCA and also in Paris. Served with Artists Rifles 1915-19. Exhibited at most principal London galleries. President of London Sketch Club 1902-4. Represented in many public collections, home and abroad, and was a considerable contributor to RWS exhibitions. Won gold medal at Barcelona International Exhibition and bronze medal at Chicago. Lived and worked in France for some time, then in London. Became member of RWS in 1936, aged 67 and vice president in 1947. Died 10/2/1952. Produced LNER posters. He had a lovely painting style (see page 88).

Reginald Montague Lander (1913-19xx)

Born in London 18/8/1913. Freelance commercial artist in gouache and watercolour, poster designer. Educated Clapham Central School and studied at Hammersmith School of Art. Chief designer and studio manager at Ralph Mott Studio (1930-9). Worked for Government Ministries and British Transport Commission. Lived New Malden, Surrey. Produced very many posters for all regions of BR

and the Post Office. Famous for his bold style, almost modernistic.

Alan Carr Linford (1926 -)

Alan Carr Linford is an eminent poster artist. He studied at the Royal College of Art 1943-47, gaining professional qualifications in art by the age of 20, and winning several prestigious scholarships. A student of Sir William Halliday, his work was seen in 1949 by the then Princess Elizabeth at Clarence House. Over the years Queen Elizabeth II has collected several of his drawings. He has painted for Royalty all over the world. One of my favourite posters of all, is his depiction of High Street Oxford; it has quite superb artwork, depth and movement. See also his painting of York (page 224).

Alasdair Macfarlane (1902-1960)

Born in Ballymartin, Tiree 26/9/1902; Gaelic speaking, later bilingual, he was a self-taught artist. Moved to Glasgow 1922. Worked on ships for P Henderson & Co. Joined Clyde Navigation Trust in 1929. Drew ships for Evening Citizen newspaper, Glasgow from 1929. Exhibited 1932-7. Served with Ministry of War Transport in London 1940-45 and re-joined Clyde Navigation Trust. Produced private and commercial work latterly and ship drawings for Glasgow Evening Times 1950-60. Died from heart attack 1960. Produced posters for BR and Caledonian MacBrayne of Scotland.

Freda Marston (1895-1949)

Born at Hampstead 24/10/1895 (nee Clulow). Painter & etcher of landscapes & figures. Educated, Hampstead, London. Studied art at Regent Street Polytechnic, in Italy and under Terrick Williams 1916-20. Married Reginald St Clair Marston in 1922. Now represented in several public collections. She was the only woman artist commissioned by the railway for carriage prints. Lived Amberley, Sussex

and later at Robertsbridge. Died 27/3/1949. Produced posters for LMS & BR.

Frank Henry Algernon Mason (1875-1965)

Marine painter in oil & watercolour, etcher, illustrator, author & poster designer. Born Seaton Carew, Co Durham 1/10/1875. Son of a railway clerk. Educated at *HMS Conway* and followed sea for a time as a ship engineer. Later engaged in engineering and shipbuilding at Leeds and Hartlepool. Travelled abroad extensively and painted many subjects in watercolour. Served 1914-18 as Lieutenant in the RNVR in North Sea and Egypt. Studied under Albert Strange at the Scarborough School of Art. Member of RBA 1904, RI 1929. Exhibited at the RA from 1900; prolific output of a railway artwork. Wrote the book *Water Colour Painting* with Fred Taylor. Lived at Scarborough, then London. Represented in several public collections. Produced posters for many UK areas. Many appear throughout this Volume.

Fortunino Matania (1881-1963)

Born in Naples, Italy, he moved to London around the outbreak of World War I. He illustrated books and magazine, as well as his poster work for the railways. He created some of the most spectacular posters ever produced by any railway company. (His Southport duo to appear in Volume 3, are magnificent). His unique style lent itself well to portraying the 20s.

Jack Merriott (1901-1968)

Landscape & portrait painter in oil & watercolour, poster designer, author. Born 15/11/1901. Educated at Greenwich Central School. Studied at Croydon School of Art and at St Martins School of Art, both in London. Lectured in Royal Army Education Corps (1945-6). President of Wapping Group of artists 1947-60. Lived in Shirley, Surrey; then Storrington, Sussex and later in

Polperro, Cornwall. Illustrated some of the *'Beautiful Britain'* series of books by Blackies. Lectured widely on watercolour and produced the *'Pitman Guide to Watercolour'* and wrote *'Discovering Watercolour'*. Was Vice President of RI and achieved a prolific output of railway-related artwork. Produced posters for BR, several of which are found throughout this Volume.

Claude Grahame Muncaster (1903-1974)

Painter in oil & watercolour; etcher of landscapes, town scenes & marines, lecturer & writer. Born 4/7/1903 in W.Chiltington, Sussex, son of Oliver Hall (RA). Educated at Queen Elizabeth School, Cranbrook. Elected a Member of RWS in 1936. In November 1945, he adopted above name by deed poll but had exhibited under that name from 1923, and previously as Grahame Hall. First one-man show at the Fine Art Society 1926. Wrote book *'Rolling Round the Horn'*, pub.1933, telling of his four-month voyage from Australia to Britain. Represented in many public collections. Wrote several books on art. Lived near Pulborough, Sussex. Produced posters for GWR & LMS.

Bernard Myers (1925-2007)

Bernard Louis Myers, artist and teacher: born in London 22 April 1925. He worked in instrument-making (radio location), and took a short course in Physics at London University before volunteering for the RAF at the age of 18. Royal College of Art 1961-80, Professor of Design Education 1979-80; Professor of Design Technology, Brunel University 1980-85; died London 30 September 2007. Known for his abstract style posters for British Railways, which today are more collectible than during his lifetime.

Brendan Neiland (b 1941-)

Born in Lichfield Staffordshire, he studied art at the Birmingham College of Art and then the Royal College of

Art in London. After winning numerous prizes and awards he was elected a Royal Academician in 1992, and a Fellow of the Royal Society of Arts in 1996. He is currently Professor at the University of Brighton. One of the UK's most distinctive painters, his modern renditions of British stations are real collectors' items. Has exhibited internationally, and his work is held in major public, private and corporate collections worldwide. His 1991 station posters for Newcastle, York and Leeds are found within this Volume.

Frank Newbould (1887-1951)

Born in Bradford, he became one of the 'Big Five' poster artists after studying art at the Camberwell School. Joined the war office in 1942 and was assistant under the famous Abram Games. His many posters were undertaken for the LNER, GWR, Orient Line and Belgian Railways. A great poster artist, he sadly died at too young an age. There are many examples of his fine poster artwork in this Volume.

Charles Oppenheimer (1875-1961)

Born in Manchester, this well known artist spent much of his life in Kirkcudbright and died there. Oppenheimer studied under Walter Crane at Manchester School of Art and in Italy. He settled in Kirkcudbright, and for 52 years painted views of the landscape in his local area. He was a keen fisherman, and many of his paintings dealt with rivers and the effect of light on water: he was also a fine painter of snow and an acute observer of weather conditions. He painted both oils and watercolours in a fresh, direct and realistic manner and his popularity is due to his great sensitivity to landscape and light. He retained a love of Italy and produced some excellent canvases of Florence and Venice. His expansive style produced some wonderful posters (e.g. Whitby page 83).

James McIntosh Patrick (1907-1998)

Landscape & portrait artist in oil & watercolour, etcher. Born 4/2/1907 in Dundee, son of an architect. Studied at Glasgow School of Art under Grieffenhagen (1924-8) and in Paris. Worked for Valentines Cards. Received Guthrie award in 1935. Exhibited at the Fine Art Society and represented in many public collections, including the Tate Gallery. Based in Dundee for many years and died 7/4/1998. Produced posters for LNER & BR.

Charles Pears (1873-1958)

Yorkshire-born Pears was a prolific railway poster artist and some of his classic posters are highly collectible. He was an Official Naval Artist during the First World War and also president of the Society of Marine Artists. He was 60 when he married Tiger in 1933, just two years after the death of his first wife, Miriam in 1931.

Tom Purvis (1888-1959)

Born In Bristol, the son of famous marine artist TG Purvis, Tom Purvis became one of the best poster artists of all. He studied at the Camberwell School of Art, and worked for six years at Mather and Crowther, before becoming a freelance designer. His bold style used blocks of colour in a two-dimensional manner and he largely eliminated detail. Worked under William Teasdale, the Advertising Manager at the LNER and then his successor Dandridge, for 20 years and rose to prominence in the poster art field very quickly. Our database shows almost 100 posters, produced over his entire working life and several are featured herein. He tended to focus on places and the landscape rather than trains or people (though people featured on page 183). His famous stand-alone set of six posters for the LNER could be placed together panoramically: way ahead of its time.

Gyrth Russell (1892-1970)

Printer, etcher of landscapes & marine subjects. Born Dartmouth, Nova Scotia on 13/4/1892. Son of Benjamin Russell, Judge of Supreme Court, Nova Scotia. Studied art at Boston USA, also in Paris at the Academie Julian and Artelier Colarossi 1912-14. Represented in several public collections including Canada's National Gallery. Was official war artist with the Canadian Army during World War I. Lived in Topsham, Devon and later in Penarth, Glamorgan and Sussex. Died 8/12/1970 in Wales. Produced posters for GWR & BR. One of his best is found on page 99, and several are in my own collection, and will appear throughout this series.

Sir Henry George Rushbury (1889-1968)

Painter in watercolour, etcher & draughtsman of architectural subjects. Born 28/10/1889 at Harborne, Birmingham. Studied stained glass design and mural decoration at Birmingham College of Art 1903-09, later working as assistant to Henry Payne (RWS). Settled in London in 1912. First one-man show held at Grosvenor Gallery in 1921. Studied at Slade School for six months under Tonks. Became member of RWS in 1926. Worked home and abroad and represented in many public collections. Created CVO 1955, CBE 1960, KCVO 1964. Lived London, Sussex and Essex. Produced some truly outstanding posters for LMS, LNER & BR (see page 181).

Charles Shepherd (1892-19XX)

Signed his posters as 'Shep'. He also went under the name Captain Shepherd. He studied art under Paul Woodroofe and later became head of the studio at the Baynard Press. First commissioned to produce posters for the LNER, then the Southern Railway and several for London Transport. Worked for almost 40 years, finally producing some notable BR artwork.

Frank Sherwin (1896-1986)

Marine & landscape painter in oil & watercolour, poster designer. Born Derby 19/5/1896, son of Samuel S Sherwin (painter). Educated Derby and studied at Derby School of Art and at Heatherleys School of Fine Art in Chelsea 1920. Exhibited from 1926 to 1940. Served in WWII as camouflage advisor around East Anglian airfields. Lived in Cookham, Berks for many years. Prints were produced from some of his artwork. Achieved a prolific output of art for the railways. Produced posters for GWR, LMS, LNER & BR. Died in Slough in 1986.

Ellis Luciano Silas (1883-1972)

Marine & landscape painter in oil & watercolour, poster and stained glass artist. Born London, son of Louis F.Silas, a decorative artist and founder member of the United Artists; and grandson of Edouard Silas, a composer. Studied art under his father and Walter Sickert. He was war artist for the Australian government 1914-18 and spent three years in Papua, painting and collecting curios which he described in his book 'A Primitive Arcadia'. President of the London Sketch Club in 1930. Lived in London for many years.

Walter Spradbery (1889-1969)

He was born in Dulwich, East London and educated at Walthamstow Art School. He specialized in landscapes showing the countryside around London, and regularly exhibited at the Royal Academy. His poster designs were produced mainly for London Transport, although he received some commissions for the LNER and British Railways. A lifelong pacifist, he served in the Royal Army Medical Corps during the First World War, and was also an official war artist. A memorial exhibition was held at the William Morris Gallery, London in 1970, the year after his death.

Leonard Russell Squirrell (1893-1979)

Painter & etcher of landscapes & architectural subjects, writer. Born at Ipswich 30/10/1893. Educated at British School, Ipswich and studied at Ipswich School of Art under G. Rushton and at the Slade School. Won British Institution Scholarship in engraving 1915. Received gold medals at the International Print Makers Exhibitions in Los Angeles in 1925 & 1930, and silver in 1923. Represented in many collections, home and abroad. Transferred from the RI to the RWS during his career. Published 'Landscape Painting in Pastel' 1938, and 'Practice in Watercolour' 1950. Lived near Ipswich and was founder member of the Ipswich Art Club.

Kenneth Steel (1906-1970)

Painter in watercolour, engraver & lithographer of landscapes & street scenes; poster designer. Born in Sheffield 9/7/1906, the son of G.T.Steel, an artist and silver engraver. Studied at Sheffield College of Art under Anthony Betts. Represented today in several public collections. Achieved a prolific output of artwork for the railways because of a bold style ideal for advertising. Based in Crookes, Sheffield for years. Produced posters for LNER & BR, he was one of the most prolific artists in the early BR days.

Fred Taylor (RI 1875-1963)

Landscape & architectural painter in watercolour, poster designer. Born in London 22/3/1875. Educated at St John the Evangelist. Studied art in Paris at the Academie Julian, then at Goldsmiths College School (awarded gold medal for posters) and in Italy. Worked at the Waring & Gillow studio. He was a poster artist from 1908 to 40s. In 1930, he designed four ceiling paintings for the Underwriting Room at Lloyds, London. Worked on naval camouflage during World War II. Renowned for his topographical accuracy and prolific output, especially for the railways.

He was one of Teasdale's favoured artists in very early LNER days. Wrote the book 'Water Colour Painting' with Frank H Mason. Represented in several public collections and exhibited at the Royal Academy. Lived in London for many years. Produced posters for MR, GWR, LMS, LNER, BR, LT, EMB & several shipping companies.

Norman Wilkinson CBE (1878-1971)

Born in Cambridge. Educated at Berkhamsted School and St Paul's Cathedral choir school, he had little training in art but largely developed his style through his maritime career. Norman's greatest love was painting, his subjects were seascape and landscape in both oil and watercolour. His early career as an illustrator for the Illustrated London News enabled him to develop his talents as both artist and entrepreneur. Norman made a contribution to WWI with the invention and development of Dazzle Painting, a form of ship camouflage. One of the finest marine painters of the century, he is well represented in many public collections, including Greenwich and the NRM York. During WWII he painted a record of the major sea battles and presented the series of 54 paintings to the Nation. They are kept at the National Maritime Museum. Norman's commercial work included many illustrated books and he initiated a revival in poster painting for LMS Railways. Honoured with the CBE in 1948.

Anna Katrina Zinkeisen (1901-1976)

Born in Kilcreggan, Dunbartonshire, she was a pupil of the Royal Academy School, holding medals from there. Designed posters for the LNER and SR. She won scholarship to the Royal Academy from Harrow School of Art, winning the Landseer Prize in 1920 and 1921. She also worked for Wedgwood as a ceramics designer. She and sister Doris were commissioned to paint large murals in the RMS Queen Mary, which can still be seen at Long Beach California. Both she and elder sister Doris (below) had very distinctive painting styles.

Doris Clare Zinkeisen (1898-1991)

Elder sister of Anna, (see above), she also studied at the RA Schools. Lived in London: she also undertook theatrical and set design work. Her classic poster of 'Coronation' can be found on page 3, and her striking self-portrait on page 19. She worked as official artist to the St. John Ambulance during WWII, when she and younger sister Anna were nurses. Arrived in Belsen shortly after liberation and had recurring nightmares about the place until she died.

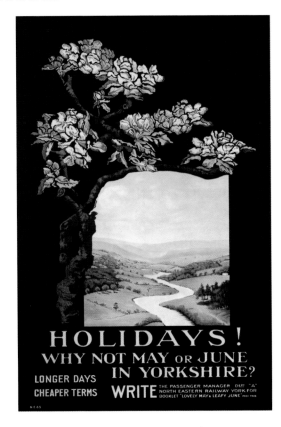

Written by the Author: Database with Valerie and Simon Kilvington

The following pages show the result of literally thousands of hours of work, put in by all three of us since I (RF) began the database research after my first visit on the project to the NRM in the spring of 2002. All three of us were working on it by the end of 2002, and it is no exaggeration to say that many hours every week are taken up with adding, checking and amending our information. It is a bit like 'painting the Forth Bridge'. The following pages list those Yorkshire and North-East England related posters found during the research work. They form part of a much larger database of several thousand entries, and almost 100,000 separate pieces of information, that supports the master spreadsheet. This now runs to 140 pages. We have collected digital images for more than 98% of all entries, and this in itself has become a major research library.

Since the publication of Volume 1, we have been asked to answer queries on posters from all over the world. We were also very grateful to receive a large amount of new data, information (and corrections) from several people. The names of the English counties and their boundaries that existed prior to the formation of Metropolitan areas are used, in keeping with the titles and locations used on many of the posters. Thus there is no Tyne and Wear, no Cleveland and no South Yorkshire for those readers who may say, where is my county? Even today, it is noticeable that many railway posters do not refer to the present county names.

The NRM, SSPL, Onslows and Christies have been very supportive of this Volume in the project, and their location information is given. The spaces in the following pages are all filled in our master database, so every poster has full traceability on its source. The poster entries are mainly for the years 1890-1970, as we are still collating and checking many hundreds of modern and contemporary images for the period 1971-2009. However, some of the better and more visually appealing posters from this period can be found in Chapter 10. We also have photographic and letter-press type posters to collate, but the sheer number of these is a serious obstacle to the speed of our cataloguing. Therefore, the 15 pages that follow are only the preamble to more comprehensive future listings.

The first group of entries are listed under **Adverts** (column four). There are many more to be found in Volume 8, but the 37 entries given on the next page are clearly issued by, or relevant to, the region, as opposed to a general advertising poster. Several of these can be found in Chapters 1 or 10. Some are quite famous posters, such as Brangwyn's "North East Industries" from 1935, or Fred Taylor's "LNER Centenary" poster from 1925.

The next group covers **County Durham**. This land of princes and bishops is a shadow of former and greater times, when powerful families defended the northern English border against the marauding Scots. 32 posters have been found and listed, many around the City of Durham, but others cover Teesdale, Barnard Castle, Teesside and the seaside resorts of Roker and Seaburn. Some of the loveliest river scenes ever painted come from upper reaches of the Tees. The name derives from the Saxon word 'Dunholme' meaning a hill and an island in the river: the area is found on pages 45-54.

Northumberland has 66 entries, which cover the whole county from Berwick in the north down to the Tyne, and across the area where the Romans were our guardians in former times. Not surprisingly Whitley Bay is well represented at 16 entries. Some of these are masterpieces of art. The name was first recorded in 895 AD as Norohymbraland – meaning 'the place of those north of the Humber'. This is true Anglo-Saxon. It is a surprising county, usually overlooked by travellers heading for Scotland. But Chapter 1 shows, its scenery is stunning, its history and culture are rich.

And so to **Yorkshire**, with well over 420 entries; by far the greatest number for any British county in the entire master database. (I could have written the whole book on Yorkshire alone). The name comes from the Roman Celtic word *Eboracum*, used for part of Chapter 9 title. This became *Eoforwic* (as pronounced by the Angles), and when the Vikings arrived, this changed again to *Jorvik*. It was easier to shorten this to York. It covers a very large area (12% of England), with a great diversity in landscape and local culture. The old capital, the City of York, has more than 50 poster entries, and many of these came from Fred Taylor, who seems to have painted the whole of York at some time in his long career. The tour of York is to be found on pages 211-230. Needless to say, the Yorkshire seaside resorts of Scarborough, Filey and Bridlington also have many entries, as the railways tried to entice the West Yorkshire millworkers to take their trains to these resorts for holidays and day-trips. Scarborough has almost 50 posters; Bridlington has almost 30 and Filey seven, reflecting the relative advertising status of the three towns. Harrogate was also a major railway destination for health, theatrical and social events. 35 posters represent the town, which was sadly neglected by British Railways. Industrial posters for Hull also figure highly: some superb images have been produced over the years depicting industrial scenes from all over the region.

ARTIST	YEAR	TITLE	LOCATION	COMPANY	SIZE	SOURCE	SOURCE DETAILS		IMAGE REF	NRM REF
Wilkinson, Norman	1950	Service to Industry: Steel	Advert	BR(LMR)	QR	SSPL	10173784	Drawer D022	Advert073	1978-9150
CEP	1950s	The Master Cutler: Business Man's Train	Advert	BR(ER)	DR	SSPL	10170919	Drawer D156	Advert080	1990-7015
Anon	1905	Xmas Excursions from London	Advert	GNR	DR	SSPL	10289067		Advert1025	
Cooper, Austin	1926	Blast Furnaces Served by the LNER	Advert	LNER	DR	SSPL	10173481	Drawer D096	Advert116	1978-8943
Cooper, Austin	1926	Coal shipped on LNER	Advert	LNER	DR	SSPL	10174250	Drawer D096	Advert117	1978-9432
Anon	1959	Great Northern Line: Good in 1909: better in 1959	Advert	BR(ER)	DR	SSPL	10170920		Advert198	1990-7016
Anon	1961	Holidays on the North East Coast	Advert	BR(NER)	DR	SSPL	10175602		Advert205	1978-1021
Anon	1976	Settle - Carlisle Railway: Centenary Day Special 1st May	Advert	BR(LMR)	DR	SSPL	10171778	Drawer D111	Advert249	1979-7823
Gawthorn, Henry George	1933	Capacity - Mobility on the LNER: Ardwick Depot Manchester	Advert	LNER	QR	SSPL	10172883	Drawer D009	Advert304	1984-8206
Steel, Kenneth	1963	Service to Industry – Steel	Advert	BR(NER)	DR	SSPL	10173159		Advert319	1977-5598
Anon	1977	The Electrics are Coming	Advert	BR(NER)	DR	SSPL	10175203		Advert393	1978-0640
Anon	1960s	You have voted Trans-Pennine a Hit!	Advert	BR(NER)	DR	SSPL	10175564		Advert404	1978-0983
Turpin, Peter	1992	Settle - Carlisle Line: A Journey Through History	Advert	BR(NER)	DR	SSPL	10171247		Advert426	1992-7718
Clausen, G.	1924	British Industries: Coal	Advert	LMS	QR	SSPL	10171854	Drawer D004	Advert445	1979-7899
Clausen, G.	1924	British Industries: Coal Stock poster	Advert	LMS	QR	NRM	1978-8957	Drawer D004	Advert445a	1978-8957
Taylor, Fred	1925	LNER: Our Centenary 1825-1925	Advert	LNER	QR	SSPL	10171859	Drawer D017	Advert446	1979-7904
Peto, Gladys	1928	Outings on the LNER: picnic image	Advert	LNER	DR	Onslows	19/12/06 Lot 350		Advert492	
Anon	1927	The Centre a Total Eclipse of the Sun	Advert	LNER	DR	NRM-EC2			Advert545	
Anon	1927	A Total Eclipse of the Sun	Advert	LNER	DR	NRM-EC3			Advert546	
Mervyn, Stuart	1951	Butlins for Holidays	Advert	BR Exec	DR	Christies	12/09/2007 lot 280		Advert610	
Black, Montague Birrell	1930s	Associated Humber Lines: Steamship Routes	Advert	LNER	QR	NRM	1978-9015	Drawer D012	Advert703	1978-9015
Anon	1950s	British Railways North Eastern Region; system map	Advert	BR(NER)	DR	NRM	1994-8237	Drawer D154	Advert821	1994-8237
Mason, Frank Henry Algernon	1930s	Holland: Via Hull-Rotterdam: ship entering harbour	Advert	LNER	DR	SRA			Holland27	
Rodmell, Harry Hudson	1960s	Ship via Hull	Advert	Hull Dock Office	DR	SRA			Hull12	
Brangwyn, Sir Frank William	1935	North East Coast Industries: dark industrial image	Advert	LNER	QR	SSPL	10176009	Drawer D015	NECoast Industry	1988-7984
Green	1960s	North Eastern Region - At Your Service	Advert	BR(NER)	DR	SSPL	10275616		NER Advert001	1978-1035
Johnson, Andrew	1925	George Stephenson Started us 100 years ago	Advert	LNER	DR	SSPL	10176030	Drawer D094	NER Advert003	1988-8005
Anon	1908	North Eastern Railway Hotels	Advert	NER	DR	SSPL	10172539		NER Advert004	1986-8971
Lander, Reginald Montague	1957	The North East Coast: Yorkshire, Durham Northumberland	Advert	BR(NER)	DR	SSPL	10175603		NER Advert005	1978-1022
Nevin	1959	North East England: Lovely to Look At, Delightful to Know	Advert	BR(NER)	DR	SSPL	10175574		NorthEastEngland	1978-0993
Wigston, J.E.	1975	Anniv. Of Stockton & Darlington Rly: loco no.1	Advert	BR Exec	Large	Onslows	19/12/06 Lot 328		Northumberland27	
Blake, Frederick Donald	1950s	Northumberland and Durham pictorial map	Advert	BR(NER)	QR	SRA			Northumberland29	
Shep (Chas Shepherd)	1937	West Riding Limited	Advert	LNER	DR	SSPL	10175987	Drawer D079	WestRidingLtd	1988-7962
Anon	1960s	Recipe for Success; The Trans Pennine	Advert	BR(NER)	DR	SSPL	10175592		Yorksadvert09	1978-1011
Anon	1930s	Weekly Holiday Season Tickets: Yorkshire Area No. 23	Advert	LNER	QR	SSPL	10173616	Drawer D010	Yorksadvert13	1986-9269
Blake, Richard		Map of Northumberland and Durham	Advert	BR(NER)	DR	Talisman				
Zinkeisen, Doris Clare	1937	Service to Industry: Steel	Advert	LNER	QR	SRA				
Taylor, Fred	1930s	Durham: It's Quicker By Rail: autumn scene	Durham	LNER	DR	SSPL	10174614	Drawer D100	Durham01	1978-9587

ARTIST	YEAR	TITLE	LOCATION	COMPANY	SIZE	SOURCE	SOURCE DETAILS		IMAGE REF	NRM REF
Taylor, Fred	1930	Durham: castle building	Durham	LNER	DR	SSPL	10174289	Drawer D100	Durham02	1978-9471
Brangwyn, Sir Frank William	1923	Durham by LNER	Durham	LNER	QR	SSPL	10175884	Drawer D015	Durham03	1987-9158
Lee, Sydney	1935	Durham: It's Quicker By Rail; castle and cathedral	Durham	LNER	QR	SSPL	10173719		Durham04	1978-9117
Taylor, Fred	1923	Durham Castle	Durham	LNER	QR	SSPL	10173863	Drawer D017	Durham05	1986-9362
Taylor, Fred	1930	Durham Cathedral: The Nave	Durham	LNER	QR	SSPL	10173344	Drawer D017	Durham06	1986-9172
Moody, John Charles	1946	Upper Teesdale AR 1039	Durham	LNER	DR	SSPL	10170961	Drawer D095	Durham07	1990-7069
Lambart, Alfred	1953	Roker and Seaburn	Durham	BR(NER)	DR	SSPL	10175593		Durham08	1978-1012
Steel, Kenneth	1950	Durham: litho type image of cathedral	Durham	BR(NER)	QR	SSPL	10173566	Drawer D023	Durham09	1978-9002
Newbould, Frank	1935	Durham: It's Quicker By Rail: through carriage window	Durham	LNER	QR	SSPL	10173796	Drawer D014	Durham10	1978-9162
Zinkeisen, Doris Clare	1932	Durham by LNER: St Cuthbert's Bones	Durham	LNER	QR	SSPL	10173821	Drawer D015	Durham11	1986-9320
Gawthorn, Henry George	1925	South Shields: For Happy Seaside Outings	Durham	LNER	DR	SSPL	10174393	Drawer D079	Durham13	1987-8913
Tittensor, H	1924	Durham: cathedral from the river	Durham	LNER	DR	Christies	25/05 1994 Lot 29		Durham14	
Cooper, Austin	1930s	Old World Market Places - Barnard Castle	Durham	LNER	DR	SSPL	10174611	Drawer D097	Durham15	1978-9584
Mason, Frank Henry Algernon	1910	Historic Monuments in North East England: No. 1 Barnard Castle	Durham	NER	DR	SSPL	10174651		Durham16	1978-9624
Cuneo, Terence Tenison	1962	Service to Industry ICI Works, Billingham D1962	Durham	BR Exec	QR	SSPL	10173687	Drawer D023	Durham17	1978-9085
Anon	1977	We've put Newton Aycliffe on the Map	Durham	BR(NER)	DR	SSPL	10175204		Durham18	1978-0641
Kersting, A.F.	1953	Durham: fro m photograph	Durham	BR(NER)	DR	SRA			Durham19	
Anon	1950s	Your invitation for holiday from Roker/Seaburn	Durham	BR(NER)	DR	SRA			Durham20	
Anon	1920	Barnard Castle: Proud Barnard's Bannered Walls	Durham	NER	DR	SRA			Durham21	1986-8974
Purvis, Tom	1931	Durham: LNER It's Quicker By Rail	Durham	LNER	QR	Christies	10/09/2008 Lot 109		Durham22	
Schabelsky	1930s	Rambles Around Durham and Northumberland	Durham	LNER	DR	NRM	LNER album C11.2 -3 1991-7011/3		Durham23	1991-7011/3
Mason, Frank Henry Algernon	1936	East Coast Industries: Colliery at Sunset	Durham	LNER	QR	SSPL	10172609	Drawer D013	Durham24	1983-8415
Mason, Frank Henry Algernon	1938	East Coast Industries: Colliery at Sunset	Durham	LNER	QR	SSPL	10174094	Drawer D013	Durham24a	1978-9277
Fish, Laurence	1962	Roker + Seaburn: Sunderland's twin resorts	Durham	BR(NER)	DR	SSPL	10175605		Durham25	1978-1024
Merriott, Jack	1958	Teesdale: The Tees at Barnard Castle	Durham	BR(NER)	DR	SSPL	10172984		Durham26	1985-8847
Wesson, Edward	1962	Teesdale: See Britain by Train: High Force, Middleton-in-Teesdale	Durham	BR(NER)	DR	SSPL	10172786		Durham27	1983-8563
Haslehust, Ernest William	1930s	Teesdale: It's Quicker By Rail	Durham	LNER	QR	SSPL	10323890	Drawer D008	Durham28	1986-9288
Haslehust, Ernest William	1930s	Teesdale: The Tees near Barnard Castle (gorge)	Durham	LNER	QR	SSPL	10322822	Drawer D008	Durham29	1986-9287
Haslehust, Ernest William	1930s	Teesdale: The Tees near Barnard Castle (autumn)	Durham	LNER	QR	SSPL	10323880	Drawer D008	Durham30	1986-9286
Black, Montague Birrell	1935	Explore Durham and Northumberland	Durham	LNER	QR	NRM	1994-8613 Drawer D012		Durham31	1994-8613
Taylor, Fred		Durham School	Durham	LNER	DR	PA				
Cattermole, Lance Harry Mosse	1949	A map of Northumberland and Durham	Northumberland	BR(NER)	DR	SSPL	10175598	Drawer D151	Northumberland01	1978-1017
Merriott, Jack	1950s	Northumberland Coast: See England by Rail Bamburgh Castle	Northumberland	BR(NER)	QR	SSPL	10173003	Drawer D023	Northumberland02	1985-8858
Armengol, Mario	1948	Northumberland: country view, sheep and man	Northumberland	BR(NER)	QR	SSPL	10172607	Drawer D026	Northumberland03	1983-8413
Black, Montague Birrell	1934	Northumberland and Durham	Northumberland	LNER	QR	SSPL	10172998	Drawer D009	Northumberland04	1985-8855
Fullerton, J.G.	1950s	Northumberland: Seahouses	Northumberland	BR(NER)	QR	SSPL	10173756	Drawer D023	Northumberland05	1978-9130
Johnson, Grainger	1920s	Northumberland: coast view train on viaduct	Northumberland	LNER	QR	SSPL	10173872		Northumberland06	1986-9371
Harris, Edwin Lawson James	1948	Northumberland: See England by Rail: old bridge image	Northumberland	BR(NER)	DR	SSPL	10175583		Northumberland07	1978-1002

ARTIST	YEAR	TITLE	LOCATION	COMPANY	SIZE	SOURCE	SOURCE DETAILS		IMAGE REF	NRM REF
Squirrell, Leonard Russell	1953	Northumberland: The Roman Wall	Northumberland	BR(NER)	DR	BRP47			Northumberland08	
Lander, Reginald Montague	1962	See Northumberland by Train	Northumberland	BR(NER)	DR	SSPL	10175585		Northumberland09	1978-1004
Anon	1961	The Northumberland Coast: key to bird life P161	Northumberland	BR(NER)	DR	SSPL	10175607		Northumberland10	1978-1026
Scott, Septimus Edwin	1929	North East Coast Exhibition Newcastle May-Oct 1929	Northumberland	LNER	QR	SSPL	10170761	Drawer D012	Northumberland12	1991-7144
Spencer, E.H.	1960	Northumberland and Durham: regional map centre 1/3	Northumberland	BR(NER)	QR	SSPL	10173001	Drawer D023	Northumberland14	1985-8857
Mason, Frank Henry Algernon	1930s	East Coast Craft No. 5: Northumberland Coble	Northumberland	LNER	DR	SSPL	10173076	Drawer D098	Northumberland15	1976-9222
Purvis, Tom	1934	Northumberland LNER: It's Quicker By Rail	Northumberland	LNER	QR	SSPL	10173339	Drawer D016	Northumberland16	1986-9168
Taylor, Fred	1930	The Road of the Roman: The Roman Wall	Northumberland	LNER	QR	SSPL	10173366	Drawer D018	Northumberland17	1986-9184
Photographic	1920s	Royal Station Hotel, Newcastle on Tyne	Northumberland	LNER	DR	SSPL	10174443	Drawer D079	Northumberland18	1987-8963
Mason, Frank Henry Algernon	1910	Historic Monuments in North East England: No. 2 Lindisfarne	Northumberland	NER	DR	SSPL	10174650		Northumberland19	1978-9623
Taylor, Fred	1933	Alnwick Castle by LNER: It's Quicker By Rail	Northumberland	LNER	QR	SSPL	10174077	Drawer D017	Northumberland20	1978-9260
Flint, William Russell	1925	Bamburgh: the castle from the beach	Northumberland	LNER	QR	SSPL	10173855	Drawer D015	Northumberland21	1986-9354
Mason, Frank Henry Algernon	1932	The Tyne: modern equipment for heavy shipments	Northumberland	LNER	QR	SSPL	10173390	Drawer D013	Northumberland22	1986-9196
Purvis, Tom	1936	Bamburgh Northumberland by LNER: coastal abstract i	Northumberland	LNER	DR	SSPL	10175991	Drawer D057	Northumberland23	1988-7966
Brangwyn, Sir Frank William	1924	Newcastle on Tyne: LNER industrial centre	Northumberland	LNER	DR	SSPL	10176031	Drawer D077	Northumberland24	1988-8006
Lambart, Alfred	1926	Tynemouth	Northumberland	LNER	DR	SSPL	10176039	Drawer D077	Northumberland25	1988-8014
Wollen, W.B.	1925	The Road of the Roman: The Roman Wall	Northumberland	LNER	DR	SSPL	10176163	Drawer D077	Northumberland26	1994-8647
Neiłland, Brendan	1996	Newcastle	Northumberland	Railfreight	DR	SSPL	10308314		Northumberland29	1997-8440
Merriott, Jack	1950	Northumberland: The Roman Wall	Northumberland	BR(NER)	DR	Christies	12/09/2002 lot 85		Northumberland30	
Chater, John	1952	Northumberland: British Railways: worlds busiest railway system	Northumberland	BR(NER)	DR	SRA			Northumberland31	
Simpson, Fred	1910s	Picturesque Holiday Resorts: Hexham & Roman Wall	Northumberland	NER	sm.	SRA			Northumberland32	
Spurrier	1930s	Northumberland: fishwife	Northumberland	LNER	DR	SRA			Northumberland33	
Photographic	2005	Crossing the Border: Voyager at Berwick	Northumberland	Virgin Trains	DR	NRM	2005-7574	Drawer D272	Northumberland35	2005-7574
Anon	1977	Northumbrian Ranger; Tour the Easy Way	Northumberland	BR(NER)	DR	NRM	1978-9728	Drawer D155	Northumberland36	1978-9728
Ions, A	1910s	North East England: The Land of Lore and Legend	Northumberland	NER	DR	Onslows	22/11/05 Lot 388		Northumberland37	
Anon	1910s	Northumberland for the Holidays	Northumberland	NER	QR	NRM	1986-9060	Drawer D001	Northumberland38	1986-9060
Home, Percy	1912	North Eastern Railway: map of Tyne/Tees	Northumberland	NER	QR	NRM	1979-7890	Drawer D001	Northumberland39	1979-7890
Mason, Frank Henry Algernon	1910	Historic Monuments in North East England: No. 3 Bamburgh	Northumberland	NER	DR	SSPL	10172571	Drawer D088	Northumberland40	1986-8984
Mason, Frank Henry Algernon	1926	Remember the Northumberland Coast: Longstone	Northumberland	LNER	DR	NRM	LNER album C11.2 -1	1991-7011/1	Northumberland41	1991/7011/1
Flanders, Dennis	1958	Hexham Abbey and The Lovely Tyne Valley #58	Northumberland	BR(NER)	DR	SSPL	10175572		Northumberland42	1978-0991
Purvis, Tom	1937	The Coronation Crossing the Royal Border Bridge	Northumberland	LNER	QR	SSPL	10173132	Drawer D016	Northumberland43	1976-9263
Rushbury, Henry	1934	Berwick-Upon-Tweed: It's Quicker By Rail	Northumberland	LNER	DR	SSPL	10170973	Drawer D095	Northumberland44	1990-7081
Higgins, Reginald Edward	1930	Berwick-Upon-Tweed: historic walled town	Northumberland	LNER	DR	Christies	23/9/1999 lot 66		Northumberland45	
Mason, Frank Henry Algernon	1935	Berwick-Upon-Tweed: view of town from pier	Northumberland	LNER	DR	SSPL	10175977	Drawer D098	Northumberland46	1988-7952
Mason, Frank Henry Algernon	1931	Havens and Harbours on the LNER: No. 4 Berwick	Northumberland	LNER	DR	SSPL	10174311	Drawer D098	Northumberland47	1994-7415
Anon	1948	Berwick-Upon-Tweed: collage of 4 pictures	Northumberland	BR(NER)	DR	SSPL	10175610		Northumberland48	1978-1029
Jones, Van	1930s	Berwick-Upon-Tweed; view through bridges	Northumberland	LNER	DR	SSPL	10174409	Drawer D095	Northumberland49	1987-8929
Squirrell, Leonard Russell	1956	Berwick-Upon-Tweed: It's Quicker By Rail	Northumberland	BR(ER)	DR	Christies	12/9/2002 lot 86		Northumberland50a	

ARTIST	YEAR	TITLE	LOCATION	COMPANY	SIZE	SOURCE	SOURCE DETAILS		IMAGE REF	NRM REF
Zinkeisen, Doris Clare	1930s	Berwick-Up on-Tweed: It's Quicker By Rail :	Northumberland	LNER	QR	SSPL	10176134	Drawer D012	Northumberland51	1994-8618
Cattermole, Lance Harry Mosse	1950s	Berwick-Upon-Tweed: girl on swing NER 55	Northumberland	BR(NER)	DR	SRA			Northumberland52	
Davies	1958	Whitley Bay, Northumberland	Northumberland	BR(NER)	DR	SSPL	10175591		Whitley Bay01	1978-1010
Blake, Frederick Donald	1951	Whitley Bay: Coastal lighthouse	Northumberland	BR(NER)	DR	SSPL	10175578		Whitley Bay02	1978-0997
Michael, Arthur C.	1930s	Whitley Bay: It's Quicker By Rail	Northumberland	LNER	QR	SSPL	10173644	Drawer D008	Whitley Bay04	1978-9042
Mason, Frank Henry Algernon	1933	Whitley Bay: It's Quicker By Rail	Northumberland	LNER	QR	SSPL	10174021	Drawer D013	Whitley Bay05	1978-9204
Mason, Frank Henry Algernon	1933	Whitley Bay: It's Quicker By Rail	Northumberland	LNER	QR	SSPL	10173571	Drawer D013	Whitley Bay05	1978-9005
Anstruther	1960s	Whitley Bay	Northumberland	BR(NER)	DR	SRA			Whitley Bay06	
Amstutz, Andre	1950	Whitley Bay: semi abstract: woman and paper	Northumberland	BR(NER)	DR	SSPL	10175560		Whitley Bay06	1978-0979
Davies	1957	Whitley Bay	Northumberland	BR(NER)	DR	SSPL	10175580		Whitley Bay07	1978-0999
Fish, Laurence	1960	Life is Gay at Whitley Bay	Northumberland	BR(NER)	DR	SSPL	10175594		Whitley Bay08	1978-1013
Taylor, Fred	1927	Whitley Bay	Northumberland	LNER	QR	SSPL	10173372	Drawer D018	Whitley Bay09	1986-9187
Newbould, Frank	1939	Whitley Bay: It's Quicker By Rail	Northumberland	LNER	QR	SSPL	10173706	Drawer D014	Whitley Bay10	1978-9104
Newbould, Frank	1927	Whitley Bay: beach scene, couple and dog	Northumberland	LNER	QR	SSPL	10174040	Drawer D014	Whitley Bay11	1978-9223
Newbould, Frank	1927	Whitley Bay: beach scene, couple and dog	Northumberland	LNER	QR	SSPL	10174041	Drawer D014	Whitley Bay11a	1978-9224
Purvis, Tom	1930s	Whitley Bay by LNER: It's Quicker By Rail	Northumberland	LNER	QR	SSPL	10174025	Drawer D016	Whitley Bay12	1978-9208
Anon	1910s	Whitley Bay (Northumberland): 3 miles of clean sands	Northumberland	NER	QR	SSPL	10173022	Drawer D001	Whitley Bay13	1986-9049
Littlejohns, John	1929	Whitley Bay: bathers on the rocks	Northumberland	LNER	QR	SSPL	10173663	Drawer D008	Whitley Bay14	1978-9061
Kesteven, Peter	1962	Whitley Bay: travel by train: abstract collage	Northumberland	BR(NER)	DR	SSPL	10175561		Whitley Bay15	1978-0980
Michael, Arthur C.	1950s	Whitley Bay	Northumberland	BR(NER)	DR	SSPL	10175568		Whitley Bay16	1978-0987
Wood, Frank	1923	Berwick-Up on-Tweed: view of town bridges and links	Northumberland	LNER	DR	MCRA				
Anon	1980s	Make the Most of your Local Network: West Yorkshire	Yorkshire	BR/Metrotrain	DR	SSPL	10172656		Advert301	1983-8462
Anon	1988	Winter Savers from Harrogate	Yorkshire	BR Intercity	DR	AR089			Advert565	
Anon	1992	Harrogate Line	Yorkshire	BR	DR	AR276			Advert571	
Anon	1986	Scarborough Spa Express: Super Day Trips	Yorkshire	Inter-City	DR	Private			Advert977	
Blake, Frederick Donald	1950	Bridlington Yorkshire: original artwork for QR	Yorkshire	LNER	sm.	SRA			Bridlington01	
Purvis, Tom	1935	Bridlington: mother and child: blue sky	Yorkshire	LNER	QR	SSPL	10174029	Drawer D016	Bridlington02	1978-9212
Taylor, Fred	1928	Bridlington: regatta type image	Yorkshire	LNER	QR	SSPL	10173398	Drawer D017	Bridlington04	1978-8867
Blake, Frederick Donald	1950	Bridlington: view of seafront and coast	Yorkshire	BR(NER)	QR	SSPL	10173445	Drawer D023	Bridlington05	1978-8910
Newbould, Frank	1935	Bridlington: It's Quicker By Rail: couple foreground	Yorkshire	LNER	QR	SSPL	10173705	Drawer D014	Bridlington06	1978-9103
Gawthorn, Henry George	1927	Bridlington: Promenade Scene: lady red dress, flags	Yorkshire	LNER	QR	SSPL	10173752	Drawer D015	Bridlington07	1986-9292
Ayling, George	1958	Bridlington: Yorkshire's gay seaside playground	Yorkshire	BR(NER)	DR	SSPL	10175576		Bridlington08	1978-0995
Tatt	1957	Bridlington: Sun and Fun for Everyone	Yorkshire	BR(NER)	DR	SSPL	10175608		Bridlington09	1978-1027
Mason, Frank Henry Algernon	1930s	Bridlington: sailing boats entering harbour	Yorkshire	LNER	QR	SSPL	10174023	Drawer D013	Bridlington10	1978-9206
Gawthorn, Henry George	1927	Bridlington: seafront promenade	Yorkshire	LNER	QR	SSPL	10173015	Drawer D010	Bridlington11	1986-9043
Taylor, Fred	1935	Bridlington: three people on seafront; colourful	Yorkshire	LNER	QR	SSPL	10173457	Drawer D017	Bridlington12	1978-8919
Johnson, Andrew	1930s	Bridlington: female red outfit on balcony	Yorkshire	LNER	QR	SSPL	10172690	Drawer D008	Bridlington13	1986-9012
Newbould, Frank	1935	Bridlington: It's Quicker By Rail: ship and people at pier	Yorkshire	LNER	QR	SSPL	10173447	Drawer D014	Bridlington14	1978-8912

ARTIST	YEAR	TITLE	LOCATION	COMPANY	SIZE	SOURCE	SOURCE DETAILS		IMAGE REF	NRM REF
Scott, Septimus Edwin	1935	Bridlington: It's Quicker By Rail: promenade scene	Yorkshire	LNER	QR	SSPL	10173019	Drawer D010	Bridlington15	1986-9046
Scott, Septimus Edwin	1935	Bridlington: It's Quicker By Rail: promenade scene	Yorkshire	LNER	QR	SSPL	10174138	Drawer D009	Bridlington15a	1978-9321
Petrie, Graham	1920s	Bridlington: view of pier	Yorkshire	LNER	QR	SSPL	10173873	Drawer D009	Bridlington16	1986-9372
Dugdale, Thomas Cantrell	1930s	Bridlington: view of beach from carriage	Yorkshire	LNER	QR	SSPL	10173636	Drawer D008	Bridlington17	1978-9034
Barribal, William	1925	Bridlington: beach; boat of people woman in cape	Yorkshire	LNER	DR	SSPL	10173047		Bridlington18	1975-8395
Barribal, William	1925	Bridlington: beach; boat of people woman in cape	Yorkshire	LNER	QR	SSPL	10173618	Drawer D008	Bridlington18a	1978-9016
Greenup, J.	1936	Bridlington: It's Quicker By Rail	Yorkshire	LNER	QR	SSPL	10173412	Drawer D008	Bridlington19	1978-8880
Littlejohns, John	1930	Bridlington: family overlooking harbour	Yorkshire	LNER	QR	NRM	1978-9069	Drawer D009	Bridlington20	1978-9069
Eckersley, Tom	1955	Bridlington: modern image; beachball, bucket, spade and hat	Yorkshire	BR(NER)	DR	Christies	14/9/2006 Lot 77		Bridlington21	
Wootton, Frank	1953	Bridlington: pleasure boat in harbour	Yorkshire	BR(NER)	DR	SSPL	10175609		Bridlington22	1978-1028
Anon	1913	Bracing Bridlington	Yorkshire	NER	DR	NRM11			Bridlington23	
Appleby	1960s	Bridlington: sun and fun for everyone	Yorkshire	BR(NER)	DR	NRM	1977-5597 drawer D151		Bridlington24	1977-5597
Higgins, Reginald Edward	1930s	Bridlington: pleasure boat in harbour	Yorkshire	LNER	QR	eBay			Bridlington25	
Shoesmith, Kenneth Denton	1934	Bridlington: It's Quicker By Rail: Royal Princes Parade	Yorkshire	LNER	QR	NRM	1986-9033 and 1986-9034 Drawer D009		Bridlington26	1986-9033
Anon	1910s	Bright, Breezy, Bracing Bridlington	Yorkshire	NER	QR	NRM	1986-9058 Drawer D001		Bridlington27	1986-9058
Anon	1930s	Bridlington: It's Quicker By Rail: steamers in harbour	Yorkshire	LNER	DR	eBay			Bridlington28	
Witherington	1934	Bridlington: boy and girl looking out of compartment	Yorkshire	LNER	DR	SRA			Bridlington29	
Higgins, Reginald Edward	1925	Filey for the Family; people on beach yellow parasol	Yorkshire	LNER	DR	SSPL	10174612	Drawer D093	Filey01	1978-9585
Silas, Ellis Luciano	1952	Filey: beach scene AR 7012	Yorkshire	BR(NER)	DR	SSPL	10175573		Filey02	1978-0992
Foley, Michael	1934	Filey for the Family: It's Quicker By Rail; children on beach	Yorkshire	LNER	DR	SSPL	10174417	Drawer D095	Filey03	1987-8937
Anon	1935	Filey for the Family: children on rocks	Yorkshire	LNER	DR	SSPL	10174255	Drawer D093	Filey04	1978-9437
Simmons, Graham	1925	Filey for the Family: Lowry-type image	Yorkshire	LNER	DR	FTC1			Filey05	
Horder, Margaret	1931	Filey for the Family: 2 girls with baby	Yorkshire	LNER	DR	SSPL	10174508	Drawer D057	Filey06	1978-9490
Pears, Charles	1924	Filey for the Family: fishing on breakwater	Yorkshire	LNER	DR	SSPL	10170640	Drawer D093	Filey07	1990-7151
Russell, Gyrth	1956	Fountains Abbey Yorkshire: See Britain by Train	Yorkshire	BR (NER)	DR	SSPL	10170693		Fountains Abbey05	1990-7006
Rushbury, Henry	1946	Fountains Abbey: See England by Rail AR1031	Yorkshire	LNER	QR	SSPL	10173698	Drawer D009	FountainsAbbey01	1978-9096
Rushbury, Henry	1952	Fountains Abbey: See England by Rail reissue AR 1031	Yorkshire	BR(NER)	QR	SRA			FountainsAbbey01a	1978-9096
Taylor, Fred	1927	Fountains Abbey: Ripon station LNER	Yorkshire	LNER	QR	SSPL	10173869	Drawer D017	FountainsAbbey02	1986-9368
Taylor, Fred	1927	Fountains Abbey: Hall and abbey	Yorkshire	LNER	QR	SSPL	10174072	Drawer D017	FountainsAbbey03	1978-9255
Johnson, Andrew	1930s	Fountains Abbey: then and now	Yorkshire	LNER	DR	SSPL	10174504	Drawer D093	FountainsAbbey04	1978-9486
Taylor, Fred	1930s	Fountains Abbey on the LNER; grey ruins	Yorkshire	LNER	DR	SRA			FountainsAbbey06	
Petrie, Graham	1920s	Fountains Abbey: ruins and autumnal trees	Yorkshire	LNER	DR	SSPL	10174423	Drawer 095	FountainsAbbey07	1987-8943
Spradbery, Walter Ernest	1930s	Fountains Abbey: trees foreground, abbey behind	Yorkshire	LNER	DR	Guido Ton	Zurich Auctions 2004		FountainsAbbey08	
Mason, Frank Henry Algernon		Fountains Abbey: Historic Monuments Series	Yorkshire	NER	sm.	SRA			FountainsAbbey09	
Lee, Sydney	1930s	Fountains Abbey: Ripon station Yorkshire	Yorkshire	LNER	DR	SRA			FountainsAbbey10	
Anon	1910s	Fountains Abbey	Yorkshire	NER	DR	NRM	1986-8974 Drawer D88		FountainsAbbey11	1986-8974
Harrison, George	1923	Express Ease: The Harrogate Pullman	Yorkshire	LNER	DR	SSPL	10170890	Drawer D077	Harrogate Pullman1	1989-7127
Anon	1925	Harrogate: The Pullman Train	Yorkshire	LNER	DR	BB735			Harrogate Pullman2	

ARTIST	YEAR	TITLE	LOCATION	COMPANY	SIZE	SOURCE	SOURCE DETAILS		IMAGE REF	NRM REF
Merriott, Jack	1957	Harrogate: floral gardens: street scene	Yorkshire	BR(NER)	DR	SSPL	10175595		Harrogate01	1978-1014
Forsyth, Gordon Mitchell	1935	Harrogate: street scene and gardens	Yorkshire	LNER	QR	BRP59			Harrogate02	
Michael, Arthur C.	1935	Harrogate: It's Quicker By Rail: Gardens night scene	Yorkshire	LNER	QR	SSPL	10173013	Drawer D009	Harrogate03	1986-9041
Gawthorn, Henry George	1920s	Harrogate: people outside park: dog foreground	Yorkshire	LNER	DR	SSPL	10176034	Drawer D095	Harrogate04	1988-8009
Brangwyn, Sir Frank William	1924	Over the Nidd near Harrogate	Yorkshire	LNER	QR	SSPL	10176008	Drawer D015	Harrogate05	1988-7983
Higgins, Reginald Edward	1930s	Harrogate: woman; art deco dress and cape	Yorkshire	LNER	DR	SSPL	10172675	Drawer D094	Harrogate06	1986-8997
Hocknell, Lilian	1925	Harrogate: classic view Pavilion Gardens	Yorkshire	LNER	QR	SSPL	10172696	Drawer D009	Harrogate07	1986-9018
Taylor, Fred	1935	Harrogate: It's Quicker By Rail: The Royal Baths	Yorkshire	LNER	QR	SSPL	10174065	Drawer D017	Harrogate08	1978-9248
Carney	1960	Speaking of Holidays - I'm going to Harrogate	Yorkshire	BR(NER)	DR	SSPL	10175571		Harrogate09	1978-0990
Moody, John Charles	1950	Harrogate: The Pavilion Gardens	Yorkshire	BR(NER)	QR	SSPL	10172990	Drawer D023	Harrogate10	1985-8852
Mason, Frank Henry Algernon	1930	Harrogate: The British Spa: view of gardens	Yorkshire	LNER	QR	SSPL	10173009	Drawer D013	Harrogate11	1986-9037
Clark, Christopher	1923	Harrogate: The British Spa; Pavilion interior	Yorkshire	LMS	DR	SSPL	10327518	Drawer D092	Harrogate12	1999-7357
Anon	1961	Harrogate: Britains Floral Resort	Yorkshire	BR(NER)	DR	SSPL	10175563		Harrogate13	1978-0982
Newbould, Frank	1930	Harrogate: men on horses	Yorkshire	LNER	QR	SSPL	10173541	Drawer D014	Harrogate14	1986-9224
Zinkeisen, Anna Katrina	1934	Harrogate: colourful abstract of people	Yorkshire	LNER	QR	SSPL	10172688	Drawer D009	Harrogate15	1986-9010
Taylor, Fred	1920s	Harrogate via LNER: The Royal Music Hall	Yorkshire	LNER	QR	SSPL	10327877	Drawer D017	Harrogate16	1986-9359
Greenup, J.	1935	Harrogate Yorkshire on the LNER	Yorkshire	LNER	DR	Christies	23/9/1999 lot 99		Harrogate18	
Scott, Septimus Edwin	1933	Harrogate: It's Quicker By Rail: gardens day scene	Yorkshire	LNER	QR	SSPL	10173000	Drawer D008	Harrogate19	1986-9032
Purvis, Tom	1930s	Harrogate: The British Spa; tennis players	Yorkshire	LNER	QR	SSPL	10173007	Drawer D016	Harrogate20	1986-9035
Cooper, Austin	1930s	Harrogate: It's Quicker By Rail; The British Spa	Yorkshire	LNER	QR	NRM	1986-9020 Drawer D009		Harrogate21	1986-9020
Steel, Kenneth	1953	Harrogate: tree lined street looking downwards	Yorkshire	BR(NER)	DR	SSPL	10175588		Harrogate22	1978-1007
Anon	1910s	Harrogate: Britains 100% Spa	Yorkshire	GNR	DR	SSPL	10172267		Harrogate23	1986-8857
Taylor, Fred	1920s	Harrogate: buildings; old cars foreground	Yorkshire	LNER	QR	Onslows	1/11/2000 Lot 387		Harrogate24	
Mercer	1958	Harrogate: Go by Rail; poster montage	Yorkshire	BR(NER)	DR	SRA			Harrogate25	
Templeton	1920s	Harrogate Via LNER: Taking the Waters	Yorkshire	LNER	QR	Swann NYC	New York Auction 2002		Harrogate26	
Tittensor, H	1941	Harrogate: It's Quicker By Rail: couples strolling	Yorkshire	LNER	QR	NRM	1986-9039 and 1986-9040 drawer D009		Harrogate27	1986-9039
Anon	1936	Harrogate: It's Quicker By Rail: Band concert, trees, people	Yorkshire	LNER	QR	NRM	1986-9044 Drawer D010		Harrogate28	1986-9044
Anon	1960s	Harrogate: Britain's Floral Resort (Photographic)	Yorkshire	BR (NER)	DR	eBay			Harrogate29	
Anon	1910s	Harrogate: Britain's Health Resort	Yorkshire	GNR	DR	SSPL	10172267	Drawer D087	Harrogate30	1986-8858
Taylor, Fred	1920	Harrogate: The Royal Baths	Yorkshire	NER	QR	Council			Harrogate31	
Anon	1910	Harrogate: Britains Health Resort	Yorkshire	NER	DR	Council			Harrogate32	
Rodmell, Harry Hudson	1926	Hornsea East Yorkshire: Lakeland by the Sea	Yorkshire	LNER	DR	SSPL	10174589 & 10172680 drawer D057		Hornsea01	1978-9662
Brown, F. Gregory	1920s	Hornsea:Lakeland by the Sea	Yorkshire	LNER	DR	SSPL	10172684	Drawer D093	Hornsea02	1986-9006
Scott, Septimus Edwin	1930s	Hornsea:It's Quicker By Rail: looking out of window	Yorkshire	LNER	DR	SSPL	10172681	Drawer D079	Hornsea03	1986-9003
Freiwirth	1923	Hornsea: Lakeland by the Sea	Yorkshire	LNER	DR	SSPL	10170734	Drawer D057	Hornsea04	1991-7116
Loten, C.W.	1911	Hornsea, Yorkshire: Lakeland by the Sea	Yorkshire	NER	DR	NRM Book	Page 7		Hornsea05	
Oakdale, Edmund	1935	Hornsea East Yorkshire: It's Quicker By Rail	Yorkshire	LNER	DR	NRM	1986-9007 Drawer D095		Hornsea06	1986-9007
Hick, Allanson	1950s	The Continent via Hull and Goole	Yorkshire	BR(ER)	DR	SSPL	10174795		Hull01	1987-9110

ARTIST	YEAR	TITLE	LOCATION	COMPANY	SIZE	SOURCE	SOURCE DETAILS	IMAGE REF	NRM REF
Mason, Frank Henry Algernon	1938	East Coast Industries: St. Andrew's Dock, Hull	Yorkshire	LNER	QR	SSPL	10176123 Drawer D013	Hull02	1994-8607
Rodmell, Harry Hudson	1952	The Continent via Hull and Goole; large ship	Yorkshire	BR(NER)	DR	SSPL	10175556	Hull03	1978-0975
Rodmell, Harry Hudson	1955	The Continent via Hull and Goole; small ship	Yorkshire	BR(NER)	DR	SSPL	10175557	Hull04	1978-0976
Johnston	1961	Associated Humber Lines: Regular Cargo Services	Yorkshire	BR(NER)	DR	SSPL	10175558	Hull05	1978-0977
Johnston	1961	Overnight to the Continent: Via Hull-Rotterdam; yellow sky	Yorkshire	BR(NER)	DR	SSPL	10175559	Hull06	1978-0978
Gawthorn, Henry George	1929	Hull: Britain's Cheapest Port	Yorkshire	LNER	QR	SSPL	10173486	Hull07	1978-3486
Home, Percy	1910s	Hull Docks and the Humber Estuary	Yorkshire	NER	DR	SSPL	10175848	Hull08	1978-1271
Rodmell, Harry Hudson	1950	The Continent via Hull and Goole NER59	Yorkshire	BR(NER)	QR	SSPL	10172610 Drawer D023	Hull09	1983-8416
Mason, Frank Henry Algernon	1930s	LNER & Wool: Hull Wool Sheds	Yorkshire	LNER	DR	SSPL	10324056 + 10176115 Drawer D098	Hull11	1994-8532
Sherwin, Frank	1957	Ilkley: Gateway to the Yorkshire Dales	Yorkshire	BR(NER)	DR	SSPL	10175600	Ilkley01	1978-1019
Brundrit, Reginald G	1926	Ilkley: Amidst Beautiful Moorland Scenery	Yorkshire	LMS	QR	SSPL	10324299 Drawer D005	Ilkley02	1992-7444
Sherwin, Frank	1960	Ilkley: Gateway to the Yorkshire Dales 60 BR NE	Yorkshire	BR(NER)	DR	SSPL	10171745	Ilkley03	1979-7790
Merriott, Jack	1953	Knaresborough; rail bridge from river	Yorkshire	BR(NER)	DR	SSPL	10174305	Knaresboro01	1994-7409
Merriott, Jack	1954	Knaresborough (USA Version with no totem logo)	Yorkshire	Tourist poster	DR	Swann NYC	New York Auctions 2002	Knaresboro01a	
Gawthorn, Henry George	1930s	Knaresborough: It's Quicker By Rail; original artwork	Yorkshire	LNER	DR	SSPL	10283827	Knaresboro02	1987-9227
Gawthorn, Henry George	1930s	Knaresborough: It's Quicker By Rail; view from carriage	Yorkshire	LNER	DR	SSPL	10174521 Drawer D057	Knaresboro02a	1978-9503
Malet, Guy	1930s	Knaresborough: It's Quicker By Rail; river scene	Yorkshire	LNER	DR	SSPL	10174414 Drawer D095	Knaresboro03	1987-8934
Higgins, Reginald Edward	1930s	Knaresborough: bridge green image	Yorkshire	LNER	DR	SSPL	10174200 + 10308315 Drawer D093	Knaresboro04	1978-9383
Johnson, Andrew	1930s	Knaresborough near Harrogate: then and now	Yorkshire	LNER	DR	SSPL	10176042 Drawer D093	Knaresboro05	1988-8017
Williams, Wilton	1930	Knaresborough: women on the river	Yorkshire	LNER	DR	SSPL	10174180 Drawer D094	Knaresboro06	1978-9363
Cooper, Austin	1932	Old World Market Places - Knaresborough	Yorkshire	LNER	DR	SSPL	10174238 Drawer D097	Knaresboro07	1978-9420
Wilkinson, Norman	1935	A Sheffield Steel Works: Main Line St. Pancras to North ERO 53351	Yorkshire	LMS	QR	SSPL	10173811 Drawer D006	NER Steel2a	1978-9177
Black, Montague Birrell	1948	North Yorkshire For Seaside And Moorland Holidays	Yorkshire	BR(NER)	QR	SSPL	10172999 Drawer D023	North Yorkshire	1985-8856
Cooper, Austin	1930	Redcar: family beach scene	Yorkshire	LNER	QR	SSPL	10173140 Drawer D010	Redcar01	1986-9080
Martin, A.E.	1925	Redcar: view of seafront	Yorkshire	LNER	QR	SSPL	10173815 Drawer D015	Redcar02	1986-9306
Sherwin, Frank	1958	Redcar: North Yorkshire's Family Resort	Yorkshire	BR(NER)	DR	SSPL	10171740	Redcar03	1979-7785
Fish, Laurence	1960	Redcar	Yorkshire	BR(NER)	DR	SSPL	10175604	Redcar04	1978-1023
Silas, Ellis Luciano	1950	Redcar: promenade, pavilion and beach	Yorkshire	BR(NER)	DR	SSPL	10175581	Redcar05	1978-1000
Anon	1953	Feel on Top of the World this Coronation Year at Redcar	Yorkshire	BR(NER)	DR	SSPL	10175606	Redcar06	1978-1025
Mason, Frank Henry Algernon	1930s	Redcar: It's Quicker By Rail: Zetland Park	Yorkshire	LNER	DR	SSPL	10174517 Drawer D098	Redcar07	1978-9499
Oakdale, Edmund	1930s	Redcar: It's Quicker By Rail: The Children's Corner	Yorkshire	LNER	QR	SSPL	10174129 Drawer D008	Redcar08	1978-9312
Chevins, Hugh	1962	Redcar ref P1/62	Yorkshire	BR(NER)	DR	SSPL	10175575	Redcar09	1978-0994
Cusden, Leonard	1936	Redcar: It's Quicker By Rail	Yorkshire	LNER	QR	SSPL	10172693 Drawer D009	Redcar10	1986-9015
Newbould, Frank	1932	Redcar	Yorkshire	LNER	QR	SSPL	10173561 Drawer D014	Redcar11	1986-9231
Purvis, Tom	1920s	Redcar: Beautiful Sands For The Children	Yorkshire	LNER	QR	SSPL	10176058 Drawer D016	Redcar12	1988-8033
Sharp, Dorothea	1934	Redcar: It's Quicker By Rail	Yorkshire	LNER	QR	SSPL	10172991 Drawer D009	Redcar13	1986-9027
Gawthorn, Henry George	1920s	Redcar: people on beach pier behind	Yorkshire	LNER	QR	NRM	1985-8854 Drawer D009	Redcar14	1985-8854
Taylor, Fred	1930s	Richmond on the LNER Railway: castle background	Yorkshire	LNER	DR	Onslows	11/04/02 Lot 399	Richmond 1	

ARTIST	YEAR	TITLE	LOCATION	COMPANY	SIZE	SOURCE	SOURCE DETAILS		IMAGE REF	NRM REF
Wesson, Edward	1962	Richmond Castle: See Britain by Train	Yorkshire	BR(NER)	DR	SSPL	10172923		Richmond 2	1984-8246
Anon	1930s	Richmond: by LNER	Yorkshire	LNER	QR	SRA			Richmond3	
Spradbery, Walter Ernest	1924	LNER Ripon: Cathedral from the river	Yorkshire	LNER	DR	SSPL	10174604	Drawer D095	Ripon01	1978-9577
Taylor, Fred	1930s	Ripon: It's Quicker By Rail	Yorkshire	LNER	QR	SSPL	10174352	Drawer D100	Ripon02	1987-8872
Taylor, Fred	1930s	Ripon Cathedral: aerial view	Yorkshire	LNER	QR	SSPL	10170951	Drawer D018	Ripon03	1990-7059
Buckle, Claude	1960	Ripon for the Yorkshire Dales: The Town Cryer	Yorkshire	BR(NER)	DR	SSPL	10171398		Ripon04	1994-7197
Ginner, Charles Isaac	1930s	Ripon: It's Quicker By Rail	Yorkshire	LNER	DR	SSPL	10174613	Drawer D093	Ripon05	1978-9586
Newbould, Frank	1930	Ripon: view of city monument	Yorkshire	LNER	DR	Christies	23/9/1999 lot 92		Ripon06	
Rushbury, Henry	1932	Ripon: market day scene	Yorkshire	LNER	DR	Onslows	02/04/2009 Lot 290		Ripon07	
Gawthorn, Henry George	1923	Saltburn-by-the-Sea	Yorkshire	LNER	DR	SSPL	10172683	Drawer D093	Saltburn01	1986-9005
Mason, Frank Henry Algernon	1930s	Saltburn-by-the-Sea	Yorkshire	LNER	DR	SSPL	10174610		Saltburn02	1978-9583
Mason, Frank Henry Algernon	1925	Saltburn-by-the-Sea	Yorkshire	LNER	DR	SSPL	10174516	Drawer D098	Saltburn02a	1978-9498
Gawthorn, Henry George	1920s	Saltburn-by-the-Sea: couple overlooking beach	Yorkshire	LNER	DR	SSPL	10174523	Drawer D094	Saltburn03	1978-9505
Mason, Frank Henry Algernon	1920s	Saltburn-by-the-Sea: boats and harbour	Yorkshire	LNER	DR	SSPL	10174362	Drawer D098	Saltburn05	1987-8882
Greenup, J.	1930s	Saltburn and Marske-by-the-Sea: It's Quicker By Rail	Yorkshire	LNER	DR	SSPL	10172676	Drawer D094	Saltburn06	1986-8998
Newbould, Frank	1930s	Saltburn-by-the-Sea, Yorkshire: Its Quicker By Rail	Yorkshire	LNER	DR	SSPL	10172678	Drawer D099	Saltburn07, 07a	1986-9000
Anon	1900s	Saltburn-by-the-Sea	Yorkshire	NER	DR	Private			Saltburn09	
Anon	1930s	Saltburn: country scene; blues and greens with burgundy border	Yorkshire	LNER	DR	Swann NYC	New York Auctions 1995		Saltburn10	
Photographic	1960s	Discover the Leeds S+C: England's greatest scenic rly	Yorkshire	BR Exec	DR	GWRA			371 Settle	
Oakdale, Edmund	1936	Scarborough: It's Quicker By Rail	Yorkshire	LNER	QR	SSPL	10172695 + 10174135	Drawer D009	Scarborough01	1978-9318
Johnson, Andrew	1933	Scarborough: It's Quicker By Rail	Yorkshire	LNER	QR	SSPL	10173401	Drawer D008	Scarborough02	1978-8870
Newbould, Frank	1928	Scarborough Castle on hill coloured beach huts front	Yorkshire	LNER	QR	York book	Poster 29 in Yorkshire Poster book		Scarborough03	
Gorbatoff, Konstantin Ivanovic	1934	Scarborough: It's Quicker By Rail	Yorkshire	LNER	QR	SSPL	10173540	Drawer D008	Scarborough04	1978-8985
Uptton, Clive	c1950	Scarborough: The Tonic Holiday	Yorkshire	SBCouncil	DR	SC22	Scarborough Council		Scarborough05	
Mason, Frank Henry Algernon	1935	Scarborough: It's Quicker By Rail: Tunny fleet at Scarborough	Yorkshire	LNER	DR	SSPL	10174544	Drawer D098	Scarborough06	1978-9517
Barribal, W.H.	1925	Scarborough: beach scene	Yorkshire	LNER	QR	SSPL	10327649	Drawer D008	Scarborough07	1996-7340
Michael, Arthur C.	1935	Scarborough	Yorkshire	LNER	DR	SSPL	10172595	Drawer D077	Scarborough08	1986-8996
Cooper, Austin	1932	Scarborough: couple foreground town behind	Yorkshire	LNER	QR	SSPL	10173559	Drawer D008	Scarborough09	1978-8997
Witherington (photo)	1935	Scarborough: It's Quicker By Rail	Yorkshire	LNER	DR	SSPL	10172679	Drawer D093	Scarborough10	1986-9001
Vandersyde, Gerritt	1920	Scarborough on the Sunny Yorkshire Coast	Yorkshire	SBCouncil	DR	SC21	Scarborough Council		Scarborough11	
Newbould, Frank	1930s	Scarborough: image of speedboat	Yorkshire	LNER	QR	SSPL	10174048	Drawer D014	Scarborough12	1978-9231
Woolrich, J.F.	1910s	Scarborough: prom night scene	Yorkshire	NER	QR	SSPL	10173072	Drawer D001	Scarborough13	1986-9056
Mason, Frank Henry Algernon	1948	Scarborough: aerial view of the bay	Yorkshire	BR(NER)	QR	SSPL	10174102	Drawer D023	Scarborough14	1978-9285
Newbould, Frank	1934	Scarborough: It's Quicker By Rail: castle ruins	Yorkshire	LNER	QR	SSPL	10174047	Drawer D014	Scarborough15	1978-9230
Taylor, Fred	1920s	Scarborough: aerial view of bathing pool	Yorkshire	LNER	QR	Onslows	06/10/95 Lot 601		Scarborough16	
Russell, Gyrth	1950	Scarborough (+ poster 45 in York book)	Yorkshire	BR(NER)	QR	SSPL	10173633	Drawer D023	Scarborough17	1978-9031
Anon	1961	Scarborough: dusk scene couple on front	Yorkshire	BR(NER)	DR	SSPL	10175586		Scarborough18	1978-1005
Zinkeisen, Doris Clare	1935	Scarborough: In Grandmother's Day	Yorkshire	LNER	QR	SSPL	10172995	Drawer D009	Scarborough20	1986-9030

ARTIST	YEAR	TITLE	LOCATION	COMPANY	SIZE	SOURCE	SOURCE DETAILS		IMAGE REF	NRM REF
Mason, Frank Henry Algernon	1948	Scarborough: view of the bay: Lido in front	Yorkshire	BR(NER)	DR	SRA			Scarborough22	
Anon	1958	Scarborough	Yorkshire	BR(NER)	DR	SSPL	10175612		Scarborough23	1978-1031
Anon	1908	Scarborough Braces You Up - The Air Does It	Yorkshire	NER	DR	SSPL	10172593		Scarborough24	1986-8994
Broadhead, W. Smithson	1935	Scarborough: It's Quicker By Rail	Yorkshire	LNER	QR	SSPL	10172697	Drawer D009	Scarborough25	1986-9019
Broadhead, W. Smithson	1935	Scarborough: It's Quicker By Rail	Yorkshire	LNER	QR	SSPL	10173662	Drawer D008	Scarborough25a	1978-9060
Taylor, Fred	1939	Scarborough: It's Quicker By Rail: The Spa	Yorkshire	LNER	QR	SSPL	10173376	DrawerD018	Scarborough26	1986-9189
Higgins, Reginald Edward	1929	Scarboro left hand part of poster only	Yorkshire	LNER	QR	SSPL	10173411		Scarborough27	1987-8879
Higgins, Reginald Edward	1925	Scarborough: smaller version of poster above	Yorkshire	LNER	QR	Christies	09/02/1995 Lot 205		Scarborough27a	
Mason, Frank Henry Algernon	1939	Scarborough: It's Quicker By Rail; new sea water pool	Yorkshire	LNER	DR	SSPL	10174371	Drawer D098	Scarborough28	1987-8891
Purvis, Tom	1936	Scarborough by LNER	Yorkshire	LNER	DR	SSPL	10174428	Drawer D057	Scarborough29	1987-8948
Ellis, Hamilton	1950s	The Scarborough Flyer; pic timetable	Yorkshire	BR(ER)	DR	SRA			Scarborough30	
Newbould, Frank	1920s	Scarborough: famous hotel and castle	Yorkshire	LNER	QR	D578			Scarborough31	
Baumer, Lewis	1900	Scarborough	Yorkshire	GNR	DR	SC19	Scarborough Council		Scarborough32	
Michael, Arthur C.	1940	Scarborough	Yorkshire	LNER	QR	SC20	Scarborough Council		Scarborough33	
Purvis, Tom	1931	Scarborough	Yorkshire	LNER	Large	Christies	23/9/1999 Lot 95		Scarborough34	
Michael, Arthur C.	1940	Scarborough	Yorkshire	LNER	DR	Christies	23/9/1999 Lot 96		Scarborough35	
Kesteven, Peter	1960	Scarborough: Travel by Train (couple sunbathing)	Yorkshire	BR(NER)	DR	SRA			Scarborough36	
Anon	1954	Scarborough; yellow bikini and cooli hat	Yorkshire	BR(NER)	DR	Christies	10/09/2008 Lot 176		Scarborough37	
Brown, F. Gregory	1920	Scarborough: Queen of the Watering Places	Yorkshire	NER	QR	York book			Scarborough38	
Mason, Frank Henry Algernon	1926	Scarborough: Queen of the Watering Places	Yorkshire	LNER	QR	York book			Scarborough39	
Mason, Frank Henry Algernon	1938	Scarborough: A pageant of Tannhauser	Yorkshire	LNER	DR	York book			Scarborough40	
Anon	1954	Scarborough: beach scene tanned belle	Yorkshire	BR(NER)	DR	KRA			Scarborough41	
Taylor, Fred	1934	Scarborough: The Italian Gardens	Yorkshire	LNER	DR	York book			Scarborough42	
Lewis, David	1950	Scarborough: timetable poster	Yorkshire	BR(ER)	DR	SRA			Scarborough43	
Taylor, Fred	1920s	Scarborough: The Bathing Pool	Yorkshire	LNER	DR	Onslows	25/06/2008 Lot 220		Scarborough44	
Taylor, Fred	1930	Scarborough Spa: original litho from LNER poster	Yorkshire	LNER	QR	Onslows	25/06/2008 Lot 251		Scarborough45	
Mason, Frank Henry Algernon	1914	Scarborough: Centre for Northern Tours	Yorkshire	NER	QR	NRM	1986-9062 Drawer D001		Scarborough47	1986-9062
Anon	1930s	Scarborough: View of the Bay	Yorkshire	LNER	QR	Stamp Book			Scarborough48	
Russell, Gyrth	1960	Scarborough Day Excursions 30th June: pic timetable	Yorkshire	BR(NER)	DR	SRA			Scarborough49	
Hauff, K.	1930	Whitby: It's Quicker By Rail	Yorkshire	LNER	QR	SSPL	10173469	Drawer D008	Whitby01	1978-8931
Russell, Gyrth	1959	Whitby	Yorkshire	BR(NER)	QR	SSPL	10173637 + 10170914	Drawer D023	Whitby02	1978-9035
Cooper, Austin	1920s	Whitby	Yorkshire	LNER	QR	SSPL	10173483	Drawer D008	Whitby03	1978-8945
Newbould, Frank	1920s	Whitby: fishing boats and abbey ruins	Yorkshire	LNER	QR	SSPL	10173563	Drawer D014	Whitby04	1986-9232
Taylor, Fred	1928	Whitby: Capt Cook embarking in 1776	Yorkshire	LNER	QR	SSPL	10174082	Drawer D017	Whitby05	1978-9265
Arnesworth, E	1933	Whitby: It's Quicker By Rail	Yorkshire	LNER	QR	SSPL	10174142		Whitby07	
Amstutz, Andre	1954	Whitby: floral illustration like well dressing	Yorkshire	BR(NER)	DR	SSPL	10175889		Whitby08	1978-1008
Lee-Hankey, W.	1935	Whitby: view of harbour	Yorkshire	LNER	QR	SSPL	10173555	Drawer D008	Whitby10	1978-8995
Taylor, Fred	1929	Whitby: the abbey ruins	Yorkshire	LNER	DR	SSPL	10174221	Drawer D100	Whitby11	1978-9404

ARTIST	YEAR	TITLE	LOCATION	COMPANY	SIZE	SOURCE	SOURCE DETAILS		IMAGE REF	NRM REF
Mason, Frank Henry Algernon	1931	Havens and Harbours on the LNER: No. 3 Whitby	Yorkshire	LNER	DR	SSPL	10172479	Drawer D098	Whitby12	1983-8333
Ainsworth, Edgar	1933	Whitby: It's Quicker By Rail	Yorkshire	LNER	QR	SSPL	10174142	Drawer D009	Whitby13	1978-9325
Johnson, Andrew	1931	Whitby: Then and Now: Capt Cook leaving 1768	Yorkshire	LNER	DR	SSPL	10174406	Drawer D077	Whitby14	1987-8926
Anon	1960s	Whitby: photographic harbour scene	Yorkshire	BR(NER)	DR	SSPL	10175990		Whitby15	1978-1009
Anon	1958	Whitby: Gem of the Yorkshire Coast	Yorkshire	BR(NER)	DR	SSPL	10175567		Whitby16	1978-0986
Anon	1960s	Whitby: photographic harbour scene	Yorkshire	BR(NER)	DR	SSPL	10175566		Whitby17	1978-0985
Cattermole, Lance Harry Mosse	1956	Whitby: children sandcastles and abbey	Yorkshire	BR(NER)	DR	Christies	10/9/2003 Lot 113		Whitby18	
Mason, Frank Henry Algernon	1930	Whitby	Yorkshire	LNER	QR	Onslows	25/06 2008 Lot 282		Whitby19	
Zinkeisen, Anna Katrina	1930s	Whitby: Captain Cook at Whitby	Yorkshire	LNER	QR	NRM	1977-5605 Drawer D007		Whitby20	1977-5605
Macnab, Iain	1930s	Whitby: It's Quicker By Rail	Yorkshire	LNER	DR	Solent			Whitby21	
Mason, Frank Henry Algernon	1930s	Whitby: It's Quicker By Rail; building Cook's ship	Yorkshire	LNER	QR	SSPL	10173415	Drawer D013	Whitby22	1986-9200
Oppenheimer, Charles	1950s	North East Coast; See England by Rail: view of Whitby	Yorkshire	BR(NER)	QR	SSPL	10171253	Drawer D023	Whitby23	1992-7725
Briby, Maud	1933	Withernsea, Yorkshire	Yorkshire	LNER	DR	SSPL	10174379	Drawer D095	Withernsea01	1987-8899
Horder, Margaret	1933	Withernsea: It's Quicker By Rail	Yorkshire	LNER	DR	SSPL	10174519	Drawer D093	Withernsea02	1978-9501
Mason, Frank Henry Algernon	1920s	Withernsea	Yorkshire	LNER	DR	SSPL	10174298	Drawer D098	Withernsea03	1978-9480
Lambart, Alfred	1920s	Withernsea	Yorkshire	LNER	DR	Sothebys			Withernsea04	
Nicholl, Gordon	1930s	Royal Station Hotel, York	Yorkshire	LNER	DR	NRM	1987-9176 Drawer D095		York01	1987-9176
Danvers, Verney L.	1924	York: Centre of a Glorious Holiday District	Yorkshire	LNER	DR	SSPL	10174391	Drawer D057	York02	1987-8911
Steel, Kenneth	1960	York: See England by Rail: Bootham Bar	Yorkshire	BR(NER)	DR	SSPL	10175582		York03	1978-1001
Anon	1990	York by Train: It Ain't Half a Bargain	Yorkshire	BR Intercity	DR	SSPL	10547673		York04	
Buckle, Claude	1952	York: Petergate	Yorkshire	BR(NER)	DR	SSPL	10173274		York06	1986-9112
Linford, Alan Carr	1962	York: Come by Train: The Shambles	Yorkshire	BR(NER)	DR	SSPL	10175584		York07	1978-1003
Taylor, Fred	1920s	York: walled city of great antiquity: Stonegate	Yorkshire	LNER	QR	SSPL	10276203		York08	
Taylor, Fred	1935	York: Stonegate	Yorkshire	LNER	QR	Onslows	25/06/2008 Lot 286		York08a	
Photographic	1950	York in daffodil time	Yorkshire	BR(NER)	DR	SSPL	10173075		York10	1976-9221
Taylor, Fred	1924	York Minster: View from Bootham Bar	Yorkshire	LNER	QR	SSPL	10171335	Drawer D017	York11	1993-8115
Taylor, Fred	1923	York Minster: England's Treasure House of Stained Glass	Yorkshire	LNER	QR	SSPL	10170953	Drawer D018	York12	1990-7061
Taylor, Fred	1924	York by LNER: choir in procession; sepia type image	Yorkshire	LNER	QR	SSPL	10173350	Drawer D017	York13	1986-9176
Schabelsky	1929	York: scraper board type image of Petergate	Yorkshire	LNER	DR	SSPL	10170906	Drawer D093	York14	1989-7143
Taylor, Fred	1946	York: It's Quicker By Rail: The Minster West Front	Yorkshire	LNER	DR	SSPL	10172881 + 10174264	Drawer D100	York15	1984-8204
CL??	1930s	York Minster: scaperboard image top 2/3rds	Yorkshire	LNER	DR	SSPL	10174412	Drawer D093	York16	1987-8932
Taylor, Fred	1930	York: Monkbar (also reissued in 1934)	Yorkshire	LNER	DR	SSPL	10175958	Drawer D100	York17	1988-7933
Taylor, Fred	1935	York: Travel by Rail: The Treasurers House	Yorkshire	LNER	DR	SSPL	10174218	Drawer D100	York18	1978-9401
Taylor, Fred	1931	York Minster: interior view of Tomb	Yorkshire	LNER	DR	SSPL	10173918	Drawer D100	York19	1987-8763
Taylor, Fred	1931	York: Kings Manor House exterior	Yorkshire	LNER	DR	SSPL	10326399	Drawer D100	York20	1995-7041
Shep (Chas Shepherd)	1954	York: See Britain by Train: The Treasurer's House	Yorkshire	BR(NER)	DR	SSPL	10175596		York21	1978-1015
Spencer, E.H.	1956	York: See Britain by Train: Minster and heraldry	Yorkshire	BR(NER)	QR	SSPL	10175905	Drawer D023	York22	1987-9179
Taylor, Fred	1930	York: By LNER: The Treasurer's House	Yorkshire	LNER	QR	SSPL	10174033	Drawer D017	York23	1978-9216

ARTIST	YEAR	TITLE	LOCATION	COMPANY	SIZE	SOURCE	SOURCE DETAILS		IMAGE REF	NRM REF
Zinkeisen, Doris Clare	1934	To York: Dick Turpin's Ride	Yorkshire	LNER	QR	SSPL	10171873	Drawer D009	York24	1979-7918
Taylor, Fred	1928	York: St. William's College	Yorkshire	LNER	QR	SSPL	10173509	Drawer D017	York25	1978-8967
Bawden, Edward	1954	York: The Historic City PR54	Yorkshire	BR(NER)	QR	SSPL	10171110	Drawer D023	York27	1992-7451
Rushbury, Henry	1935	York: It's Quicker By Rail	Yorkshire	LNER	QR	NRM York	Page 28 in NRM Guide to York		York28	
Taylor, Fred	1935	York: The Local Government Centenary Procession	Yorkshire	LNER	QR	SSPL	10173512	Drawer D017	York29	1978-8969
Taylor, Fred	1920	York: Walled City of Great Antiquity: Lendal Bridge	Yorkshire	NER	QR	Onslows	25/06/2008 Lot 296		York30	
Tittensor, H	1938	York: It's Quicker By Rail: The Shambles	Yorkshire	LNER	DR	SSPL	10171889	Drawer D094	York31	1979-7931
CJ	1910	Historic York	Yorkshire	NER	DR	SSPL	10171887		York32	1979-7932
Taylor, Fred	1920s	York: Walled City of Ancient Days: Stonegate	Yorkshire	LNER	QR	SSPL	10173434	Drawer D017	York33	1978-8899
Taylor, Fred	1930	York Minster: choir in procession	Yorkshire	LNER	QR	SSPL	10173521	Drawer D017	York34	1978-8974
Taylor, Fred	1932	York: Architecture - Perpendicular 14-15th Century	Yorkshire	LNER	DR	SSPL	10174330	Drawer D100	York35	1987-8850
Steel, Kenneth	1955	York: Ancient Walled and Many Towered	Yorkshire	BR(NER)	DR	Christies	30/05/1997 Lot 129		York36	
Zero (Hans Schleger)	1960	Visit the Railway Museum York	Yorkshire	BR Exec	DR	SSPL	10374637		York37	1978-9610
Fraser, Eric	1977	York 100: Exhibition to celebrate the station Centenary	Yorkshire	BR(ER)	DR	SSPL	10174907		York38	1978-9751
Spencer, E.H.	1955	York: The Gateway to History	Yorkshire	BR(NER)	DR	SSPL	10175562		York39	1978-0981
Anon	1987	York: Enjoy a Day Out by Train at a Fascinating City	Yorkshire	BR CAS	DR	SSPL	10175941		York40	1987-9215
Anon	1992	Oh to be in England. Rail Rovers poster of York Walls	Yorkshire	BR Regional	DR	SSPL	10171283		York41	1992-7755
Neiland, Brendan	1991	York AA0082A /A1/9.91	Yorkshire	Railfreight	DR	SSPL	10308305		York42	1997-8437
Michael, Arthur C.	1935	Royal Station Hotel York	Yorkshire	LNER	DR	LNER Book			York43	
Keely, Patrick Cockayne	1961	York Races; semi pic timetable Ref. A2/61	Yorkshire	BR(NER)	DR	Private			York44	
Taylor, Fred	1930s	York: It's Quicker By Rail Stonegate: The marching band	Yorkshire	LNER	DR	SRA			York45	
Steel, Kenneth	1965	York: Bootham Bar	Yorkshire	York City Counc	DR	YCC	1965 Book		York46	
Steel, Kenneth	1965	York from the City Walls	Yorkshire	York City Counc	DR	YCC	1965 Book		York47	
Taylor, Fred	1930s	York: View of Stonegate	Yorkshire	LNER	DR	eBay			York49	
Anon	1995	First Stop York	Yorkshire	Regional Rlys	DR	NRM	2002-7290 Drawer D357		York50	2002-7290
Anon	1990s	Live the Sory of Railways at the NRM York	Yorkshire	Regional Rlys	DR	NRM	2001-9584 Drawer D357		York51	2001-9584
Anon	1970s	York: Part of our National Heritage	Yorkshire	BR(NER)	DR	SSPL	10173272		Yorksadvert02	1977-5684
Schabelsky	1932	Rambles in the West Ridings of Yorkshire	Yorkshire	LNER	DR	SSPL	10174184	Drawer D095	Yorksadvert03	1978-9367
Schabelsky	1923	Rambles on the Yorkshire Moors: Bridestone	Yorkshire	LNER	DR	SSPL	10174433	Drawer D079	Yorksadvert04	1987-8953
Schabelsky	1920s	Rambles on the Yorkshire Moors and Coast	Yorkshire	LNER	DR	SSPL	10174592	Drawer D077	Yorksadvert05	1978-9565
Anon	1977	MetroLink: West Yorkshire Rail Network	Yorkshire	BR Exec	DR	SSPL	10175200		Yorksadvert06	1987-0637
Anon	1977	LinkLine: South Yorkshire Rail Network	Yorkshire	BR(ER)	DR	SSPL	10175201		Yorksadvert07	1978-0638
Anon	1977	British Rail - Yorkshire	Yorkshire	BR(NER)	DR	SSPL	10175202		Yorksadvert08	1978-0639
Morton, Edwin	1935	The Yorkshire Pullman: Hull and London in 3 1/2 Hours	Yorkshire	LNER	QR	SSPL	10172875	Drawer D094	Yorksadvert10	1984-8198
Anon	1910	Moorland Holidays - (Yorkshire)	Yorkshire	NER	DR	SSPL	10172525	Drawer D88	Yorksadvert11	1986-8962
Technical Art Services	1970	1758 Middleton Railway Leeds	Yorkshire	Middleton Rly	DR	SSPL	10173110		Yorksadvert12	1986-9066
Mason, Frank Henry Algernon	1937	Yorkshire Coast near Whitby: It's Quicker By Rail	Yorkshire	LNER	QR	SSPL	10173493	Drawer D013	Yorkshire Coast01	1986-9207
Sherwin, Frank	1960	The Yorkshire Coast: Robin Hood's Bay	Yorkshire	BR(NER)	QR	SSPL	10173789	Drawer D023	Yorkshire Coast02	1978-9155

ARTIST	YEAR	TITLE	LOCATION	COMPANY	SIZE	SOURCE	SOURCE DETAILS		IMAGE REF	NRM REF
Lander, Reginald Montague	1950s	Explore the Yorkshire Coast by Train: map abstract montage	Yorkshire	BR(NER)	QR	SSPL	10173754	Drawer D023	Yorkshire Coast03	1978-9129
Mason, Frank Henry Algernon	1949	Yorkshire Coast: Flamborough fishing boats going to sea	Yorkshire	BR(NER)	DR	SSPL	10171785		Yorkshire Coast05	1979-7830
Bee, John Francis	1950s	Yorkshire Coast	Yorkshire	BR(NER)	DR	SSPL	10175599		Yorkshire Coast06	1978-1018
Bee, John Francis	1950s	Yorkshire Coast: See England by Rail	Yorkshire	BR(NER)	DR	SSPL	10174888		Yorkshire Coast06	1978-9732
Wesson, Edward	1960s	Yorkshire: See Britain by Train: North Landing Flamborough	Yorkshire	BR(ER)	DR	SSPL	10171744		Yorkshire Coast07	1979-7789
Bone, Stephen	1933	Yorkshire Coast by LNER: feet in rock pool	Yorkshire	LNER	QR	SSPL	10173597	Drawer D010	Yorkshire Coast08	1986-9250
Mason, Frank Henry Algernon	1933	Yorkshire Coast: Line Fish	Yorkshire	LNER	DR	SSPL	10174616	Drawer D098	Yorkshire Coast09	1978-9589
Newbould, Frank	1926	Yorkshire Coast: mainly white poster	Yorkshire	LNER	DR	SSPL	10170830	Drawer D099	Yorkshire Coast10	1989-7065
Russell, Gyrth	1959	Yorkshire Coast: one of nature's holiday areas	Yorkshire	BR(NER)	DR	SSPL	10175611		Yorkshire Coast11	1978-1030
Mason, Frank Henry Algernon	1910s	The Yorkshire Coast: 'Twixt Moors & Sea	Yorkshire	NER	QR	SSPL	10173070	Drawer D001	Yorkshire Coast13	1986-9055
Mason, Frank Henry Algernon	1930s	East Coast Craft No. 4: Yorkshire Coble	Yorkshire	LNER	DR	SSPL	10173421	Drawer D098	Yorkshire Coast14	1978-8888
Brown, F. Gregory	1925	The Yorkshire Coast	Yorkshire	LNER	QR	SSPL	10173576	Drawer D010	Yorkshire Coast15	1986-9237
Cooper, Austin	1930	The Yorkshire Coast For Happy Holidays: semi abstract	Yorkshire	LNER	QR	SSPL	10173583	Drawer D010	Yorkshire Coast16	1986-9241
Knight, Dame Laura	1929	The Yorkshire Coast: The Holiday Handbook	Yorkshire	LNER	QR	SSPL	10173753	Drawer D015	Yorkshire Coast17	1986-9293
Mason, Frank Henry Algernon	1938	The East Coast: between Whitby and Sandsend	Yorkshire	LNER	QR	SSPL	10174100	Drawer D013	Yorkshire Coast18	1978-9283
Russell, Gyrth	1950	The Yorkshire Coast	Yorkshire	BR(NER)	QR	Christies	25/05/1994 Lot 21		Yorkshire Coast19	
Johnson, Andrew	1930s	The Yorkshire Coast	Yorkshire	LNER	QR	SSPL	10324279	Drawer D015	Yorkshire Coast20	1986-9357
Armengol, Mario	1955	The Yorkshire Coast For Holidays	Yorkshire	BR(NER)	DR	SSPL	10175601		Yorkshire Coast21	1978-1020
Anon	1934	Rambles on the Yorkshire Coast and Moors	Yorkshire	LNER	DR	LNER Book			Yorkshire Coast22	
Mason, Frank Henry Algernon	1920	The Yorkshire Coast: Alice in Holidayland	Yorkshire	LNER	QR	SSPL	10173095	Drawer D001	Yorkshire Coast22	1986-9061
Purvis, Tom	1930s	Yorkshire Coast: Travel By LNER; baby on sands	Yorkshire	LNER	QR	SSPL	10173316	Drawer D016	Yorkshire Coast23	1986-9146
Purvis, Tom	1936	Robin Hood's Bay, Yorkshire By LNER	Yorkshire	LNER	DR	SSPL	10175992	Drawer D057	Yorkshire Coast24	1988-7967
Mason, Frank Henry Algernon	1930s	Remember the Yorkshire Coast Next Summer: cliff image	Yorkshire	LNER	DR	Christies	13/09/2007 Lot 149	LNER C11.2.1	Yorkshire Coast25	1991-7011/1
Anon	1910	Runswick Bay Yorkshire	Yorkshire	NER	DR	NRM	1986-8976 Drawer D88		Yorkshire Coast26	1986-8976
Mason, Frank Henry Algernon	1920	The Yorkshire Coast: Such Quantities of Sand	Yorkshire	GNR	QR	NRM	1986-9048 Drawer D001		Yorkshire Coast27	1986-9048
McKenzie, Alison	1930s	Yorkshire Coast: It's Quicker By Rail: Staithes	Yorkshire	LNER	DR	NRM	LNER album C11.2 -1 1991-7011/1		Yorkshire Coast28	1991-7011/1
Bootie, F.W.	1911	The Yorkshire Coast	Yorkshire	NER	DR	Christies	12/09/2001 Lot 161		Yorkshire Coast29	
Anon	1900	Yorkshire Coast	Yorkshire	NER	DR	York book			Yorkshire Coast30	
Mason, Frank Henry Algernon	1920s	Yorkshire Coast: Fight off Scarborough 1779	Yorkshire	LNER	QR	SSPL	10173453	Drawer D013	Yorkshire Coast31	1986-9205
Squirrell, Leonard Russell	1948	Yorkshire Dales	Yorkshire	BR(NER)	DR	SSPL	10171742		Yorkshire Dales01	1979-7787
Tollemache, Duff	1930	To the Dales by LNER	Yorkshire	LNER	DR	SSPL	10174512	Drawer D095	Yorkshire Dales02	1978-9494
Greenwood, Orlando	1930s	The Dales by LNER: It's Quicker By Rail	Yorkshire	LNER	DR	SSPL	10174284	Drawer D093	Yorkshire Dales03	1978-9466
Greenwood, Orlando	1930s	The Yorkshire Dales - original artwork	Yorkshire	LNER	QR	Christies	08/02/1996 Lot 82		Yorkshire Dales04	
Cooper, Austin	1920s	Yorkshire Dales By LNER: The Holiday Handbook	Yorkshire	LNER	DR	SSPL	10174194	Drawer D097	Yorkshire Dales05	1978-9377
Greenwood, Orlando	1920s	Yorkshire Dales By LNER	Yorkshire	LNER	DR	SSPL	10174262	Drawer D095	Yorkshire Dales06	1978-9444
Greene, John	1959	Ribblesdale: North West Yorkshire LM 21659	Yorkshire	BR(LMR)	QR	SSPL	10170765	Drawer D022	Yorkshire Dales08	1991-7149
Byatt, Edwin	1930s	Yorkshire Dales	Yorkshire	LNER	QR	SSPL	10173901	Drawer D015	Yorkshire Dales09	1987-8746
Sherwin, Frank	1953	Yorkshire Dales	Yorkshire	BRNER	DR	SSPL	10171741		Yorkshire Dales10	1979-7786

ARTIST	YEAR	TITLE	LOCATION	COMPANY	SIZE	SOURCE	SOURCE DETAILS	IMAGE REF	NRM REF
Schabelsky	1930s	The Dales By LNER; watermill scene	Yorkshire	LNER	DR	SSPL	10173487 Drawer D095	Yorkshire Dales11	1978-8949
Lampitt, Ronald	1961	Yorkshire Dales: A National Park Area	Yorkshire	BR(NER)	DR	SSPL	10175569	Yorkshire Dales12	1978-0988
Anon	1914	The Magic of the Yorkshire Dales Ref. 058G	Yorkshire	NER	QR	SSPL	10173074 Drawer D001	Yorkshire Dales13	1986-9057
Greenwood, Orlando	1930s	The Yorkshire Dales - original artwork Richmond Castle	Yorkshire	LNER	QR	Christies	08/02/1996 Lot 83	Yorkshire Dales14	
McKenzie, Alison	1930s	Yorkshire Dales: It's Quicker By Rail	Yorkshire	LNER	DR	NRM	LNER Album C11.2 -3	Yorkshire Dales15	1991-7011/3
Gabain, E	1930s	The Yorkshire Dales: It's Quicker by Rail	Yorkshire	LNER	DR	NRM	LNER Album C11.2-3	Yorkshire Dales16	1991-7011/3
Mason, Frank Henry Algernon	1910	Teesdale Yorkshire	Yorkshire	NER	QR	SSPL	10170719	Yorkshire Dales17	1991-7100
Grainger, Tom	1924	By LNER to the Moors	Yorkshire	LNER	QR	SSPL	10173601 Drawer D010	Yorkshire Moors01	1986-9254
Littlejohns, John	1920s	By LNER to the Moors: The Holiday Handbook	Yorkshire	LNER	QR	SSPL	10173766 Drawer D015	Yorkshire Moors02	1986-9298
Purvis, Tom	1930	Yorkshire Moors: couple walking	Yorkshire	LNER	QR	SSPL	10311578 Drawer D016	Yorkshire Moors03	1986-9144
Purvis, Tom	1930s	Yorkshire Moors by LNER: Mallyan Spout, Goathland	Yorkshire	LNER	QR	SSPL	10173333 Drawer D016	Yorkshire Moors04	1986-9162
Russell, Gyrth	1948	Yorkshire: See Britain by Train; farm and landscape image	Yorkshire	BR(NER)	QR	SSPL	10173638 Drawer D023	Yorkshire01	1978-9036
Marston, Freda	1960	Kirkham Abbey, Yorkshire ref. AR 1102	Yorkshire	BR(NER)	DR	SRA		Yorkshire03	
Schabelsky	1930s	Ripon Minster: Rambles in the West Riding	Yorkshire	LNER	DR	SRA		Yorkshire06	
Photographic	1930s	Zetland Hotel, Saltburn-by-the-Sea	Yorkshire	LNER	DR	SSPL	10170766 Drawer D079	Yorkshire08	1991-7150
Photographic	1930s	Zetland Hotel, Saltburn-by-the-Sea	Yorkshire	LNER	DR	SSPL	10176155 Drawer D077	Yorkshire08a	1994-8639
Black, Montague Birrell	1934	Explore Yorkshire By LNER (Pic Relief Map)	Yorkshire	LNER	QR	SSPL	10176140 Drawer D015	Yorkshire09	1994-8624
Byatt, Edwin	1940	North East Dales	Yorkshire	LNER	QR	SSPL	10172184 and 10323869 Drawer D008	Yorkshire10	1986-8786
Clark, Estra	1949	A Map of Yorkshire PP1096	Yorkshire	BR(NER)	QR	SSPL	10173798 Drawer D023	Yorkshire11	1978-9164
Clark, Estra	1949	Pictorial Map of Yorkshire	Yorkshire	BR(NER)	QR	SSPL	10171764 Drawer D023	Yorkshire12	1979-7809
Cuneo, Terence Tenison	1950	Giants Refreshed: Pacifics at Doncaster works	Yorkshire	BR(ER)	QR	SSPL	10171843	Yorkshire14	1979-7888
Cuneo, Terence Tenison	1950	Giants Refreshed: Pacifics at Doncaster works	Yorkshire	BR(ER)	QR	SSPL	10173363	Yorkshire14a	1978-8848
Cuneo, Terence Tenison	1930s	Giants Refreshed: Pacifics at Doncaster works	Yorkshire	LNER	QR	SSPL	10324271	Yorkshire14b	1999-8246
Purvis, Tom	1930s	Yorkshire: LNER It's Quicker By Rail	Yorkshire	LNER	QR	SSPL	10173340 Drawer D016	Yorkshire15	1986-9169
Hall, Oliver	1930	Bolton Castle: Redmire Station LNER Yorkshire	Yorkshire	LNER	QR	SSPL	10173726 Drawer D010	Yorkshire16	1986-9271
Wilkinson, Norman	1929	Sedburgh School, Yorkshire	Yorkshire	LMS	DR	SSPL	10170969 Drawer D092	Yorkshire17	1990-7077
Ions, A.	1908	The Yorkshire Moors - Tranquil Solitude	Yorkshire	NER	DR	SSPL	10172535	Yorkshire18	1986-8969
Anon	1905	The Gateway to England's Best Holiday Ground	Yorkshire	NER	DR	SSPL	10172548	Yorkshire19	1986-8975
Merriott, Jack	1960	Service to the Fishing Industry: St. Andrew's Dock, Hull	Yorkshire	BR(NER)	QR	SSPL	10172611 + 10173069 Drawer D023	Yorkshire20	1983-8417
Wilkinson, Norman	1930s	Goole - SS "Don" Coaling at the 40-ton Crane	Yorkshire	LMS	QR	SSPL	10173123 Drawer D006	Yorkshire21	1976-9257
Steel, Kenneth	1960	Hull, New Holland and Barton-on-Humber Diesel Rail Car Services	Yorkshire	BR(ER)	DR	SSPL	10171533	Yorkshire23	1979-7578
JP of McCorquodale	1920s	Goole Steam Shipping: Regular Services	Yorkshire	LMS	QR	SSPL	10173966 Drawer D005	Yorkshire24	1987-8811
Mason, Frank Henry Algernon	1920s	The Humber: Famous Rivers of Commerce Series	Yorkshire	LNER	QR	SSPL	10173968 Drawer D013	Yorkshire25	1987-8813
Taylor, Fred	1932	Selby: Architecture – Decorated 13-14th Century	Yorkshire	LNER	DR	SSPL	10174330 Drawer D100	Yorkshire26	1987-8875
Bossfield Studios	1939	Meet the Sun on the East Coast	Yorkshire	LNER	DR	SSPL	10174383	Yorkshire27	1987-8903
Mason, Frank Henry Algernon	1910	Historic Monuments in North England: No. 5 Richmond Castle	Yorkshire	NER	DR	SSPL	10174647	Yorkshire28	1978-9620
Mason, Frank Henry Algernon	1910	Historic Monuments in North England: No. 4 Rievaulx	Yorkshire	NER	DR	SSPL	10174648	Yorkshire29	1978-9621
Taylor, Fred	1933	Rievaulx Abbey: Helmsley Station, Yorkshire	Yorkshire	LNER	QR	SSPL	10327673 Drawer D017	Yorkshire30	1996-7350

ARTIST	YEAR	TITLE	LOCATION	COMPANY	SIZE	SOURCE	SOURCE DETAILS		IMAGE REF	NRM REF
Lee, Sydney	1930s	Rievaulx Abbey: Helmsley Station, Yorkshire	Yorkshire	LNER	QR	SSPL	10175948	Drawer D015	Yorkshire31	1986-9314
Cooper, Austin	1933	The Booklovers' Britain: Coxwold, Yorkshire	Yorkshire	LNER	DR	SSPL	10174575	Drawer D097	Yorkshire32	1978-9548
Home, Percy	1890s	The Tees Ports and The Railway Connections	Yorkshire	NER	DR	SSPL	10175078		Yorkshire33	1978-9922
Linford, Alan Carr	1963	See Yorkshire by Train	Yorkshire	BR(NER)	DR	SSPL	10175570		Yorkshire34	1978-0989
Steel, Kenneth	1950	Selby Abbey: See England By Rail; Abbott Hugh's Pillar	Yorkshire	BR(NER)	DR	SSPL	10175577		Yorkshire35	1978-0996
Haslehust, Ernest William	1930s	Aysgarth Falls Yorks: It's Quicker By Rail	Yorkshire	LNER	QR	SSPL	10173817	Drawer D015	Yorkshire36	1986-9308
Taylor, Fred	1934	Byland Abbey, Yorkshire	Yorkshire	LNER	QR	SSPL	10173370	Drawer D018	Yorkshire37	1986-9186
Photographic	1957	England's Stately Homes: Castle Howard; interior view	Yorkshire	BR(NER)	DR	SSPL	10173956		Yorkshire38	1987-8801
Taylor, Fred	1933	Jervaulx Abbey: Yorkshire	Yorkshire	LNER	QR	SSPL	10174080	Drawer D017	Yorkshire39	1978-9263
Shepherd	1956	England's Stately Homes; Travel By Train: Newby Hall	Yorkshire	BR(NER)	DR	SSPL	10173957 & 10278375		Yorkshire40	1987-8802
Coates	1910s	Holidays! Why Not May or June in Yorkshire?	Yorkshire	NER	DR	SSPL	10175943		Yorkshire41	1986-8963
Whatley, F	1924	Ingleton: The Land of Waterfalls: Newly Discovered Caverns	Yorkshire	LMS	DR	SSPL	10175989	Drawer D091	Yorkshire42	1988-7964
Neiland, Brendan	1996	Leeds: modern image	Yorkshire	Railfreight	DR	SSPL	10308309		Yorkshire44	1997-8435
Mason, Frank Henry Algernon	1932	The Tees: Middlesbrough; centre of iron and steel	Yorkshire	LNER	QR	SSPL	10173396	Drawer D013	Yorkshire45	1986-9198
Anon	1950	Excursions to Thirsk: Horse Racing	Yorkshire	BR(NER)	DR	SSPL	10327501		Yorkshire46	1999-7092
Photographic	1935	Gracie Fields: On the East Coast	Yorkshire	LNER	DR	SSPL	10171720		Yorkshire47	
Tripp, Herbert Alker	1940	Rambles on the Yorkshire Coast and Moors: Hayburn Wyke	Yorkshire	LNER	DR	Christies	14/9/2006 lot 78		Yorkshire48	
Tomkin, William Stephen	1909	Ravenscar	Yorkshire	NER	DR	C15748			Yorkshire49	
Luty, Malcolm	1924	Leeds Waterfront	Yorkshire	Waterways	DR	BW-NER5			Yorkshire50	
Morton, Edwin	1935	The Yorkshire Pullman	Yorkshire	LNER	DR	NRM26			Yorkshire51	
Prince, Frank	1917	Interior of Brighouse East Junction Signal Box; artwork	Yorkshire	L+Y	QR	SSPL	10283460		Yorkshire52	1978-1589
Padden, Percy		Aysgarth Falls; original artwork	Yorkshire	LNER	QR	Onslows	11/04/2002 Lot 155		Yorkshire53	
Schabelsky	1930s	Rambles in the Clevelend District of Yorkshire	Yorkshire	LNER	DR	SRA			Yorkshire54	
Squirrell, Leonard Russell	1954	Yorkshire:See Britain By train ; Richmond	Yorkshire	BR(LMR)	DR	NRM	1998-11605 Drawer D151		Yorkshire55	1998-11605
Gawthorn, Henry George	1927	Middlesbrough: Handling Heavy Machinery	Yorkshire	LNER	DR	York book	Poster 61 in Yorkshire Poster Book		Yorkshire56	
Mason, Frank Henry Algernon	1930s	Richmond Yorkshire by LNER	Yorkshire	LNER	DR	SRA			Yorkshire57	
Greene, John	1958	Skipton Castle, Yorkshire LM 19258	Yorkshire	BR(LMR)	DR	NRM	1984-8192 Drawer D078		Yorkshire58	1984-8192
Steel, Kenneth	1960	Beverley Minster: The Percy Tomb	Yorkshire	BR(NER)	DR	SSPL	10171784		Yorkshire59	1979-7829
Kersting, A.F.	1959	Bolton Abbey; photo image	Yorkshire	BR(NER)	DR	Cundalls			Yorkshire60	
Blake	1960s	Historic and Beautiful Whitby (abbey ruins)	Yorkshire	BR(NER)	DR	SRA			Yorkshire62	
Cole, Alice	1920s	Hayburn Wyke: 7 miles from Scarborough	Yorkshire	LNER	DR	York book			Yorkshire63	
Taylor, Fred	1918	Robin Hood's Bay: Victoria Hotel	Yorkshire	NER	DR	York book			Yorkshire65	
Spurrier	1910s	Whitby Moors: shepherd with pipe	Yorkshire	LNER	DR	SRA			Yorkshire66	
Gawthorn, Henry George	1930s	Hull England: The Natural Port For Wool	Yorkshire	LNER	DR	SRA			Yorkshire67	
Mason, Frank Henry Algernon	1910	Historic Monuments in North England: No. 6 Fountains Abbey	Yorkshire	NER	DR	NRM	1978-9619 Drawer D88		Yorkshire68	1978-9618
Anon	1910s	Yorkshire's Attractions: Moorland and Sea	Yorkshire	NER	QR	NRM	1986-9059 Drawer D001		Yorkshire69	1986-9059
Mason, Frank Henry Algernon	1910s	Teesdale, Yorkshire: Magnificent Waterfalls	Yorkshire	NER	QR	NRM	1986-9054 Drawer D001		Yorkshire70	1986-9054
Anon	1991	Meadowhall Now Stopping for Shopping	Yorkshire	Intercity	DR	NRM	1998-11306 Drawer D042		Yorkshire71	1998-11306

ARTIST	YEAR	TITLE	LOCATION	COMPANY	SIZE	SOURCE	SOURCE DETAILS	IMAGE REF	NRM REF
Anon	1930s	Richmond Yorks LNER	Yorkshire	LNER	QR	NRM	LNER album C11.2 1991-7011/2	Yorkshire72	1991-7011/2
Haslehust, Ernest William	1930s	Rievaulx Abbey: Helmsley Station, Yorkshire	Yorkshire	LNER	QR	NRM	LNER album C11.2 1991-7011/2	Yorkshire73	1991-7011/2
Ralph & Mott (Pub)	1930s	Goole to the Continent	Yorkshire	LMS	DR	D547		Yorkshire74	
Buckle, Claude	1930s	Ingleton: Land of Waterfalls and Caves	Yorkshire	LMS	DR	SRA		Yorkshire75	
Anon	1977	The Esk Valley Line	Yorkshire	BR (ER)	QR	NRM	1984-8247 Drawer D050	Yorkshire76	1984-8247
Valentine (Photographer)	1910	Pictureseque Pickering	Yorkshire	NER	DR	SSPL	10172591	Yorkshire77	1986-8993
Photochrom	1909	England's First Aviation Races at Doncaster	Yorkshire	GNR	DR	SSPL	10198438	Yorkshire78	1987-0736
Mason, Frank Henry Algernon	1933	North East Coast: Crabs: Scarborough	Yorkshire	LNER	DR	SSPL	10174615 Drawer D098	Yorkshire79	1978-9588
Anon	1909	First Aviation Meeting in England: Doncaster	Yorkshire	Publicity poster	DR	SSPL	10198439	Yorkshire80	1987-0737
Bell, Stuart	1989	Embsay Steam Railway: Yorkshire's Friendly Line	Yorkshire	Embsay Rly	DR	SSPL	10170916	Yorkshire81	1989-7221
Anon	1950	1/2 day Excursion: Penistone + Wath to Bridlington Yorkshire	Yorkshire	BR(ER)	DR	SRA postal			
Grimshaw, T (photo)	1960s	Discover Leeds, Settle and Carlisle: scenic rly	Yorkshire	Cumbria CP	QR	Solent			
Anon		Fountains Abbey	Yorkshire	LNER	DR	NRM	1987-8810		1987-8810
Cooper, Austin	1932	Scarborough	Yorkshire	LNER	QR	HTP21			
Anon		Scarborough: From Heeley, Rotherham semi-pic	Yorkshire	BR(NER)	DR	MRA			

Information Copyright R. Furness/V.Kilvington

Entries made up to 31/01/2010

Posters and Prints

- Bownes, D. and Green, O. (Eds.) (2008). *London Transport Posters – A Century of Art and Design*. Lund Humphries (Publishers) , Aldershot, Hampshire, GU11 3HR. ISBN 978-08533-1984-9
- Cole, B and Durack, R.(1992). *Railway Posters 1923-1947*, Laurence King Publishing, London. ISBN 1-85669-014-8
- Delicata, A. and Cole, B. (2000). *Speed to the West GWR Publicity and Posters 1923-1947*. Capital Transport Publishing, London ISBN 185414-228-3
- Furness, R.A (2009). *Poster to Poster Volume 1: Scotland*: JDF and Associates Ltd, Gloucestershire: ISBN 978-9562092-0-7
- Green, Oliver (1990). *Underground Art: London Transport Posters 1908 to the Present*. Laurence King Publishing London. ISBN 1-85669-166-7
- Hillman, T. And Cole, B. (1999). *South for Sunshine- SR Publicity and Posters 1923-1947*. Capital Transport Publishing, London. ISBN 185414-213-5
- Norden, G. (1997). *Landscapes under the Luggage Rack*, GNR Publications Northampton, UK. ISBN 0-95296-02 0-6
- Palin, M. (1987). *Happy Holidays*, Pavilion Books, ISBN 1-85145-130-7
- Shackleton, J.T. (1976). *Golden Age of the Railway Poster*. New English Library ISBN 0-450031-168-3
- Scarborough Borough Council (1990). *Railway Posters of the Yorkshire Coast*. Printed by E.T.W. Dennis and Sons, Scarborough. ISBN 0-9051-2002-7

Railways

- Biddle, Gordon (2003). *Britain's Historic Railway Buildings*. Oxford University Press. ISBN 0-19-866247-5
- Biddle, G and Nock, O.S (1983). *The Railway Heritage of Britain*. Studio Editions, Sheldrake Press, London. ISBN 1-851170-595-3
- Bonavia, M.R: (1990). *A History of the LNER: part 1 – The Early Years 1923-33*. George Allen and Unwin 1990 reprint of original 1983 book
- Bonavia, M.R: (1990). *A History of the LNER: part 2 – The Age of the Streamliners 1934-39*. George Allen and Unwin 1990 reprint of original 1983 book
- Bonavia, M.R: (1990). *A History of the LNER: part 3 – The Last Years 1939-48*. George Allen and Unwin 1990 reprint of original 1983 book
- Butt, R.V.J. (1995). *The Directory of Railway Stations*. Patrick Stephens Ltd, Sparkford, Somerset BA22 7JJ. ISBN 1-85260-508-1
- Carter, E.F. (1959). *An Historical Geography of the Railways of the British Isles.* Cassell & Company, Red Lion Square London WC1
- Crawley, J (2001). *The London North Eastern Railway in Focus*. Wharton Press, Northamptonshire. ISBN 1-899597-12-3
- Edwards, C. (2001). *Railway Records: A Guide to Sources*. Public records Office, Richmond. ISBN 1-903365-10-4. Cromwell Press, Trowbridge
- Fawcett, W. (2001). *A History of North Eastern Railway Architecture: Part 1*. NE Railway Association, ISBN 1-873513-34-8. Printed by Amadeus Press
- Fawcett, W. (2001). *A History of North Eastern Railway Architecture: Part 2*. NE Railway Association, ISBN 1-873513-48-8. Printed by Amadeus Press
- Gammell, C.J., (1980). *LMS Branch Lines, 1945 - 1965*, Oxford Publishing Company, ISBN 0-86093-062-9
- Gammell, C.J., (1999). *Scottish Branch Lines*, Oxford Publishing Company, ISBN 0-86093- 540-X

- Hamilton Ellis, C. (1959). *British Railway History 1877-1947*. George Allen and Unwin Ltd. London. 2nd edition (1960)
- Hendry, R.P. and Hendry, R.P. (1982). *An Historical Survey of selected LMS Stations, Layouts and Illustrations, Volume 1*, Oxford Publishing Company, ISBN 0-86093-168-4
- Hoole, K (1986). *Rail Centres – Newcastle*. Ian Allan Publishing Ltd. ISBN 0 7110 1592 9
- Jenkins, S.C and Quayle, H (2006). *Railways Across the Pennines*. Ian Allan Publishing Ltd. ISBN 0-7110-1840-5.
- Jowett, Alan (1989) *Jowett's Railway Atlas*. Guild Publishing London. Ref CN2155
- Morrison, G. (1999). *Scottish Railways New and Then*. Ian Allen Publishing , Shepperton Surrey UK ISBN 0-7110-2684-X
- Nock, O.S. (1982). *A History of the LMS. Vol. 1: The First Years, 1923-1930*, George Allen & Unwin, ISBN 0-04-385087-1
- Nock, O.S. (1982). *A History of the LMS. Vol. 2: The Record Breaking 'Thirties, 1931-1939*, George Allen & Unwin, ISBN 0-04-385093-6
- Simmons, J. (2009). *The Victorian Railway*. Thames & Hudson, London WC1V 7QX. ISBN 978-0-500-28810-8
- Simmons, J and Biddle G. (1997). *The Oxford Companion to British Railway History*. Oxford University Press. ISBN 0-19-211697-5
- Vaughan, A.(1990). *Signalman's Reflections*, Silver Link Publishing, ISBN 0-947971-54-8
- Whitehouse, P. and Thomas, D. St. J. (1995). *LMS 150: The London, Midland & Scottish Railway: A Century and a Half of Progress*, Greenwich Editions, ISBN 0-86288-071-8 [Recommended for general LMS overview]
- Whitehouse, P. and Thomas, D. St. J. (1989). *LNER 150: The London North Eastern Railway: A Century and a Half of Progress*, David and Charles, Newton Abbott. ISBN 0-7153-9332-4 [Recommended for general LNER overview]
- Wignall, C.J (1985). *British Railways Maps and Gazetteer 1825-1985*. Oxford Publishing Company. ISBN 0-86093-294-X

Miscellaneous

- Boumphrey, G. (1964). *Shell and BP Guide to Britain*. Ebury Press: George Rainbird Ltd. London W2.
- Grimson, J (1976). *The North Sea Coasts of England*. Robert Hale and Company Ltd, London EC1. ISBN 0-7091-5557-3
- Mee, A (1964). *The Kings England: Northumberland.* Hodder and Stoughton Press, London EC4
- Pearson, M: (2007). *Iron Roads North of Leeds*. WayZgoose. ISBN 0-9545383-5-8
- Pevsner, N (1966). *The Buildings of England: Yorkshire North Riding*. Penguin Books, Harmondsworth, Middlesex. ISBN 0 14 071029 9
- Somerville, C (2008). *The Living Coast -Aerial Views of Britain's Shoreline*. Last refuge Publications, BA5 1PN. ISBN 978-0-9558666-0-9
- White, P.A: (1971). *Portrait of County Durham*. Robert Hale and Company, London SW7. ISBN 7091-0995-4
- Wood, G.B: (1967) *Yorkshire.* B.T. Batsford Ltd, London.
- Wood, G.B: (1971). *Yorkshire Villages*. Robert Hale London. ISBN 0-7091-8144-2

Poster Image Sources

All Images [see pages (iii) to (x) for details] courtesy SSPL/NRM National Collection except for:

Authors Collection:	Images 1, 29, 45, 63, 80, 120, 149, 167, 204, 314, 316, 328, 334
Bonhams	Image 243
Bridgeman Art Library London	Images 138,161, 206, 278
Buckle Estate Trust	Image 79
Norden Carriage Print Collection	Images 90, 96, 208, 230
Onslows Poster Library	Images 12, 13, 150, 307, 337, 363, 373
Scarborough Borough Council	Images 386, 387

Authors Note: Strict copyright protection exists for all the images in this book. Copying and reproduction by any means is expressly forbidden under existing copyright laws. The Author acknowledges the assistance of Tom Vine at the Science and Society Picture Library, Joanne Hardy at the Bridgeman Art Library, Patrick Bogue at Onslows, Greg Norden at the Travelling Art Gallery and Gabrielle Jandzio of Scarborough Borough Council in helping to source image copyright. All due care, attention, and due diligence has been employed in this research with regard to the traceability and establishment of copyright.

SSPL Prints

Most of the posters featured in this series are available to purchase as prints from www.ssplprints.com, the official print sales website for the National Railway Museum, York. The large number of SSPL historical posters includes the largest collection of railway posters in the world. They are available in sizes A0 down to 8" x 6", framed or unframed.

Recommended Websites www.railway-posters.com

www.nrm.org.uk	www.scienceandsociety.co.uk	www.ssplprints.com
www.onslows.co.uk	www.christies.com	www.bridgemanart.com
www.travellingartgallery.co.uk	www.travelpostersonline.com	www.ltmuseum.co.uk

The series of poster books will now number eight in total. They will appear at regular intervals over the next three years. Eight volumes, each of more than 250 pages, and featuring more than 300 posters per volume, allows many previously unpublished posters from Victorian to Modern Times to be seen as intended – an inducement to travel. Each volume has a regional focus (the first time this has been attempted) and the locations will be based on the older British county names rather than the modern administrative areas. This is in keeping with more than 80% of the classic images used. The books are largely colour-coded (where possible) to match the regional colours used by British Railways after 1948.

The next volume to appear will be Volume 5, written out of sequence. This covers an area of England I grew up in, and am now involved with the various railway preservation societies, who expressed the wish for their area. This covers the Midlands and Wales and features a journey from Buxton, Derbyshire to Pembroke, South Wales. It will cover (and include) posters from the counties of Derbyshire, Nottinghamshire, Leicestershire, Northamptonshire, Warwickshire, Oxfordshire, Gloucestershire, Worcestershire, Staffordshire, Shropshire, Herefordshire, Monmouthshire, plus Mid-Wales and South Wales (the old-named counties of Merioneth, Montgomery, Radnor, Cardigan, Monmouth, Brecknock, Glamorgan, Carmarthen and Pembroke). The front cover is Alan Carr Linford's wonderful Oxford High Street with Leonard Richmond's Tintern Abbey on the rear.

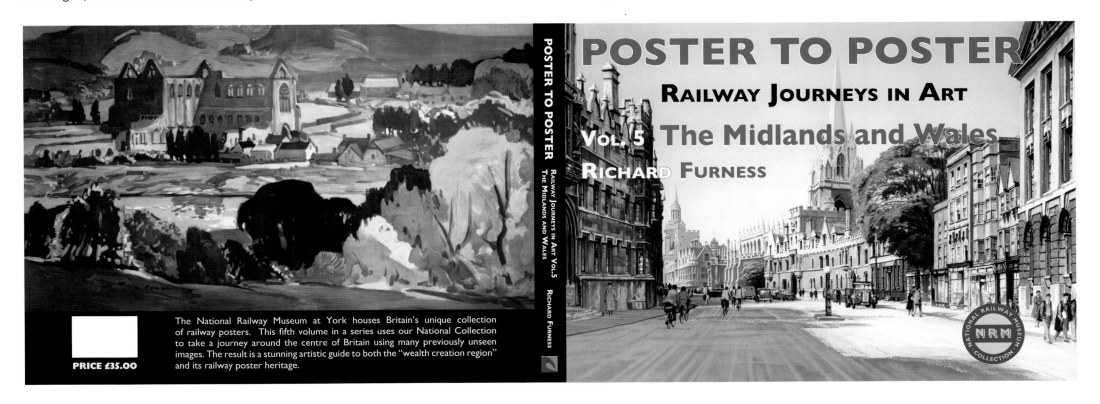

POSTER TO POSTER

POSTER TO POSTER

RAILWAY JOURNEYS IN ART

VOL. 5 The Midlands and Wales

RICHARD FURNESS

POSTER TO POSTER RAILWAY JOURNEYS IN ART VOL.5 THE MIDLANDS AND WALES RICHARD FURNESS

The National Railway Museum at York houses Britain's unique collection of railway posters. This fifth volume in a series uses our National Collection to take a journey around the centre of Britain using many previously unseen images. The result is a stunning artistic guide to both the "wealth creation region" and its railway poster heritage.

PRICE £35.00

The area covered by Volumes 3, 4, 6 and 7 their covers are shown below. They will appear at approximately 6 monthly intervals in 2011 and 2012.

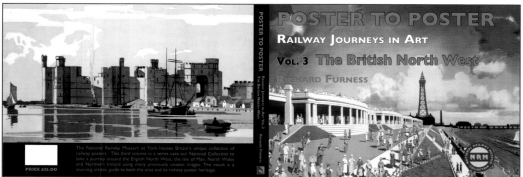

Vol. 3 North West England, North Wales, Northern Ireland & Isle of Man

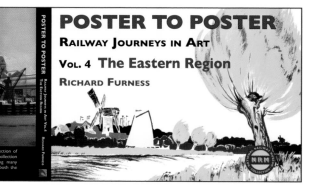

Volume 4: The Eastern Counties of England, Lincolnshire down to Essex

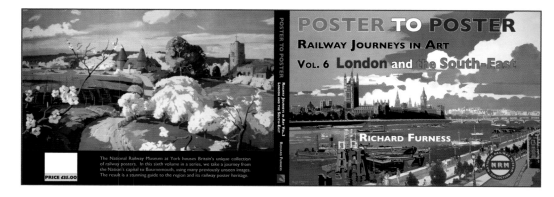

Volume 6: London, Kent, Sussex, Surrey, Berkshire and Hampshire

Vol. 7: Somerset, Wiltshire, Dorset, Devon, Cornwall, Scilly & Channel islands

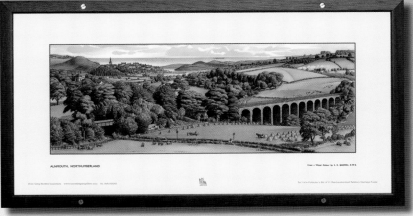
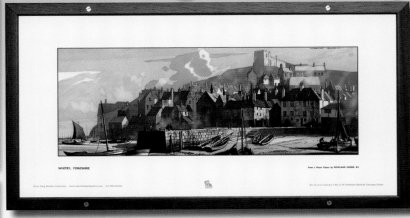
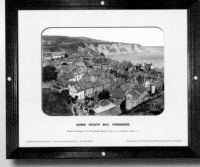

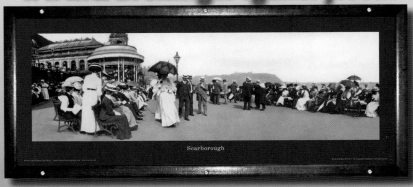

Already Available

The first Volume in the series (Scotland) was published in July 2009. It has received critical acclaim since publication, winning '**Non-fiction Book of the Year 2009**' from the Edinburgh Evening News. The volume features some 330 Scottish posters in a volume of 250 pages total. ISBN 978-0-9562092-0-7 and available directly from **JDF and Associates Ltd, Rydal Water, The Old Pitch, TIRLEY, Gloucestershire GL19 4ET.** It can be ordered on the Internet from <u>www.railway-posters.com</u>.

Review Comments Include:

"*Evocative, comprehensive and stunningly illustrated, this Magnum Opus is destined to become a classic*" **Railway Antiques Gazette**

"*Some books just sell themselves and none more so perhaps than Richard Furness's Poster to Poster*" **Edinburgh Evening News**

"*Dr Furness has done a superb job in recording for posterity, the significance of these National Treasures*" **Friends of the National Railway Museum**

"*A hitherto neglected subject is well served by this, undoubtedly definitive, work*" **Scottish Railway Preservation Society**

"*It is a lovely book that is also an important and fascinating reference: Recommended*" **Editor: Steam Railway**

"*A stunning artistic guide as well as a comprehensive look at Scotland's railway poster heritage*" **The Scotsman**

"*A great book that should appeal to everyone, not just railway enthusiasts. Well worth the cover price*" **Editor: Railways Illustrated**

"*This book is astounding: If you love Scotland and her railways, this is a MUST for the collection*" **Editor: West Highland News**

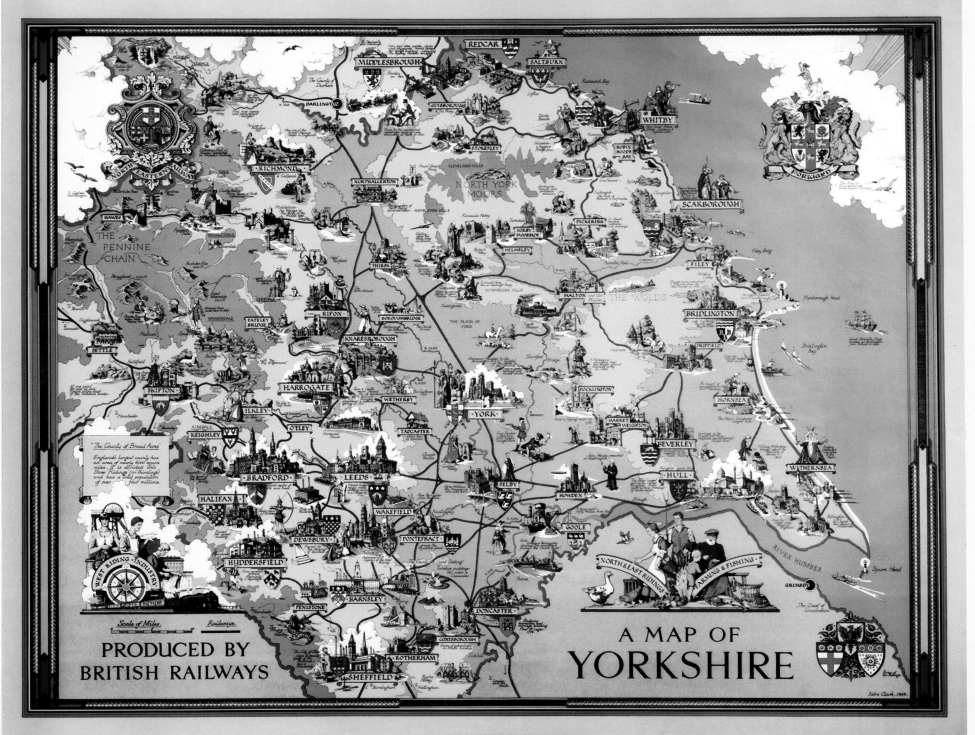

PRODUCED BY
BRITISH RAILWAYS

A MAP OF
YORKSHIRE